SPECULATIVE ART HISTORIES

Analysis at the Limits

Edited by Sjoerd van Tuinen

EDINBURGH
University Press

Edinburgh University Press is one of the leading university presses in the UK.
We publish academic books and journals in our selected subject areas across the
humanities and social sciences, combining cutting-edge scholarship with high
editorial and production values to produce academic works of lasting importance.
For more information visit our website: edinburghuniversitypress.com

Edinburgh University Press Ltd
The Tun – Holyrood Road, 12(2f) Jackson's Entry, Edinburgh EH8 8PJ

Typeset in Warnock by Biblichor Ltd, Edinburgh,
and printed and bound in Great Britain by
CPI Group (UK) Ltd, Croydon CR0 4YY

A CIP record for this book is available from the British Library

ISBN 978 1 4744 2104 1 (hardback)
ISBN 978 1 4744 2106 5 (webready PDF)
ISBN 978 1 4744 2105 8 (paperback)
ISBN 978 1 4744 2107 2 (epub)

This book is published in association with Witte de With
Center for Contemporary Art, Rotterdam.

Contents

List of Figures

Acknowledgements

This collection of essays is published following the three-day international research symposium *Speculative Art Histories*. This symposium took place in May 2013 and was organised by Samuel Saelemakers (Witte de With Center for Contemporary Art) and Sjoerd van Tuinen (Centre for Art and Philosophy – Erasmus University, Rotterdam) with the help of the Faculty of Philosophy and the Erasmus Trustfund of the Erasmus University, Rotterdam. Thanks to Jelle Baan for proof-reading and indexing, thanks to Marnie Slater for formatting and revising the manuscript and to Carol Macdonald at Edinburgh University Press for her enthusiasm.

Foreword

Speculating wildly

THERE IS A certain wildness inherent to the word speculation. Although the concept has by now firmly found its place in the language of international contemporary art – roughly since 2007, the year the Speculative Realism conference was held at Goldsmiths College – its more customary habitat of capitalist economics and globalised finances has since then certainly not failed to put into practice the principles of speculative action nor to illustrate its unruly outcomes. In today's art world, speculation seems to be most often used as a term to validate the love of open-endedness so embedded in many contemporary art practices. Regardless of the question whether indeterminacy is a valid artistic strategy or not, the tolerance of the use of speculation, especially in its manifestation as a verb, seems to be wearing thin by now. And, although in philosophy the adage reigns that an idea one cannot formulate clearly is an idea one hasn't quite understood, speculative writing, tentative formulations and variations of thought are common throughout the entire history of philosophical thinking. By speculating wildly, both art and philosophy seek to break away from pre-given boundaries or definitions. *What if . . .*

The increased use of speculation as a term and as a strategy can be considered in parallel to the decline or even complete absence of absolute or finite systems of meaning in both contemporary visual art and philosophy. When speculative realism is described as a proper school of thought, this act of delineation is always immediately countered by the statement it is no such thing. It seems this day and age is too volatile to support any grand philosophical systems or pictorial regime.

Both art history and art philosophy suffer from the same all too easily formulated accusation: either they contain too little art, or they neglect to obey the academic

principles of history and philosophy respectively. In this volume, the two domains of inquiry meet and philosophy ventures into the realm of art history. The book stems from a year-long reading group held at Witte de With Center for Contemporary Art and organised together with the Centre for Art and Philosophy of the Erasmus University. The reading group focused on recent writing by philosophers gathered under the umbrella of Speculative Realism, as well as canonical art historical texts which sought to reinvent the way art history could be written. The aim was to investigate the possibilities the so-called speculative turn in continental philosophy holds for art history and art theory. Authors that were studied include John Dewey, Georges Didi-Huberman, Henri Focillon, Michael Fried, Graham Harman, Brian Massumi, Quentin Meillassoux and Reza Negarestani. The reading group lead to a three-day research symposium, the results of which are gathered in this collection of essays.

When we return to the linguistic roots of speculation, we encounter the Latin word *specularia*, which means both 'window' and 'to look'. I would like to thank all contributing writers for opening so many unexpected windows and perspectives on art and art history. On behalf of Witte de With I also extend my gratitude to Sjoerd van Tuinen, all reading group participants and the Centre for Art and Philosophy – Erasmus University for their commitment to the project.

Samuel Saelemakers
Curator Witte de With Center for Contemporary Art

Introduction

Sjoerd van Tuinen

THIS BOOK EXPLORES some of the implications of and opportunities within the speculative turn in continental philosophy from the perspective of art history. Speculation? Besides its only legitimate domain today, that of finance, is this not a thing of the past, when metaphysicians were used to making unverifiable claims about the nature of God, the World and the Self? From Kant to Wittgenstein, critical philosophy has taught us to remain silent on that of which we cannot speak. Likewise, art history has come a long way in establishing itself as a positive human science independent from its metaphysical beginnings. In both cases, enlightened, self-critical and self-reflective thought has worked hard on closing the door to ontology, on reducing the Ideas of reason to ideology and on limiting the domain of knowledge to phenomenal objects. Speculation, it seems, has not been *en vogue* for quite some time.

Quentin Meillassoux has recently labelled the anti-speculative status quo as 'correlationism': the conviction that there can be no access to a reality that is independent of human subjectivity and its mediations through the senses, the unconscious, language, technology or, indeed, art and aesthetics.[1] If, by contrast, new speculative philosophies realign themselves with pre-critical philosophy, this is not necessarily because they cultivate a dogmatic belief in the powers of human reason, but because the inherent limitations of the critical (i.e. relativist) stance become more apparent by the day. We urgently need to get over ourselves. Just as the financial crisis teaches us that the future must be reclaimed from those speculative investments whose only aim is to cancel it out, the slow awareness that we are living in the Anthropocene forces the humanities to resituate themselves with a much less anthropocentric and much more inclusive perspective. As Peter Sloterdijk writes, the problem with the grand narratives of metaphysics was not that they were too big, but rather that they were not big enough.[2] The problem of

philosophy is no longer the contradictions to which every attempt to find first principles necessarily falls victim, just as the problem of the humanities is no longer the losing out of facts to theoretical illusion. On the contrary, the facts themselves appear in a new light and with new depth, which involve the future of life and the cosmos. It is time for a new, speculative realism, which treats human beings, science, and social relations as things having no more status than neutrinos or jellyfish. It is time for a *bio-* or even a *geo-art-history*. Whereas art history is a fetishist, even *the* fetishist, historical discipline, Adi Efal in her contribution to this book develops the concept of habitude as a tool through which speculative art history can understand the work of art as produced thing, and therefore as inseparable from its mesh of conditions of production and duration. The same goes for art itself. Paraphrasing from the chapter by Elisabeth von Samsonow: if ours has been the age of 'archiheresy', a period characterised by the dissimulation of the ontological tie between architecture and the earth, architecture itself should learn to overcome the fetishisation of its objects and become a para-geology.

Speculative philosophy seeks to recuperate a pre-critical sense of, and more direct access to, something Absolute, an Outside called Spirit, Life, Chance, Nihil or a Nethermost point of view, while also taking into account the undeniable progress that is due to the labour of critique. The nature of this Absolute and the principles according to which it can be thought form the bifurcation points between the various, often mutually excluding speculative trajectories. This book uses an extended concept of speculation, which covers not only the rationalistic nihilism of Ray Brassier, the accelerationism of Reza Negarestani, the object-oriented ontology of Graham Harman, the philosophy of nature of Iain Hamilton Grant, and so on, but also includes the transcendental empiricism of Gilles Deleuze, the speculative constructivism of Isabelle Stengers, the speculative pragmatism of Brian Massumi and the new materialism of Karen Barad. Perhaps what unites all these positions is a common enemy: if not Kant, then at least a shallow neo-Kantianism, or the reduction of critical thought to the legitimation of what already exists and the defence of human values. Even if few speculative philosophers would acknowledge it, and some would resolutely deny it, speculative philosophy is thus reminiscent of the romantic and vitalist reactions to the eighteenth-century Enlightenment. This reminiscence becomes all the more striking as it is particularly in circles of contemporary art and its institutions that its concepts have found resonance. Hence the question posed by this book: how could today's materialist, realist, pragmatist, object-oriented, vitalist and/or rationalist speculations, as well as speculative art histories from the past, offer alternatives to the contemporary complementarity of the philosophy of art (including aesthetics) and art history, often based on mutual recognition and critical limitation rather than imaginative crossover?

In order to see where the contemporary speculative turn differs from romanticism, it is instructive to have a look at Jean-Marie Schaeffer's famous critique of the speculative idealist theory of art. In his *Art of the Modern Age: Philosophy of Art from Kant to Heidegger* (1992), Schaeffer famously locates the birth of the speculative theory of Art in the shift from Kantian aesthetics to romantic aesthetics.[3] Since it was rooted in an experience of disorientation and nostalgia, he argues, romanticism must be seen as the restorative reaction to the Enlightenment as embodied by Kant. It compensates for the crisis in the religious foundations of humanity and for the crisis in the transcendental foundations of philosophy with the mirage of Art as the privileged medium for the harmonious and organic reintegration of everything that seemed discordant, alienated and dispersed. From Novalis, Hölderlin and the Schlegel brothers to Schelling, Schopenhauer and Nietzsche and even to Heidegger, romantic speculation would thus consider art to be a more adequate expression of the Idea than philosophical discourse, and attributes to it the power of access to something absolute where philosophical discourse fails. In this way, romanticism performs a 'sacralization of art',[4] even if it is still up to philosophical discourse to provide its legitimation. For precisely by seeking the essence of art in a cognitive and ontological status that would be peculiar to it, philosophy simultaneously makes this essence into art's dogmatic foundation.

According to Schaeffer, the idea of art as ontological revelation has been the *doxa* of reflection on art and its discourse of legitimation from romanticism to modernism. For almost 200 years, art has been the Other of philosophy, the place where the latter would reflect itself, all the while compromising our actual relation to the arts in their historical plurality and variability. By contrast, Schaeffer seeks to return to a strict distinction between art and speculative thought and regain a view on 'the multiple and changing reality of the arts and art works'.[5] Neither art theory nor art practice, he argues, has ever needed philosophy to exist. Art is not even an object endowed with an internal essence but 'only is (becomes) what people make of it'.[6] Philosophically, this positivist self-limitation of philosophy to an empirical point of view coincides with a 'come-back to Kant', that is not Kant's theory of art (which does not exist[7]), but Kantian aesthetics as a critique of the discourse on art: 'a declaration of the cognitive nullity of any philosophical doctrine founded on a definition of the essence of art, and a limitation of aesthetic discourse to the critical evaluation of art works and (I would add) to the study of their phenomenal judgment.'[8] In other words, the Kantian correlationism between the thing in itself (the object) and its enjoyment by us (the subject) is re-established, as is the wrenching duality of aesthetic reception and artistic production, or the duality of aesthetics as a theory of natural beauty and a theory of artificial beauty. Philosophy is good only for meta-aesthetic contemplation: an anthropology of aesthetic experience and an inquiry into the status and legitimacy of judgements of taste.

Schaeffer's critical or anti-speculative return to Kant mirrors the development of art history in the past century. Initially, the speculative theory of Art marked the rise of historicism, which turned works of art into empirical manifestations of transcendental determination (this involved evolutionism as much as objective idealism). It is from historicism, especially Hegel's compelling account of the relation between art's history and the emergence of art as historical object,[9] that art history was born. For reasons of brevity, we mention here only the vehement interpretative gestures of the Vienna School, from Aloïs Riegl's *Kunstwollen* to Hans Sedlmayr's *Strukturanalyse*.[10] Much more than Panofsky or Gombrich, who would later deal with the instability they found in works of the past by injecting them with redeeming universal or humanist content, the authors from the Vienna School liberated themselves from any empiricist superintendence. By draining individual works of art of mimetic reference and symbolic content, as Vlad Ionescu shows in his contribution to this book, they made them look all the more inhuman and prodigal, dissipating human subjectivity in anonymous landscapes through the concept of mood. Their method of extracting the transcendental schema from the work of art would be taken up by authors writing on the interface of philosophy and art history such as Georg Lukács, Walter Benjamin, Mikhail Bakhtin, Viktor Shklovsky, Aby Warburg, Theodor Adorno and Henri Focillon. Regardless of the differences in the traditions these figures come from, each of them defies the empiricist complacency and the overwhelming bias within the humanistic disciplines towards classicism. Whether it is through eidetic apprehension, montage, intuition or Gestalt psychology, their aim is always to produce historical intelligibility by discovering the virtual presence of the world at large (e.g. the anonymous history of 'style', the cyclical 'life of forms', symbolic structure, the state of development of the means of production, and so on) inside the concrete work of art.

But if speculative intuition lay at the origin of art history, albeit hidden behind the mask of scholarly conventions, the young discipline was quick to exhaust its speculative potential. As Georges Didi-Huberman points out in his influential, even if somewhat partial discussion of Panofsky, the latter's re-edition of *Idea* features a preliminary warning (CAUTIUS!) that should protect his discipline from immoderations in the cognitive exercise of reason. It is this fear that led art history to the anti-speculative stance that it has consolidated until today: 'Panofsky's *CAUTIUS* is not only a call for prudence; it is the cry of someone who went too far into the shifting sands of philosophical idealism, and who found only the worst branch – that of positivism, of iconography in a shrunken sense – to prevent his sinking.'[11] Even the recent calls for more interdisciplinarity, heard in art history and art theory no less than in academic circles, tend to consolidate this call for prudence more than they overcome it, as the modern gap between philosophy and art history, and the postmodern call for more interdisciplinarity are both equally inspired by a consensual

abhorrence of more speculative approaches to art. Thus while it is easy to see how, in the course of the twentieth century, art history and the philosophy of art have followed diverging trajectories, it is also important to point out that they converge in at least one respect. Just as art history, in order to establish itself as a scientific discipline, has inclined towards a positivist and objectivist 'analysis' of art (iconology and semiotics), the professionalised philosophy of art has tended towards the facticity and subjectivism of strong correlationism (hermeneutics and phenomenology). Both have come either to focus on themes and meanings, general tendencies of the psychology of perception, cultural symptoms and other kinds of humanist knowledge, or to suspend their intrinsic sense of problematising in their admiration of science, media and technology. For this reason, it was common to speak equally of the 'end of Art', the 'end of history' and the 'end of metaphysics' not so long ago. It is against this defeatism in art history and philosophy alike that this book takes a stance.

One recent attempt to reassess the gains as well as the limits of speculative approaches to art history can be found in Peter Osborne's *Anywhere or Nowhere at All: Philosophy of Contemporary Art* (2013). By pointing out that contemporary art is post-conceptual (as opposed to aesthetic) art, Osborne argues against Schaeffer's metaphysical disinvestment of our understanding of art, as if the latter would 'get along very well on its own' (i.e. without critical discourse). In fact, this disinvestment has opened an immense gap between canonical art history and contemporary art. If modernism simultaneously adhered to the idea of the work of art and sought to dismantle it, and if postmodernism continued to draw on history to provide meaning all the while replacing one compelling Art History with multiple empirical art histories,[12] then the exodus of contemporary art from the narration of art from the point of view of aesthetics has famously led to a legitimation crisis of art. In this more-than-post-historical context, the popularity of speculative theory in contemporary practice may well be a sign of the fact that art's authority and critical function remain problems for which its metaphysical dimensions are a conceptual condition.[13] Even if it is not reducible to them, contemporary art and its critics, theorists and practice-based researchers therefore thrive on discursive and philosophical resources. Perhaps we could even say that philosophy has become art's Other and that critical art now equals art criticism. Whereas Schaeffer completely disconnects art history from art criticism, or subordinates the latter's question 'What is art?' to the former's empirical answers, Osborne seeks to regain a post-Hegelian conception of art history as historical reflection, that is an art history capable of restoring to 'art criticism its central role in constituting the history of art, not simply at the level of its canon, but at the level of the historical temporality of art itself.'[14]

In the opening chapter of this volume, Armen Avanessian makes a similar argument vis-à-vis aesthetics. If contemporary art happens outside of art's history, its

a-synchronous present cannot be captured by the senses and their recognised material reality. To the extent that philosophy serves as an orientation in the present, correlationism is therefore by definition deficient. Whereas aesthetics already binds the contemporary to the empirical status quo of its immediate past and implements the hermeneutic relation between the object and its observer or reader, only a new, speculative proposition can make us grasp contemporary art in its heterochronic contemporaneity. The present, Avanessian argues, exists only by virtue of a poetic fiction gathering together various diverging and non-sensible pasts. For this reason, Érik Bordeleau demonstrates in his reading of Taiwanese cinema, speculation must be understood as the cultivation of the sense and presence of the possible (as opposed to the probable) in a given, historical situation. Through speculation, philosophy itself becomes an art of immanent attention.

Besides answering to the problematic of art criticism and the contemporary, however, the speculative turn may also offer new possibilities for reinterpreting multiple art histories according to their anachronistic logic and diffractive ontology. Only from the modernist point of view are we forced to say that speculation, like art, is responsible for the future, whereas art history is responsible for the past. But this denies the plasticity of becoming in which history finds its very *raison d'être*.[15] Worse still, from the modernist perspective the very identity and interiority of the idea of art's history – as opposed to natural history – implies human subjectivity as its unchanging basis of meaning and composition. Traditional art history is therefore correlationist not accidentally but essentially and necessarily. By 'traditional', we mean art history in its objective genitive sense, i.e. in the sense of the *history* of art. A speculative perspective, by contrast, is focused on the history of *art* in its subjective genitive sense.[16] Following Henri Bergson, the aim of such a history would be to reconnect with the living sources in the historical genesis of art. These creative forces of art are by definition a-historical and non-artistic in themselves, since they can be human but just as well animal, vegetal or mineral (or indeed technological). As a consequence, we leave the domain of speculative idealism and enter the domain of speculative materialism. It is here, at the illogical level of the genesis and contingency of the new, that speculative philosophy is no longer based on necessary and eternal Ideas but opens up new ways of extending art into biology, mathematics, or the digital – in short, all those forces that never cease to invert the whole system of the fine arts and its orderly linear progression into a simultaneous multiplicity of virtual becomings. Thus while art history can be understood as a system of positive feedback and lock-in relations, as Francis Halsall demonstrates, Kamini Vellodi points out that the new will always be a futural vector outside of historical time and chronological determination.

Even if materiality and physicality have become commonplace in art history, especially since it has passed from museological history and style to archives, media

and images as its privileged objects, they are hardly ever explored beyond the point where the identity of art historical writing as such is put at stake.[17] But perhaps the contemporary breakdown of art as a chronological concept is simultaneously also a speculative breakthrough in which material practices such as the slowness and detail of studio work or the self-abstracting patterning of Gothic architecture and design, stripped from the fetish of the subjectivity and skill of the artist as well as the associated market dominance of the artistic original, again receive the rational and critical attention they deserve. For Lars Spuybroek, our contemporary fascination with crafts and craftsmanship is no longer a symptom of postmodern nostalgia, i.e. past 'options' or 'instances' allowed to make a second appearance. Rather, it is our very experience of time that has changed. What seemed old and left behind by art appears authentically new again. Whereas both modernism and conceptual art developed under the aegis of the sublime, constantly emphasising the aesthetic incommensurability between the product and its process of production, but also between the work as an object and art as idea,[18] Spuybroek rediscovers in the Gothic a concept of a restless vital beauty that resists the claims of correlationism and that is 'too moving to be confined to any particular age',[19] leading to a production aesthetics based on the sympathy between *things in the making*. Similarly, Kerstin Thomas reads the art theories of Focillon and Meyer Schapiro as object-oriented, relational and dynamic positions that are pertinent for overcoming the idealism and language centredness of conventional art historical methods.

Finally, if there is an intrinsic connection or interference between art and philosophy, then we probably should not look for this connection at the level of art history in its objective sense, i.e. at the level of the history of art. We will find it rather at the level of the history of art in its genitive sense. As Bergson (whose work was highly influential for impressionism and Symbolism as well as for Fauvism, Futurism and cubism) argues, if 'art is a figured metaphysics', then 'metaphysics is a reflection of art', while 'it is the same intuition [of the new], variously applied, which makes the profound philosopher and the great artist'.[20] Rather than just another interdisciplinary exercise, the aim of this book is to propose a sort of experimental counter-discourse of speculative art histories. Instead of the kind of inferior empiricism proposed by Schaeffer, which leaves us merely with art theories on one side and art's history on the other as so many accumulated facts, authors in this book such as Bertrand Prévost, Andrej Radman and myself are looking for what Deleuze, following Schelling, has called a 'superior empiricism':[21] a speculative philosophy which seeks its reason in the aesthetic rather than in the conceptual, that is to say in difference behind identity, in intensity below the self-evidence (extension and quality) of the image, in chaos beneath order or, in other words, in a world where both art and philosophy are subject to constant metamorphoses and permutations. Along similar transversal lines,

Fleur Courtois-l'Heureux explores resonances between choreography (Mats Ek's *Shadow of Carmen*) and philosophy (Étienne Souriau's *The Shadow of God*). Whereas specialisation makes scientists, philosophers and artists go ever further in the same direction, Sarah Kolb draws on Roger Caillois's project of a diagonal science in order to establish a dialogue between Bergson and Duchamp. And contrary to practices of artistic research in neo-liberalism, that 'cul-de-sac of the knowledge economy', it is in a project such as Constant's *New Babylon* (1956–69) that Bram Ieven finds a theoretical and aesthetic framework for confronting the reality of the present with new, unstable trajectories of thought.

Notes

1. Quentin Meillassoux, *After Finitude: An Essay on the Necessity of Contingency*, trans. Ray Brassier (London and New York: Continuum, 2008), p. 5.

2. Peter Sloterdijk, *Im Weltinnenraum des Kapitals. Für eine philosophische Theorie der Globalisierung* (Berlin: Suhrkamp Verlag, 2005), p. 14.

3. Jean-Pierre Schaeffer, *Art of the Modern Age: Philosophy of Art from Kant to Heidegger*, trans. Steven Rendall (Princeton: Princeton University Press, 2000), pp. 6–7.

4. Ibid. p. 70.

5. Ibid. p. 13.

6. Ibid. pp. 6, 273–4.

7. Whereas Schaeffer's argument for the disconnection between art and philosophy is based on the premise that the category of art did not exist before romanticism (Jean-Pierre Schaeffer, *Art of the Modern Age*, p. 137), Panofsky has famously traced back the roots of a speculative theory of art to sixteenth-century Mannerism, when it was not the philosophers but the artists themselves who claimed that art is capable of thinking speculatively and not just practically, thus raising for the first time the question of what it means to have an idea in art. Contrary to Panofsky, who famously interprets the doctrine of *disegno* as a rationalist precursor to the Kantian theory of the aesthetic Idea beyond all speculation and cognition, I have argued that Mannerism made speculation immanent to a continuous circuit between thinking, knowing and acting. The artistic idea was not a matter of rational contemplation but of sensible intuition, even if it came to need conceptual legitimation. The real problem of Mannerism, the intuition that led it into conceptual speculation, is thus not that it is devoid of genius or the artistic idea, as Kant once suggested and as is still common sense today, but rather that the speculative idea does not exist outside, and has to be found within, its changing material conditions. See Sjoerd van Tuinen, '*Disegno*: A Speculative Constructivist Interpretation', *Speculations*, V (2014), pp. 434–73.

8. Schaeffer, *Art of the Modern Age*, pp. 12–13.

9. Margaret Iversen and Stephen Melville, *Writing Art History. Disciplinary Departures* (Chicago/London: University of Chicago Press, 2010), pp. 151–73.

10. For an overview, see Christopher Wood's introduction to: *The Vienna School Reader: Politics and Historical Method in the 1930s* (New York: Zone Books, 2003).

11. Georges Didi-Huberman, *Confronting Images: Questioning the Ends of a Certain History of Art*, trans. John Goodman (University Park, PA: Pennsylvania State University Press, 2005), pp. 125, xxv.

12. Hans Belting, *Art History after Modernism*, trans. Caroline Saltzwedel, Mitch Cohen and Kenneth Northcott (Chicago and London: University of Chicago Press, 2003), pp. 7–16.

13. For first assessments, see *Speculative Aesthetics*, ed. Robin Mackay, Luke Pendrell and James Trafford (Falmouth: Urbanomic, 2014), *Realism Materialism Art*, ed. Christoph Cox, Jenny Jaskey and Suhail Malik (New York: Center for Curatorial Studies, Bard College; Berlin: Sternberg Press), and the special issue of *Speculations*, V (2014).

14. Peter Osborne, *Anywhere or Not at All: Philosophy of Contemporary Art* (London and New York: Verso, 2013), pp. 11, 3, 7.

15. Georges Didi-Huberman, *Das Nachleben der Bilder. Kunstgeschichte und Phantomzeit nach Aby Warburg*, trans. Michael Bisschoff (Berlin: Suhrkamp Verlag, 2010), pp. 172–87.

16. I borrow this distinction between two kinds of art history from: Georges Didi-Huberman, *Confronting Images*, p. 39.

17. James Elkins, 'On Some Limits of Materiality in Art History', *Das Magazin des Instituts für Theorie*, 12 (2008), pp. 25–30.

18. Sebastian Egenhofer, 'Aesthetic Materiality in Conceptualism', in *Aesthetics and Contemporary Art*, ed. Armen Avanessian and Luke Skrebowski (Berlin: Sternberg Press, 2011), pp. 87–99 (p. 98).

19. Brian Massumi, 'Foreword', in Lars Spuybroek, *The Sympathy of Things. Ruskin and the Ecology of Design* (London and New York: Bloomsbury, 2015).

20. Henri Bergson, *The Creative Mind: An Introduction to Metaphysics*, trans. Mabelle L. Andison (New York: Philosophical Library, 1946), p. 197.

21. Gilles Deleuze, *Difference and Repetition*, trans. Paul Patton (New York and London: Continuum, 2001), pp. 56–7.

1 Asynchronous Present Past

Armen Avanessian

Introduction

I WILL START WITH an – admittedly polemical – observation: despite their interest in and engagement with contemporary art, most art historians have trouble evaluating art that is being created in their own time, art that points the way, i.e. the way to the future. I do not think that this trouble arises from the intellectual limitations of particular individuals, nor do I think that it stems from a fundamental tension between art *history* and *contemporary* art. That would be too easy. The reason for the difficulties art historians have in dealing with contemporary art has to be a more profound one.

The thesis I would like to develop here is that art theory (like literary theory) has come to uphold a specifically aesthetic understanding of art and of history that is in itself problematic. The problem, of course, applies to (continental) philosophy as a whole: within the set of rules that Jacques Rancière describes as *régime esthétique*, philosophical theory – and philosophy's reinvention of itself via aesthetics around 1800 in particular – plays a central role.

For philosophy, the power grab aesthetics made at the end of the nineteenth century to the detriment of rhetoric and poetics has turned out to be a double-edged sword. This is so first of all because critical aesthetics after Kant, in spite of post-Kantian idealism, rejects philosophy's speculative potential. This results in a self-inflicted limitation, which Peter Sloterdijk describes as follows: 'From the time sovereignty was transferred from theory to modern art, nonsubordinate philosophy continued to be feasible only through an alliance with the arts.'[1]

The question of the relation between art and history is thus a genuine philosophical question and, more precisely, a question of the philosophy of time. How can we think

the present beyond a metaphysics of presence, a present that is neither present as a synchronous unity nor present to us as spatialised materiality? How can we think a con-temporary that is open both to the past and to other presents when the con-temporary is by definition not captured by the senses (which is the precondition for any aiesthetic approach)? The task of a truly con-temporary poetics, of a time-poetics, in my view, then is to articulate a literary- and art-historical alternative that speculatively allows room for the asynchrony of every (past) present.

The following reflections form part of my larger project of poeticising philosophy, a project that opposes the aestheticisation of philosophy.[2] My focus here is on outlining, in broad strokes, a different, poetic model of artistic and literary history.

Why (Aesthetic) Art History Cannot Think Con-temporary Art

Why, then, do aesthetics and aesthetic art history have a problem with certain kinds of art? Examples include, at the beginning of the nineteenth century, the resentful discourse directed by Hegel (and his followers) against the Romantics; a hundred years later, we see the failure of academic philosophy in addressing the artistic avant-gardes; today, an emphatic refusal to think beyond the modes of production and the reception of contemporary art (which is what speculative approaches at the margins of academia attempt to do).

Both contemporary aesthetics – the term 'con-temporary' has to be used with caution – and art history, insofar as it follows the logic of the aesthetic regime, oppose what they see as art theory without art: its concept of art implies an opposition to eccentric concepts without relation to reality and materiality. This tendency is evident as early as Hegel's criticism of Romanticism in the *Aesthetics* or Gustav Spet's criticism of futurism in his *Aesthetic Fragments*. The reason for such incomprehension on the part of the German idealist and the Russian phenomenologist, the reason as well for today's critics' confusion when confronted with 'reasons to destroy contemporary art' (Suhail Malik), is that the material, aiesthetic basis of art, which is the *sine qua non* of aesthetics, has come under threat. This is not to take up the debates proliferating since the 1960s about dematerialised or immaterial art: such practices have long since been integrated into the processing plant that is the art market, aided and abetted by an always so critical art criticism. 'The greater part of "art criticism" is – now willingly, now unwittingly – a propaganda tool for a "market-compliant" discourse.'[3] Rather, what begins to appear on the horizon of neo-liberal post-democracy is the necessity of an art beyond spectatorship, of artistic practices that draw consequences from the general economic and consumerist deployability of art (objects): 'In theory as in practice, much depends on whether we will succeed in undoing the fetish character of the work of art.'[4] Most recently, Markus

Metz and Georg Seeßlen's comprehensive study, *Kunst frisst Geld – Geld frisst Kunst* [*Art Eats Money – Money Eats Art*], has discussed the re-mythologisation of art objects in the course of the last few years. 'In the "popular super-object", art has entirely turned into a myth once more, into a "myth of the everyday", and, 'the super-object represses the interest in the object of art.'[5] But what if there is no repression and no return to an authentic interest in art objects? Using a concept of Timothy Morton's, we ought perhaps to identify the art objects relevant in our present (and, all the more so, in the future) as *hyperobjects* that, instead of benefiting from a neo-liberal art market's catering to a regressive desire for (super-)objects, tend to further accelerate the existing conditions of production, communication or distribution and take seriously the fragmentation that comes with it.[6] Here I am thinking of the different practices of (artist?) groups like K-Hole, DIS Magazine, Shanzhai Biennial and increasingly more others that at least try to move beyond the paradigm of critical art practice and discourse.

Yet my topic here is less the fundamental crisis of contemporary art and its (usually merely) ideological function within post-bourgeois society than it is the complicity of a certain kind of art theory and the general difficulties aesthetic theory encounters in trying to think beyond the status quo. We also have to forego an examination of the history of the problem in favour of a short exposition of the current situation. Salient in this context is Malik's claim that a philosophical materialism or realism 'speculatively indicates the conditions for *another art than contemporary art.*'[7] For Malik, 'realism's provocation to art' positively consists in the fact that it undoes 'aesthetic experience as a condition or term of art, even in the avowal of art's ineluctable materiality.'[8] Malik mobilises the rationalist variant of speculative realism – as opposed to its object-oriented variant – and its explicit opposition to official aesthetics and especially to what Ray Brassier calls the 'specious mystique of aesthetic experience as ethico-political edification.'[9] Such a speculative inhumanism[10] aims to explore the place and status reason holds in subjects, contrary to any aesthetic theory based on 'the perceptual' and 'the psychological', as recently analysed by David Joselit:

> How does a work of art connect to a person? In the past several decades, art history has developed two models for this type of connection: the perceptual, which focuses on optical sensation as a form of knowledge, and the psychological, which attends to how works of art create dynamics of identification between persons and images. As valid as any other, these approaches are typically based on the spectator's self-possession of her subjectivity. Such a presumption of the self as property naturally corresponds to a type of artwork as property (which is the contemporary norm).[11]

What does this imply for the question with which I started, namely for the tension between forward-looking tendencies of art today on the one hand and 'contemporary' aesthetic art history on the other? The problem, it seems to me, is that art historical approaches usually criticise (or misunderstand or vehemently oppose) the (Romantic-avant-gardist) attempt to destroy the material and perceptible basis of art (and this is even more so the case wherever the focus lies on the experiential condition). Because, as we can see again, aesthetics needs this basis to maintain its hegemony: without an aisthetically accessible infrastructure of art, there can be no superstructure of aesthetics (no aesthetic experience so to say, happening between subject and object and supposed to mysteriously transcend both of them). This ignores the futural moment inherent to any present. The present *ipso facto* is not materially available and thus difficult to access aisthetically. (To be clear: this does not imply any 'theoretical' enthusiasm for indeterminacy, the non-identical and other such terms that usually serve as vague promises of a political utopia in 'critical' theory.) This also explains the tendency of aesthetics, which since Hegel has laid out its arguments in art *historical* terms, to base its theory on whatever artistic movement came just before the current one: German classicism in Hegel's case, symbolism in Spet's, and today the art that was most critical (of institutions) in the 1960s and 1970s, along with its epigones. This orientation towards the past – which would be touching were its proponents not so ruthless – obviously does not impede the success of aesthetics. On the contrary: it makes aesthetics or critical-aesthetic thinking the perfect henchman of what Boltanski and Chiapello discuss as contemporary capitalism's critical spirit, what Andreas Reckwitz and others call 'aesthetic capitalism'.[12] Criticism tends to look backwards and aesthetically judge the contemporary in terms of what is already known, what has already shown itself and been there before.

Con-temporary (or) Aesthetics?

Accordingly, art criticism and art history today fail to address (or simply ignore) those 'immaterialisations' in art (and art theory) that seek to oppose the correlationism of contemporary art. Hence the basic assumption of Malik's theory, namely that in

> having a subject of aesthetic experience as its condition *contemporary art is a correlationism.* To be clear: Contemporary art as the aesthetic experience of sense- and value-making, i.e. as the co-constitution of the art object *and* subject, assumes correlationism and reproduces it, affirms it, in every moment of its open-ended experience.[13]

The inability to think a different materialism or realism of art, to think specu-latively, then, manifests itself today in a fetishisation of an aesthetic correlationism first articulated by Kant: subjects encounter works of art as aesthetic objects within a sensual realm; and also the converse: the object needs to be 'completed' by the subject.

That is why it would be a grave misunderstanding and a gross simplification to reduce art historians' trouble with the present to a mere backwardness of individuals. Nor would it make sense to counter the second-to-last conception of art with a conception based on whatever one sees as the latest already-established forms of art. To do so would merely perpetuate a *critical* or *aesthetic* logic. It would not lead to a *speculative* and *poietic* explanation (*poiesis* understood in the original sense of bringing forth something new and pro-ducing a truth). It is more than a coincidence that an art history dominated by aesthetics is oriented towards the past. The peculiar backwardness of the proponents of aesthetics points to the limits of what, following Foucault, could be called their 'critical ontology'.[14] This relates to the question of time on at least two levels: the question of the orientation or direction of time and the question of its starting point. The question is whether time flows chronologically from the past to the present, whether historians look from the present to the past, or whether time runs from the future through the present (in accordance with Quentin Meillassoux's speculative-materialist thesis that 'the past is unpredicta-ble').[15] In order to push the present towards a future worth its name we might be obliged to accelerate towards a futural point of view, looking back at a past that is our (contingent) present.

In that respect I would like to suggest a speculative extension of Foucault's critical-ontological approach, of his attempt at thinking ourselves historically, gene-alogically or, rather, archaeologically. We need an ontology that has a temporal dimension as well. A first element of such an ontology we find in Peter Osborne's argument that the present constitutes itself as a speculative fiction. It can never be the object of an aesthetics but is necessarily the object of a poetics. 'There is no critically relevant pure "aesthetics" of contemporary art, because contemporary art is not an aesthetic art in any philosophically significant sense of the term. And there is no critically relevant non-historical ontology of art'.[16] According to Osborne, then, it is only art that is *contemporary* that can live up to the task of the fictional *poiesis* of a shared present.[17] Philosophical or poetical thinking can only succeed in this task and overcome the resistance of aesthetics by employing a 'post-aesthetic poetics' at which Osborne gestures without ever detailing it.

Asynchronous Present

Yet, the last word has not been said when philosophy is aestheticised in a melancholy turn to the past, when it seeks to avoid the future or a different present that actually points to the 'future'. That is why, for several years now, I have been working on a Speculative Poetics, a project originally concerned with problems in literary history. A pertinent example is the phenomenon of the 'present-tense novel'.[18] Since the middle of the first half of the twentieth century, we have been witnessing the publication of novels written not in the past tense – as they had been for centuries, if not millennia – but in the present tense. To understand these novels, the chronological approach of literary history does not suffice. The history of present-tense novels in the late twentieth century (of which Claude Simon's and Thomas Pynchon's great large novels about the past and about history are an integral part) remains incomprehensible if it is described as a progressive history, i.e. if one posits an avant-gardist leap from the traditional (past) tense of the novel (in classical fiction, characterised by a metaphysics of presence, by a presentification of what is past) to the modern, advanced present tense. Nor is there any continuity between the first present-tense texts (interior monologues, factographic texts, early present-tense novels by Beckett, for example), which focus on the present moment and have long been seen as anti-narrative or anti-fictional, and the history novels about the past of the second half of the century. The difference between the earlier modern and the later 'alter-modern' novels is that the latter seek once more to narrate the past, as classical narration had tried to do, while modernism was highly suspicious of such attempts and suspected them of ideological excess. Yet the alter-modern novel's past is completely different from that of the classical novel. It calls for entirely new temporal means, namely an asynchronous present tense divided in itself, a present tense that is about a (traumatic, inexperienceable or unnarratable) past, a past that has never been present to itself and that no look back from the present, however confident, can describe with any certainty.

For this reason, a speculative literary theory or poetics no longer focuses on great authors or great works, the way classical poetics did and most studies in literary studies still do. It focuses on *literature at large*. 'Asynchrony' has many methodological implications, but it is of special importance for understanding processes of literary development and transformation. If Osborne is right and we have to deal with the 'differential historical temporality of the present', then the 'inadequacy of any merely chronological conception of the time of art history' or literary history can only be overcome by a poetics that takes the temporal character of literature into account (both on the level of linguistics and of the history of language, e.g. by focusing on grammatical details such as tense).[19]

Speculative Temporalities

From the perspective of such an asynchronous poetics of time, the difference between a singular history and a plurality of histories of art or histories of literature lies in that the latter allow for the basic non-simultaneity of our 'current' present as well as for the non-simultaneity of any past present. For in each instance, we live in different presents on the basis of wholly divergent pasts.

This asynchronous conception of time, it seems to me, also lies at the basis of several philosophies in the movement formerly known as Speculative Realism. Examples include Iain Hamilton Grant's reflections on the non-temporal becoming of time or Ray Brassier's nihilistic look back from the future after the extinction of the sun; here, however, I would like to focus only briefly on Meillassoux's thoughts on the topic.

In general, one can say that current speculative philosophy no longer settles for a (philosophical self-)confinement within the boundaries set by criticism and aesthetics. At the same time, however, it is its philosophy of time in particular that distinguishes it from earlier attempts at a speculative overcoming of Kant's critical philosophy. It differs markedly, for example, from Hegel's speculative idealism which, as Catherine Malabou's studies show, is ultimately concerned with smoothing out breaks and asynchronies (of which he is nonetheless fully aware):

> Time for Hegel is understood as the past tense of spirit: spirit must pass over (*übergehen*) into time in order to fulfil its own identity with itself as absolute and eternal. That identity, in its turn, is itself a past but a past not yet temporally passed away. It is the timeless antiquity of 'presence', the *'parousia'* of the absolute.[20]

The figure that best describes Hegel's speculative dialectics is the *anacoluthon*. This figure, Lore Hühn explains, traditionally indicates 'a break in the (grammatical) structure of the proposition'. In Hegel, the anacoluthon becomes the 'figure of a speculative dialectics that recommences time and again intermittently to refract each and every form within itself' and yet in so doing refers to a timelessly past Being.[21] As Hegel writes in the *Logic* (whose temporal ontology is consistently paradoxical or counterintuitive): 'What is thus found only *comes to be* through being *left behind*.'[22]

The difference between Hegel's reflective dialectic of sublation (with its temporal ideal of non-temporality) and a dialectic that is no longer reflective (or critical-aesthetic) but recursive (or poietic-productive) lies in a temporal 'diffraction' (Karen Barad),[23] that conceives of time less in speculative-idealist than in speculative-materialist terms: *the past is unpredictable* in a very material sense. The starting point of Meillassoux's speculative philosophy of time is *ancestrality*: there was a

present that was never present to itself and at which neither we nor any other object were present to experience it. In *After Finitude*, he develops the concept of ancestrality precisely to assign an objective existence to the past (beyond the present). This, however, alters the status and orientation of time as a whole: chrono-logical linearity is replaced by a temporality that arrives from the future and alters both the contingent present and the necessity of the past.

In contrast to the subjectivised past (my own or that of people past), the ancestral past is an originary past that has never been present,[24] at least not to any consciousness. For the purpose of this essay (and maybe moving beyond Meillassoux), we can follow from this: the past, conceived asynchronously, has never *been*, it never *was* present, and it *will* be accessible only from the future. The linguist Gustave Guillaume provides a concrete linguistic foundation for this speculative temporal figure. For him, the present is an *operative time* whose only function is to reverse time. (In this reversal, tense has what Guillaume calls a 'chrono-genetic' function.)[25]

These speculative-linguistic or speculative-poetic reflections also allow us to specify a concept that has recently become popular again but remains underdetermined: the concept of speculation. The idea of non-metaphysical speculation would be to turn the ultimate absence of a ground of all things, their radical contingency, into an absolute. This may lead to a discourse that, far from renouncing reasons and talking nonsense – what Meillassoux calls *déraisonner* – would consist in precise arguments capable of reassessing the problems inherited from the philosophical tradition (e.g. the syntheses of time in Deleuze) or from literary history (e.g. the change in fiction-tenses in the twentieth century or the question of the fundamental asynchrony of narrating in the present).

Such a speculative look back from the future is not the least of reasons for the necessity of thinking a plurality of (literary or art) histories, including histories of our artistic present. Every present is asynchronous and contingent in itself, and it will therefore always be more than *one* past. There is not *one* present, and there are (always) pasts different from the past described by (aesthetic) art history. To poeticise the history of literature or art – as part of a general poeticisation of philosophy – thus means primarily that our task, our ethical and political task, is to produce new pasts *in writing*.

Notes

1. 'Ancient philosophy represents a mistress that politics wanted to make into its maid. In the Christian era, politics itself became the maidservant of theory. [. . .] After its defeat, philosophy agreed to be democracy's maidservant or receptionist. This final subordination characterizes present-day academic philosophy: it imprints philosophy almost

pervasively with an unhappy consciousness based on its concept of the world as well as its scholastic concept.' Peter Sloterdijk, *The Art of Philosophy: Wisdom as a Practice*, trans. Karen Margolis (New York: Columbia University Press, 2012), pp. 100–1, note 11.

2. See Armen Avanessian, *Überschreiben. Ethik des Wissens – Poetik der Existenz* (Berlin: Merve, 2015).

3. Markus Metz and Georg Seeßlein, *Geld frisst Kunst – Kunst frisst Geld: Ein Pamphlet*, quotation trans. Nils F. Schott (Berlin: Suhrkamp, 2014), p. 338.

4. Ibid. p. 474.

5. Ibid. p. 402.

6. Cf. Timothy Morton, *Hyperobjects: Philosophy and Ecology after the End of the World* (Minneapolis: University of Minnesota Press, 2013). I am indebted to Christopher Kulendran Thomas for his insights concerning the application of the concept 'hyperobject' to art theory and to a different kind of art practice.

7. Suhail Malik, 'Reason to Destroy Contemporary Art', *Spike*, 37 (2013): 128–34 (p. 132).

8. Ibid.

9. Ray Brassier, 'Genre Is Obsolete', in *Noise and Capitalism*, ed. Mattin and Anthony Iles (Donostia-San Sebastián: Arteleku Audiolab, 2009), pp. 60–71.

10. In the terms of Kant's aesthetics, this concerns the rejection of an a priori psychologism he and his successors represented. Recent speculative authors focus instead on an a posteriori of the faculties, not their happy and enlivening interplay in aesthetic experience. See Reza Negarestani, 'Synechistic Critique of Aesthetic Judgment', in *Realism Materialism Art*, ed. Christoph Cox, Jenny Jaskey and Suhail Malik (Berlin: Sternberg Press, 2015), pp. 351–62.

11. I would argue that what David Joselit, on p. 60 of his *After Art* (Princeton: Princeton University Press, 2013), considers to be the hegemonic approach of the last decades has been the dominant aesthetic model for the last two centuries.

12. Cf. Andreas Reckwitz, *Die Erfindung der Kreativität. Zum Prozess gesellschaftlicher Ästhetisierung* (Berlin: Suhrkamp, 2012).

13. Malik, 'Reason to Destroy', p. 130.

14. See Michel Foucault, 'What is Enlightenment?', in *The Foucault Reader*, ed. Paul Rabinow (New York: Pantheon, 1984), pp. 32–50.

15. Quentin Meillassoux, 'Time without Becoming', *Spike*, 35 (2013): 28–105 (p. 95).

16. Peter Osborne, *Anywhere or Not at All: Philosophy of Contemporary Art* (London: Verso, 2013), p. 10.

17. Cf. Peter Osborne, 'The Fiction of the Contemporary: Speculative Collectivity and Transnationality in The Atlas Group', in *Aesthetics and Contemporary Art*, ed. Armen Avanessian and Luke Skrebowski (Berlin: Sternberg Press, 2011), pp. 101–23 (p. 109).

18. For a construction of this phenomenon (a construction made necessary by its previous complete absence from literary history and theory), see Armen Avanessian and Anke

Hennig, *Present Tense: A Poetics*, trans. Nils F. Schott (New York: Bloomsbury, 2015). I would also like to note the importance of the collaboration with Anke Hennig especially for this and many other essays.

19. Osborne, *Anywhere or Not at All*, pp. 22, 19.

20. Catherine Malabou, *The Future of Hegel: Plasticity, Temporality and Dialectic*, trans. Lisabeth During (London and New York: Routledge, 2005), p. 3.

21. Lore Hühn, 'Zeitlos Vergangen: Zur inneren Temporalität des Dialektischen in Hegels *Wissenschaft der Logik*', in *Der Sinn der Zeit*, ed. Emil Angehrn, Christian Iber, Georg Lohmann and Romano Pocai, quotation trans. Nils F. Schott (Weilerswist: Velbrück Wissenschaft, 2002), pp. 313–30 (p. 320).

22. Georg Wilhelm Friedrich Hegel, *Science of Logic*, trans. A. V. Miller, §842 <https://www.marxists.org/reference/archive/hegel/works/hl/hl399.htm> (accessed 22 January 2015); cf. Hühn, 'Zeitlos Vergangen', p. 320.

23. See 'Interview with Karen Barad', in *New Materialism: Interviews and Cartographies*, ed. Rick Dolphijn and Iris van der Tuin (Ann Arbor: MPublishing, 2012), pp. 48–70.

24. Quentin Meillassoux, *After Finitude: An Essay on the Necessity of Contingency*, trans. Ray Brassier (London: Continuum, 2010).

25. It is no coincidence that the significance Guillaume has for Deleuze's philosophy of time is hard to overestimate; cf. my postface to: Gustave Guillaume, *Zeit und Verb: Theorie der Aspekte, der Modi und der Tempora*, trans. Bernd Klöckener and Esther von der Osten (Zurich and Berlin: Diaphanes, 2014), pp. 149–57.

2 (Dis)enchanted Taiwanese Cinema, Schizoanalytic Belief and the Actuality of Animism

Érik Bordeleau

Comparative Chinese Ghostly Matters

THIS ARTICLE AIMS at outlining a schizoanalytic and speculative approach to the complex dynamic of enchantment, disenchantment and re-enchantment at work in Taiwanese cinema. It takes as a starting point the pragmatist question of how to inhabit and activate a sense of the possible in a given, situated situation, that is how we conceive of our participation in the ever-going process of (re)animating our world(s).

The feature that interests me the most in modern Taiwanese cinema is arguably an insignificant feature barely worth mentioning to most local researchers, who are perhaps all too familiar with the phenomenon: Taiwanese films abound with religious rites, spirits, spectres, ghosts, gods and other *surexistential* forces.[1] To take only a few recent examples, at random, we may think of: *No puedo vivir sin ti* (不能没有你, 2009) and its opening possession ritual; *Monga* (艋舺, 2010) or *Spin Kid* (電哪吒, 2011) with their close relation to local temples; *God Man Dog* (流浪狗神人, 2007) and its multi-confessional plot; Zero Chou's *Splendid Float* (艷光四射歌舞團, 2004) with its Taoist priest/queer performer; the magical surrealism of *Orz Boyz* (囧男孩, 2008); the haunting of a dead brother in the acclaimed *The Fourth Portrait* (第 4 张画, 2010); the historical drama revolving around the destiny of headhunter warriors' souls in the afterlife in *Seediq Bale* (2011); the work of mourning and the lengthy coexistence with Lu Yi-Ching's spirit in Tsai Ming-Liang's *Face* (脸, 2009), without mentioning the spectral presences in *What Time Is It There?* (你那邊幾點 ?, 2001) and *It's a Dream* (是 梦, 2007) etc.

What would a pragmatist, schizoanalytic and speculative constructivist way of dealing with these uncanny and sometimes disturbing presences look like? How

John Giorno, WE GAVE A PARTY FOR THE GODS AND THE GODS ALL CAME, 2012, serigraphy on canvas, 122 × 122 cm. © John Giorno. Courtesy private collection. Image copyright Almine Rech Gallery

should we conceive of our involvement in this complex web of disseminated and animated agencies that populate East Asian cinema in general and Taiwanese cinema in particular? Can the essential liminality and heterogeneity of spiritual matters be thought of in terms of active assemblages and transformative becomings? Or, to put it in blunter and somewhat naive terms: what does it actually mean to *believe* in gods, ghosts and spirits?

Each year in Taiwan (and elsewhere in Asia), during the seventh lunar month, the wandering souls of the forgotten dead and those who have no descendants to perform their ceremonies of remembrance travel through the gate of hell to come back and haunt the world of the living. Everywhere on the streets, small altars filled with food and other offerings are set up to placate the lonely and hungry ghosts (*preta*, in the Buddhist tradition) who have not yet settled accounts with a world they have a hard time leaving. Ghosts and all presences associated with death are considered to be expressions of yin (dark energy, passive, and 'feminine') that must be actively chan- nelled for the benefit of all. To ward off these spectral presences and conjure their rather problematic tenor of existence, the Taoist ritual gestures, far removed from the slow gestures of the Christian priest, are effectuated with great speed and sharp- ness that leave no doubt as to their essential proximity to the martial arts.[2] Stirring the most fear are the ghosts of women who died before marriage, people who have committed suicide, those who died of drowning and, more generally, from any violent means (anybody who is slightly familiar with Asian cinema probably knows this already). For those who would like a lively crash course on the subject, I recommend the friendly *Grandma and Her Ghosts* by Shaudi Wang (魔法阿媽, 2000), a Taiwanese animation movie for children. With limited but well-ordained means, the film mobi- lises the bestiary of Taiwanese ghosts with the purpose of initiating kids to the subtle art of living with ghosts and other spooky forces.

The presence of spiritual matters in Taiwanese cinema is more often than not linked to the affirmation of identity and the celebration of a local sense of belonging, an important aspect of Taiwanese cinema's recent successes at the box office. As a matter of fact, popular religion and ghostly matters in Taiwanese cinema are typically territorial, deeply rooted in the particularistic and the local.[3] Interestingly, these features characterising Taiwanese cinema are relatively absent from a significant part of Mainland China's cinematic production. Apart from more obvious concerns regarding sensitive political issues, Mainland China's censorship of film also applies to a wide range of issues related to what could be broadly defined as the fantastic: anything related to what is regarded as myth, superstition, reincarnation or time travel is put under particular scrutiny. This has recently lead such a prominent figure in Chinese cinema as Jia Zhangke to hit out at state censorship and denounce the 'cultural over-cleanliness and naivety' that prevents Chinese directors from freely

producing genre movies.[4] Such a strict attitude regarding the apparently innocuous realm of the fantastic is congruent with the Chinese Communist Party's long-lasting hostility towards matters of religion and its attempt at (re)shaping the core beliefs of its citizens. Ultimately, it informs us of the epic of progress that characterises the different strands of really existing socialism that have prevailed in the twentieth century: an overarching narrative of disenchanted rationality set in a homogeneous and chronological time frame.

This marked difference in the treatment of the spirit world on both sides of the Taiwan Strait has not gone unnoticed by producers and film-makers involved in the *10+10* (2011) project. This collection of short features of 5 minutes each, curated by the Taipei Golden Horse Festival to celebrate the Republic of China's 100th anniversary, gathered ten established and ten emergent directors. Movies had to meet only one requirement: to highlight Taiwan's distinctive identity and uniqueness, a typically sensitive issue considering the intensification of pressures coming from the Mainland to accelerate the process of reunification. Incidentally, the first three short films of the collection are all related, in one way or another, to spiritual matters. In *Ritual* (謝神, 2011), Wang Toon, director of *Hill of No Return* (1993), humorously shows two men who want to pay tribute to gods located on the summit of a hill by offering them an unexpected spectacle: a 3D projection (yes, gods like to be entertained!). In the second feature, *A Grocery Called Forever* (有家小店叫永久, 2011), by Wu Nien-jen, an influential member of the Taiwanese new wave who co-wrote many films with Hou Hsiao-Hsien, an old, sick lady prays for her deceased husband to help her by bringing in at least one client to her little shop. Otherwise, she will lose the bet she made with her son and will have to end her trade, unable to maintain ground against the growing popularity of the 7-Eleven convenience store next door (a ubiquitous emblem of modernity throughout the island).[5] Her prayer is answered when a young boy knocks on the little store's door late at night, looking for spirit money, an item that cannot be found at the more modern competitor, to honour the cult of ancestors. The third short feature, *Debut* (登場, 2011) by Wei Te-Sheng, unfolds as a long prayer narrated by Lin Ching-Tai, the main actor of *Seediq Bale*, as he is preparing to walk the red carpet at the 68th Venice Film Festival. In this film, we discover that the man who plays the role of a tribal chief fiercely attached to his animist traditions in the immensely popular aboriginal movie is, in real life, a Presbyterian pastor. Each of these films, and there are many others to discuss in this project alone, question and problematise Taiwanese modernity. They foreground its cultural uniqueness by emphasising its living relation to religious ritual and the spirit world.

Gods and Spirits as Force Fields of Differences

The omnipresence of gods, spirits and religious rituals in Taiwanese cinema lends itself to numerous considerations concerning Taiwan's politics of cultural representation. Here, I would rather leave this problem aside, in order to focus on the active pluralism and metamorphic powers that are, I argue, constitutive of the cinematic assemblages with spiritual agencies and other surexistential matters. Chris Berry's reading of what he calls the *haunted realism* that pervades Taiwanese cinema offers a good point of departure. In a seminal analysis of Chang Tso-Chi's *The Best of Times* (美麗時光, 2002), Berry describes how the cinematic treatment of an 'otherwise quotidian passageway' used many times by the protagonists of the movie becomes 'a symbolically loaded liminal space of transformation'.[6] He then goes on to discuss how in Chang's film, 'visible religious practices' signify 'a different and distinctly Taiwanese modernity', characterised by an 'extended and reconfigured spectral time [that] can be called haunted realism'.[7] Berry's analysis of haunted realism as a disturbance of linear time is framed within a discussion about Taiwan's postcolonial condition. Departing from his insightful remarks, I would here focus instead on the transformative power of haunted realism's intrinsic liminality, arguing that the presence of spirits, the fantastic and religious practices in Taiwanese cinema points towards an enriched way of dealing with the coexistence of temporalities. It highlights a con-temporaneity conceived of as a heterogeneous and generative force field of differences that moves away from any notion of a symbolic or imaginary realm set in opposition to a material, 'real' world.

In *Specters of Marx*'s exordium, following the fall of the Soviet Union and the proclaimed demise of the legacy of Marxist thought, Jacques Derrida enjoins us to 'learn to live with ghosts' if we are to 'learn to live finally'.[8] This ethical investigation leads him to question *the modes of presence of spectres* – their intrinsic eventfulness – and the renewed relation to historical time they command. Beyond, or rather alongside, the instaurative power of codified worship's rituals and other deliberate *dispositions d'esprits*, spirits are always on their way in, always in the process of arriving. As discrete yet persisting events, they complicate our relationship to time, call for a radical plurality of durations and produce a richer sense of locality.

Derrida's (un)timely considerations of historical heterotemporalities find further developments in Bliss Cua Lim's seminal work on the fantastic and temporal critique in cinema. In *Translating Time*, following Bergson's conception of duration, she coins the concept of 'immiscible times' to describe the 'untranslatable temporal otherness' challenging the uniform chronological epic of disenchanted secular modernity. Lim discusses extensively Dipesh Chakrabarty's critique of the European conception of progress, drawing on his idea about how, 'the moment we think of the world as

disenchanted, we set limits to the way the past can be narrated'.[9] 'For Chakrabarty', writes Lim, 'the fiction of a single present is a containment of heterotemporalities',[10] or in other words: 'the time of history is one in which heterogeneity is translated into homogeneity in order to govern unsettling, radical difference'.[11] Controlling the potential disruptiveness of enchanted pasts (and presents) is a key operation for any colonial or imperial endeavour. In this sense, as a rationalist, progressive and communist country, Mainland China wants to be done with the ghosts of the past and will not allow their discrete yet pervasive temporal otherness to haunt and divert its march towards a glorious and unilateral future. Yet we should not congratulate the 'free world' too rapidly: as Lim often highlights, 'the pre-emptive workings of contemporary capitalist governance' also 'dreams of foreclosing futurity'[12] and is not necessarily more welcoming to what is often envisaged as superstitions and remnants of a pre-modern, 'animist' past. What is ultimately at stake here is whether or not we are ready to envisage ghosts, spectres, gods and other surexistential forces as beings of metamorphosis belonging to force fields of differences that are irreducible to the homogeneous time of secular historiography and progress.

It is with such ethical, political and somehow 'spiritual' concerns in mind that I now wish to briefly outline a schizoanalytic and speculative pragmatic approach to the mode of presence of spirits, gods and surexistential forces within Taiwanese contemporary cinema. In a very schematic way, I believe such an approach could be articulated around three general lines of thought: (1) Deleuze and Guattari's complex understanding of what it means to believe (in the world); (2) the neo-materialist and animist turn in recent post-Deleuzian thought, as put forth in the work of Eduardo Viveiros de Castro, Maurizio Lazzarato, Bruno Latour, Jane Bennett and many others; (3) a detailed characterisation of the spirits' virtual presence in terms of metamorphic assemblages, surexistence and what Isabelle Stengers calls, in the wake of Whitehead's process philosophy, 'propositional efficacy'.

The point here, as one can easily imagine, is not about trying to establish whether or not Taiwan is 'really' infested with spirits or whether we should or should not believe in them; and it is certainly not, as Graham Harman playfully suggests, about inquiring into whether there would be something about Asia, or Taiwan for that matter, that is more 'welcoming to these lonely spirits'.[13] Avoiding the pitfalls of reductivist or positivist approaches to ghostly matters, which, in the end, can only try to explain away the phenomenon in the name of science, the idea is, rather, to adopt a pragmatic and speculative stance in order to stay as close as possible to the smooth space of spirits and the transformative or, more precisely, *transductive experience* they convey.

A key concept in Gilbert Simondon's work, and one which has deeply influenced Gilles Deleuze's thought, transduction involves an ontogenetic philosophy of

individuation for which each process of knowing is itself a process of individuation. For Simondon, beings 'do not possess a unitary identity in a stable state in which no transformation is possible; beings possess transductive unity'.[14] Interestingly, the concept of transduction allows for descriptions of individuation processes that directly involve the observer. Indeed, in a transductive perspective, each activity of knowing is itself a process of individuation. That is why for Simondon transduction is also a 'procedure of the mind as it discovers. This procedure consists in following being in its genesis, in carrying out the genesis of thought at the same time as the genesis of the object is carried out'.[15] In a quite literal fashion, transduction is but a material intro-duction, an active 'mattering' beyond representations.

The way of gods and ghosts and the flux of participation they command can thus be said to be transductive in the sense that they involve *transformative (re)cognition*. As Avery Gordon nicely suggests:

Following the ghosts [or the gods] is about making a contact that changes you and refashions the social relations in which you are located [. . .]. Being haunted draws us affectively, sometimes against our will and always a bit magically, into the structure of feeling of a reality we come to experience, not as cold knowledge, but as transformative recognition.[16]

The presence of spirits, gods and the fantastic in Taiwanese films opens up an ethical and spiritual dimension of transformative recognition that involves what I would call, following Isabelle Stengers,[17] an *art of immanent attention*. In the language of speculative constructivism, this amounts to envisaging the propositional efficacy of spirits in film: how do imaginary, spiritual or ghostly entities get a hold over subjectivities and induce a leap of imagination that engages a transformation, a becoming? How do they operate as lures for feeling? For when spirits are invoked or ghosts come back to haunt the living, we are more often than not brought to a threshold, at a liminal and transformative passage. Each time, spirits and other ambiguous entities become intercessors for becoming, ethical and spiritual superconductors accelerating or dramatising crucial moments of life at a threshold.

The question of spiritual liminality and manners of producing existential territories is closely linked to the complex issue of (dis)enchantment. *Anti-Oedipus'* discussion of capitalism's process of deterritorialisation and re-territorialisation, the production of neo-archaisms and the situation of belief in today's world appears most relevant in order to refine our approach to the metamorphic efficacy of cinematic spiritual assemblages. The mode of presence of gods and spirits in films is, I would argue, greatly altered whether they are conceived of and presented as part of a process of *re*-enchantment of the world, or if they stand 'for themselves' so to

speak, as heterogeneous forces that always already complicate the present. In the first case, the mode of presence of spiritual matters is ultimately subjected to the modern conception of homogeneous time, acting as some sort of symbolic and soulful supplement to fill up a spiritual void. As Latour efficiently puts it, 'the symbolic is the magic of those who have lost the world. It is the only way they have found to maintain "in addition" to "objective things" the "spiritual atmosphere" without which things would "only" be natural.'[18] Against such a world-view, a schizo-analytic and pragmatist approach to spirit matters cannot but start from the immanent presupposition that 'we have never been modern' – talking about disen-chantment and re-enchantment means that one has already lost the (ever-enchanted) world in the first place.

The Question of Intensive Belief

How not to lose the world then? And what does it actually mean to 'believe' in gods, ghosts and spirits? There is a creative tension between the disqualification of the notion of belief in *Anti-Oedipus* and the much-praised and pragmatist-inclined idea of believing in the world developed in *Cinema 2* and afterwards that I will now outline in order to characterise more precisely what a Deleuze-inspired approach to spiritual matters in Taiwanese cinema might involve. These considerations will lead us to the core of some issues central to the pragmatist and speculative constructivist reception of Deleuze's thought. As I will further argue, the idea of believing in the world and the related animist conception of subjectivity come as a calibrated elabo-ration that focuses on partial and disseminated agencies. This approach contrasts with the accelerationist reading of Deleuze and Guattari's idea of the body without organs and the rush towards the outside initially brought forth by Nick Land and more recently extended by Reza Negarestani and others.

The question of belief is one of the main recurring themes of *Anti-Oedipus*, passionately discussed in numerous occasions throughout the book, almost always in negative terms (the verb *to believe* is often put in italics to highlight its importance and relative ambiguity). Deleuze and Guattari criticise the operation of belief for being an outcome of psychoanalysis' reduction of the unconscious as a desiring and productive machine to a mere theatre of representation.[19] According to *Anti-Oedipus*, belief is a conscious or pre-conscious operation, an 'extrinsic perception'[20] that becomes necessary only because of the introduction of an order of representation that superposes itself onto the world. The real becomes impossible, as Lacan puts it, and Freudian psychoanalysis conceives of the desiring subject as someone who needs to learn how to acknowledge an external regulating 'principle of reality'. For psycho-analysis, the world indeed is lost. Reversely, Deleuze and Guattari refuse the operation

of representational belief in the name of an immediate productive unconscious in direct relation to the outside. Schizoanalysis, as they explain with a forceful tautology, requests 'nothing more than a bit of a relation to the outside, a little real reality'.[21] The affirmation of the possibility of a full, immediate relation to the real-outside is *Anti-Oedipus'* greatest task and accomplishment.[22] It is most suggestively performed by the characterisation of the artist and the revolutionary not as forceful (or blind) believers, but as seers:

> Revolutionaries, artists, and seers are content to be objective, merely objective: [. . .] It is not a matter of saying that Oedipus is a false belief, but rather that belief is necessarily something false that diverts and suffocates effective production. That is why seers are the least believing of men.[23]

This provocative contrast between seers and believers finds many resonances in contemporary Taiwanese cinema. On the side of the cultivation of an immanent art of seeing intensely, one might think of Chiang Hsiu-chiung's *Let the Wind Carry Me* (乘著光影旅行, 2009), an entrancing documentary celebrating world-famous cinematographer Mark Lee Ping Bing's passion for light and colour (he has worked with acclaimed directors such as Hou Hsiao-Hsien, Wong Kar-Wai, Tran Anh Hung and Hirokazu Koreeda). At the other end of the spectrum, we find numerous tongue-in-cheek critiques of the entrepreneurial instrumentalisation of faith, as in the case of *A Place of One's Own*, in which a young man is trained to repeat incessantly the formative credo of his real-estate agency: 'I have to be successful / I have to sell my first house / I have faith.'

If belief was necessarily false for Deleuze and Guattari at the time of *Anti-Oedipus*, it is because they envisaged a more direct connection to the world that bypasses objective representations and the subjects that sustain them, a connection to an intensive plane of immanence that allows for qualitative distinctions among ways to relate to the world. Those who deplore that 'we do not believe in anything anymore' should leave their litany aside, for no representational belief is up to the challenge of producing existential territories that can resist today's capitalism. Indeed, as goes *Anti-Oedipus'* most famous claim, capitalism is but a formidable machine of deterritorialisation, and it is in vain that we try to slow it down through the revival of residual territorialities and the re-territorialising power of localised belief. Rather, *Anti-Oedipus* suggests to accelerate the deterritorialising process by exacerbating its schizophrenic component – schizophrenia understood here as the absolute limit of any society. It is from this global, accelerationist perspective that the authors of *Anti-Oedipus* severely judge the proliferation of neo-territorialities as neo-archaisms, a world 'reconstructed through archaisms having a modern function',[24] and other

attempts at imbricating and sectioning off seemingly viable spaces and other subjec-
tive oases oblivious to capitalism's abstractive power:

> Capitalism institutes or restores all sorts of residual and artificial, imaginary, or
> symbolic territorialities, thereby attempting, as best it can, to recede, to rechannel
> persons who have been defined in terms of abstract quantities. Everything returns
> or recurs: States, nations, families. That is what makes the ideology of capitalism '*a
> motley painting of everything that has ever been believed*'.[25]

Deleuze and Guattari present Oedipus as the code name for capitalism's social and
intimate operation of re-territorialisation by which henceforth-derived private people
can relate 'correctly' to a world in rapid extinction under the accumulation of clichés.
Singing Chen's *God Man Dog*, a choral film presenting an acute sociological overview
of Taiwan's contemporary spirit-scape, offers a well-informed illustration of this kind
of privatised re-territorialisation processes. Criss-crossing between different subplots
centred on spiritual and religious concerns – an aboriginal's doubt about his faith
('Jesus doesn't work', we hear him say in a moment of despair), a woman's crisis after
losing her child and converting to Christianity, an eccentric man repairing Buddhist
god figurines – *God Man Dog* seamlessly integrates on the same plane of representation
less obvious forms of contemporary belief tied with capitalism's consumerist identifi-
cation and its function as vector of (re-)enchantment (note that Singing Chen has
worked for an advertising agency). These thoughtful insertions set the critical tone of
the work. A few minutes into the film, billboards depicting women scroll on with
glittering light, and are then contrasted with a sign taped on a telephone pole saying:
'Heaven is near'. Thereafter, we attend a discussion between an architect and the
promoters of a domiciliary complex to be built in the middle of an untouched oceanic
landscape, a 'heavenly retreat' where future owners will be able to 'break free from the
material world' (the advertisement for the complex shows people doing meditation).

Anti-Oedipus repudiates belief because it remains too personal and tied to the
surface of representation instead of accessing the intensive order where things are
actually generated. Against the masquerade of privatised identification and its multi-
ple commercialised declinations, schizoanalysis aims at the liberation of pre-personal
singularities. 'The unconscious is totally unaware of persons as such',[26] or as Brian
Massumi has recently put it with a slightly different focus,[27] the animal in us mistrusts
representations, as it is directly engaged with the inorganic body where the emergence
and differentiation of collective deliriums and hallucinations take place. Deleuze and
Guattari are keen to note that 'all delirium possesses a world-historical, political, and
racial content'; 'the first things to be distributed on the body without organs are
races, cultures, and their gods.'[28] Incidentally, they also add that cinema is particularly

well adapted 'to capture the movement of madness, precisely because it is not analytical and regressive, but explores a global field of coexistence,'[29] of which gods and other heterogeneous spiritual forces are, undoubtedly, an integral part. In this regard, Huang Ming-Chuan's work, and in particular *Flat Tyre* (破輪胎, 1999), a low-budget film documenting the passage from political to religious iconology after the end of martial law on the island, constitutes a great example of how cinema is able to plunge into the core of world-shaping dreams and deliriums.[30]

The affirmation of the intensive-affective order is grounded in a theory of individuation that involves a (magical) practice of characterisation and nomination. It is at this point that one can start envisaging how *Anti-Oedipus'* disqualification of belief is not contradictory to the authors' later, more cautious stance regarding the composition of a body without organs, and the promotion of the idea of believing in the world and how it has been relayed by different thinkers in a more pragmatist perspective. If *Anti-Oedipus'* inflamed charge against private people indeed allows for accelerationist and an all-dissolving, anti-humanist understanding of the body without organs in the grandiloquent style of Land or of Negarestani's *Cyclonopedia: Complicity with Anonymous Materials*, what I am interested to highlight here is how *Anti-Oedipus'* theory of proper names can be understood as part of an enlarged conception of enunciation that includes a positive understanding of *intensive belief* concordant with the animist turn, partial subjectivities, factishes and the instauration of surexistential beings, in and throughout films.

Echoing the conceptual persona of Zarathustra and Nietzsche's schizo-necessary grand politics of delirium as expressed most stringently in a letter to Jacob Burckhardt ('*every name in history is I*'), Deleuze and Guattari develop a machinic and highly speculative-disjunctive conception of historical formations. They state that:

> Individuations are brought about solely within complexes of forces that determine persons as so many intensive states [. . .]. Yet it was never a question of identifying oneself with personages, as when it is erroneously maintained that a madman 'takes himself for so-and-so . . .' *It is a question of something quite different: identifying races, cultures, and gods with fields of intensity on the body without organs, identifying personages with states that fill these fields, and with effects that fulgurate within and traverse these fields.* Whence the role of names, with a magic all their own: there is no ego that identifies with races, peoples, and persons in a theater of representation, but proper names that identify races, peoples, and persons with regions, thresholds, or effects in a production of intensive quantities. The theory of proper names should not be conceived of in terms of representation; it refers instead to the class of 'effects': effects that are not a mere dependence on causes, but the occupation of a domain, and the operation of a system of signs.[31]

The magical art of naming and characterisation requires a direct, immanent participation with the body without organs conceived of as a generative field of intensities. Otherwise, without a solid take on the inorganic body and its call for the outside, nomination attempts run the risk of falling flat. There are certainly good and better ways to address beings and spirits; but if too much attention is given to the right formulation and not enough to the type of quality of presence and connection to the flowing immediacy of the body without organs, the pragmatist care for the right naming might lock itself into mitigated and over-controlled representations. Aesthetically speaking, inclusive disjunctions' infinite excess is crucial to preserve the freshness and novelty of artistic and filmic characterisations of spirit matters. This being said, the emphasis on active nominations and differentiating characterisations corresponds closely to *A Thousand Plateaus'* cautious warning about schizo-nomadic disregard for the sedentary component of practices and the danger of being caught up in black holes of desubjectivation where, as Stengers puts it, 'everything begins telling the same story'.[32] In the end, as Guattari suggests in *Chaosmosis*, 'every drive towards a deterritorialized infinity is accompanied by a movement of folding onto territorialized limits, correlative to a jouissance in the passage to the collective-for-itself and its fusional and initiatory mysteries'.[33]

The Actuality of Animism

Never believe that a smooth space will suffice to save us.[34]

We are now able to reintroduce the notion of belief, or better, of intensive belief, understood as direct participation in the world as a force field of differences, instead of being over-imposed on a plane of representation. Intensive belief stays close to the productive tension that runs between the experience of depersonalisation and nomination; it coincides with virtual movements animating things and situations at the moment of their most intense discernibility. It is endowed with *instaurative* power inasmuch as it operates directly in the intensive field, instead of being subjected to representation. Considered from this angle, the problem of believing in the world should not be confused with run-of-the-mill wilful action. The intensity of belief only partly coincides with the strength of conviction. What matters here is how value is introduced in the world, or in other words, how a certain mode of existence is intensified and brought to its creative limit. To believe in the world, then, is indiscernibly active and passive; it is to contemplate – and *be contracted.*

Belief, understood in machinic terms, involves a sense of active cut and rupture that entertains a lively relation with the possible. For William James and the pragmatist tradition, belief is a disposition to action. The obscure region of our power to

act goes beyond what we know of it. The indeterminate and the unknown are the natural milieux of our belief and practice, that is to say: from the perspective of belief, what matters is not so much the limits of our knowledge but the affirmation and activation of new modes of being, in spite of the absence of certainty.

Believing in the world is tied to the active emergence of the new and is always 'local', linked to a definite, practical situation. Or to put it more directly: one never believes in the world 'in general'. In a dialogue with Toni Negri, Deleuze states this idea as follows: 'If you believe in the world you precipitate events, however inconspicuous, that elude control; you engender new space-times, however small their surface or volume. Our ability to resist control, or our submission to it, has to be assessed at the level of our every move.'[35] To believe in the world is thus to participate actively in the production of internal ruptures and interstices through which a possible might come into existence. What matters here is how belief involves an immanent *implication* in the world and the production of a specific mode of existence, as opposed to the *application* of a transcendent content of truth or belief.

If belief as generous and expansive power obviously involves a part of subjective investment, what really matters for Deleuze and Guattari is how belief puts us into contact with affective and perceptive intensive forces that do not simply belong to us. Rather, as Maurizio Lazzarato explains, 'they permeate us and at the same time bring about a change and expansion of "consciousness" and thus enhance our "ability to act"'.[36] The idea of machinic animism goes one step further in the characterisation of the composition of forces inherent to our power to act, entailing that things possess an agency of their own. It suggests that the real is literally animated by a complex web of heterogeneous and disseminated agencies. Coined in the field of anthropology by Edward Tylor in his foundational *Primitive Culture* (1872), the heavily evolutionist concept of animism usually suggests that primitive people are wrong in attributing life- and person-like qualities to objects in their environment. This concept is inextricable from modernist considerations about the enchantment and disenchantment of the world. In the words of Theodor Adorno and Max Horkheimer, 'the Enlightenment's program was the disenchantment of the world. It wanted to dispel myths, to overthrow phantasy with knowledge. The disenchantment of the world means the extirpation of animism'.[37] In short, animism was a key term in the operation of recasting the anachronistic non-moderns as precursors of a unified and mono-natural modernity.

However, in a post-Deleuze and Guattari fashion, animism is understood in a radically contrasting way, denoting a positive decentring of subjectivity that escapes the usual ontological dualisms of modern thought, in order to plunge beneath the subject/object division so as to reload the real with possibles. Machinic animism participates in an enlarged conception of enunciation that emphasises the plurality of forces active

in any assemblage. As Lazzarato and Angela Melitopoulos explain, 'in "machinic animism", there is not a unique subjectivity embodied by the Western man – male and white – but one of "heterogeneous modes of subjectivity". These partial subjectivities (human and non-human) assume the position of partial enunciators.'[38] The machinic in machinic animism reinforces, against an expressionist or vitalist point of view, the sense of positive ruptures and constitutive heterogeneity in the multiple assemblages actualising the belief in the world. The magical art of characterisation and naming discussed earlier is thus an integral part of the *actuality* of animism.

Latour came up with the concept of 'factish' in order to problematise the way we moderns look down at people who 'really believe' in the animist power of fetishes. The notion of factish or *faitiche* effectively breaks with the radical modern divide between animated subjects and inert objects. The idea is not so much to bring all beings to the same level or regime of action, or to load them with intentionality, as to allow us to recognise that in many subtle ways, it is the relations we nurture with these 'factish' beings that make us do things or make us talk (*faire-faire, faire-parler*). This idea is illustrated beautifully in one scene of Singing's *God Man Dog*. The film revolves in great part around a character who is endowed with the 'supernatural' capacity to retrace statues of Buddhist gods that have been thrown away by newly converted Christians – a direct connection with the smooth plane of gods, as it seems. In one of the most powerful sequences of the film, and arguably of recent Taiwanese cinema, we see the man collecting statues and talking to them in a very personal way. 'I have to take care of the gods', he says, expressing how the relation with the gods is active and thoroughly reciprocal, as they protect him in return. The sequence then goes on, bringing us to feel how his privileged relation to the gods extends to a community of believers that collectively produce a zone of active indetermination. What is active in it is not so much a suspension of disbelief as it is a concerted art of equivocal naming and worshipping that suspends critique and acts as a transformative and fabulatory lure for feeling and becoming.

Latour has noted that what he means by factish is akin to what is at stake in Etienne Souriau's notion of instauration. The passage through a dimension of surexistence that is involved in that process is further exemplified in another meaningful cinematic moment from the movie *Orz Boys* (Yang Ya-Che, 2008). There, two imaginative young boys create a machine able to bring them to the utopian dreamland of 'hyperspace'. This assemblage is both material (they use fans and feathers to create a fairy-like atmosphere) and highly fabulatory, like a kid's game is expected to be. What is most interesting here is the feverish passion with which the two young boys actualise a parallel imaginary world within the interstices of this one reality. They 'really' believe in it, as we say. Keeping with the machinic animist perspective unfolded here, the intensity of their fabulation should not be considered so much as a flight out of this

world, but rather as a way to intensify their presence and connect with new possibilities within their actual lives (in this case, motivated by the desire to give some comfort to their young comrade who is moving to another city). Enchantment here is in fact the privileged access to the 'real reality'.

The gods in *God Man Dog*, the actualised and fabulated hyperspace of *Orz Boys* and the different instaurative liminalities discussed throughout this essay can all be conceived of as animist and surexistential processes, as the result of active characterisation practices that involve an intensive belief connected with a plurality of partial subjectivities and disseminated agencies. All the examples cited here evoke ways by which we can approach the vivid relation to imaginative and spiritual beings that populate Taiwanese cinema (and not only) in ways that avoid treating them as mere symbols or spiritual elements providing a soulful supplement. Commenting on Souriau's concept of surexistence, Latour and Stengers write: 'The surexistant beings needs us, they require our fervor to exist because this fervor is the name for the modulation that testifies for their reality.'[39] Paying more attention to the different ways in which we are entangled in liminal and transformative relations with surexistential beings no doubt constitutes an essential element in the attempt at fostering a pragmatic and speculative art of immanent attention, through cinema, and beyond.

Notes

1. Throughout this essay, and following Étienne Souriau's existential pluralism, I will speak of *surexistential* forces and beings rather than using the more common adjective 'supernatural'. The latter term tends to reinforce rather than question the nature/culture divide; it steers us away from the transformative dimension attached to these invisible entities that Bruno Latour aptly calls, in his *Inquiry into the Modes of Existence* (Cambridge, MA: Harvard University Press, 2013), the 'beings of metamorphosis'.

2. 'The popular narrative traditions reflect an understanding of the spirit world that clearly marks the martial art as the embodiment of supernatural power, a view already fully developed in the religious beliefs of the Han dynasty.' Avron Boretz, *Gods, Ghosts, and Gangsters: Ritual Violence, Martial Arts, and Masculinity on the Margins of Chinese Society* (Honolulu: Hawai'i University Press, 2010), p. 6.

3. For a cosmopolitical account of 'soulful' locality in Taiwanese cinema, see Érik Bordeleau, 'Soulful Sedentarity: Tsai Ming-Liang at Home / at the Museum', *Studies of European Cinema*, 10, 2 & 3 (2014): 179–94.

4. Tania Branigan, 'Chinese film director hits out at state censorship', *Guardian*, 16 June 2011 <http://www.theguardian.com/world/2011/jun/16/chinese-film-director-hits-censorship> (accessed 23 March 2015).

5. Taiwan has allegedly the highest density of convenience stores in the world. For an interesting enquiry into 7-Eleven's visual and architectural presence on the island, see Roan Ching-Yue, *7 Eleven City* (Taipei: Garden City, 2009).

6. Chris Berry, 'Haunted Realism: Postcoloniality and the Cinema of Chang Tso-Chi', *Cinema Taiwan: Politics, Popularity and State of the Arts*, ed. Darrell William Davis and Ru-shou Robert Chen (New York: Routledge, 2007), pp. 33–50 (p. 34).

7. Ibid. p. 47.

8. Jacques Derrida, *Specters of Marx* (New York: Routledge, 1994), p. xiv.

9. Dipesh Chakrabarty, *Provincializing Europe: Postcolonial Thought and Historical Difference* (Princeton: Princeton University Press, 2007), p. 89.

10. Bliss Cua Lim, *Translating Time: Cinema, the Fantastic and Temporal Critique* (Durham, NC: Duke University Press, 2009), p. 14.

11. Ibid. p. 19.

12. Ibid. p. 13.

13. Graham Harman, *Circus Philosophicus* (Washington, DC: Zero Books, 2010), p. 56.

14. Quoted by Muriel Combes in *Gilbert Simondon and the Philosophy of the Transindividual*, trans. Thomas Lamarre (Cambridge, MA: MIT Press, 2013), p. 6.

15. Ibid. pp. 6–7.

16. Avery Gordon, *Ghostly Matters* (Minneapolis: University of Minnesota Press, 1997), pp. 8, 22.

17. Isabelle Stengers, 'Reclaiming Animism' [2011], *e-flux journal*, 36 (July 2012) <http://www.e-flux.com/journal/reclaiming-animism/> (accessed 24 March 2015).

18. Bruno Latour, *The Pasteurization of France* (Cambridge, MA: Harvard University Press, 1993), p. 187.

19. 'We therefore reproach psychoanalysis for having stifled this order of production, for having shunted it into representation. [...] [T]his idea of unconscious representation marks from the outset its bankruptcy or its abnegation: an unconscious that no longer produces, but is content to believe.' Gilles Deleuze and Félix Guattari, *Anti-Oedipus* (Minneapolis: University of Minnesota Press, 1983), p. 296.

20. Ibid. p. 92.

21. Ibid. p. 334.

22. 'The order-word of D&G's philosophy is the anti-orderword of the call of the outside: listen closely for existential imperatives which, rather than limiting I and I's realm of virtuality, take it out of bounds.' Brian Massumi, *User's Guide to Capitalism and Schizophrenia* (Cambridge, MA: MIT Press, 1992), p. 41.

23. Deleuze and Guattari, *Anti-Oedipus*, pp. 27, 107.

24. Ibid. p. 132.

25. Ibid. p. 34 [emphasis added].

26. Ibid. p. 46.

27. Brian Massumi, *What Animals Teach Us About Politics* (Durham, NC: Duke University Press, 2014).

28. Ibid. pp. 85, 88.

29. Ibid. p. 274.

30. For a more detailed analysis of Huang Ming-Chuan's work in terms of oneirical power and modes of presence, see Érik Bordeleau, 'Rêves et drame de la présence: quelques notes autour de Huang Ming-Chuan', in *An Oniric Drama: Huang-Ming-Chuan's Cinema and Myths* (Taipei: Diancang yishu jiating, 2013), pp. 80–95.

31. Gilles Deleuze and Félix Guattari, *Anti-Oedipus*, p. 86 (emphasis added). This evocation of a magical art of nomination on the threshold of the impersonal echoes directly with this wonderful passage from *A Thousand Plateaus*: 'Every love is an exercise in depersonalization on a body without organs yet to be formed, and it is at the highest point of this depersonalization that someone can be *named*, receives his or her family name or first name, acquires the most intense discernibility in the instantaneous apprehension of the multiplicities belonging to him or her, and to which he or she belongs.' Gilles Deleuze and Félix Guattari, *A Thousand Plateaus* (Minneapolis: University of Minnesota Press, 1987), p. 35.

32. Isabelle Stengers, 'Gilles Deleuze's Last Message' (date unknown) <http://www.recalci-trance.com/deleuzelast.htm> (accessed 19 March 2015).

33. Félix Guattari, *Chaosmosis* (Bloomington: Indiana University Press, 1995), p. 103.

34. Deleuze and Guattari, *A Thousand Plateaus*, p. 500.

35. Gilles Deleuze, *Negotiations* (New York: Columbia University Press, 1995), p. 176.

36. Maurizio Lazzarato, 'From Knowledge to Belief, from Critique to the Production of Subjectivity', *transversal* (April 2008) <http://eipcp.net/transversal/0808/lazzarato/en/#_ftn3> (accessed 19 March 2015).

37. Theodor W. Adorno and Max Horkheimer, *Dialectic of Enlightenment* (Stanford: Stanford University Press, 2002), p. 2.

38. Maurizio Lazzarato and Angela Melitopoulos, 'Machinic Animism', in *Animism*, vol. 1, ed. Anselm Franke (Berlin: Sternberg Press, 2011), pp. 97–108 (p. 102).

39. Bruno Latour and Isabelle Stengers, 'Le sphinx de l'œuvre', introduction to Étienne Souriau, *Les différents modes d'existence* (Paris: PUF, 2009), pp. 5–79 (p. 72) (author's translation).

3 Attractors and Locked-In Art: Art History as a Complex System

Francis Halsall

Introduction

WHAT IF ART history was a system? That is my speculation here. It is not the first time such a speculation has been made. In 1951 Paul Oskar Kristeller wrote about 'The Modern System of the Arts' emerging in the eighteenth century,[1] and Kristella's argument has been revisited by Larry Shiner in his *The Invention of Art: A Cultural History*.[2] It might also be possible to argue that the institutional theories of art often attributed to Danto can also be thought of as assuming art to be somewhat like a system that differentiates art from not-art.[3] However, while the arguments developed in these cases are that art is an organised and somewhat autonomous network of interconnected and historically specific behaviours, this is not done so using the specific vocabularies of systems theory such as cybernetics, dynamical systems theory, social systems theory or suchlike. Niklas Luhmann, on the other hand, uses the specific and often highly technical vocabulary of social systems theory in his *Art as a Social System* to argue for art emerging as a social system during modernity.[4] But in doing so he ignores specific art historical examples or debates in favour of his (notorious) abstractions.[5]

In this text I hope to offer something different to these positions. In doing so I will both develop and summarise arguments I first formulated in my book *Systems of Art*.[6] In short, I take a specific type of behaviour found in complex systems: that of positive feedback or 'lock-in'. I then speculate as to whether such behaviour is evident in art history. My argument is that yes, it is and that in recognising this, a new way of thinking about art and its histories – specifically in relation to what Craig Owens called 'Representation, Appropriation and Power' – is opened up.[7]

The systems theory I am specifically engaging with emerged in the mid-twentieth century along with related theories such as cybernetics and information theory. Recently it expanded to incorporate the developments of second-order cybernetics (Gregory Bateson) and dynamical systems theory (Ludwig von Bertalanffy); examples of such developments include the Social Systems Theory of Niklas Luhmann and the use of systems by Bruno Latour and Gilles Deleuze. While often very different, these theories share an interest in self-organising systems, their behaviour and how they are defined by their interactions with their immediate environment.

Systems theory understands phenomena in terms of the systems of which they are part. A system is constituted by a number of interrelated elements that form a 'whole' different from the sum of its individual parts. When applied to art discourse, it means considering not only works of art but also art museums, art markets and art histories as systems that are autonomous, complex, distributed and self-organising.

Here I will use a specific example taken from W. Brian Arthur's analysis of economic markets in terms of a particular process of self-organisation: that is, complexity and positive feedback. I will use this to unpack one art historical example: the corpus of Rembrandt.

My overall position is that the systems approach throws up ways of thinking about art and history that are not only surprising and creative but effective, too. This position is underwritten by two further claims that there is not space to unpack here but which I have explored previously.[8]

Firstly, I argue that the systems approach is particularly effective in dealing with art after modernism, which is characterised by, among other things: non-visual qualities, unstable or de-materialised physicality and an engagement (often politicised) with the institutional systems of support. By prioritising the systems of support over the individual work of art or the agency of the individual artist, such an approach is not tied by an umbilical cord of vision to an analysis based on traditional art historical categories such as medium, style or iconography.

Secondly, I wish to engage in a specific tradition within art historical writing; that which Michael Podro called *The Critical Historians of Art*.[9] This tradition is better known in the German tradition as *Kunstwissenschaft* (the systematic or rigorous study of art). I do so both as a means of clarifying what I mean when I say art history but also as a means of identifying a tradition within art history of self-reflexivity and the systematic investigation of methods and limits.

From a systems-theoretical perspective it is an interesting question in its own right to ask why the model of *Kunstwissenschaft* has become the dominant mode of historiography (since the 1980s at least). As a discourse, it has become, in systems-theoretical terms, 'locked-in' (via positive feedback). It is my view that the

systems-theoretical approach to art discourse can be enacted *within* the art historical tradition of *Kunstwissenschaft* and is not in opposition to it. In summary, it is not my intention to either attack or defend a caricature of what art history is. Rather, I am seeking a body of work, a canon or discursive system with which to engage and participate.

Overall, my claim is that the systems-theoretical approach to art discourse is a continuation of this rich and worthy heritage (of finding historical models to match the art under scrutiny) – not a break from it.

'Lock-In': Positive Feedback and Irreversibility

'Lock-in', positive feedback and irreversibility are key features of complex systems. It is my speculative argument here that it can be used to describe how, in general, social and discursive systems are fixed around particular forms of activity such as dominant cultural forms. In particular, I argue, it gives an account of how certain cultural forms such as types of art or art historical methods both become and remain dominant.

The economist W. Brian Arthur defined lock-in thus:

> Dynamical systems of the self-reinforcing or auto catalytic type – i.e., systems with local positive feedbacks – in physics, chemical kinetics, and theoretical biology tend to possess a multiplicity of asymptotic states or possible 'emergent structures'. The initial starting state combined with early random events or fluctuations acts to push the dynamics into the domain of one of these asymptotic states and thus to select the structure that the system eventually locks into.[10]

Arthur uses the economic history of the domestic videocassette (VCR) market and the evolutionary competition (during the period between 1975 and the mid-1980s) between the two leading formats (VHS and Betamax) to show how systems become 'locked-in' to certain behavioural patterns.

In 1975, the Betamax format, which had been devised and was still controlled by Sony, held the monopoly on the sale of domestic VCRs.[11] In America alone, Sony sold 30,000. However, the following year, JVC introduced the VHS format. By January 1977, JVC's hand was strengthened by the announcement that a further four Japanese electronics manufacturers (including RCA) had decided to construct and market VHS-format VCRs. By 1978, Sony, who were still only marketing Betamax, held just 19.1 per cent of the VCR market, compared to RCA's share of almost twice that at 36 per cent. By 1979, VHS had become 'locked-in' as the system that led the market and in 1981 only 25 per cent of operating systems used the Betamax format. 'The battle [was] over' by 1987, according to an article that appeared in *Rolling Stone*

the same year.[12] The following year, with VHS players now holding 95 per cent of the VCR market, Sony finally conceded to manufacturing VHS-formatted VCRs as articles in *Business Week* and *Time* recall.[13]

Arthur took the VCR market to be a subsystem within the larger system of the economic market. In doing so, the VHS/Betamax case demonstrated an isomorphic principle that applies to the paradigms of dynamical systems theory in general, namely that through positive feedback, systems may perform in a 'self-reinforcing', 'autocatalytic', and 'locked-in' manner. 'Locked-in' means that in a situation where any number of states are possible for a system to achieve, the system becomes phase-locked into one developmental path, regardless of the merits of the alternatives, and that this occurs through a combination of random factors, the effects of which are accentuated by positive feedback.

Arthur's conclusion was somewhat surprising in his field as it contradicted conventional economic theory, which suggests that economic systems are subject to the principle of diminishing returns. Arthur argued that some markets do in fact behave like complex systems and are subject to increasing returns. He states:

> Positive feedback economics, on the other hand, finds its parallels in modern non-linear physics. Ferromagnetic materials, spin glasses, solid-state lasers and other physical systems that consist of mutually re-enforcing elements show the same properties of the economic examples I have given. They 'Phase-lock' into one of many possible configurations; small perturbations at critical times influence which outcome is selected, and the chosen outcome may have a higher energy (that is, be less favourable) than other possible end states.[14]

In short, through a combination of factors, the VHS format ended up gaining an upper hand in the VCR market and no matter how slight this advantage initially was it became multiplied through positive feedback. Subsequently, VHS ended up holding a virtual monopoly in the domestic market. This lock-in occurred because a number of factors were brought into play. For example, once a customer was enticed into buying one product it was unlikely that they would buy a similar product for economic as well as pragmatic reasons, as Arthur relates:

> Each format could realize increasing returns as its market share increased: large numbers of VHS recorders would encourage video outlets to stock more pre-recorded tapes in VHS format, thereby enhancing the value of owning a VHS recorder and leading more people to buy one. In this way, a small gain in market share would improve the competitive position of one system and help it to further increase its lead.[15]

There is also evidence to suggest that VHS was technically inferior and that the factors leading to its dominance may have been arbitrary – indeed Betamax is still the industry standard for video recording in film-making and broadcasting (although Lardner notes that JVC were the first to produce a (VHS) machine which doubled Sony's initial Betamax recording time of one hour, and it may have been this advantage which swung the balance[16]). Whatever the reasons, the general principle remains, namely that in the developmental life of a complex and non-linear system, a point of no return, or a bifurcation point, may be reached beyond which there is no turning back. The system thus becomes 'locked-in'.

The suggestion that some observations on the dynamics of complex systems are creatively and meaningfully transferable (to economic systems for example) in turn opens up a rich variety of descriptive possibilities allowing for the discursive suggestion that other cultural systems, such as the art market, art galleries and art histories may also be seen to behave according to complex dynamics. In other words that they also become 'locked-in' around singular foci.

Phase-Lock and System Attractors

The cumulative effects of positive feedback are also observable in another way. This is that small causes may produce the large effects of phase-lock, which is commonly referred to as the 'butterfly effect' (i.e. that the flapping of a butterfly's wings in Paris could affect the weather in New York, or that small causes eventually led to the monopoly of VHS in the VCR market). When a system has become 'locked-in' (as the VCR market had by the mid-1980s), it has settled in around an *attractor*. The apparent order can then be regarded as an emergent property of the system. Such emergent (or macro) properties are common to the behavioural patterns of complex systems, as Roger Lewin describes:

Most complex systems exhibit what mathematicians call attractors, states to which the system eventually settles, depending on the properties of the system. Imagine floating in a rough and dangerous sea, one swirling around rocks and inlets. Whirlpools become established, depending on the topography of the seabed and the flow of the water. Eventually you will be drawn into one of these vortexes. There you will stay until some major perturbation, or change in the flow of water, pushes you out, only to be sucked into another. This, crudely, is how one might view a dynamical system with multiple attractors: such as cultural evolution with attractors equivalent to bands, tribes, chiefdoms and states. This mythical sea would have to be arranged so that the hapless floater would be first susceptible to whirlpool one first, from which the next available would be whirlpool two, and so on. There would be no

necessary progression from one to two to three to four. History is full of examples of social groups achieving a higher level of organisation and then falling back.[17]

Such emergent order of the so-called *attractors* within complex systems can be visualised by means of what is called 'phase space'. Phase space maps are visual maps that can be used in the study of physical systems, such as chaotic systems, and their behaviour. On a two-dimensional graphic map the X and Y coordinates of a graph are used to represent the horizontal and vertical position of a point in space. But in phase space, one variable of the map represents a position, while the other variable of the map represents, for example, the speed associated with the position. James Gleick gives the following concise explanation of phase space:

> Any state of the system at a moment frozen in time was represented as a point in phase space; all the information about its position or velocity was contained in the coordinates of that point. As the system changed [. . .], the point would move to a new position in phase space. As the system changed continuously, the point would trace a trajectory. For a simple system like a pendulum, the phase space might be just a rectangle: the pendulum's angle at a given instant would determine the east-west position of a point and the pendulum's speed would determine the north-south position. For a pendulum swinging regularly back and forth, the trajectory through phase space would be a loop, around and around as the system lived through the same sequence of positions over and over again.[18]

The descriptive use of such a visual representation is that what is plotted is not what one would literally see since only one variable is a physical position. Instead, one is presented with a plot within the imagined phase space which depicts a general view of the behavioural patterns of the system, a view that, while abstract, is both a suggestive and highly effective tool for studying the nature of complex systems.

Attractors are the parameters around which the system oscillates, which, when visualised in a representation of phase space, appear as the area and orbit around which the system becomes attracted. When plotted in phase space, what at first appeared to be chaotic systems – from dripping taps to global economies – may in fact demonstrate some kind of order when visualised. This order is manifested in the characteristic butterfly shape of the so-called Lorenz Attractor (named after Edward Lorenz, a pioneering theorist of chaos theory).[19] This raises such questions as: Is there an emergent order in chaos? And, if so, at what stage does this order appear? From such questioning emerges the suggestion that order occurs within 'chaos' due to self-organisation within complex, adaptive systems. Order thus arises as an emergent property or a macro-property of complex systems.[20]

As seen in the video markets and the competition between VHS and Betamax, the system reaches a point of no return beyond which it is very hard, if not impossible, for the system to return to its previous state. This point of no return, or the *bifurcation point*, is used to illustrate the irreversibility of complex systems. In the video market, this point of no return was the point at which VHS became the dominant format and, via positive feedback, from this point gained an exponentially increasing market share over Betamax. The effect of positive feedback occurs because complex systems have memory. And, because they have memory, each state of the system is subsequently related to the previous system state. Hence, when a system becomes 'locked-in' around an example, it becomes very difficult to change the system's behaviour.

Art History and the Author Function

However, my discussion here is not about video cassettes but art history. What if, I speculate, art history is similarly locked-in around certain examples which are regulated by processes of reinforcement and positive feedback? If so, given that art history focuses on artists then it follows that the figure of 'the artist' is one example of such systemic lock-in.

Giorgio Vasari famously put the individual artist at the centre of his history of the 'Lives of the Artists'. In doing so he firmly linked artworks with the origin of the artists' individual subjectivity. Such prioritisation of the artistic subject was subsequently dissolved in the various attempts since to provide a different set of criteria for historical reflection. These include analyses such as Heinrich Wölfflin's 'Art History Without Names', which he explicitly conceived as an attempt to distance himself from overly biographical considerations. The desire to differentiate a critical art history from questions of biography in favour of addressing more general cultural questions can also be seen in Aloïs Riegl's claim that the artistic 'genius' does not, as is often thought, 'stand outside' the cultural systems within which art operates.[21] It is also revisited in Erwin Panofsky's iconological archaeology of social systems through the systems of artistic representation.

Similarly, in her defence of a critical discipline of art history that is grounded in formalism, Rosalind Krauss launched a critique of 'art history as a history of the proper name', a biographical art history that singles out particular artists as the central focus for critical attention: 'It is as though the shifting, changing sands of visual polysemy, of multiple meanings and regroupings, have made us intolerably nervous, so that we may wish to find a bedrock of sense.'[22] It is a common art historical strategy to find this 'bedrock of sense' in the identity of the author/artist who provides the key, coherence or origin to a body of work.

The identification of the author as the single and unique origin for the work of art faced two major problems in its confrontation with the modernist work of art. The first challenge arises in the light of the pronounced autonomy of the modernist art object. The proclamation that the modernist art object can speak on its own terms, as defended by Clement Greenberg and his claim that the 'purely plastic or abstract qualities of the work of art are the only ones that count',[23] means that qualities extraneous to these abstract qualities are negated; such terms might include not only iconographic meaning but also the biographical details connected to the author.

The second challenge to the 'art history of the proper name' comes in the aftermath of the demise in faith in the modernist art object. The subsequent disappearance of the autonomous art object did not see the reinstatement of the author/artist as the prime origin of the work as is demonstrated by the poststructuralist claims of the 'death of the author'. Within the field of art, this disappearance occurred when the modernist work of art was questioned from within both artistic and art historical practice in favour of diverting attention to the various systems of support. Such a critique is exemplified by the claim of artistic relativism Rauschenberg made by sending the telegram reading 'This is a portrait of Iris Clert if I say so' (1962) as a proxy for an absent object (and by which he, the artist himself, also distanced himself from the work).

Despite the artistic statements of postmodernism, such as Rauschenberg's, it is in the face of the loss of the modernist work of art that the attractiveness of the 'Art History of the Proper Name' might potentially be seen to increase. This is by using the concept of the author/artist as an anchor of attention and as a site around which a discursive system can become locked-in. This is to say that, given the loss of a discrete object, the proper name of the artist can function in a system of representation as a stand-in for the dematerialised art object, as it does in Rauschenberg's telegraph. However, what also needs to be acknowledged is that this statement of Rauschenberg's does not stand as a reclamation of mastery of the artist over the act of representation. While it makes any easy differentiation between art object, artist and environment impossible, it is also true that the work can only function because the figure of the artist depends upon the same continuum as the artwork itself. This continuum is the complex system of distributed representation within which object, artist and art-world environment are all incidents of where the system has become 'locked-in'.

In the Name of Rembrandt

I have claimed, then, that art history is a complex system locked-in around certain attractors such as artists. Rembrandt is just such an attractor.

Rembrandt's large body of work presents several problems for the systems of art history. Central to these problems is the very persona or 'name' of Rembrandt himself.

Clearly the personality of Rembrandt (like that of any artist in the canon) is inextricably bound up with the body of work referred to as 'Rembrandt'. This holds to such an extent that this art historical personality (as opposed to the biographical or biological one) dominates much of the discourse. The most acute illustration of this is provided by the self-portraits, where 'Rembrandt' becomes something of the work of art; his personality has thus explicitly become the object of art historical discourse. As Svetlana Alpers observes, this raises certain procedural questions for art historians:

> Individual uniqueness, monetary worth, aesthetic aura – the name of Rembrandt summons up different but nevertheless convergent notions of value. And to what precisely does the name itself refer? *Rembrandt* as it is commonly deployed tends to elide the works with the man. Is all of this a recent invention, a prejudice of the nineteenth century to which we are heir? Or is it appropriate to Rembrandt's own making a marketing of his own works that they should offer an example of that relationship between the production and valuing of a person, property and aesthetic worth that lies so deep in our culture.[24]

The corpus collected under the name 'Rembrandt' thus provides us with an excellent example of the 'Art History of the Proper Name', which Krauss had critiqued.

In the following section I use the work of the Rembrandt Research Project (RRP) to show the way the proper name 'Rembrandt' functions within the complex system of art history. In short, for the whole body of work which makes up the corpus of 'Rembrandt' and is archived under that name, 'Rembrandt' serves as an organising principle and attractor rather than as a signifier for a single originating source.

The RRP was established in 1968 with a grant from the Netherlands Organization for the Advancement of Pure Research. It was born from a perceived need among scholars to scrutinise and possibly reduce the large number of works (which at one stage had reached over a thousand) attributed to the single source of Rembrandt. For there were clearly numerous works that did not originate from Rembrandt's own hand. As the RRP identified, 'by the 1960s it was difficult for an impartial eye to accept all the works currently attributed to Rembrandt as being by a single artist'.[25]

One result of this process of differentiation that arose from the RRP's investigations was the establishment of three categories for further classification of 'Rembrandts': first, those works identified beyond all reasonable doubt as being by Rembrandt himself; second, those of uncertain authorship (the RRP acknowledged that this second category was necessary but also pointed out that given its ambiguity this category should be kept as small as possible); third, those works identified as *not* produced by Rembrandt. These works, previously accepted as authentic, included paintings by his studio or 'after Rembrandts' as well as fakes and pastiches. Examples

of these types of work include two works now officially accepted as non-Rembrandts *David and Saul* (Mauritshuis, The Hague) and *Man With the Golden Helmet* (Gemäldegalerie, Berlin), as well as the still-contested *The Polish Rider* (Frick Collection, New York).

The first stage of the RRP (between 1968 and 1972) involved collating the information that existed for all works that were attributed to Rembrandt. This was done in the form of a literal description of each work and an accompanying photographic record. This meant that the RRP had an established and definitive body of works which were, at the time, recognised as 'Rembrandts'. In the second stage of the RRP's modus operandi this larger set of 'Rembrandts' was reduced to a much smaller number of works comprised of all those pieces said to consistently display clear similarities to one another.

The initial information used by the RRP was taken from an established and recognised art historical archive: the catalogue compiled by Abraham Bredius in 1935. The assumption was that this contained all the works by Rembrandt in existence alongside other work. In total, this body of work of unproven provenance was estimated as comprising about a thousand paintings. The choice of Bredius's catalogue already meant the exclusion of an even larger body of work based on nineteenth-century compilations that included works of dubious provenance which had nonetheless been identified, at some point, as 'Rembrandts'. By taking the task of defining and purifying Rembrandt's *oeuvre* as the guiding principle and ethos of their method, the RRP have so far been able to reduce the number of what is generally accepted as Rembrandt's work to below 400 pieces. In collating their results, the RRP produced *A Corpus of Rembrandt Paintings Vol. I–V* (Stichting Foundation/RRP, 1982), which they hoped would become the authoritative work of attribution.

Starting from this central question of attribution, the members of the RRP then sought to establish working strategies that could accommodate and address the particular problems that the Rembrandt corpus presented.

The first major problem was that Rembrandt's work is both highly distinctive and extremely well-known. Consequently, Rembrandt originals have been much copied and emulated in acts of homage, pastiche and fraud. The fact that there are so many works referred to as 'Rembrandts' that, however, cannot beyond reasonable doubt be attributed to the hand of Rembrandt Harmensz van Rijn of Leiden who died in 1669 (for example the *Flayed Ox* in the collection of the Kelvingrove Museum in Glasgow which until relatively recently was wrongly attributed to Rembrandt) makes it very clear how problematic the attribution of works of art to a single individual artist/author is.

Secondly, the case study of Rembrandt and the RRP further highlights the problem of attributing works of art to specific historical individuals with regard to the issue

of the unique autographed work. Common to working practice in seventeenth-century Holland, Rembrandt worked with a studio of apprentices and assistants; in fact he had over fifty students and assistants working for him during his working life.[26] This means that many hands may have worked on a work which was subsequently identified as an 'original' Rembrandt.

This problem of attribution is complicated by two issues. On the one hand: 'In the *Night Watch* and the *Conspiracy of Julius Civilis* – large pictures for which he could have used help – there is no evidence that a hand other than the original touched the original work.'[27] On the other hand, Rembrandt's studio system was markedly different from that of, for example, Rubens. Rubens undertook large-scale decorative projects (such as the decorations for the Luxembourg Palace, 1622) and as a result would have used a whole team of assistants as a normal working practice. The very fact that Rembrandt does not seem to have worked on such collaborative projects might be taken to suggest that in his case single works might indeed be attributed to a single, originating source.

However, it is also known that Rembrandt worked closely with his pupils and that he often altered drawings they had made. Thus his hand may have been at work in a number of pieces which he neither started nor finished but which were instead executed in the main by students and colleagues. Further, as Jakob Rosenberg et al. claim: 'It is difficult to determine how many Rembrandt school pictures are based upon the master's own inventions, but the number is probably high, and in a few cases a definite connection can be established.'[28]

The examples they cite in order to give an impression of the way in which the studio operated include an engraving after the painting *Anna and the Blind Tobit* (1630, National Gallery, London). It is signed 'Rembr. van Rijn fecit' despite the fact that the original was identified as having been painted by Gerrit Dou. Dou was a member of Rembrandt's studio and there is evidence that Rembrandt did add some cursory, last-minute touches to the painting. Those works which had been updated by the master were identified at the time as being 'retouched by Rembrandt'.[29] These include the *Sacrifice of Isaac* (the Pinakothek, Munich), attributed to Govert Flinck, which is based upon the master's treatment of the same subject matter which can be seen in both the slightly earlier painting of the same subject (1635, Leningrad) and a chalk drawing (c.1634–5, British Museum). According to Rosenberg et al.: 'The inscription in Rembrandt's hand at the bottom of the Munich (*Rembrandt verandert En overgeschildert*, 1636) announces that the master was not satisfied with his pupil's results, and that he changed and retouched the work.'[30]

The issue of Rembrandt's signatures, especially with regard to its appearance on work that did not otherwise conform to the criteria of being 'Rembrandt', is one

which the RRP paid particular attention to as part of their attempts to provide empirical evidence for their attribution of works. They wrote:

> In some instances they do come so close in form to that of an autograph signature that one wonders whether the artist may not also have put his signature on paintings produced, in his workshop and under his supervision, by others.[31]

This quotation is from an article by the RRP on the unfinished painting, *Self-Portrait*, from 1642 in the Royal Collection (UK) that was originally derived from another painting which Rembrandt began and then abandoned but which was later updated and thus 'finished'. The RRP argue that such alterations provide further evidence of the work's originality since 'traces of other paintings are found in approximately one third of Rembrandt's accepted self-portraits.'[32]

The working method of the RRP is based upon thorough empirical research supported by technical and scientific methods of material analysis. In doing so, the RRP thus return to the materiality of the art object as the central focus for their interpretative method. The technical means that the RRP have at their disposal to facilitate the process of attribution include: dendrochronology (the dating of the wood supports of painted panels); X-ray imaging (to see earlier versions of the image including pencil sketching and so forth); infra-red photography; microscopy (to identify micro-details of the support); and autoradiography (in which a beam of neutrons is fired at the painting to help identify aspects of the layers of paint). The rationale behind this was to seek to establish grounds for authenticity on material terms.

However, although the project went to great lengths to provide rigorous empirical evidence for their attribution, ultimately the process of differentiation was not a purely technical one. While the description of the paintings was primarily grounded in purely materialist terms (in terms of paint, canvas, frame, etc.), which was practised as being the most basic and fundamental act of investigation and differentiation, this was, in turn, mediated by the interpretative act of art historical representation. It is a notable feature of the RRP that it is composed not of scientists but of art historians. Therefore, as expressed by members of the RRP, the interpretative act of historical evaluation does takes precedence over pure material empiricism:

> Apart from elementary information on the materials used, we have not attempted a systematic study of pigments, media, drying agents, dilatants etc.; such studies may yield further specific technical information as analytical methods become more refined, though it remains to be seen whether the results will help solve problems

of attribution. We have, rather, selected such information as can clarify the stratified structure of the painting as it results from the actual painting procedure.[33]

This refusal to rely upon purely technical data in the identification of the works was to allow for the foregrounding of particular interpretative reasons of attribution based on stylistic and qualitative evaluations on the part of the art historians.

According to the RRP, the difference between a purely materialist and an art historical investigation and historical reconstruction is

> provided by the differences in the sort of questions asked and the working method adopted by a scientist and an art historian, even when they approach the work of art as a shared object of study. Each is conditioned by the traditions of his own discipline. Without being unfair to either, we might perhaps say that the scientist arrives at his interpretation from relatively fragmentary and, of itself, unstructured information relating to the physical make-up of the work of art, while the art historian is concerned mainly with the stylistic interpretation of the picture and its execution. Their common frame of reference ought to be an understanding based on source studies, of the craft that governed artistic practice.[34]

It was also noted by the authors of the project that materialist accounts of the work in terms of attribution had already been well developed in Rembrandt studies, but that this was limited in so far as 'this is only seldom clearly related to what the art historian is seeking.'[35] What the art historian is seeking, in this case, is the process of historical reconstruction. Thus the attribution of works to the Rembrandt corpus requires the interpretative act of the art historian (or historians in this case) to establish a coherency between works beyond that of mere materiality. This coherency can be identified as an organising principle in the systems of both the Rembrandt corpus and larger art-world systems (such as art historical discourse, the gallery system, and so forth). These grounds of authenticity are based on consistency among the accepted pieces of the corpus.

In other words, within the system of Rembrandt there is 'lock-in' around particular examples. And if anything does not correspond to the organising principles then it is be deemed as inauthentic and hence not a 'Rembrandt'. This coherency is, in turn, achieved through the act of historical interpretation, which thus requires the imposition of a narrative between the work and the 'Rembrandt' corpus. I propose that this narrative can be seen, from a systems-theoretical perspective, as a system which observes, differentiates and is locked-in around some works as belonging to the Rembrandt *oeuvre* and others as not; it does so around the organising principle of *paintings that look like Rembrandts.*

Thus, in the attribution of identity, the project invoked the working method of Morelli[36] who claimed that a process of attribution should be informed by the connoisseur's eye which was tuned to the smallest details of the work. In doing so, the connoisseur would be able to identify the involuntary stylistic ticks and unconscious habits of the painter's style in otherwise similar paintings. In the case of Rembrandt, however, the analysis of attribution of works via brushstrokes was considered insufficient by the members of the RRP for two reasons. First, unlike the art of the Renaissance, which Morelli concentrated on, Rembrandt often did not work on the incidental details of his paintings but instead left such matters to be completed by his studio. Second, Rembrandt's brushwork is highly distinctive. For this reason it is one of the characteristics of his art that was most appropriated by students and members of the studio, copied by contemporaries and those whom he influenced, and parodied by forgers. This makes subsequent attributions based on the features of his handling of pens and brushes highly problematic.

It was because of the problems in using techniques of the artist's hand, such as brushstrokes, that the RRP required a different conceptual organising principle by which to differentiate the *paintings that looked like Rembrandts* from other works of art. In doing so they turned, ultimately, to questions of 'style'. This was a complicated procedure because the Rembrandt corpus had become locked-in around the style of Rembrandt, hence the need for the project's work in the first instance.[37]

In summary, the working method of the RRP was an intricate process of differentiating those paintings from the larger corpus that appeared to be sufficiently 'Rembrandt-esque'[38] and not an attempt to identify a *single* authorial voice manifest in all of them. To the contrary, RRP tried to determine a set of *multiple* criteria that all the works within the *oeuvre* of 'Rembrandt' would display.

Thus a 'Rembrandt' is not defined by virtue of an external reference which the work signifies, i.e. Rembrandt the artist. The process of attribution and differentiation instead functions according to the criterion of internal coherence within the system 'Rembrandt'. And it is due to this internal coherence that a unity emerges among the works that the Rembrandt system has locked-in around regardless of whether they were painted by one artist or not.

Paradoxically, the focus on style could also be interpreted as a (if only unintentional) return to the author in art history. As Mieke Bal concluded on the work of the RRP:

> True, some Rembrandt critics (the members of the Rembrandt Research Project are among them . . .) voluntarily question the quality of some of the works, and even take pride in their demythologising attitude. Yet the very fact that these aesthetic criticisms lead to the rejection of the authenticity of the works as

Rembrandt provides evidence of the basically unchallenged status of both author as genius and of aesthetic quality as determinable. Hence these acts of judgement rest on the possibility to delimit *high art* from other art. An ever *higher* purer Rembrandt is thus safeguarded.[39]

and:

That many of these works are now in the process of being disavowed as part of the Rembrandt corpus does not bother me; it rather supports my argument that *Rembrandt* is a cultural text rather than a historical reality. *Rembrandt* constitutes these works and the response to them, responses that range from their mistaken attribution to attempts to challenge their authenticity on the basis of a holistic and elitist concept of authorship.[40]

However, although the RRP take the question of authorship as a starting point, their conclusions demonstrate that ultimately, rather than being defined purely in terms of either materiality or the individuality of the artist, *Rembrandt* is instead a product of a particular process of positive feedback within the discursive systems of the art world.

Locked-In Art History

My argument so far has been that cultural systems (like other complex systems), while being complex and unpredictable, are also predisposed to inertia in so far as they lead to a certain stability being achieved within those systems. In Arthur's VHS/Betamax system, a stability could be observed to emerge within the market. And in cultural systems this could be likened to the emergence of dominant cultural forms. It is thus suggested that this systemic stability is manifested as a form of cultural inertia, which, in turn, has implications within the larger social systems with which it interacts.

In concluding I return to the two leading claims of this chapter. First: discourse *in general* displays certain systemic principles and can therefore be understood in terms of a systems-thinking approach as a complex representational system. Second: discourse on art *in particular* can equally be understood in these terms. This is to say that discursive systems are complex systems too, and they will therefore display behavioural patterns common to all complex representational systems.

Above, this correlation was demonstrated by the argument that these distributed discursive systems could become, like other systems, 'locked-in' around certain concepts and behavioural patterns. In the above examples, discursive systems of art had become 'locked-in' around certain narrative tropes, such as the method of 'art

history of the proper name' or common expectations of typical biographical motifs within art history, and also around particular artists, such as Rembrandt.

Underlying all of these arguments is the claim that by identifying discourse on art as a subsystem of the system of art one can recognise that it is isomorphic to other complex systems. More specifically, isomorphic behaviour can be identified across all of the complex systems from which art emerges. These include: individual works of art and collections of artworks; the art gallery/museum; and discourse on art. In fact, even this book itself constitutes a part of this whole as it operates according to the concepts of the discursive systems of art. It too is 'locked-in' around certain fundamental concepts (namely art and art history).

In this way we are able to map the behaviour of one system onto other systems. Thus it becomes evident that the isomorphic artistic systems of distributed representation, display and preservation of the art world are all locked-in around the concept of art. The very ambiguity of the concept of art serves to highlight that the processes of distributed representation, differentiation, display and preservation take place across the various systems of art. Consequently the meanings of the concept of art in the subsystems of the artwork, the gallery and art discourse are systematically related and cannot be understood in isolation from one another. In addition, these processes of differentiation, while related to art in the systems outlined above, are not unique but are also observable across a range of complex systems where a systems analysis has been applied including those studied in biology, physics, economics, cognitive science, etc.

Furthermore, Thomas Crow has observed processes that I am likening here to those of positive feedback and 'lock-in' at work in the art market too, which follows given their situation within other economic systems: 'While governments and large corporations have plainly acquired a stake in contemporary art, the financial risks are miniscule by comparison', he writes. Both the film industry and professional sports, for example, 'demand elaborate forms of concentration, monopoly, and state intervention in order to secure the enormous financial commitments involved'. According to Crow, this is not true of the fine arts.

> With their low costs of entry and potential for exponential returns, the fine arts seem closer in this respect to computer software, our era's most potent form of intellectual property. Art seems similarly well adapted to a world in which markets are completely internationalised, politics are subordinated to them, and economic exchanges, unconstrained by time and space, are expressed in disembodied, quasi-fictional forms of information transfer.[41]

Curiously, the economy of art was described by Crow in almost the exact same terms in which William Burroughs described the economy of the heroin market,

which also displays positive feedback (that is big returns for small investment). This could be taken to mean that art, like heroin, is one of the most exemplary expressions of the commodity system. They are both 'things which don't need any advertising'.[42] Perhaps, then, positive feedback in cultural systems (manifested in cultural and systemic memory, in irreversibility and ultimately cultural inertia) can be understood as a type of systemic 'addiction'. Thus Crow's claim that 'the art world's continual circulation of information and services has become a primary source of profit in itself'[43] explains how the economy of the art market has 'locked-in' around particular cultural paradigms and has become a system which is self-organising and self-perpetuating (which is to say, in systems-theoretical terms, auto-poietic). Extending this analogy further, the other systems of the art world, including art discourse, are not only 'locked-in' around art they are addicted to it too.

That the discursive systems of art are locked-in around the concept of art is something which has come under scrutiny in the ongoing debates concerning visual culture studies and the reconfiguration of art historical practice, a debate which is still an unresolved exchange of claim and counterclaim and which will not be revisited here. What I will take from these ongoing debates, however, is the non-trivial observation that art history requires both a concept of art and of history in order to function in a recognisable form (distinct from other academic disciplines). As Thierry de Duve claims:

> Whatever the history of art – most often indeed the history of styles – does, it postulates (when it doesn't simply prejudge) the continuity of its substance, the invariance of its concept, the permanence of its foundations, and the unity of its limits. You are a historian of art and this is why, even though (all things considered) you don't know what art is, as far as you are concerned its history must be cumulative. Despite changes, even despite revolutions, the history of styles, accumulated in the mass of things that humans have called art over the course of time, appears to you as a cultural heritage. It belongs, you say, to humanity, and this is why your discipline is humanist. It is made up of objects but also of relations between those objects, ties of filiation, hinges of influence through which history obeys its own causality, broken influences and new departures through which art renews itself, naked as on the first day [. . .] As a humanist historian, you redefine this corpus historically: it is a patrimony. Its manifest heterogeneity gives way to its cumulative continuity, which is grounded in the fact that an essence called art maintains itself unchanged through a succession of avatars.[44]

Finally, there is also a political dimension to the critique of such discursive 'lock-in' or addiction, which couches the arguments in terms of an equation of cultural inertia

with hegemony and power. Donald Preziosi has argued that the 'art' (which I have identified here as a concept and 'attractor' around which the systems of the art world are 'locked-in') is part of a more general language of dominant cultural forms and norms. Art is, in short, part of the 'Esperanto' of Western hegemony and power relations. He states:

> On a global scale art has come to be a universal method of (re)narrativising and (re) centring 'history' itself by establishing a standard or canon (or medium, or frame) in or against which all peoples of all times and all places might be seen together in the same epistemological space.[45]

Art, as we know, is not a meritocracy. The best art (whatever this may be) is not necessarily the art we have ended up with. It is regulated by hegemonic structures of representation, appropriation and power. I have argued here that when thought of in terms of systems these structures can be rethought according to such processes as lock-in and positive feedback. The risk is that this leads to arid abstractions; the reward, though, is that such thinking allows one to think of how art and its relationship to social systems might be reimagined and speculated upon.

Notes

1. Paul Oskar Kristeller, 'The Modern System of the Arts: A Study in the History of Aesthetics', *Journal of the History of Ideas*, 12, 4 (1951): 496–527; James Porter, 'Is Art Modern? Kristeller's 'Modern System of the Arts' Reconsidered', *British Journal of Aesthetics*, 49, 1 (2009), 1–24.
2. Larry Shiner, *The Invention of Art: A Cultural History* (Chicago: University of Chicago Press, 2001).
3. Robert J. Yanal, 'Institutional Theory of Art', in *Encyclopaedia of Aesthetics*, ed. M. Kelly, 2nd edn, vol. 3 (Oxford: Oxford University Press, 2014), pp. 491–4.
4. Niklas Luhmann, *Art as a Social System*, trans. E. Knodt (Stanford: Stanford University Press, 2000).
5. Francis Halsall, 'Niklas Luhmann', in *Encyclopaedia of Aesthetics*, ed. M. Kelly, 2nd edn, vol. 4 (Oxford: Oxford University Press, 2014), pp. 220–4.
6. Francis Halsall, *Systems of Art: Art, History and Systems Theory* (Oxford: Peter Lang, 2008).
7. Craig Owens, *Beyond Recognition* (London: University of California Press, 1992).
8. Halsall, *Systems of Art*.
9. Michael Podro, *The Critical Historians of Art* (New Haven: Yale University Press, 1984).

10. W. Brian Arthur, 'Self-Reinforcing Mechanisms in Economics', in *The Economy as an Evolving Complex System*, ed. Phillip Anderson, Kenneth Arrow and David Pines (Redwood City, CA: Addison-Wesley, 1988), pp. 9–31 (p. 10).

11. James Lardner, *Fast Forward* (New York: New American Library, 1997).

12. 'Format Wars', *Rolling Stone*, 15 January 1987, p. 10.

13. 'Sony Isn't Mourning the "Death" of Betamax', *Business Week*, 25 January 1988; 'Goodbye Beta', *Time*, 25 January 1988.

14. W. Brian Arthur, 'Positive Feedbacks in the Economy', *Scientific American*, 262, 2 (1990): 92–9 (p. 93).

15. Ibid. p. 92.

16. Lardner, *Fast Forward*.

17. Roger Lewin, *Complexity* (New York: Macmillan, 1992), p. 20.

18. James Gleick, *Chaos* (New York: Vintage, 1987), p. 49.

19. Edward Lorenz, *The Essence of Chaos* (London: UCL Press, 1995).

20. Gleick, *Chaos*.

21. Michael Ann Holly, *Panofsky and the Foundations of Art History* (Ithaca, NY: Cornell University Press, 1984), p. 75.

22. Rosalind Krauss, 'In the Name of Picasso', *October*, 16 (1981), pp. 5–22 (p. 6).

23. Clement Greenberg, 'Towards a Newer Laocoon', in *Art in Theory 1900–1990*, ed. Charles Harrison and Paul Wood (Oxford: Blackwell, 1992), pp. 554–61 (p. 555).

24. Svetlana Alpers, *Rembrandt's Enterprise* (London: Thames & Hudson, 1988), p. 3.

25. Rembrandt Research Project, *A Corpus of Rembrandt Paintings I* (The Hague: Stichting Foundation/Rembrandt Research Project, 1982), p. i.

26. Alpers, *Rembrandt's Enterprise*, p. 59.

27. Jakob Rosenberg, Seymour Slive and Engelbert Kuile, *Dutch Art and Architecture 1600–1800* (New Haven: Yale University Press, 1966), p. 142.

28. Ibid. p. 143.

29. Ibid. p. 144.

30. Ibid. p. 142.

31. Rembrandt Research Project, *A Corpus of Rembrandt Paintings I*, p. 59.

32. Ernst van de Wetering and Paul Broekhoff, 'New Directions in the Rembrandt Research Project, Part I: The 1642 Self-Portrait in the Royal Collection', *Burlington Magazine*, 138, 1 (1996): 174–80 (p. 174).

33. Rembrandt Research Project, *A Corpus of Rembrandt Paintings I*, p. xi.

34. Ibid. p. xii.

35. Ibid.

36. See Domenico Morelli, *Italian Painters* (1890), in which Morelli, in the narrative guise of an elderly Italian traveller whom the author meets, relates his thesis on the nature of a correct art historical method founded upon close attention to detail and informed

connoisseurship. 'A true knowledge of art is only to be attained by a continuous and untiring study of form and technique, that no one should venture into the domain of the history of art without first being an art connoisseur.' Quoted in *Art History and Its Methods*, ed. Eric Fernie (London: Phaidon, 1995), p. 110.

37. 'The process of illegitimate accretion to the oeuvre, which took place in the 18th and even as early as the 17th century, can be glimpsed from the prints put out in those years and purporting to reproduce paintings by Rembrandt. When John Smith published the first catalogue of the paintings, in 1836, his work inevitably reflected a corrupted tradition and consequently gave a distorted view. Eduard Kolloff (1854) and Carel Vosmaer (1868) deserve credit for bringing some kind of order into chaos, as Scheltema had done for biography; but it was particularly the young Wilhelm Bode who, in the 1880s, produced a corrected image of Rembrandt's work, especially that from the early years.' From Rembrandt Research Project, *A Corpus of Rembrandt Paintings I*, p. ix. Other names which are cited as providing the foundations for the body of work accepted as 'Rembrandt' at the time of the beginning of the RRP include Hofsted de Groot (1915), Hans Sedlmayer (1897–1905), Kurt Bauch (1966), Alfred von Wurzbach (1911) and John van Dyke (1923).

38. Broos and Alpers identified three broad types of 'Rembrandt-esque' paintings that show his influence both materially and conceptually. Alpers classifies them thus: '(1) Study heads taken home by pupils, (2) copies after Rembrandt and (3) paintings by the assistants sometimes perhaps even signed and sold as Rembrandts.' Alpers, *Rembrandt's Enterprise*, p. 125. See also Ben Broos, 'Fame Shared Is Fame Doubled', in *Rembrandt: The Impact of a Genius*, ed. Albert Blankert et al. (Amsterdam: K. & V. Waterman, 1983), pp. 35–58 (p. 41).

39. Mieke Bal, *Reading Rembrandt* (Cambridge: Cambridge University Press, 1994), p. 7.

40. Ibid. p. 8.

41. Thomas Crow, 'The Return of Hank Herron: Simulated Abstraction and the Service Economy of Art', in *Modern Art in the Common Culture* (New Haven: Yale University Press, 1996), p. 79.

42. 'Junk is the ideal product [. . .] the ultimate merchandise. No sales talk necessary. The client will crawl through a sewer and beg to buy [. . .]. The junk merchant does not sell his product to the consumer, he sells the consumer to his product. He does not improve and simplify his merchandise. He degrades and simplifies the client. He pays his staff in junk. Junk yields a basic formula of "evil" virus: "The Algebra of Need". The face of "evil" is always the face of total need. A dope fiend is a man in total need of dope. Beyond a certain frequency need knows absolutely no limit or control. In the words of total need: "Wouldn't you?" Yes you would. You would lie, cheat, inform on your friends, steal, do "anything" to satisfy total need. Because you would be in a state of total sickness, total possession, and not in a position to act in any other way.' William Burroughs, *The Naked Lunch* (London: Flamingo, 1986), p. 9.

43. Crow, 'The Return of Hank Herron', p. 82.

44. Thierry de Duve, 'Art Was a Proper Name', in *Kant After Duchamp* (Cambridge, MA: MIT Press, 1996), pp. 3–88 (pp. 8–9).

45. Donald Preziosi, 'Collecting/Museums', in *Critical Terms for Art History*, ed. Robert Nelson and Richard Shiff (Chicago: University of Chicago, 1996), pp. 407–18 (p. 416).

4 Enduring Habits and Artwares

Adi Efal

Art's Value

THE PRESENT ESSAY draws several guidelines for a realist history of art. The realism assumed here could be understood as a 'naive' realism in the traditional sense of the term, a realism referring to the existence of reality outside of the mind, a reality which is ancestral as it is anterior to all givenness.[1] With regard to living things, i.e. to organisms (possessing inner and outer organs, senses, gestures and postures), the exterior status of reality demands a process by which that external reality is being gradually integrated into the reality of the organism. It is upon this interface that we will also try to locate art. A realist art history, in the manner we will define it here, is interested in discerning the *use-value of artworks*. We are trying to disentangle plastic artworks, at least partially, from their fetishised status as commodities[2] while seeking to approach what Karl Marx has called their 'substantial value.'[3] If one removes from an artwork its exchange surplus-value, what is left is a produced thing, or *a work* in the general sense of the word, and this work can still possess a use-value.

Use-value (*Gebrauchswert*) was differentiated by Marx in his *Das Kapital* from exchange-value (*Tauschwert*), which is the value typical of commodities.[4] Marx determined that: 'The utility of a thing, its character of satisfying some human need, makes it a use value' ('Die Nützlichkeit eines Dinges, seine Eigenschaft, menschliche Bedürfnisse irgendeiner Art zu befriedigen, macht es zum Gebrauchswert').[5] Use-value is a proportion between a need and that which satisfies or appeases that need.[6] Organisms have needs because they are not totally self-sufficient and because they *possess* an exterior reality. The economy of values installs and manages the transaction between an organism and its reality, but it is use-value that stands as the most

elemental and therefore substantial value, according to Marx. The science of the history of art is burdened with the task of making distinct the use-value of artworks, as Marx adds: 'To discover the various uses of things is the work of history.'[7] Yet the specific needs of organisms are not always naturally given but can also be constituted gradually by processes of habituation, until they (i.e. the needs) become naturalised,[8] like second nature. Generating, installing, educating and maintaining a need is the second degree of realism that is attempted here, and this is also the kind of work, we suggest here, which is realised by art.

Sylvie Mas's *Elements* (2011) engage with such a transactional process where the use-value of things is transfigured into a plastic riddle. By binding and sticking together various used objects, in gestures of smears of plaster and pushing, folding, sticking, actions that undeniably result from a human hand, she crafts new-born things recalling the needs they were supposed to fulfil and weaving those needs into a new interface, suggesting strange and unknown ways of handling and of usage. Indeed, differently from the claims of various 'disinterested' aesthetics, in Mas's *Elements*, utility becomes a part of plastic engagement, and this is also the direction in which this essay proceeds. Utility and verity, so claimed John Ruskin in 1854, are the two basic demands of art.[9]

Sylvie Mas, *Elements*, 2011, tiles, tow, Placostil®, plaster, pullboy, plastic bag, 120 × 40 × 30 cm. Courtesy the artist

Artworks as Habituation Processes

Artistic things, like all other produced things, take part in the economy of human needs. Artistic things install in humans standards of taste and of meaning. The process of installation of needs by the production and maintenance of works is the reality that interests us here. This work process is, as suggested above, essentially one of habituation. The concept of habituation, as it is used here, takes its cue from the spiritualist philosophy of Félix Ravaisson-Mollien,[10] contemporary to that of Marx. Ravaisson-Mollien's concept of habit can account for several aspects and characters of the methodic realism in art history that is suggested here. Reality, according to the mechanics of habit, is primarily that to which one has to *get used to*. It is non-wished for, often-unwelcomed data arriving to the organism by nature or by fate, and to which the organism must habituate itself in order to survive (that is to say, in order to endure). The reality of habituation therefore is a movement of inter-nalisation. It is a process of transfiguration of the status of an exterior reality: from being conceived as a threat and a disturbance to the organism's normal functioning, it becomes immanent to it, included in the organism's regular existence. With the help of habituation, this exterior reality becomes bearable or even approved and registered within the borders of the organism, rather than staying perceived as a disturbance or otherness. The internalising negotiation of transference takes place primarily on the surface of the organism, on its skin, on its upper levels of contact with reality. Ravaisson-Mollien emphasises that art exists only as a surface of the deep web of habits:

> Art [. . .] has purchase only on limits, on surfaces, on the outside; it can act only on the exteriority of the mechanical world, and possesses no other instrument than movement. Nature works on the inside, and even in art, is the sole constituent of depth and solidity.[11]

Indeed art is first and foremost a matter of surfaces. Art happens on surfaces and it is effective first and foremost as a surface and as a protecting and covering membrane. So are Mas's earlier *Angulations* from 2007, on which the surfaces of plaster and plastic bags combine into figurations of movement in a cloth that works effectively as a habit, covering and dressing the wall upon which they are hung. These reliefs are added on the wall and they ornate it, they stand between the public and the wall, as a double-winged door, scarf, curtain; they invite the viewer to the wall in a gentle, held and frozen weaving movement, annexing the two physical realities (person and wall) together as a mediating, hampering joint, putting people and walls together but also preventing their total unification. Two physical realities that are

not necessarily bounded (one organic, one inorganic) are brought together by these habits-reliefs. Bringing and holding together things that are not necessarily and naturally joined: could that be one of the central functions of art? Aristotle wrote that 'to pursue an art means to study how to bring into existence a thing which may either exist or not'.[12] Art, productive *making*, is bounded with *contingency*, with what may or may not take place. Art, therefore, leans on an undetermined capacity of the organism that can be determined, formed and reformed by habituation. Habit, therefore, is a *determination process* of the second-order needs and capacities of the organism. It does not reside in the primary nature of the organism but rather in the qualities that the organism is capable of acquiring and possessing. Yet, 'once acquired, habit is a general permanent way of being and if change is transitory, habit remains for a change which is no longer or is not yet; it remains for possible change.'[13] Thus habit institutes the capacities of the organism to welcome or reject future changes, that is to say to cope with reality later on.

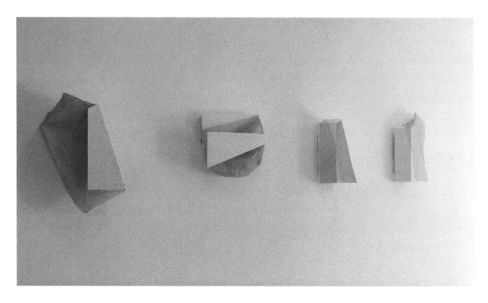

Sylvie Mas, *Angulations*, 2007, plaster, tow, translucent blue 60 liter trash bag, 80 × 40 × 40 cm. Courtesy the artist

Habit is a prosthetic quality that is mounted on the organism, an accessory which is stabilised and naturalised by rehearsals and repetitions.[14] We suggest to think of art as a habit, as a cover of the organism, regulating the organism's needs. And if the Marxian use-value is mainly material, the use-value that we wish to delineate here takes place, at its radical manifestation, as mental reality. This value merits to be referred to as a *use-value* in the limited sense that it registers a thought

which is able, retroactively, to transfigure traditional habits. This use-value there-fore could also be named *speculative use-value*. This value is neither a consumption-based exchange value, nor an aesthetic value of gratification or sublime shiver. It is a value registering a movement of thought that was covered and wrapped by the artwork and which could not literally or explicitly be distin-guished as such until the moment of an art historical inquiry. Instead, it denotes the manner in which a thought, an operating principle (neither to be confused with an 'idea' nor with a 'concept') is actively maintained by a work. Thus, for the art historian, the specific artwork has a speculative use-value in so far as it helps the art historian to understand better the tradition within which he or she is working. The movement of thought that is being enveloped by the work can be likened to a geological break or tectonic eruption, causing a series of mutations upon and within the surface of the earth of history. In order to approach the area of the original crack, we must follow the trail of the mutated matter and move in a retrograde manner back into the histories of art and thought. The endurance of the thoughtful break within ages of traditions, schools, replacements and reloca-tions is to be articulated as a curve within history, rather than as a straight narrative line of evolution or decadence.

The value that registers this durational reality of a work we suggest referring to as an 'age-value' (*Alterswert*), a term that the nineteenth-century art historian Aloïs Riegl coined. Age-value is a value registering the endurance of a work through different eras and cultures. This value is not a use-value in the simple sense, but it is also not essentially an exchange-value. In fact, when a thing has (or 'is', in Marxist terms) age-value, it has a certain resistance to being exchanged with other things or goods. Rather, the culture of monuments aspires to preserve the thing as it is, not trading it for something newer, more beautiful or more efficient. On the other hand, one cannot say that age-value is devoid of any usage: age-value answers to a human need, the human need to be bounded with the past and with tradition as well as with the endurance of natural powers and eras. The realist inquiry into the age-value of artworks in this framework is a retrograde and restor-ative one, and it follows a work's endurance through ages and cultures in order to discover its principle of operation.[15]

Age-value, Duration and Habituation

In his 1903 essay on the modern culture of monuments, Riegl deployed a typology of the values that modern culture ascribes to old things. Among these, he analysed a special form of value that he called age-value, a value he differentiated from *historical-value.* Riegl's analysis of age-value uncovers a less recognised segment

of the late-modern relation to our material past. *Alterswert*, says Riegl, is the value which is ascribed to things surviving generations and mutations over time, *because* these things survived and endured.[16] In more general terms, *Alterswert* is a durational value, inscribing not only the length of the duration of the work in history but also the supplementary qualities, meanings and usages that the work has been absorbing during the various episodes of its insistence. 'Duration', writes Ravaisson-Mollien, 'does not decrease the pleasure in the action, but rather augments it.'[17] *Alterswert* is the value of persistent, preserved and persevering things; it is the value of things that stay within tradition, in archives, in museums, at home or in other resorts. This quality of duration is distinguished from what we consider as 'beautiful' according to the standards of the Western theory of art or aesthetics, yet it is also differentiated from the standards of historical or historicist narratives of development. Riegl points out that, in many cases, historical considerations stand in conflict with the ones that age-value demands. For example, in as much as historical investigation demands to restore the original state of the monument in order to study it most clearly, age-value does not demand to restore a monument but rather to preserve it in its declining stage. In as much as historical-value usually demands organising history according to some developmental narrative form, the preservation of an age-value of a monument demands posing the historical narrative at a secondary place, while many other factors and many other parameters figuring local causal contacts between the work and other things, such as influences, interpretations, readings and misreadings, but also earthquakes and wars, take instead primal importance. It is possible to include in the concept of the *Alterswert* not only the 'aesthetic', sensual signs of time, but also the traces of reading, interpretations, classifications, presentations, contracted and contained in the preservation of monuments and documents of all kinds. Age-value, in this extended sense, encompasses the scratches, mutations, deformations, elaborations and interpretations that thoughts have left upon a work which survives, which persists, which endures. This value includes not only the traditions existing in a condensed form in the work, but also the duration of the principle of the operation of the work through series of readings. In other words, age-value refers to the covers, the exterior levels that have been stored and gathered on (and in) the outer layers of a work. Can a historical knowledge of works give up the claim for linearly oriented development, and instead give an account of the effective, undetermined, non-directional past of a thing?

Alterswert is applicable to any work, either a useful tool or an artwork. But whereas the 'ordinary' useful work registers upon its surface primarily the signs of time – dust, rust, cracks, etc. (and when we travel to museums of applied arts or go to visit a medieval ruin we usually enjoy, besides viewing the work itself, also witnessing those

Sylvie Mas, *Bases*, 2014, digital project in process. Courtesy the artist

distinguishable signs of time) – an artwork possesses its durational reality not only gradually, by and over time, but at the very moment of its generation it contracts, compresses and realises a long duration of traditions, transmutations, renaissances and declines of meanings and qualities. In a way, the artwork, when produced, is already old, and only by being so is it truly and wholly innovative. This may account for the reason why, in comparison to the former case of the 'useful thing', one would not usually appreciate seeing Rembrandt's *Nightwatch* vandalised or covered by dust, but rather prefer to see it in a restored state. If we look again at Mas's *Elements* and in her *Bases* from 2014 as well, one can see that she is gathering such age-value into her wares. She compresses not only different utilisations but also different ages together, meaning thus that the speculative-value of her works includes not only operations and usages but also various historical moments. A thing carrying an age-value creates, practically and literally, a past. It retroactively produces a *tradition* by posing itself at the end of a series of a habituation process, in which an act or a work was reshaped and rethought through the ages.

The Ware and the Artware

We come now to the definitions of ware and of artware. Ware, it seems, can be understood as the kind of reality that artworks are. Ware is a term referring to artefacts, mostly products of craft and made originally out of clay or glass. Furthermore, a ware is also a primitive form of commodity, merchandise, a 'good', offered to the people by the producer. The German '*Ware*', used by Marx, has the same etymology, and in its modern reception, ware could be referred to as 'real merchandise', that is to say a good waiting to be possessed, not only consumed or exchanged. One could suggest a weak (i.e. a non-substantial) differentiation between a 'ware' and an 'artware'. In as much as a ware is capable of being immediately absorbed into practical habits (and therefore we can deduce retroactively its objective, its 'goal'), an artware deviates and makes a curve regarding practical concerns. The durational curve of an artware does not necessarily support praxis, but rather delineates a threat of disintegration, dissemination, dissipation, or loss of cohesiveness that latently incubate a certain habitual reality, that is, a certain functioning organism, personality, culture, polis, discourse or tradition. The ware is being transferred from hand to hand, from the hand of the producer to the hand of the user. It has direct, immediate contact with the two members of the transaction and it serves as a transference agent between the two. Note that both members of the operation are active in some manner: the craftsperson produces the ware, in as much as the consumer appropriates and then possesses the ware, integrating it in his or her own everyday life. The recent global phenomenon of designers opening their studios directly to consumers exemplifies such a relation. In such a framework, the history of art would be charged with making that movement of transference explicit, deploying it, externalising and distinguishing it.

This movement of transference of the ware has a theatrical structure. There is a place of meeting (The 'stage'), where an artware is produced, realised, presented and then carried away further according to the needs of the public. Mas's *Bases* (see p. 67), being essentially an elaboration on the function of the base in the plastic arts (continuing a long tradition of this topos, for example in Auguste Rodin, Constantin Brâncuşi or Donald Judd), takes one also further away to this theatrical situation of the stage upon which a good is exposed, offered to the public, but is also sustained and preserved. The scene of the artware is a stage whose reality, its production mechanism, is wrapped and enacted by the artwork. The production mechanism and its principles make the reality of an artware and they endow it also with its speculative use-value, that mental use-value that the work carries. The relevant art historical method will be initiated by an examination of the surface of wares when being met by the inquirer. This preliminary 'superficial' starting position of the inquiry does

not mean that there is no depth in this inquiry but rather that depth is traced *as an interface, that is to say as a site of negotiation between a present consciousness (that of the inquirer) and its past.* The spatial structure of this inquiry is a theatrical one. In theatre, the backstage takes a necessary, unavoidable part in the theatrical rehearsal. Yet that which comes into contact with the users of the work is the exposed stage alone. Note that the relationship between the stage and the backstage is particular: what happens on stage by no means represents or even *presents* what is happening backstage, rather the production mechanisms and operations that are active backstage have their results or actualisation on stage, on the theatrical 'skin'. Thus the artware should be conceived as a theatrical situation, whose backstage is an obscured conglomeration of habits and working principles.

The Depth of Habit

Art works without, whereas nature works within. The 'content' of art is its nature, its production mechanism, the same obscure activity which we referred to above as the 'backstage' of the theatrical situation, that machinery encompassing age-value and the speculative value of the transfiguration of habit. Habit is an active tissue binding an organism's interior with its exterior and with reality, and in its extended sense habit binds a certain work with its numerous usages or applications. Habit is a mechanism of appropriation of covers, accessories and, more generally, of 'habits' or costumes by an actor. Mas's *Angulations* (see p. 64) are such habits, working as configurations of covers and layers, juxtaposed and superimposed surfaces, embracing in the interstices refined territories of air empty space, breathing like the space between cloth and skin.

This metaphysics of the cover can sustain a historiographical model in which that which was made can be unmade, that which was covered and laid could also be lifted or released. Even if habit is difficult to change, the very effort to shape it and to 'keep it in shape' counts as a productive operation by itself. The history of art could be thought of as the continuous effort of this making, un-making and remaking: the work of opening and unlacing the stitches of history, the same stitches that were described above with the help of the metaphor of the geological break initiated by a work in the earth of history.

The understanding of habit as cloth is pertinent already to the *Metaphysics Delta*,[18] where Aristotle gives the example of the relation between the wearer and his cloth as a demonstration of *hexis*, which is the Greek original word for the Latin *habitus*. *Hexis-habitus* is derived, in Greek, from the verb *ekhein*, and in Latin, from the verb *habere*, both meaning 'to have'. *Habitus* is a shared ownership existing between a wearer and his or her costume. In fact, habit is a case of bilateral possession: the

bearer owns and possesses his or her cloth, but the cloth also physically holds its bearer within itself or under itself, and it functionally gives the wearer not only its place in reality but also its special task. The bearer, or the wearer, on the other hand, possesses his or her *hexis*, or her *habitus*, as her cover, her skin, her second skin, her make-up or, in other words, her figure. Not only the user, but also the craftsperson wears his or her habit. Artistic habit, or the artware, therefore, is being worn both by the craftsperson and by the user. This wearing itself is artistic habit. Artistic habit mediates between the craftsperson and his or her ware. This was also confirmed by Aristotle; he suggests that between the producer (*poie*) and the product (*poietai*) exists a habit (*hexis*), and this habit has a special name: it is called *poiesis*.[19] The same habitual structure of active possession is to be found between the maker and his or her product and between the wearer and his or her cloth, between the user and the ware. Between the actor and the result or the product of his or her acts exists a habit. This suggests that there is an engagement between the producer and the artware that is not synonymous with the momentary act of generation; instead, between the producer and the product exists an enduring relation that can be retraced and restored historically. During the installation of habit as a situation of an active having, an actor wears its outside encountered reality. Art and its history participate in such a mechanism of habituation. The artwork, in this sense, is worn by an actor (whose identity is radically open: it can be the actor, the spectator, the patron, etc.) in order to *exteriorise* a certain habit. Art is therefore a process of distinction of a habit, a process that pushes the habit back from the internalised status within the organism to its surface (sometimes on its way to be excluded again). Crucially, artistic *habitus* in this sense belongs neither to the producer, nor to the product, nor to the viewer: it rather belongs to the habitual subject entailing and operating synchronically all the above participants.

Artistic Subjects and Artwares as Their Accessories

It is essential to establish a vocabulary for referring to the various organs of the reality of this above-described 'art-industry' (*Kunstindustrie*[20]), so that when we say 'thing', we mean a thing, and when we say 'work' we mean a work, and when we say 'object' we mean an object rather than a work or a thing. Therefore, the next definition that should be given regards the status of reality of the artware qua a historical reality, taking into account that the concepts of thing, work and object each expresses a different type of reality of the work of art. Recently, we have witnessed an object-oriented 'turn' in continental philosophy, which has been concentrating on things and objects.[21] While sharing its engagements with reality and with things of all kinds, our position should be differentiated from the position of the authors adhering to

this important turn. In the present realist framework, that which is emphasised is rather the *subject*, understood as a constellated, active and generative reality and distinguished from that which is understood as 'subjective' or 'subjectivity'.[22] The 'place of the subject', as Alain Badiou explains, is an ethical process, maintaining an enduring fidelity to an encountered truth.[23] The truth is to be found as an object to which a subject adheres and to which the subject is loyal. Informed by the psycho-analysis of Jacques Lacan, Badiou's concept of the subject places the object first and foremost at the point of a constitutive lack in the subject, a lack that in our terms stands for the reality of a permanent situation of exteriority between an organism and its reality.[24] The subject exists for Badiou as a moral involvement, it is a process and a procedure, working for an ethic of fidelity to a truth. Artware, too, should be understood as the materialisation of a subject's fidelity to a lack, a lack which in our scheme exists as the exterior reality to which one has to habituate in order to endure.

In its moral struggle to endure with truth, to habituate the exterior, the subject needs helmets, covers, embellishments and other accessories of many kinds, assisting this fidelity to take shape. These accessories work as binding joints, installing, sustaining and maintaining this engagement. These accessories are like local adhesion matter, being installed on the surface of the organism. Like an accessory, an artware can be understood as an instrument whose function is to localise and make distinct certain parts of an organism: any artistic work, according to this suggestion, is annexed to a body taken as a functioning cohesiveness from which the artwork slices a part (i.e. the eye, the ear, the eye and the ear, the mouth and the eye, etc.). Artware annexes and adjusts itself to some sensing part of the body and at the same time it rearranges the body in its entirety; it thus configures an organism and draws outlines of some of its parts. Like a garnish, like lipstick or eyeshadow, the artware settles on a certain territory of the organism, being integrated into the organism's movements, gestures and postures. The artware re-naturalises a certain body part in the form of a pros-thesis enabling the organism to operate with an exterior reality. As an embellishing prosthesis, the artware participates in the normal, regular, ordinary movements and operations of the body. The soft and receptive organ is supplemented by the prosthesis of the artware with the help of instruments and tools that are softer or harder than the organ itself: the pencil, the piano, the hammer. Artistic habits annex bodies to places, figures, institutes, ideas, models, etc. Artwares in this sense always possess a habitual aim: they necessarily externalise a stable binding between an actor and its reality. And artworks, in this sense, always have a function, a function extending or re-figuring the normal and habitual function of an organism.

Artworks are figurations of habits, *figures* having the capacity to soak up the depth of habits back into the surface of things. The figure limits and refreshes a habit by delineating and soaking up the habit's depth into the approachable surface of things

and bodies. For the sense of sight, writes Ravaisson-Mollien, 'the figure of things detaches itself in a way from their matter, entirely at the same time forming an ensemble from which we embrace at the same moment all the parts'.[25]

Mas's artwares often generate figurations of this kind, where an assemblage of several parts of technical objects is being gathered to form a new organism-machine (pp. 62 and 67). Its organs are adjunct and annexed to each other as each other's prostheses, and by that they produce new functions and new needs for the known and habitual objects. In those chimeras, different usages and different ages are synthesised into a ware, inviting the potential wearer to adhere to them. The different organs of her artwares lean on each other, shuffle against each other's boundaries, take part in each other's figures. This transfiguration is no longer merely organic or material, it exists as a poietic, speculative value, embracing the parts like a gentle, transparent coating.

The Actor, the Wearer and the Subject of Artware

In order to define the artistic subject we have to distinguish between the actual wearer of the habit (the user, the spectator, the art historian), the actor (the actual producer of the ware) and the habitual subject (which is a synthesis of the two former members).

To continue to work with the model of the theatre: the theatre actor is a tool for the realisation of a work; his or her status is similar to that of the tool or the instrument. As in any theatrical production, moreover, the actor *knows in advance* the structure of the work (its narrative, its beginning and end, its general principles of operation); the actor possesses the knowledge regarding the overall structure and principle (i.e. the 'subject') of the certain work. Notwithstanding, the actor has *to act as if he or she does not know* what is going to happen. I think this is the case with most artists and with most artwares: artists should know something on the structure of what they do, on the history of what they wish to bring forward, etc. Nevertheless, in the moment of actualisation itself one should leave this knowledge also to the side, performing the gesture in a quasi-automatic, already habituated manner. The identity of the actor (the one who serves as the efficient cause of the work) is determined by the question that the inquirer asks in her inquiry: different questions, different problems, will retroactively produce different actors. In a historical inquiry, the artware is valued, consumed, appropriated according to a certain question that is being addressed to the work, a question serving the usage, the thesis that the historian wishes to test. Therefore the more general function of the 'producer' of the work should be conceived rather elastically. Sometimes the efficient producer is indeed the one who is identified as the 'artist/s', but sometimes it is the patron, or the forms themselves, the wall upon which the picture is hung, or the idea which was working

its way through various media, histories, or any possible combination of the above. At any rate it is impossible to know a priori, before the beginning of an art historical inquiry, who or what is actually the efficient cause of the work of art. And the art historian must be prepared at any moment to rethink his or her presuppositions regarding the definition of the actor.

In habitual situations, the ware is conceived as *an instrument* of binding between the actor and the wearer and not necessarily as the end task in itself. And what about the function of the wearer? The function of the wearer is parallel to the one of the user or of the 'spectator' or the 'public'. She is the one going to church or to the theatre or to the museum, making use of the ware and receiving it to herself. In that sense, the user is an indispensable part of the realisation process of the work. 'Interactivity' would therefore be a redundant term in our framework, as any realisation of a work includes its wearer, an artware cannot be essentially more or less interactive than another artware. Nevertheless in the artware scenery one does not so much talk about 'inter' action, but rather of an action *tout court*, being realised by the habitual subject, which, to remind, embraces all participants as equal adherents.

Can we think of art history as playing a part in a theatre-subject that is the stage upon which products and pieces occur? A certain piece is realised, exposed and present, yet backstage a whole repetitive mechanism of dressing, waiting, lighting, directing, etc., takes place. And it is this mechanism that makes the depth of habit, at the same time that the principle of operation, defining the artistic subject, arranges the entire theatrical demonstration (the 'spectacle'). In this, theatre, various actors, art historians, advocates, nurses and artists participate in order to fabricate what one calls generally 'the artist'. To paraphrase Henri Focillon: 'The artist is the geometer and the mechanic, the physician and the chemist, the psychologist and the historian.'[26] This expression is extremely close to Ravaisson-Mollien presenting the scenery of the actuality of habit where: 'The author, the drama, the actor, the spectator are all one.'[27] Art history may and should take upon itself the ethical engagement in this scenario, by making explicit the age-value at work.

The Past of the Ware

In this frame of thought, art is not considered primarily as a site of sensual experiences or events. Rather, it is to be considered as *rehearsed production* – no more, but no less either. *The rehearsal is itself the product*: it is a repetition of the work's principles of operations. That would mean that the use-value of the work we mentioned at the outset is to be assigned to its being a produced work, in the same sense that a Coca-Cola can, a dress or a cheesecake are produced things. Moreover,

both the ware and the artware are habits, and both have a relation to ideas. Only then do we see that the ware and the artware differ in the direction of movement between ideas and work: in as much as the designed-thing is accomplished by the bringing into work (the *energeia*) of an idea, a model or a prototype (and therefore it adheres to practices and their teleologies), the artware receives its principle of production, its *dynamis* only in retrospect,[28] as a curve or a deviation in habits of thought, culture and tradition. Consequently, the historical restoration of the production of the thing will also be different between the two cases of the ware. In as much as models, manifestos, artistic manuals, drafts, etc., suffice in order to understand the ware's principle or operation, the artware demands from thought to capture the gap between any model or context and the certain thing in question, and it is this gap that embodies the principle of the work.[29] The artware's principle of production is not (or rather, not *only*) a preconceived model, it is essentially a retroactive transition *from* a state of an 'after' *into* the 'before' of the realisation of the work. The art historian exploring this process of transference retroactively passes from the situation in which the work is realised (rehearsed, used, annexed, worn) and already locatable in historical reality and in its habits into the distinction of the principle of the work, the special condensation of the past that the work carries within itself but which was un-identifiable by habitual systems of beliefs and judgements available at the moment of production. In other words, the misrecognition of the principle of the artware should be corrected by the art historian. When a thing's realisation is wholly restorable using available habits, so we suggest (following Bergson at this point), the artware is actually presented not as an artwork but as a designed, i.e. a 'merely' useful ware. The artware turns the habitual structure upside down and inside out: from the interfacial encounter with a work, the art historian seeks to make explicit a latent principle of operation, and an obscure subject is to be reconstructed through the following of the work's age-value and its various layers of usage.

Thought's Inhabitation and Its Prerequisites

Within the plethora of questions relating to habit, one of the central questions is how to make a place for thought, how to wrap the *res cogitans* and dress it, how to give it a territory or a body in which it could find the intimate freedom of producing its subtle distinctions. Indeed, when we say 'giving a body' or 'dressing the *res cogitans*' we are not talking metaphorically but rather describing things as they are. The artware is in this framework a dress, a shell enabling the movement of thought and the preservation of a body that carries that thought. A habit is a nest,[30] a place in which the work of distinction, the elementary operation of the *res cogitans*, can take place. Yet from the moment when a habit is contracted by an actor and a wearer and makes a

subject, it functions as a second nature, a fixed disposition, which sometimes, when one wishes to be away with it, stays around its wearer, sometimes being too rigid and impossible to change, suffocating the wearer's vitality. Thus sometimes habit is an instrument in a realisation of an action and a nest for thought, and sometimes it creates a blockage to action and for thought to take place. During the nineteenth century, the ambivalent relation between habit and action was readdressed. Already in the first years of the nineteenth century, Maine de Biran found that a repeated realised action is not only the foundation of habit, but could also be a menace to it: a careless, effortless automatic repetition can diminish and even destroy a habit.[31] De Biran determined that the function of repetition, regarding habitus, must be recalibrated. If thought cannot do without established series and assumptions, it cannot allow itself to rely solely upon that which is already established either. Thus the theory of habit developed, most notably by Ravaisson-Mollien, as a theory of tension between effort and disintegration. The challenge is to maintain the habitual tension. Habit must not loosen the grip of the reality to which it is directed, because when it loses its realistic claim, it becomes automated and self-contained, and therewith begins the deterioration process of habitual tension. In other words, habit is found to be maintaining cooperation between two realities, a tension between the organism and its outside, and this wearing of the outside is the principle of operation that is maintained by habit.

What makes enough of an effort in order to keep the habitual tension awake? This is exactly where the task of the historian gets into the scenery of artistic theatre. An intellectual effort (*effort intellectuelle*[32]) regarding the habit of an artware involves a restoration of its principle of operation. According to Bergson, an intellectual effort is exactly the interstitial movement between the several layers of habits of an organism. We recognise how much, in the history of art, the contraction of new habits demands effort, and how much effort is needed in order to change a status or an art historical metanarrative. Ravaisson-Mollien was well aware of the Biranian critique of habit a few decades before him. He nevertheless took habitual tension as a challenge and elaborated on the manner in which even the most conservative habit carries a core of freedom. The danger of automatic repetition, delineated by Biran, was found by Ravaisson-Mollien to be a gate, an obscure door that is opened by any of our most ordinary actions and gestures, an aperture inviting one to descend into the depths of the non-conscious web of mechanisms of both our soul and body. According to Ravaisson-Mollien, when this change itself is contracted and interiorised by the organism, through a repetitive act containing both the mimesis of the change and its own gestural reaction towards that change, a process of habituation takes place. In other words, habit's first condition is effort. Ravaisson-Mollien writes: 'It is [. . .] within this mysterious middle ground of effort that there is to be found [. . .] the

clearest and most assumed consciousness of personality.'[33] When effort is gone, the habitudinal tension cannot also survive. This effort, in the present framework, is caused by the original, ancestral exteriority of reality to the organism, this original discontent, demanding the work of habituation. The tension of effort constitutes an 'obscure activity', which, when followed and fine-tuned by the various acts of repetition and adherence, can lead, by a tangent, to a point of elementary, original, ancestral splitting between nature and will.[34] Thus the movement of habit is a retrograde one: one cannot advance in the construction and the refinement of a habit without descending into the infinitesimal nuances of the body, which are always, to some extent, obscure.

Habitual Body and the Past

The concept of habit, when taken in an extended sense, supplies an approach to the body and therefore to the organic part of the *res extensa*. Extension *is* approachable to the human mind, by the movement, shaping, maintaining of its habits. Gilles Deleuze has emphasised the element of organic contraction that constitutes habit. According to him, contraction as primary passive synthesis of repetition constitutes not only actions but also humankind in themselves and, as Deleuze writes, the 'primary habits that we are'. All bodies are condensed reservoirs of contracted habits.[35] Habitual reality, whose beats extend and shrink simultaneously, degrades one, takes one down, lower and lower, deep and deeper, backwards, into the wearer's own extended reality. The work of habit is therefore a work of retreat and retraction, but it is a retreat and retraction that moves into the material bodily extension (both of the actor and of the wearer). And, simultaneously, the effort of habit is a constant movement into and from the past of the wearer. In other words, within habitual reality there is a parallelism between the body and the past, and the materiality of the artwork in this context is understood as composed of history. In this framework, it is through *art history* that one approaches the question of art itself, and not vice versa. Art history *precedes* and does not *succeed* the artistic deed. Art is always and primarily historical. And bakers, pharmacists, art historians, philosophers and artists, as well as all other producers, capable of contracting the past through the appropriation of repeating gestures, all these participate in the extended habitual reality of artware. And at any moment, by many means, some of them artistic, it is possible to sample this reality by adhering to some human work. The habitual perspective suggests that when we adhere to an artware we actually wear the work, as a second nature, as a cloth; we effectively join the costume and make bits of tradition our accessories. Wearing the artware means locating oneself within the ware or below it, continuing to do what we do while carrying also the artwork with

us and upon us. All of us inhabit architectures, clothes and cities. Some of us, that is to say the art historians, inhabit also museums, libraries or conference halls from time to time. But how can one inhabit an artware? We would suggest that to be the inhabitant of an artware means to be habituated to it and to take upon oneself, to *assume*, the tradition which is contracted by it. It means primarily and simply to stay with a ware, to adhere to the ware, trying to wear it on oneself as a cover, as a custom or as an accessory.

Work History and Production

If the sciences of art would be willing to take up the challenge of the participation in the artware, as we tried to delineate above, this may relieve them a little from the fetishist tendency that was suggested at the opening. Art history is a fetishist, even *the* fetishist, historical discipline. From its very beginning, from Giorgio Vasari onwards, art history has been oriented not only to value but more specifically to things possessing a non-destructible surplus-value. Artworks have been regarded as possessing a permanent, secure surplus-value, a value which can neither be reduced to their labour-value nor to their use-value. This surplus-value makes artworks behave as super-commodities, in the sense that ideally, their surplus-value should be gradually growing over time, as history progresses. The art historian is responsible for the maintenance and nurturing of this artistic surplus-value, as the art historian is the one in charge of installing the historical, scholarly conditions and categories upon which the curator, the critic, the audience and the collector operate.

The historical science that would wear the artware will not be interested in artistic things in themselves, nor with their existence as images, nor in the meaningful impression that they evolve either in the genius-artist or in the overwhelmed aestheticised or un-aestheticised spectator. Instead, this art history would be interested in the maintenance of the artware's habit. Its task would be to restore a reservoir that the artware, qua produced thing, possesses. This approach suggests that *any produced thing* can be considered, studied and understood *either as a ware or as an artware*. It will be the task of the art historian, coming into contact with wares, to differentiate between the practical and the poietical use-value of the ware, and while doing that, to distinguish a place within the web of habits. The working of a *res cogitans* will be habited and dressed by this kind of research. The methodical effort that will be demanded in this framework would be to follow the habit that the work points to. This is of course a risky task to undertake, as one cannot restore a habit in a sterile manner, without contracting it to some extent. The value that may be discerned by this effort is the work's age-value, its durational capacity and the special itinerary of its passages and mutations, intuited as a curve, as a figure in history.

Notes

1. Similarly to Quentin Meillassoux, *After Finitude: An Essay on the Necessity of Contingency* (London: Continuum, 2008), pp. 1–27.
2. Karl Marx, *Das Kapital* (Stuttgart: Kröner Verlag, 2011 [1873]), pp. 52–63.
3. Ibid. p. 17.
4. Ibid. pp. 17–25.
5. Ibid. p. 17.
6. Note that for Marx, the thing itself is considered as a value, it is its own value. Here we would try to keep a certain distinction between a work and its value.
7. Marx, *Das Kapital*, p. 17.
8. Adi Efal, 'Naturalization: Habits, Bodies and their Subjects', *Phenomenology and Mind*, 6 (July 2014) <http://www.phenomenologyandmind.eu/2014/07/mind-habits-and-social-reality/> (accessed 18 March 2015).
9. John Ruskin, *Selections and Essays* (New York: Charles Scribner's Sons, 1946), pp. 280–9.
10. Dominique Janicaud, *Ravaisson et la métaphysique: Une Généalogie du spiritualisme français* (Paris: Vrin, 1997 [1969]); Félix Ravaisson-Mollien, *Of Habit*, trans. Clare Carlisle and Mark Sinclair (London: Continuum, 2008).
11. Ravaisson-Mollien, *Of Habit*, pp. 74–5.
12. Aristotle, *The Nicomachean Ethics*, trans. H. Rackham (London: Harvard University Press, 1956), pp. 334–5.
13. Ravaisson-Mollien, *Of Habit*, p. 25.
14. Efal, 'Naturalization: Habits, Bodies and their Subjects'.
15. A further examination is needed regarding the triple relationship between Riegl's formulation of age-value, Marx's distinction between use- and exchange-value, and Walter Benjamin's concept of the 'Aura' in his 'Das Kunstwerk im Zeitalter seiner technischen Reproduzierbarkeit' (Walter Benjmain, *Gesammelte Schriften*, 7 vols, ed. H. Schwepenhäuser and R. Tiedemann, (Frankfurt: Suhrkamp, 1991), I, pp. 439–40, 481–2). Indeed, the ambivalent spatio-temporal position of the aura, being always far, even while residing close by, resembles the actualisation of the ancient in a present moment of the monument carrying an age-value in Riegl's terms. Nevertheless, the auratic cultural value of the artwork is based, according Benjamin, on ancient religious rituals, and it is singular and unique. Differently, the age-value that we are trying to elaborate here, following Riegl and Ravaisson-Mollien, understood on the basis of habitual usage, loses nothing of its value by being reproduced and repeated – in fact, its value is augmented by rehearsal, and it has more to do with bodily maintenance than with a relation to divinities.
16. Aloïs Riegl, 'Der Moderne Denkmalskultus sein Wesen und seine Entstehung', in *Gesammelte Aufsätze* (Augsburg-Wien: Benno Filser Verlag, 1928 [1903]), pp. 144–93, 161–73.

17. Ravaisson-Mollien, *Of Habit*, p. 49.

18. Aristotle, *The Metaphysics Books I–IX*, trans. Hugh Tredennick (Cambridge, MA: Harvard University Press, 2003), pp. 272–3.

19. Ibid. pp. 270–3.

20. Aloïs Riegl, *Die spätrömische Kunst-Industrie* (Vienna: Staatsdruckerei, 1901).

21. Graham Harman, 'Tristan Garcia and the Thing-in-itself', *Parrhesia*, 16 (2013): 26–34.

22. Alain Badiou, *Théorie du sujet* (Paris: Seuil, 1982).

23. Ibid. pp. 40–68.

24. Ibid. pp. 150–7.

25. Félix Ravaisson-Mollien, *L'art et les mystères grecs*, ed. Dominique Janicaud (Paris: L'Herne, 1985), p. 36.

26. Henri Focillon, *Vie des formes* (Paris: Presses Universitaires de France, 1996 [1934]), p. 11.

27. Ravaisson-Mollien, *Of Habit*, pp. 38–9.

28. See Mark Sinclair, 'Bergson on Possibility and Novelty', *Archiv für Geschichte der Philosophie*, 96, 1 (2014): 104–25 (pp. 117–20).

29. Ibid. p. 109.

30. Bertrand Prévost, *La table de trichoptère* (Geneva: Haut école d'art et de design, 2013), pp. 31–4.

31. Maine de Biran, *Influence de l'habitude sur la faculté de penser* (Paris: Presses Universitaires de France, 1954 [1802]); Janicaud, *Ravaisson et la métaphysique*, pp. 15–35.

32. Henri Bergson, *L'énergie spirituelle* (Paris: Presses Universitaires de France, 2009 [1919]), pp. 153–90.

33. Ravaisson-Mollien, *Of Habit*, p. 45.

34. Ibid. pp. 58–9.

35. Gilles Deleuze, *Différence et répétition* (Paris: Presses Universitaires de France, 1997 [1968]), p. 101.

5 Mood (*Stimmung*) / Blandness (*Fadeur*): On Temporality and Affectivity

Vlad Ionescu

Art, History and Affectivity

WHAT HAPPENS WHEN art history transcends the self-evident chronological arrangement of artworks followed by their iconographic reading? Variations on these two objectives have often marked the safe limits of the rigorous *science* of art. This issue has also troubled the science of art because other alternatives are not often at hand, at least not without falling into the realm of speculation. Organising artworks and reading their motifs is a practice based on primary sources. The work of art is an object of culture, meaning that it testifies to a specific historical place and time. Yet determining a 'style', a 'feeling for form' (*Formgefühl*, according to Heinrich Wölfflin) or an 'artistic will' (*Kunstwollen*, as Aloïs Riegl wrote) is in fact a speculative enterprise insofar as the rigorous art historian shifts from actual artworks to their virtual formative principles. The style of the Renaissance can never have been *seen* like the Mona Lisa can be *looked at* in the Louvre. Further, institutions do not collect 'feelings of form' or 'artistic wills'. The painting itself is a material support, but the style it realises is a virtual structure, an anonymous way of perceiving and rendering the world that applies to an entire series of artworks. A style is not an actual *object* of art and what the viewer feels in the presence of this 'feeling of form' varies over time.

The historian may claim that these feelings and virtual structures do not interest the rigorous science of art. Today, such an attitude is not only a sardonic repetition of nineteenth-century positivism but it can also be taken as the symptom of a methodological handicap: for which rigorous modern science focuses merely on 'facts'? Enter the relation between art and speculative aesthetics because 'questions of style' (*Stilfragen*,

says the rigorous art historian Aloïs Riegl) transcend the questions of empirical sources. My objective here is firstly to show how modern art history integrated speculative aesthetic concepts in its attempt to describe art historical styles. Mood (*Stimmung*) is such a concept and it appears at the core of Riegl's and Wölfflin's art histories. In these authors, an art historical style is a visual structure that actualises an affective constitution. Secondly, because mood is a central affective category, I will examine the experience of the landscape and the ruin when viewed from the perspective of this affect.

If the landscape constitutes the correlate of an affect, then the science of art no longer merely memorises objects (in the sense of *Erinnerung*). To the contrary, art history mediates an experience (in the sense of *Erfahrung*) that refers to an affect. The memory of *facts* is transformed in an *affective* experience of space and time. When Riegl introduced mood as the character of 'age value', he offered an alternative form of historical memory. While historical value refers to any documentary data that a monument provides, age value does not postulate any documentary data. It merely refers to a monument that is taken as a correlate for the experience of the inevitable decay of all things. Viewed from the perspective of age value, everything belongs to a necessary and neutrally developing process. Mood transforms thus the memory of facts into an affective remembrance: the viewer retains an affective horizon within which all historical facts evolve. Viewing the historical ruin from the perspective of the mood means thus associating the monument to the passage of time. 'Mood' refers remembering to a bland horizon of time, without any specific value except a feeling, namely the languid unfolding of the long duration.

Because viewing a landscape or a ruin from a distance mediates a neutral affect, the mood is relatable to an important speculative concept from Chinese aesthetics: *blandness*. Like mood, blandness designates an insipid horizon of existence. We refer here to François Jullien's analysis of blandness as the affective horizon for the Chinese experience of landscape. In this sense, some affinities between Eastern and Western conceptions of affective dispositions are detected. Beyond the obvious ontological differences between East and West, my objective is to depict how mood and blandness facilitate an experience in which the subject is no longer opposed to an object but is rather absorbed in a broader environment that is experienced as a slowly unfolding duration.

Mood and the Space of Affectivity

While within philosophical aesthetics, the notion of mood designates an element pertaining to the transcendental analysis of taste (Kant), in art history it refers to the motif of certain artworks (Riegl, Wölfflin, Bahr). Yet how does an artwork present a mood? What is the nature of this affective disposition that Bahr, Riegl

and Wölfflin denominated as the content of modern art? In *Renaissance und Barock*, Wölfflin argues that art history has to determine the 'fundamental temper' (*Grundstimmung*) of a style.[1] The specificity of an image consists in the fact that it mediates an affect (and not just iconographic content). This does not oppose the self-evident observation that objects are identifiable in visual arts. However, for Wölfflin, while thought can be *conceptually* formulated, mood is directly and visually revealed.[2] A mood is an affective state that surpasses the individual and characterises an entire art historical period. While the Renaissance takes pleasure in presenting the relation between the part and the whole of an image, the baroque emphasises the visual masses of form. In this sense, diffusive colourism is an expression of a mood (*Stimmungsausdruck*),[3] just like the subordination of a part to a whole solicits the same affective disposition.[4]

Even though he employed a speculative notion such as 'mood', Wölfflin also insisted that iconological interpretations be kept away from art historical discourse. A style mediates affects not concepts. In *Renaissance und Barock* (1888), Wölfflin explained that in order to relate stylistic changes to changes in culture one would have to 'find the path that leads from the cell of the scholar to the mason's yard'.[5] Hence Wölfflin suggests that concepts and visual structures are two different spheres whose relation is merely analogical. However, in his *Grundbegriffe*, Wölfflin argues that the 'forms of presentation' also have a decorative meaning. For instance, the linear presents us with a 'sensation of beauty' (*Schönheitsempfindung*).[6] Hence, while he avoids speculating on the relation of the philosophical concept to the artistic percept, Wölfflin argues that aesthetic pleasure is intrinsic to the experience of visual forms. There is no art history without aesthetics: the analysis of the Renaissance and the baroque is formulated in terms of affective dispositions. The Renaissance presents us with 'quiet being' (*ruhigen Seins*), a 'satisfying beauty' (*befreiende Schönheit*) and the affirmation of vitality (*Lebenskraft*).[7] The baroque displays a disturbing dissonance and the 'violence of the affect' (*die Gewalt des Affekts*),[8] so that the linear and the painterly mediate an entire plethora of affects.

It seems that Wölfflin rejects the speculative interpretation of visual arts, yet he homologates the latter with an equally speculative aesthetics: visual forms mediate affects. Moritz Geiger offers a possible justification for what Wölfflin treated like a premise, namely the fact that an image presents a mood. In *Zum Problem der Stimmungseinfühlung* (1911), Geiger argues that the qualities of a landscape can be observed for their 'emotional character' (*Gefühlscharakter*). Mood is the outcome of a correlate perceived from the perspective of its emotional effect on the subject. Consciousness is not interested in the description of the correlate's qualities but in its affective working. The spiritual character of a landscape deemed as melancholic is the result of similarities between 'disparate sensitive areas' (*disparaten Sinnesgebieten*),

emotions on the one side and perceivable characteristics of the landscape on the other.[9] However, the similarity between the visual and the affective does not concern the parts of the landscape, like each and every tree or rock that constitute it as a whole. In order to generate an affect, on the contrary, the perception of the landscape requires a moment of passivity of consciousness that has in view the general tone of the landscape. The sentimental human type approaches the landscape not as an object whose individual parts are analysed, but according to the way in which its 'general character' (*Gesamtcharakter*) realises the mood.[10] This fusion between the inner affective experience and an emotional character of things is possible because the exterior correlate activates a feeling: 'the object offers only the beginning and the indication of my mood.'[11]

The argument is based on a phenomenological distinction: if the subject intends in a landscape the outline of its constitutive parts and their structural relations, then an analytic interest in the object prevails. If consciousness intends the totality of the presentation with a passive openness, then the 'affective character' (*Gefühlscharakter*) of the landscape is realised. The passivity and openness of consciousness interiorise the mood that the landscape carries. The affective character of the landscape permeates the consciousness so that the disjunction between the subject and the object disappears. In this sense, Geiger conceives of the 'empathy of mood' (*Stimmungseinfühlung*) as an analogical fusion between two spaces, the interiority of the consciousness and the exteriority of the landscape. Geiger writes: 'I immerse myself into it' (*Ich lebe mich in Sie ein*), thus 'becoming one with the object' (*in dem ich eins werde mit dem Gegenstand*), 'it is as if I drift into it' (*in dem gleichsam hineinüberwandelt in den Gegenstand*) while merging with the 'content of mood' (*Stimmungsgehalt*).[12]

Mood thus presupposes a *spatial analogy*: the disjunction between the interiority (of the observing subject) and the exteriority (of the observed landscape) is transformed into a conjunction. Mood designates a state of reflexive passivity that results in the *agglutination* between the subject and the object. The strict distinction between subject and object appears as an interval where the subject's mood, as Geiger writes, becomes the 'afterlife' (*Nachleben*) and the 'co-experience' (*Miterleben*) of the landscape's mood.[13] The autonomous subject becomes a reflexive co-habitant of a spatial extension that is affectively undergone rather than being intended as an independent exterior object. The passivity of consciousness in its relation to the mood of the landscape allows the viewer to experience space not just as depth but as an affect. In this context, mood is the spatial modality of affective life: one does not pay attention to a landscape, one abides in it.

Mood and the Temporality of Affectivity

Aloïs Riegl employed the notion of 'mood' in order to designate a specific modern type of perception. By 'modern', he refers to a culture that accepts the evolutionary character of nature and the relative value of visual arts. In *Der Moderne Denkmalkultus, Sein Wesen und Seine Entstehung* (1903), he sketches a system of values employed in the evaluation of monuments. Riegl considered the modern 'relative artistic value' as a phenomenon that appeared at the beginning of the twentieth century. Until then, visual arts realised an aesthetic canon based on absolute objective values. According to Riegl, artistic modernity is an age where art follows no absolute values. It realises the modes of perception that develop in a specific place and at a specific time. For Riegl, taste is essentially the outcome of a cultural evolution from prescribing objective standards of beauty to the acceptance of a general relativism concerning beauty. Other than for the transcendental philosopher, for the historian of art, the *sensus communis* is not an appeal to an ideal community of taste. The Kantian universal voice (*allgemeine Stimme*) that justifies the validity (*Gemeingültigkeit*) of the aesthetic judgement is identified in a temporal, local and historical society (*Gesellschaft*).

This evolutionary experience of temporality is essential in Riegl's typology of values that vary between the *historical*, the *artistic*, the *age value* and the *newness* value. Any document has historical value because it is an irreplaceable element in an evolutionary process that testifies to a past age. Yet monuments also point out the artistic volition of that past age, so they also have artistic value.[14] However, in modernity, monuments are appreciated not just for their historical value but also as signs of time's passage. A ruin, for instance, denotes a historical place, but it also connotes the inevitable decay of all material things. Riegl employs here a distinction between the two types of intentionality that Geiger will have conceptualised. When we perceive the objective qualities of a ruin, we evaluate it according to its historical value. If we observe the emotional character of a ruin, then it becomes the occasion for an affective disposition called mood.

According to Riegl, mood is specific to age value (*Alterwert*) understood as the temporal patina of a monument. The latter is a material substrate that induces an 'effect on the mood' (*Stimmungswirkung*).[15] This emotional response consists of the awareness that everything in the universe belongs to a natural chain. This mood is 'produced by mere sensuous perception' and appears as mere feeling. It is independent of historical knowledge and can affect the masses regardless of their education because it rests on a 'claim to universality' (*Anspruch auf Allgemeingültigkeit*).[16] Yet the 'claim to universality' is the literal Kantian expression that was a constitutive element of the judgement of taste. Along with the reference to mood, it proves that an evaluation according to age value is a reflexive judgement.[17]

From the perspective of age value, the ruin is merely an occasion that generates a feeling. As an affective response, age value signals the fact that nothing escapes the entropic decay of nature. Nevertheless, mood is not an aesthetic predicate comparable to the feeling of the beautiful or of the sublime. It is an existential feeling, comparable to religious emotion and beyond any historical or aesthetic education.[18] The viewer sees the singular monument as a ruin of time onto which he or she projects his or her own destiny as belonging to the natural universal order. This evaluation is altruistic and Riegl identifies this stance in the modern tendency to protect even natural monuments like forests that show no human intervention.[19]

With mood as the affective affinity of age value, Riegl proposes an alternative to the historicist conception of time as a succession of events. Viewed from the perspective of age value, a ruin mediates an experience of time that is felt as an affective disposition in which the temporal flux of duration is deferred. Age value does not refer to the years and to the historical events that a ruin testifies to. On the contrary, it subordinates historical value to an existential state of mind where the ruin reveals the progression of time. Hence, mood designates a conflict in the modern subject: whereas in modern life everything abides by the blind law of causality, the modern subject finds in mood an existential consolation for what this law signals, namely an ineluctable decay. In this reflexive stance, time decelerates for a while and the subject slowly tarries with its unfolding.

In 'Die Stimmung als Inhalt der modernen Kunst' (1899), Riegl defines mood as a sentiment of harmony and rest that overcomes chaos, dissonance, and movement.[20] It is the affective response to the visual contemplation of peaceful landscapes, viewed from a distance. Again, mood originates in the awareness that nature harmoniously abides by the law of causality.[21] The essay evokes the image of Riegl himself, standing on the peak of the Alps, the earth sinking underneath his feet, where nothing is graspable and the eyes gaze into the distance. All the oppositions that the senses bring about disappear, a 'world-soul' (*Weltseele*) permeates all things and 'unites them in a perfect harmony' (*sie zu volkommenem Einklang vereinigt*).[22] The distant view presents us with a 'unifying tranquillity' (*eine vereinigende Ruhe*) that harmonises all visual elements and is felt as mood. The landscape is not seen as an object, it is inhabited. The viewer is thus embedded within a larger and indeterminate whole where all activities are postponed. One is no longer interested in perceiving distinctions between different forms but in the observation of a world that can be inhabited without interfering in it.[23]

Whereas this situation refers to actual natural landscapes, Riegl also described its representation in the history of art. In his essay on Jacob van Ruisdael, he argues that the 'airspace' (*Luftraum*) mediates the mood in painting.[24] The haptic outline of nature disappears in Ruisdael's landscape painting due to the air, a painterly and optic

device. Instead of distinguishing clear forms (the detailed form of mountain peaks, of the trees and of the architectural elements), the air unites them into a whole.[25] A world emerges in the landscape painting that brackets our utilitarian exploration of *the* world as we do in our daily lives.[26] And for Riegl, the tranquillity of the mood brackets any intervention into the world while it appears in the distant view, outside of our reach.

Regarding the distant view that is involved in all visual presentations of mood, Riegl argued in his essay *Das Moderne in der Kunst* (1899) that modern art presents phenomena not in and for itself but from the perspective of its 'position within a greater relationship, an entire chain of causes and effects that we survey as if from a distance.'[27] The distant view involves a vague optical perception and it also integrates the viewer into a landscape where the eye is directed towards the infinite background. Looking at the landscape means observing a distance *and* taking distance from the material consistency of things. In *Objektive Aesthetik* (1902), Riegl develops this idea: modern aesthetics represses all close haptic views and transforms nature into 'colourful sensations that generate mood' (*Stimmung weckende Farbenreize*). Things are depicted not as they are when they are felt with the hand but as they appear to the eye. This perception brings about an 'increasing mood' (*gesteigerte Stimmung*).[28]

The correlation of mood and science appears also in the writings of Hermann Bahr, who applied Ernst Mach's *Die Analyse der Empfindungen* (1886) to impressionist painting. In *Zur Überwindung des Naturalismus* (1891), Bahr evokes Mach's dictum 'the I is lost' (*das Ich ist unrettbar*) and his theory of sensations. According to Mach, the subject is conceived as a nexus of sensations so that, for instance, feeling green means that the sensation 'green' is related to other complexes of sensation. The death of the subject does not mean the extinction of a real unity but of an economical entity that concentrates sensations. According to Bahr, the 'I' is a name that helps us organise representations. In a process of constant change, there is nothing but colours and tones, temperatures and pressures, spaces and times that are related to 'moods, feelings, and the will' (*Stimmungen, Gefühle und Willen*).[29] Just like Riegl, Bahr argues in *Zur Kritik der Moderne* (1890) that modernity adheres to the scientific world-view whereby all nature evolves to a state of entropy.[30]

For Bahr, impressionist art presents a perpetual change that is felt as a dynamic change. Other than Bahr, Riegl associated the causality law with an appeasing mood. And that is the peculiarity of Riegl's description of mood: an otherwise apathetic and desacralised scientific world-view produces an affective disposition. Mood as content of modern art is thought as a *depressurisation* of the psychical apparatus that is aware that 'each becoming determines a decay, each life claims a death, each movement takes place at the cost of another.'[31] The integration of the individual in a universal order produces a release of psychical tension and Riegl illustrates this mood with

painters like Max Liebermann and Storm van 's Gravesande. Their images do not present movement but the capacity to move as a *continuous duration*. Sequences of movement appear as an incessant and indolent transition.[32]

Gumbrecht is thus right to consider Riegl's understanding of mood as a concept belonging to the philosophy of history.[33] This notion introduces in Riegl's historiography a form of affective memory, that is to say an alternative to the historical value of the past. Mood is an affective disposition that assimilates the viewer into a world that is no longer a separate object. On the contrary, the landscape (painting) and the monumental ruin are spatial intervals that solicit only an affective disposition. We no longer speak of a subject versus an object but of a modification that the body undergoes when interacting with another body. This modification is the mood: the landscape's horizon is pushed back and the viewer harmonises with a consonant whole where time slowly unfolds.

Blandness and the Chinese Landscape

Mood is an affective disposition that requires the suspension of any intervention within the world. The landscape that solicits this experience is viewed as an undifferentiated totality that embraces the mind. In this sense, mood is a Western notion that suspends the distinction between a passive object and an active subject. Now, the notion of 'blandness' encompasses a similar emotional range. Having first described blandness in *Éloge de la fadeur* (1991), François Jullien associates it with the Chinese conception of the landscape in *Vivre de paysage* (2014). Jullien contrasts these Western and Eastern affective dispositions towards the landscape. Nevertheless, is a transhistorical consideration of these moods possible? If this is the case, then art history includes aesthetic categories that surpass specific genres or styles. Whereas Wölfflin's polarities constitute the transhistorical conditions of visual presentation, 'mood' and 'blandness' would then account for transhistorical aesthetic categories.

According to Jullien, blandness designates the neutral fundament of all things and an essential detachment and suspension of all position taking.[34] This does not mean that blandness is opposed to a sense of fullness or that it is equivalent to ineffability.[35] On the contrary, the neutrality of blandness refers to the potentiality of existence prior to its actualisation. Simply put, while any flavour is based on a differentiation (sweet, meaning 'not bitter'), blandness is this insipid, pale and infinite potential prior to any differentiation. Blandness is distinguishable from any flavour because every sensation limits this infinite and neutral potentiality that precedes it.[36]

On a pragmatic level, blandness refers to the cultivation of the suspension of all position taking. On the one hand, the strategist eliminates all actions that hinder the achievement of a goal. On the other hand, the blandness of a character implies a

constancy that allows the subject to relate to all perspectives of a situation without doing violence to its unfolding. One should thus intervene without imposing any position on a given situation. Any virtue that is privileged, like any flavour, fixates and sterilises the renewal of a character.[37] While flavours bespeak the realm of *aisthesis*, blandness manifests the anaesthetic horizon that heralds it.

Like mood, blandness encompasses the background from which sensations emerge and are related to each other. This background is felt as an immersion into a spatial extension where natural objects are left indeterminate. In the case of mood, the necessary unfolding of nature ensures this impartiality; also age value, other than the historical value, is experienced as a contemplation of time's passage without interest in its actual specific moments. In the case of blandness, this affective disposition re-emerges. Nevertheless, blandness does not account for the inevitable entropy of nature but for the contemplation of a pre-existent harmony.[38]

In Chinese art, Ni Zan's landscapes of blandness from the fourteenth century illustrate this sense of harmony. Jullien describes them as serene compositions where hills, the foliage of trees, shores and rocks are immersed in a diluted atmosphere. A pale chromatic scale blends individual forms. Whereas in the Western landscape the gaze is pushed towards the deep horizon, proximity and distance are homogenous in the Chinese landscape. Serenity and lightness, a lack of movement and action engulf the viewer. The relief of any insistence, the vague and pale nuances dilute and saturate Chinese landscape paintings. The paleness and blandness appear in the overall hazy atmosphere that undulates and softens the forms.[39] The register of the limpid atmosphere can be related to Riegl's notion of the 'airspace' (*Luftraum*) that performed a similar function: the outlines of objects disappear and there is nothing to touch. Jullien refers to the tenth-century landscapes of Dong Yuan in which the overall painterly vastness of nature suffuses the undulating waves and hills. The forms immerse the viewer in a space that is experienced with an unfettered tranquillity.[40]

In his recent *Vivre de paysage* (2014), Jullien emphatically demarcates the differences with the Western conception of this experience, a demarcation that can be contended. For Jullien, the landscape is a Western notion that abstracts a natural section from a broader extension. It thus presupposes the idea of an abrupt abstraction,[41] a passive fragment presented to an active subject that perceives its exclusive visual qualities.[42] In the West, the landscape is subordinated, like any object of knowledge, to the autonomous investigating subject. The West has a poor taste for ambiance and contemplation without a purpose. However, it came close to the affective evaluation of the landscape when Kant explained the aesthetic experience as an affirmation of 'vital feeling' (*Lebensgefühl*).[43] Furthermore, the Western terminology that approximates a pertinent account of the Chinese landscape is that of *Gemüt* (mood) and of affectability.[44] Yet mood as affective attunement (*Stimmung*) to the

landscape (as opposed to its perception) does not appear in Jullien's otherwise impressive account.

Contrary to the reifying Western attitude, the Chinese conceive the landscape as the dynamism of polarities. Instead of saying 'landscape' the Chinese refer to the 'mountain(s)-water(s)', combining thus an immobile and a mobile form.[45] Whereas the relation between the part and the whole constitutes Western logic, matching different elements characterises Eastern thought. The landscape is a correlation between space and affect: 'wind-light' is a landscape including two elements that infiltrate all solid frameworks.[46] Hence, affect is here thought across the spatial undulation so that the landscape becomes a threshold, an interval, a pair of sections and registers (as opposed to an object external to the subject). Does not Riegl's notion of 'airspace' (*Luftraum*) provide a Western analogue for this optical dispositive?

Yet the most significant aspect is the fact that the perception of the landscape in Chinese culture combines the affective and the visual. The distance and the gaze form a correlation, so that there is no strict perspective on a landscape. Perception *is* the modulation of the human body and Jullien distinguishes between different types of distances, all depending on the movement of the gaze. There are deep, close and low distances that combine with a gaze moving upwards, in front and behind a mountain.[47] The gaze modulates distance and envelops the landscape from all sides. Yet the gaze is also enveloped in the affective tonality of the landscape: while the tonality of the high distance is clear, the tonality of the deep distance is obscure. Hence various perceptions are modulated onto various moods so that the landscape is not so much represented as it is inhaled and exhaled.[48]

Is this symbiosis of the affective and of the perceptive, or of sensation and of tension, really different from the Western cult of vital feeling and of moods? For Kant, the subordination of the perceptive to the affect justified aesthetics: nature appears in aesthetic judgement as an occasion for mood. Wölfflin described baroque sensibility as being founded on a different correlation between the perceptive and the affective: colours and folds affect mood. A similar integration of the viewer within a broader image is evoked in Riegl's notion of 'attention' (*Aufmerksamkeit*). Even though it refers to the Dutch group portrait, attention represents for Riegl a suspension of action and the integration of the viewer into the painting. In Aert Pietersz's *The Anatomy Lesson of Dr. Sebastian Egbertsz* (1603), the figures look outside their scene in order to include the viewer into the picture. The internal coordination of the figures links to the individual viewer; it thus provides the social group with an identity. Attention correlates thus the perceptive with the affective; it turns the gaze into an affective tonality.[49]

And even though he subtly related visual distance to self-knowledge, Nietzsche showed how the landscape and the gaze are in a continuous modulation. In the

fragment from *Gay Science* entitled 'From a Distance', Nietzsche described how a mountain might make the entire surroundings (*die ganze Gegend*) look interesting. However, we might be disappointed if we climbed the mountain itself, because the change of the gaze is then disenchanted (*entzaubert*). In order to achieve their effect, some magnitudes want to be viewed from a distance and from below.[50] Like in nature, there are people who view themselves also from a distance, the only perspective that does justice to their invigorating personality. The mood of the landscape envelops us just like the mood of the people we meet.

Furthermore, as Michael Fried has pointed out in his analysis of Diderot's art theory, the criterion for the success of genre painting is the 'fiction' of inhabiting a picture and inducing in the beholder a 'profound experience of nature [. . .] one of existential reverie or *repos délicieux*', a 'passive receptivity' where 'the subject's awareness of the passage of time and, on occasion, of his very surroundings may be abolished; and he comes to experience a pure and intense sensation of the *sweetness* and as it were the *self-sufficiency* of his own existence.'[51] While the element of 'fiction' betrays the modern Western tendency of differentiating the real from the imaginary, for Diderot, genre painting can combine the blandness of self-sufficiency with an aroma of sweetness.

Hence, the fact that the West would be incapable of such an affective grasp is a debatable topic. Riegl himself argued that mood designates not just the ruin's age value but also the 'chromatic sensations that awake the mood' (*stimmungsweckende Farbenreize*) that he observed in Japanese art.[52] Both mood and blandness designate a mode of perception where apperceived sensations directly influence affective disposition. Whereas in normal circumstances one would be able to describe what one sees (in terms of colours and forms), one would have to account for what one sees in terms of what one feels. Rather than being qualities of an object, mood and blandness are principles of an emotional attunement to an environment (a landscape, a ruin, or a tone).

The Temporality of Affectivity

The Chinese landscape intensifies the feeling of life and restores an 'inner tension' to the point that we 'live off the landscape' or, as Rousseau put it, 'we breath more easily.'[53] However, is this conception not suspiciously close to Kant's (or Wölfflin's) analysis of the *Lebensgefühl* where forms were also evaluated according to their ability to affirm vital feeling? Here we have to read *Vivre de paysage* next to the preceding *In Praise of Blandness* where Jullien distinguished the modern Western variation on blandness from the Chinese aesthetics. In *En sourdine*, Verlaine writes: 'Close your eyes halfway / Fold your arms across your breast / And from your sleeping heart /

Banish all plans, forever'.[54] This mood is not the same as the plenitude of existence that blandness cultivates. Like Riegl's age value, it is a resignation in front of an inevitable extinction.

The West and the East start from different ontological positions: mood is an attunement with a *conclusive* death whereas blandness is an attunement with a *preceding* harmony. While mood implies melancholy and resignation due to a loss, blandness entails a synchronisation with an eternal fullness. Mood is an affective reconciliation because it presupposes the movement towards a *final nothingness*. Blandness is an affective constancy because it presupposes a *continual fullness*. These are different ontological hypotheses: lack is opposed to affluence and dialectics to constancy; the East cultivates the primordial plenitude of existence whereas the West conceives existence in a constant entropic movement. However, both mood and blandness rely on an aesthetics of tonalities where natural elements (landscapes) *modulate* our affective dispositions. Both notions involve the bracketing of an intervention into the world. Both notions refer to an attunement of the subject to the world (as opposed to its mere intentional grasp).

In Riegl's view, age value was an alternative to the prevailing historical value where each event plays its part in a long narrative. On the one hand, the West favours the dramatisation of being because events unfold in time towards an inexorable decay. On the other hand, the East cultivates the neutrality of being where events (and flavours) emerge from a pre-existent and enduring potential vagueness. The West emphasises the plot and focuses on the drama; the East pursues the neutral horizon on which the plot unfolds.

Nevertheless, the temporality of the affectivity involved in mood and in blandness surpasses these ontological differences. As we have seen, a flavour distinguishes itself from other sensations: the sweet is opposed to the bitter. Because of these differentiations, flavours are short-termed. No one lives continuously off sweetness or bitterness just as no one incessantly experiences the beautiful or the sublime. *Aisthesis* implies a differentiation of sensations that incite the sensitive body. Contrastingly, blandness entails an affective disposition where the subject is *slowly* immersed in the spatial extension. In the landscape, delimited shapes and details appear as a homogenous and painterly whole that is grasped in its entirety. There is no differentiation within the field of sensations, and the disjunction of flavours and shapes appears as an uninterrupted conjunction, an organic spatial agglutination. This totality excludes *discontinuous* shapes; it appears as a *continuous* expansion without distinct demarcations and outlined details. The cohesion of this neutral whole requires a *prolonged grasp* that is felt as a *long duration*.

Indicative of Riegl's conception of mood is a similar deceleration of temporality. Because nature follows its inevitable course, the mood and the age value of a

monument are privileged moments and alternatives to the division of time (and history) in distinct moments (and ages). The mood encompasses the affective grasp of time's unfolding without consideration for its distinct moment. The ruin modulates the passage of time; it is a monument that occasions the feeling of a slow duration. Mood is this affective interval where space and time provisionally decelerate for a viewer that observes the ruin in the broader landscape. What is grasped in this contemplating stance is the felt duration of time or, in other words, the passage of time as an affective disposition. The discontinuity of moments is opposed here to the long duration that overtakes the subject. In this context, blandness and mood refer to an experience of time felt as a slow continuity that overcomes us.

Distant Attunement

The fact that both mood and blandness refer to the contemplation of the landscape (painting) is not a fortuitous coincidence. These notions modify the viewer's affective disposition on two points: firstly, the quality of a felt temporality and, secondly, the felt relation to the extension of space. The mood does not only designate modern man's affective disposition towards the universal entropy of nature. The spatial extension of landscape painting affects the viewer's attitude towards temporality. In this sense, the mood betokens a felt languidness that envelops the viewer just like the landscape does. One does not perceive the constitutive parts of a landscape just like one does not count up the instants of this perceptive act. Like in the case of blandness, the long duration of the mood and the homogeneity of the landscape envelop us.

To use Geiger's notions, grasping the 'affective character' presupposes an attunement to the 'general character' of the landscape. While perceiving implies the synthesis of the shadings (*Abschattungen*) on a temporal and spatial horizon, attunement involves the passibility of the viewer, a temporary surrender to the potentiality of the landscape. Consciousness is not just openness towards phenomena; it can also be experienced as a mood when the affective character of the phenomena envelops it. Like mood, blandness revises the intentionality involved in the relation to the surrounding world. Both notions transform the *relation* between the viewer and the landscape (painting) into a *felt congruency*. The viewer does not determine a set of qualities belonging to a correlate extending in front of her. To the contrary, the landscape (painting) is an occasion to find an affective continuity and an affective community.

As speculative notions that emerge in art historical discourse, mood and blandness transform the relations we have with objects. The attention of the gaze is subordinated to its affective dissipation in the surroundings. Regardless of the differences between East and West, mood and blandness convey the elegance of harmony and tranquillity,

euphoric balance and Stoic *apatheia*. These notions transform the perception of an object into an affective adjustment to the felt continuity of the long duration, and to the plenitude of a world that emerges through the distant view.

Notes

1. Heinrich Wölfflin, *Renaissance and Baroque*, trans. Kathrin Simon (London: Collins, 1964), p. 77.
2. Ibid. pp. 77–8.
3. Ibid. p. 26.
4. Ibid. p. 85.
5. Ibid. p. 77.
6. Heinrich Wölfflin, *Kunstgeschichtliche Grundbegriffe. Das Problem der Stilentwicklung in der neueren Kunst* (Munich: F. Bruckmann, 1929), p. 18.
7. Wölfflin, *Renaissance and Baroque*, pp. 20–31.
8. Wölfflin, *Kunstgeschichtliche Grundbegriffe*, p. 72.
9. Moritz Gieger, 'Zum Problem der Stimmungseinfühlung' [1911], in *Die Bedeutung der Kunst: Zugänge zu einer Materialen Wertästhetik. Gesammelte, aus dem Nachlass ergänzte Schriften*, ed. Klaus Berge and Wolfhar Henckmann (Munich: Fink, 1976), pp. 18–59 (p. 38).
10. Ibid. p. 50.
11. Ibid.
12. Ibid. p. 53.
13. Ibid.
14. In a chapter of his 'Jour Démocratiquement du Temps', Antoine emphasises the parallelism between Riegl's conception of the unintentional monument as a potential sign of the past and the argument of Foucault, from *L'archéologie du savoir*, for whom history is fundamentally a process that transforms the document into a monument. History legitimises neutral traces from the past by endowing them with the authority to represent a pertinent significant sign. Antoine integrates Riegl into the age of representation that gives meaning to past monuments through their historical contextualisation. See Jean-Philippe Antoine, 'Jouir Démocratiquement du Temps: À propos du *Culte Moderne des Monuments d'Aloïs Riegl*', in *Six rhapsodies froides sur le lieu, l'image et le souvenir* (Paris: Descalée de Brouwer, 2002), pp. 272–3.
15. Aloïs Riegl, *Gesammelte Aufsätze* (Vienna: Dr. Benno Filser Verlag, 1929), p. 150.
16. Ibid.
17. However, in the 'Neue Strömungen' essay from 1905, Riegl holds that the emotional value of a monument (*Gefühlswert*) presupposes the *learned* ability of the subject to see

in the monument a piece of his or her own being. Aloïs Riegl, 'Neue Strömungen in der Denkmalspflege', *Mitteilungen der k.k. Zentralkomission*, 3, IV (1905), 85–104 (p. 92).

18. Ibid. p. 95.

19. The human protection of nature proves our ability to think of nature not only as a means to an end but also as intrinsically valuable. The modern subject humanises the work of nature and cherishes it as if it were a work of art. Riegl writes: 'The cult of the natural monument is the least interested: it desires from us, the living, an occasional offer to a lifeless thing of nature'. Ibid. p. 91.

20. Riegl, *Gesammelte Aufsätze*, p. 29.

21. Ibid. p. 35.

22. Ibid. p. 28.

23. For an analysis of the antinomy between landscape image and the historical image (starting from Riegl), see Bart Verschaffel, *Essai sur les genres en peinture: nature morte, portrait, paysage*, trans. Daniel Cunin (Brussels: La Lettre Volée, 2007). In the landscape image, the foreground is reduced to the minimum so that the viewer enjoys its serenity. The focus on the distant view, the middle ground and the horizon, the diminution of all dramatic elements, turns the landscape image into the ideal correlate for an evaluation according to the mood, in which, as Rilke puts it in *Von der Landschaft*, the viewer appreciates 'the great peace of things' (*die grosse Ruhe der Dinge*). See Rainer Maria Rilke, *Sämtliche Werke*, ed. the Rilke archives in collaboration with Ruth Sieber-Rilke (Wiesbaden and Frankfurt am Main: Insel, 1965), V, pp. 516.

24. Aloïs Riegl, 'Objective Aesthetik', *Neue Freie Presse. Literaturblatt*, 13 July 1902, pp. 35–6.

25. A more detailed account of the 'airspace' in painting appears in Riegl's yet unpublished manuscript, entitled 'Die Holländische Kunst des 17. Jahrhunderts'. The Riegl Archives and the Getty Research Institute are planning an edition of the 400-page manuscript.

26. Verschaffel, *Essai sur les genres en peinture*.

27. Aloïs Riegl, 'Das Moderne in der Kunst', *Mittheilungen der Gesellschaft für Vervielfältigende Kunst*, 2 (1899): 9–12 (p. 10).

28. Riegl, 'Objective Aesthetik', p. 35.

29. Hermann Bahr, *Zur Überwindung des Naturalismus* (Stuttgart: Kohlhammer, 1968), p. 99.

30. Bahr refers to 'the knowledge of the eternal becoming and decay of all things in an inexorable flight and in the insight in the continuity of all things, in the dependence of the one to others in the infinite chain of existence [. . .]. This was the first major approximation to the truth, that the earth moves and that there is really nothing except incessant movement, an eternal flow, an infinite evolution where nothing is still, and that no past ever becomes present is the second approximation'. Ibid. p. 26.

31. Riegl, *Gesammelte Aufsätze*, p. 29.

32. The original edition of the 'Der Stimmung' essay, published in *Die graphischen Künste* in 1899, contains illustrations by contemporary painters like Carlos Grethe, Sion Longley

Wenban, Carl Pippich and Rudolf Konopa. Robert Recht pointed out the parallel between Riegl's understanding of mood as an affect analogical to the religious experience and Kandinsky's *Über das Geistige in der Kunst* (1910). See Rudolf Recht, 'L'écriture de l'histoire de l'art devant les modernes (Remarque à partir de Riegl, Wölfflin, Warburg et Panofsky)', *Les Cahiers du Musée National d'Art Moderne* (Summer 1994): 5–23 (p. 15).

33. Hans Gumbrecht, *Atmosphere, Mood, Stimmung: On a Hidden Potential of Literature* (Stanford: Stanford University Press, 2012). Gumbrecht also refers to Wellbery's systematic overview of the mood from the *Ästhetische Grundbegriffe*. See David Wellbery, 'Stimmung', in *Ästhetische Grundbegriffe: historisches Wörterbuch*, ed. Karlheinz Barck, 7 vols (Stuttgart and Weimar: Metzler, 2003), V, pp. 703–33. As Euler-Rolle points out, this form of affective memory based on a universal feeling of life recalls Nietzsche's *Vom Nutzen und Nachteil der Historie für das Leben* (1874) and foresees Simmel's *Die Ruine* (1911) where the past is experienced as a union with the present in the 'unity of the aesthetic pleasure'. Bernd Eurel-Rolle, 'Der "Stimmungswert" im spätmodernen Denkmalkultus – Aloïs Riegl und die Folgen', *Österreichische Zeitschrift für Kunst und Denkmalpflege*, 1 (2005): 27–34 (p. 28).

34. François Jullien, *Éloge de la fadeur. À partir de la pensée et de l'esthétique chinoise* (Paris: Éditions Philippe Picquier, 1991), p. 19.

35. Ibid. p. 27.

36. Ibid. p. 36.

37. Ibid. pp. 54–5.

38. Ibid. p. 39.

39. Ibid. p. 130.

40. Ibid. p. 132.

41. François Jullien, *Vivre de paysage ou l'impensé de la Raison* (Paris: Éditions Gallimard, 2014), p. 23.

42. Ibid. p. 26.

43. When it comes to the evaluation of Western aesthetics, Jullien can exaggerate while at the same time he ventures to convince his readers of China's *affective* superiority. According to Jullien, Kant lost the notion of the *Lebensgefühl* when he designated with it the 'beautiful' as belonging to the 'representation' of the object (Ibid. p. 88). Further, Kant subordinates the landscape to the free play of the faculties but keeps the subject and the world separated (Ibid. p. 96). Needless to say, Kant conceived aesthetic categories as the dynamics of *mood* when the correlate appears to the free play of the faculties. Vital feeling is the tension that increases or decreases depending on the unconstrained or constrained play of the faculties. Disinterestedness, the lack of insistence or of an intervention into the world is essential in the Kantian thought that – like Wölfflin's analysis of the baroque and of the Renaissance – is a *tensive* aesthetics.

44. Ibid. p. 95.

45. Ibid. p. 39.
46. Ibid. p. 100.
47. Ibid. p. 76.
48. Ibid. p. 81.
49. Riegl's notion of 'attention' can be contrasted to Benjamin's notion of distraction, another modern correlation between perception and affectivity. While in the group portrait, attention mediates the symbolic identity of the guild, for Benjamin, the cinematic montage and the quotidian encounter with architecture point to a general state of distraction. See Andrew Benjamin's essay: 'Boredom and Distraction: The Moods of Modernity', in *Walter Benjamin and History*, ed. Andrew Benjamin (London and New York: Continuum, 2005), pp. 156–70.
50. Friedrich Nietzsche, 'Die fröhliche Wissenschaft', in *Kritische Studieausgabe Bande 3*, ed. Giorgio Colli and Mazzino Montinari (Berlin and New York: Walter de Gruyer, 1988), p. 388.
51. Michael Fried, *Absorption and Theatricality: Painting and Beholder in the Age of Diderot* (Berkley, CA: University of California Press, 1980), pp. 130–1 (emphasis added).
52. Riegl, 'Objective Aesthetik', p. 35.
53. Jullien, *Vivre de paysage*, pp. 189–90.
54. Ibid. p. 140.

6 The Plasticity of the Real: Speculative Architecture

Elisabeth von Samsonow

Introduction: Revisions of the Real

IN ORDER TO discuss the 'real' (or 'reality') and its relation to art, it is essential to first recall the dramatic story of this notion. There have already been a number of speculative waves in philosophy that gave priority to the exploration of the multifarious concept of the *real*, most of them privileging or especially engaging the senses and the sensible, thereby prompting a revision of aesthetics as well as of the philosophy of nature and its scientific, i.e. physical and biological, description. The earliest of these movements originated a couple of hundred years before Christ under the name of Stoicism and has since continued influencing philosophers over and again, from late antiquity to Renaissance philosophy to eighteenth- and late nineteenth-century sensualism. The core idea of Stoicism is universal interdependence: everything is related to everything else on a strictly materialist basis, which provides human cognition with a capacity for justification/verification when confronted with sense data. The realist and the materialist arguments are in fact closely related: on the one hand, there is the object that causes a modification of the senses, and, on the other, the senses themselves consist – on an organic, vitalist or molecular level – of the same nature as the objects.

This has little to do with the so-called correlationist argument – the idea of the perceiving mind and the object perceived having to meet in a transcendentally structured act of recognition – as it is now under fierce attack from speculative realists[1] and especially, almost ironically, from 'accelerationists'. Why ironically? Because this time realism is not about legitimating the senses but about introducing a concept of objectivity and the truth of things that validates and corroborates something 'absolute'. But, in dealing with the intelligible or sensitive, is there an alternative for philosophy

seeking for truth other than to speak about the 'faculties' of recognition, of conscious-ness, of the senses and their properties? How, then, to deal with the notions of concept and consciousness, and, at the same time, dream of a world freed from any such modifications as may occur to both subject and object the moment they interact?

In my view, the critique of correlationalism obfuscates the history of philosophy from precisely the point where this history might be seen as a result of the given problem. The 'correlational circle' is already found at the core of the late medieval debate about the status of 'concept' and language in relation to 'being'. It marks the origin of the extremely productive so-called nominalist debate. It is a highly effective argument that simultaneously saves and challenges the relation of mind and things as it would later be posited by Spinozist pantheism in the most radical fashion. One should bear in mind that there was a strong revival of late Stoicist or Spinozist thought that occurred from the mid-nineteenth century, invoked by the predomi-nance of natural science, by physics and biology, which forced philosophy to respond with a sort of materialistic turn, as can be seen, for instance, in the extremely popular work of Ernst Mach.

Materialistic tendencies that provide the subtext for speculative philosophy today remain clearly identifiable within poststructuralist conceptualisation, and the drastic change that had been introduced by eighteen- and nineteenth-century sensualists continues to haunt the discussions. What is strongly felt in Deleuze and Guattari's influential writings is a further development of subjectivity in this sense, taking a close look at things formerly thought to belong to the level of the 'inorganic' and becoming aware of their activities as relevant to the reason-endowed human being. Defining this shift in terms of a movement from molar to molecular organisation, Deleuze and Guattari in *A Thousand Plateaus* enlarge the horizon of philosophical analysis to different areas displaying altogether more of a contingent history of inventions than a discourse of an absolute through time. What may be understood as *correlative* is the way in which both human and non-human *acteurs* affect each other at the molecular level that puts subjectivity at risk. Poststructuralism in this regard differs in a way from a transcendentalist correlational approach, as on a molecular level, the *acteur* and the object are not fundamentally distinguished anymore, such that things might as well be turned upside down in philosophy: why not let the molecules, the substances, the streams of qualities affect the human mind themselves as *acteurs*, as Bruno Latour puts it?[2] Why not say that the old model of cognition, which put the lonesome subject on the throne, has come to an end and that the time has come for the subject to truly earn its name by becoming subject to all sorts of agents, internal and external? It is obvious that the risky construction of de-potentialised 'molecular' subjectivity would continue challenging philosophers of the next generation to object and counter.

Speculative realism controversially taking up these ideas profits strongly from the age of control that, in Foucault's terms, follows upon the so-called age of discipline. 'Control' in an abstract sense presupposes the presence and activity of something 'real' outside of me and thus, absurdly enough, might ontologically ascertain that something actually exists 'outside of me'. Instead of precipitously coming up with the realist argument as a metaphysical one – as Quentin Meillasoux does – one may take into account the quality of experience the actual world of media, pharmacology, medicine and capital, and their distribution of info bits inscribed in the senses and the mind that feel invaded and taken over. Apart from the 'control' exercised by spies, intelligence networks and video surveillance, there is a return of the concept of the 'whole', of a form of existential involvement that is impossible to escape from. This is precisely the moment when the Earth – that equals the 'whole' – itself consequently returns to the philosophical stage. The undercurrent of cognitive *jouissance* that is undeniably present here is what had led to the overall success of the Wachowski Brothers' movie series *The Matrix*. Coinciding with a demise of authority, the age of control is one of extreme ambivalence. And once 'control' is not only associated with tyrants and their executive organs, but with a machinic field of powerful objects, with supervision (also in the sense of Derrick de Kerckhove's idea discussed in his book *La civilisation vidéo-chrétienne*[3]), and with anonymous forces, then the change of style in basic reflections on existence of being-in-the-world becomes encompassing.

Concerning the arts, there are many examples of a realistic tendency to be found in contemporary art practice, even if it is by no means self-evident that 'realism', no matter how 'speculative', would be of any benefit for or somehow appropriate to the arts – quite on the contrary.[4] Much of what has been written in art theory over the past thirty years was actually obsessed with rejecting 'realism' in art for ideological reasons, citing Socialist Realism and the 'political' realism of certain countries under dictatorship rule as only the most recent in a long list of negative examples. Moreover, realism had been seen as interchangeable, more or less, with naturalism, or even worse, with a sort of 'political' naturalism covering a synthesis of naturalism and authority. It was strongly felt that the concept of art ought to be expanded so as to push the boundaries marked out by the imperatives of 'similitude' and 'truthfulness', which signalled art's complete submission to the notion of 'real'-ness as an ultimate authority. Gradually, these arguments have waned, giving way to an emergent new type of realism, to documentarism in film and photography, in activist art and in painting, such as with the New Leipzig School, which openly refers back to the romantic concept of realism/naturalism under contemporary conditions. The 'realist turn' in art has many facets, from lifelike portrayal, land art and *objets trouvés* to crude live acts in body-based art. One aspect to be mentioned here is the value increase of the 'object' within the framework of such 'realism' as well as its direct

expressing of capitalist interests that focus themselves in an unprecedented way on the art object and its markets.

From a philosophical perspective, this plane is of specific interest, because this becoming-art of the world seems to mirror a crucial problem: the uncertainty of what is 'being', or in other words the 'real'. There is a tendency in art that seeks to replace 'being' and offer things and objects less questionable in their ontological status. Art would then form a 'real', the access to which is guaranteed less by cognition than by connoisseurs. On the other hand, philosophers, too, tend to exchange 'ontological' subjects or being for art objects and convert epistemology into aesthetics, because the things of art, fitting the circular argument of 'making is knowing', are much less elusive to analyse than 'natural things' that have been created by causes partly unknown.

As an 'object' of this type on a larger scale, as representing more of 'the whole' modified in art, it makes sense to look at *architecture*. Architecture constitutes a field of thought as well as of practice. In an extremely complex sense, it relates all fields of political, aesthetic and materialist knowledge and in this way appears to be the most appropriate subject to discuss concerning a change in style in ontology or 'speculative art histories'. In order to deal with architecture in terms of speculative metaphysics or ontology, I will not immediately focus on specific monuments or singular buildings and discuss their aesthetic qualities or other, but ask whether architecture as such can be granted philosophical relevance.[5]

Object? Geology? Architecture?

Talking about architecture in the framework of speculative ontology brings me back to Meillassoux's strong argument from his book *After Finitude*,[6] where he quotes Hegel who holds that there can be no such thing as a philosophical perspective on geology or at least that there is no philosophical discussion about geology in the strict sense of the term. Meillassoux rejects Hegel's argument, turning Hegel's helplessness about geology into a point of his own. The existence of the Earth – the story or biography of the Earth – has to be retold in a philosophical light, to make sure that there is something ontologically prior and subsisting in relation to mind and knowledge transcending the (phenomenological but solipsistic) pre-established relation between mind and sense data. Meillassoux refers to geology as a philosophically fruitful framework of time and concatenation of reason and effect by bringing up the term of 'ancestrality'. 'Ancestrality' means that there had already been ages and things and beings before or prior to humans. There is a moment of archaisation in this concept that totally conforms to the type of regression meant by 'preoedipalisation' or a 'state of surveillance', given that the quality of early childhood is exactly

caught up by the desire to go back to earlier states of being. The notion of 'ancestrality' mirrors the idea and the ideal of *the prior* both in an ontological and a chronological mode, constructing a synthetic *genealogy* pointing towards a transpersonal level of generation. It has something tribal in it, inviting the ancestors as witnesses or princ(ipl)es. Meillassoux's geologic conclusion, I admit, confused me enormously, and I intensively experienced an immediate understanding of the 'object' as an 'ancestor', a progenitor or a symbolic mother (as it would come out under a psychoanalytical horizon), which is then certainly the one to play the principal role in 'ancestrality'. But upon continuing with reading, my Freudian *interpretation precox* of *ancestralité* was not corroborated, as there is not a single hint of birth or giving birth or any other of these feminist 'things'.

Yet, in another book worth reading in parallel with Meillasoux's text is Reza Negarestani's book *Cyclonopedia*[7] in which there a traces of things of that kind. In his account on philosophical yet fictitious geology, I finally found the symbolic mother reappearing quite directly, but in her perverted Gestalt of a black destructive mother, the evil or devouring one, whose distortion is a result of a former fall or amnesia. Negarestani's book is – apart from his distorting view of the mother, which is anyway better than not looking at her at all – the only fully valid account of contemporary philosophical geology and constitutes, finally, the reintroduction of the respective *one big object* that was missing, and may now form the ground of a new access to the world, a *realist* one. The revolutionary moment in speculative philosophy consists, in this case, in the direct short-circuiting of the 'object' and the quest for 'ancestrality' in philosophical or symbolic geology, in 'genealogy' providing a model for 'things' that are at the same 'natural' and 'generated in time' according to the series of generations. I would suggest naming this revolutionary moment of the Earth coming up in philosophical discussion, after a term coined by Peter Sloterdijk: the geistic or monogeistic turn. Perhaps the Earth is a *religious object*, as Negarestani puts it.

It is evidently impossible to think of ancestrality in the sense of 'the prior' without looking at the modes of production genealogically or *geologically* involved. Hence it is important to consider the difference between the planes of production, i.e. between generation and production. I am, from a feminist point of view, more interested in generated than in produced 'objects', but also in their difference. The capitalist preference for commodities blurs this difference, i.e. it mixes up the *generated* and the *made/produced*, it turns out, for ideological reasons. This is why the rising up of the 'object', as in Harman's proposal of his caricatural ontology of 'tool-being', can only offer a productive perspective for philosophy if 'objectivity' is grounded in a horizon within which the lines of the generated and the produced might be related without competition. The dissimulation of what has already happened politically to the 'generated' must come to an end. As long as even the idea of 'waste' has not been

completely interrogated anew, like the great philosopher Alfred Sohn-Rethel has tried, there are still too many silent, asymmetric and hierarchical interests driving the politics of non-objects, namely subjects (= generated objects). The difference between the produced and the generated – in theological terms: *genitum non factum* – should hopefully form a serious obstacle to a 'democracy of objects' that seems to be too flat and horizontal to be acceptable in political and philosophical terms even if it offers, at first glance, a perspective to overcome the simplistic opposition between objecthood and subjectivity.

In *On the Modes of Existence of Technical Objects*, Gilbert Simondon writes: 'In the realm of life the organ is not separable from the species, in the realm of technics it is, because it is just produced, which is why it may be separated from the ensemble which has brought it forth: this is the difference between the generated and the produced.'[8] This difference seems to me to be even more relevant than the difference between the organic and inorganic – which I find negligible once the relationship between the generated and the produced is properly understood. Because, within the great ontological frame of ancestrality or geology as ontology it seems impossible to still cling to the difference between the organic and the inorganic, as well as, from this very perspective, it becomes a problem to keep the difference between the produced and the generated going. On a large scale, all object-like beings filling the world are necessarily generated within *Monogeism* and may not substantially change by reciprocal interventions of beings on another – from the immanentist point of view of philosophical geology. Within *Monogeism* the idea of 'diabolic' or 'heretic' manufacturing by humans becomes unconceivable – even if this drives the major plot of all dualistic alienist, extinctionalist and conspiratorial stories.

By contrast, human activities have to be recognised as purely parasitic. Not in Lovelock's gnostic perspective that considers humans to be the *alien colonialist population* of the Earth, but in the sense that they are operated on the level of a logically undisputable complicity within the geologic system. The type of parasite I am aiming at is equivalent to the 'planned child' (*Wunschkind*). Sloterdijk once proposed to think of children as parasites of their mothers. A parasite has an ecological task of its own to fulfil. If the Earth is ready to claim the position of 'ancestrality', that is to become a subject of priority, taking over governance of the whole population, then humankind is reintegrated into the universal multiplied genre of parasites trying to react in an intelligent or artistic manner to the host's demands. But, as long as it not clear what type of planet we are living in (not on) it is hard to tell if we should consider ourselves enemies of the Earth and its destroyers or her parasitic servants and wish-fulfillers. To think that humankind serves as a wish-fulfilling institution to the Earth at this very moment doubtlessly causes some discomfort and its consequences might be absurd. But it is worthwhile trying the experiment.

Many scholars of media theory have quoted Julien Offray de La Mettrie's *L'Homme Machine* during the last thirty years, but only a few, if any at all, have ever read the text that it had originally been published together with, *L'Homme Plante*,[9] in 1748. This little text is amazing, since it not only treats human women as plants, declaring them the beautiful flowers of the species, but also because it offers a *preoedipal* (parasitic) interpretation of humanity in relation to Earth. La Mettrie says humans are equal to plants as they never leave the earth and always stay in close and intimate contact with it – a tree, for example, never withdraws its roots from the soil. La Mettrie describes *L'Homme Plante* as 'le Nourrisson de la Terre qui ne quitte jamais son sein' [the baby that never leaves its breast].

We must respect Meillassoux's reintroduction of geology into philosophy and agree with his proposal insofar as it marks the major turn within the debate (a 'geistic' turn). His argument opens the possibility of thinking the 'object' in terms of universal generation, i.e. conceiving the 'object' as the Earth and its proles in a deeply materialistic manner that allows recognition of the substance of things as a totality of chthonic productive organs. So this is exactly the moment when architecture comes in. According to Meillassoux's concept of ancestrality and its supposed ontological consequences, architecture follows from geology and therefore forms the first plane of art as the *gestalt* of human sites or *para-sites*. Against the backdrop of an ontologically charged Geology that tends to suspend metaphysics or at least to infect it successfully, architecture has to be recognised and constructed by a cybernetic loop through geology. Exclusively by means of an ontologically upgraded type of geology, it may be said today that we come-to-the-world or we have a being-in-the-world. Otherwise we would be kept or trapped in a coming-to-architecture and a being-in-architecture which, again, not only would provide us with a weird mode of reality but it would definitively lock us in a gnostic plot. Architecture under the condition of geology is explained as a cognitive and practical set in *Para-Geology*. There is a true need of a philosophical/ontological concept of geology to re-establish and corroborate the relation between Geology and Architecture.

Real Estate/Para-Sites

Architecture is not flat, it is not two-dimensional, it is neither a text nor an image. It is pure plasticity. Not an image, it is extensive and solid as far as it is 'the built'. We may assume this is architecture's being-real, such that it does not belong to the class of flat things that partake in the plane of the virtual. Architecture's realness is specific, since it is the domain of real estate. Real estate is anti-flat. It is not chaotic, a flock or felt of mixed lines and points; rather, it comprises a code, a rule, a concept, an intention or project. It has cognitive quality. Architecture triumphantly is what

philosophy would love to be: as noetic and conceptual as it is real. This pole position of architecture is a starting point from which a journey through the Earth and its history may begin. This journey has already been achieved many times. The invention of sacred stone temples has written an important chapter in the career of para-sites, for example the temple measured according to the rules of Gudea of Lagasch, one of the kings of Sumer, a hybrid of a king and an architect. For me, architecture is more than an art – like painting, drawing, installation, sculpture, multimedia, video art – but may be considered a bridge linking the two planes which are of interest to us: the plane of ancestrality, i.e. of genealogy and of art, in the sense of geological plastic art or *Para-Geology*.

Architecture and sculpture differ in the way they treat the relation between the outside and inside of a mass, quantity or body. Architecture as Para-Geology strives to create 'swollen volumes' or containers as *geo-imitation*. Sculpture, by contrast, is freer in relation to this norm, and has totally stripped itself of obligations of that kind. Architecture integrates or borrows its key function from the Earth itself, namely arranging various material and offering space. This is why it is of ontological/para-sitical importance in the first place.

As Negarestani has pointed out in his book, there is a deep form of *ressentiment* in the world, not only against the Sun that every day compromises the Earth in demonstrating that it is depending on the Sun's energy, but also against the Earth itself. The relation between the Earth and humans is disturbed. I propose that what we find is the tragedy of Electra performed on a large scale, between the figures of the Sun, the Earth, and people. In the interpretation I have given in my book *Anti-Elektra*,[10] it is not the love for the father that forms the immediate reason for Electra hating her mother, but the fact that her mother is expelled from her position as a priestess who had formerly acted according to the law of the gods. Then, in a crucial political moment, her immolation of the hero is read as a simple bourgeois murder. After it had long repressed mythopoetic and dramaturgical techniques of masking concepts in personifying them, recent philosophy again shows a certain tendency to sympathise with poetry. This is why we can guess retrospectively that the Electra complex actually narrates the Geo-complex, as much as the Oedipal complex had expressed the Theo-complex. This is easy to understand: the Geo-complex is about underworldly things, the Theo-complex about the things above, and both seem to be more or less gendered categories, especially when you understand 'gender' as a logical genus. These two complexes are extremely important for architecture, which is defined by the central axis of the cosmic void stretched out between the extremes organising its statics. The Electra complex is focused on the fate of an offspring that forever stays inside of the matrix and is therefore fixed in the girl's position. The girl is phantasising about generation or generating in the sense of 'giving birth to a living

body' (which is why it is related to 'technology'), while the Oedipal complex is centred on the hallucinative tele-commando of begetting (which is related to power). The Electra complex represents a problem of the offspring from the moment the matrix or the mother is rendered defective, castrated, impotent, subordinate. Then, by any means, this offspring tries to keep itself going in the rage of finding an exit, getting out, even if by way of self-destruction. The Earth is dependent on the Sun, which is why people let it feel that it is only a subaltern thing. The people (humankind) identify with Electra and the problem she faces when her mother loses power. Nothing is less disagreeable to depend on than a weak person or, more specifically, a (socially, politically, energetically) banned person. Inevitably one will easily get furious with that person, even if or especially when there is deep solidarity. So the *ressentiment* is more and more turned against the Earth directly, which makes it difficult today to enjoy *Para-Geology*. All the building, all the digging and hollowing out gets performed more with rage and despair against the Earth than in complicity.

This is the age of *Archiheresy*, which characterises the period that encrypts and dissimulates the ontological tie between architecture and geology. Archiheresy is not turned against a (monotheistic) god but against the Earth. It equals the dismissal of geology as the principle of architecture, from where, in open heresy, another Earth is simulated, a pseudo-Earth offering space and arranged material. Whereas the original Earth or the 'object' was conceptually degenerated to dirt or waste by the Electra complex's aggressive primal forces, heretic architecture invents and produces another, artificial pseudo-Earth equipped with stunning wonders from kitchen to garage, from temple to airport. Cartography replaces Geology, GPS technology replaces orientation. Pseudo-Earth is erected upwards, in the form of anti-labyrinthic overground building, which in itself forms the anti-thesis to ground or Earth.

Architecture under the disguise of *Archiheresy* works like the force that secures amnesia against the 'object'. Further, it works in complicity with capitalism, which strives at a similar type of contortion of principles and the same type of simulation. While *Archiheresy* degenerates the original Earth to dust, capitalism installs full amnesia in relation to the difference between generated and produced things. This is why Negarestani and Nick Land would speak about Necrocracy and the drive for extinction. If generation is conceptually deleted, of course there is neither generation nor putrefaction, but only the glory of *Archiheresy* that will be finally haunted by the 'original Earth' in the guise of global waste. Negarestani will call this the world of 'universal decay'.

Here para-sitic architecture has to intervene and offer an operational and experimental plane of tectonics that expresses and performs hermeneutically and esthetically the Earth's features. At a point of infinity there is no reason to privilege the upper against the lower realms, no reason for a hierarchisation of materials, or for the

speculative idea of a 'hell' inside the Earth. The 'hell' inside the Earth should be the bright and shiny terrestrian core, an obviously serene 'sun-in-the-earth', according to one rule proclaiming: 'the deeper the brighter'. Next to the confusion that appears when speaking of 'objects' (mixing the psychoanalytical object and the thing), there are other ones, for example the one that mixes up the sun and the centre of the earth, or depth and height. Most of the unborn children direct their heads towards the centre of the Earth like intuitive Insiders because they find this direction to be of some electromagnetic interest. But still, there is an axis more integrist than all others, namely the diameter of opposition from which infinity starts, and here begins speculative architecture. Without recognising the centre of the Earth as an origin of infinity there is no para-sitic architecture, there is nothing, only bad arguing according to false principles.

Architecture Today: From Circus to Geametry

When there had once been the circus as a parallel project, as a parody on being, especially on being in paradise, architecture today cannot even be taken as a circus anymore. Architecture has already accomplished and passed its becoming-circus in the baroque, which had overtly exposed its virtual and phantastic, take-off character. In its fixation with the 'above', modern and contemporary architecture shows symptomatically exactly what had troubled Electra, namely the turning-away from the matrix and too much love for the 'Father'. Fortunately, as in all neurotic operations, the symptom is reinforced by the endeavour to suppress uneasy memories. In the case of architecture, well-defined symptoms are to be found in the current use of geometry. As the notion of geometry makes evident, it is a technique of measuring the Earth, i.e. an immanent technique of geology. Nowadays, geometry has completely lost contact with its original definition and is considered the discipline of pure abstraction. According to the ideology of *Pseudo-Earth* or *Archiheresy* it has become more of a *Pseudometry*. Giordano Bruno calls geometers that do not know how to ontologically frame and root geometry – what he did by *infinity* – Geameters that is, those who do not have a proper measure.[11] Geameter is another word for 'pseudometre'. Lars Spuybroek, seeking a model that would repair architecture's amnesia in this realm, therefore dealt with Gothic architecture in his beautiful book *The Sympathy with Things*.[12] In the writings of John Ruskin, Spuybroek discovers an all-over structure of living things altogether harmonised and put in a continuum of fractal-like forms. He goes as far as saying that there is something 'digital' in the Gothic style. He focuses on the organic layer in the Earth's system where all forms stem from – which might by the way also illustrate his own position in architecture since he is considered one of the most important architects working with biomorph

structures. Architecture – like Gothic architecture – turns into a gardening practice. Its aesthetics culminates in a sort of blossoming or flowering, simulating the bliss of living and proliferating cells. To me, this indicates that the vector of ontologic statics or tectonics is already pointing at 'depth', that there is already an ongoing revision concerning the exclusive fixation on some 'higher' realm. What comes up here is a deeply grounded vertical solidarity which is related to *Para-Biology* or gardening. Para-Biology might become an important field for organising the interactivity of beings, which is why it forms an integral part of architecture as its social form. But it is not the whole thing, because the reference level from which architecture could draw its technique is still missing, namely what it could mean to measure the Earth, in other words: to do proper *Geo-Metry*.

Speculative Architecture

In the framework of contemporary speculative philosophy, architecture plays a specific role. The turn from subject to object, the 'democracy of objects', the 'tool-being', all point in a certain direction I would diagnose (apart from some objections concerning the fetishisation of 'objects' and objecthood in terms of the commodity): as the (up)rise of the *inferno-ject*. Negarestani localised first the inferno-ject in petrol, then he discovered it in the 'dark' centre of the Earth. The power of infinity that is at stake here, a power that regulates and balances things out according to the major oppositions, targets the core of the Earth directly there, from where it slowly turns its inert masses. The quality of these masses creates what is known as the electromagnetic field of the Earth, building up a continuum of highly specialised features we use technologically. So it is as if we would have escaped from the Earth in a sort of boomerang line not only to come back but to finally find ourselves as integral elements of the Earth's system. But is it about staying with the perverted Earth, the dark centre? I think the issue is to recognise another Earth that has not been acknowledged yet. The uprise and rehabilitation of the inferno-ject brings tectonics into balance, and makes architecture possible in the form of an unheard of Para-Geology.

A large part of the built of today could have been moulded into the thick surface of the Earth. The preference of the eye and the gaze has made architecture an issue of the visible, but this is not, as I have underscored at the beginning, its essence. It is a project of the purpose of being (in a whole body), which makes it realism. It must therefore be equipped with a proper sense of geology or space and matter. Architecture may serve as the laboratory in which the qualities of the 'object' which is pre-eminently the Earth's body itself – until now left out by all the legions of body theorists – are being researched. Concerning architecture, in a first step, as I said,

the built may 'disappear' into the Earth to a large extent, which would solve some energy problems as the temperature of the crust is stable and favourable in the superficial strata of the Earth. Techniques of lighting and aeration are well enough developed to prevent claustrophobia. Instead of impressing the public with strange new forms and fancy structures, architecture should concentrate on its geological mission. Whereas the strata of the Earth are now completely irrelevant compared to the price per square metre of the superficies, all future architecture includes mining, geologic expeditions and echo screenings, as well as meteorologic and ecologic research such as finding out where the veins of water go – as well as those of petrol and any other liquids and minerals. This will be the *geo-psychological* inferno-jectiv operations of an architecture that finally reconquers its proper foundations.

One may argue that this is exactly what Freud had prophesised saying that the death drive makes one wish first to become an animal, then a plant and finally a mineral, which is already equal to organic zero or to death. In my analysis, it may seem, I am doing nothing else, after this, but embellishing the inorganic as the realm of death and of the Underworld, hell, the depth, the things below and the grave, investing architecture into global necropolisation as well. As Negarestani and Land have suggested,[13] the OOO drive in itself is linked to the death drive, i.e. the radical deconstruction of subjectivity undertaken is only a symptom or a project in crisis, more than a project *about* a crisis.

The constitutive link between the death drive and capitalism that is critically diag-nosed by Land and affirmed by Negarestani results from a lack of differentiation between the generated and the produced. It is a symptom of a *warrior complex* – regardless of gender – that the death drive and the Underworld are explicitly addressed by Freud together, as is the same for speculative thinkers. Assuming that the inferno-ject is a symbolic equivalent to the Earth's inside and its insiders, however, from a feminist point of view these insiders can be dead individuals as well as unborn ones. The confusion about this point is remarkable. Being-dead and being-unborn are the two absolute goals of regression and where philosophical regression aims at, too. Obviously this is not about two goals, but about one. Positive-negative, live-dead qualities are mixed up in the 'inside' that forms the all-over quality of immanentism. What is at stake now is to unfold and understand what I call the *unborn condition* by focusing on generation, on the coming-to-live, slowing down the hypnotising effects of *putrefactio* and extinction. Being-inside doubtlessly forms *the* substantial quality, the ontological condition in immanentism, as the concept speaks out by itself. This is why the fantasy of 'coming-out' by being born has to be conceptually/ontologically replaced by the irreducibility of being *unborn*. Architecture itself recurs in an impressive simulation of the great stratum to the inside, to the Empire of hollow-world. The death drive is said to run towards a becoming-mineral, and when

paired with the unborn complex it fires a break through to another plane of consistence in respect to the immanentist condition. The Para-mineral or Para-Geological world of architecture grants or should grant primitive erotic effects by simulating being-unborn.

Here emerges what Deleuze and Guattari have designed as phases of becoming-molecular, in the first place becoming-animal and in the second becoming-girl. The 'girl', which has forever been the underprivileged one in a symbolic and real sense, unworthy of a specific treatment in the dramatico-tragic history of philosophy, is the most gifted one in object-orientation. It/she is itself a neutrum, neither man nor woman, not even human, and not expelled from the continent of her mother by incest taboo, half born and half unborn. Greek mythology designed her/it to go to the Underworld and become the Queen of Hades, the reign of Death. The reign over Death is at the same time victorious over it, celebrating the triumph of life that would never cease to return. Persephone would never cease to go down and up and down again. Persephone's *katabasis* may be explained as a return *to* the object as well as a return *of* the object, the comeback of the big O, which is the great generative level of the Earth itself.

The ecological movements of the 1970s failed because they were still operating with the binary logics of 'up and down' and 'organic and inorganic' and 'good and bad' and 'nature and civilisation'. They were fighting for nature from a strategic post unknown to its occupants. They were praying for an Earth not having the slightest idea what it was. Geoamnesia was huge in that time. The object-oriented people will change this for the sake of their love for the object. But one has to learn first what this object – the object of all objects – is like: the big O. The architecture they sponsor will be the proof of their own becoming-mineral and being-inside. Architecture then becomes the point where art and philosophical ecology converge.

Notes

1. Maurizio Ferraris, *Manifest des neuen Realismus. Aus dem Italienischen von Malte Osterloh* (Frankfurt am Main: Vittorio Klostermann, 2014), see ch. 1: 'Realitysmus. Der postmoderne Angriff auf die Welt'.

2. Bruno Latour, 'On Actor Network Theory: A Few Clarifications', *Soziale Welt*, 47, 4 (1996): 369–82.

3. Derrick de Kerckhove, *La civilisation vidéo-chrétienne* (Paris: Editions Retz, 1990).

4. See Robin Mackay, 'Introduction' to *Speculative Aesthetics*, ed. Robin Mackay, Luke Pendrell and James Trafford (Falmouth: Urbanomic, 2014), pp. 1–7.

5. Ferraris underscores that postmodernity affected architecture first of all in deconstructivism. So architecture, it seems, is the field of art that expresses in a way a change in

the fundamental approach to the world in philosophy. See Ferraris, *Manifest des neuen Realismus*, p. 17.

6. Quentin Meillassoux, *After Finitude: An Essay on the Necessity of Contingency*, trans. Ray Brassier (London and New York: Continuum, 2008).

7. Reza Negarestani, *Cyclonopedia: Complicity with Anonymous Material* (Melbourne: re.press, 2008).

8. Gilbert Simondon, *Die Existenzweise technischer Objekte*, French to German trans. Michael Cuntz [German to English trans. author] (Zurich and Berlin: Diaphanes, 2012), p. 61.

9. Julien Offray de La Mettrie, *Man A Machine and Man A Plant*, trans. Richard A. Watson (Indianapolis: Maya Rybalka, 1994), p. 77.

10. Elisabeth von Samsonow, *Anti-Elektra, Totemismus und Schizogamie* (Zurich and Berlin: Diaphanes Verlag, 2007); French translation: *L'Anti-Electre. Totemisme et Schizogamie*, trans. Béatrice Durand (Geneva: MetisPresses, 2015).

11. See Elisabeth von Samsonow, 'Giordano Bruno against Ge-A-Metry: An Early Model of Fractal Geometry', in *Variantology 5. Neapolitan Affairs: On Deep Time Relations of Arts, Sciences and Technologies*, ed. Eckhard Fürlus and Siegfried Zielinski (Cologne: Verlag Walter König, 2011), pp. 447–59.

12. Lars Spuybroek, *The Sympathy of Things: Ruskin and the Ecology of Design* (Rotterdam: V2_Publishing, 2011).

13. Reza Negarestani, 'Drafting the Inhuman: Conjectures on Capitalism and Organic Necrocracy', in *The Speculative Turn: Continental Materialism and Realism*, ed. Levi Bryant, Graham Harman and Nick Srnicek (Melbourne: re.press, 2011), pp. 182–201 (p. 183f.). Nick Land, *Fanged Noumena: Collected Writings 1987–2007*, ed. and with an introduction by Ray Brassier and Robin Mackay (Falmouth: Urbanomic and New York: Sequence Press, 2011), see ch. 'Occultures', pp. 545–71.

7 Expressive Things: Art Theories of Henri Focillon and Meyer Schapiro Reconsidered

Kerstin Thomas

Translation by Tina and Michael Bawden

THIS VOLUME ADDRESSES the question of whether and how the basic tenets of the speculative realism movement are pertinent to a revision of art historical methodology. The challenges connected with answering this question are worth tackling in particular because the recent unease within art history towards language-centred structuralist and poststructuralist theories has increased the search for the ontological and epistemological status of the image. Questions as to what an image is if it is irreducible to language-like structures, what we can discover in and know through art and ultimately which epistemic regime art requires have been of central importance in art history since the visual turn in the 1990s. In order to discuss the potential of a speculative art history based on speculative realism, I will analyse the positions of two art historians: Henri Focillon and Meyer Schapiro. They provide a good starting point for the question outlined at the outset because they both attempt to develop a concept of form that overcomes the idealism and language centredness of certain art historical methods.

Both scholars published their great texts on Romanesque art in the year 1931: Focillon's *L'Art des sculpteurs romans: Recherches sur l'histoire des formes* and Schapiro's 1929 dissertation on Moissac in the *Art Bulletin*.[1] Both performed a methodological turn in the study of Romanesque art by placing emphasis on formal analysis and distancing themselves from an art history interested in questions of iconography and style. Both scholars were experts in their field, but at the same time both were open towards the concrete aspects of artistic production. This

openness was due to a familiarity with the process of making art. Focillon's father Victor was a famous etcher, and Focillon learnt about the artist's profession from him early on. In the introduction of his book *Technique et sentiment* of 1919, Focillon reports:

> j'étais tenté par les secrets de la matière et de l'outil. Dans l'atelier de mon père bienaimé, j'appris à toucher les instruments de toute maîtrise, à les reconnaître, à les nommer, à les manier, à les aimer. [...] Tant que l'art se limite à des états de conscience, à des idées générales, il n'est qu'une agitation aveugle ensevelie dans l'intelligence. Il faut qu'il pénètre la matière, qu'il l'accepte et se fasse accepter d'elle, non par de froides caresses, mais par une possession galvanique.[2]

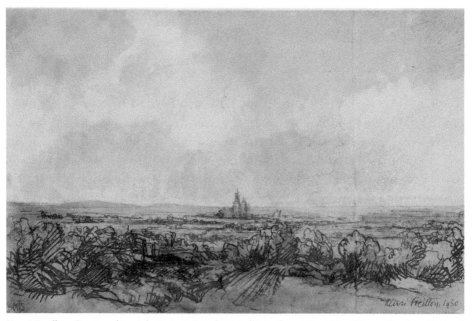

Henri Focillon, *Paysage*, date unknown, watercolour and pencil on paper, 19 × 30 cm. Courtesy National Museum of Art of Romania, Bucharest. Image copyright RMN-Grand Palais / Gérard Blot

Focillon drew himself and felt connected to artists and art critics from his father's circle throughout his life, such as Eugène Carrière, Auguste Rodin, Claude Monet and the critic Gustave Geffroy.[3] Schapiro also produced an impressive amount of art over the course of his life; alongside studying art history he attended the National Academy of Design.[4] His extensive circle of friends included artists such as Robert Motherwell and Barnett Newman, and his lectures at the New School and New York University in the 1940s and 1950s were regularly attended by artists and critics

such as Elaine and Willem de Kooning, Philip Guston, Franz Kline and Thomas B. Hess, the editor of *Art News*.[5] Despite their similarities, however, Focillon and Schapiro belonged to different generations and different academic milieux, which led to disputes and a mutual distancing.[6] These disputes have been overstated in the past, leading to a characterisation of Focillon as an aestheticist formalist and Schapiro as a historical materialist. A more detailed comparison of their respective positions sheds light on the similarity of their fundamental outlook and their quest for an anti-idealist, material-oriented foundation of art history. This offers a fruitful starting point for the methodological issues of this volume. From the perspective of a speculative art history, three of Focillon's and Schapiro's basic positions appear particularly pertinent as they correspond to the basic stipulations of speculative realism: the understanding of the object, the conception of the relational and the model of dynamic forms. In focusing on these three areas, I want to show that the conceptions of form by Focillon and Schapiro will provide a good basis for the discussion of an art historical methodology, based on tenets proposed by the speculative realism thinkers.

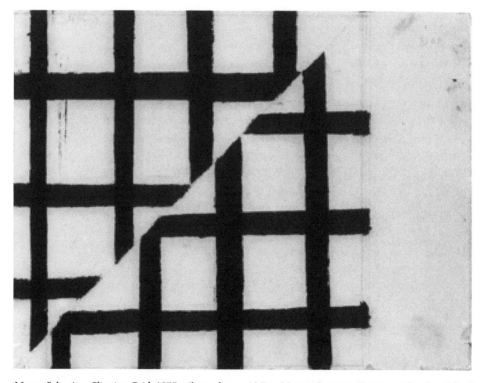

Meyer Schapiro, *Slipping Grid*, 1975, oil on plaster, 19.7 × 26 cm. Courtesy Trustee under the Will of Meyer Schapiro

The Work of Art as Object

The most important tenet that all speculative realists share is the problematic nature of an anthropocentric foundation of cognition. Central to this is the rejection of what Quentin Meillassoux in his book *Après la finitude* calls the 'correlationist' position: the assumption that the world could be reduced to thought and language, with a silent remainder.[7] Meillassoux's view that there is Being without Thought, that there are entities which exist independently of any cognitive reference to them, strengthens the idea of objects that are autonomous, with a reality of their own. Of course this is an epistemological position, which is not readily applicable to the question of how we approach art. But the revaluation of the object as an entity with its own reality inherent in Meillassoux's critique does offer great potential for the way we deal with works of art – objects which per se defy complete rational and linguistic comprehension.

In rejecting the instrumental definition of the object used by an art historical method which focuses on style and iconography, Focillon and Schapiro forged a path towards a new, object-oriented understanding, which can form an important basis for transferring theories of speculative realism to art history. It is important to both scholars to emphasise that works of art are objects with a reality of their own, and that they are more than mere representations of an artistic idea or products of an overriding cultural or stylistic movement. Focillon opens his *Vie des formes*, published as book in 1934, by claiming that: 'a work of art exists only insofar as it is form. In other words, a work of art is not the outline or the graph of art as an activity; it is art itself. It does not design art; it creates it.'[8] A work of art, according to Focillon, lays claim to singularity, it is in itself absolute and not the result of a system, be it a formal system as proposed by the Vienna School or a *Geistesgeschichte* (history of ideas) in Max Dvořák's terms. In an interview, Schapiro voices a similar opinion. In opposition to the philosophy of John Dewey, which he otherwise valued highly, he states here that the work of art, humanity and nature should not be seen as one unity, but as different forces. His objection to the view Dewey held in his book *Art as Experience* of 1934, that aesthetic experience could happen in art as well as in ordinary life, emphasises this position of dispute. He accuses Dewey of treating 'humanity and art as extensions of nature, as products of nature, without dealing with how humanity reshapes and remakes itself.'[9] Consequently, Schapiro as well as Focillon afford the work of art its own reality, even in architecture, and distinguish it strictly from the experience of the viewer. In *Vie des formes*, Focillon describes the space inhabited by the work of art as an independent world that encounters the world of the real but adheres to its own principles:

> The imaginary worlds of ornamental space, of scenic space and of cartographic space having rejoined the space of the real world, henceforth the life of forms must, it

would seem, manifest itself according to unalterable rules. But nothing of this kind occurs. For, intoxicated by its own powers, perspective at once goes headlong to meet its objectives.[10]

Schapiro later holds a similar position in claiming that '[t]he space of the cathedrals is intensely expressive, but it is a constructed, ideal space, appealing to the imagination, and not an attempt to transpose the space of everyday life.'[11] The artwork becomes an object, which is subject to its own rules. It is important to stress that Focillon's and Schapiro's conceptions of art's own world is not to be equated with platonic idealism, in which the artwork represents the world of ideas and as such is essentially inaccessible to the observer. The thought rather has its roots in both Focillon's and Schapiro's Marxist orientation and is materially founded. In this sense artistic forms are not merely reflected ideas, but they are entities which vitally prompt action and which can cause things to happen. Focillon writes:

> Forms are always tending toward realization; they do, in fact, realize themselves and create a world that acts and reacts. [. . .] Forms never cease to live. In their separate state, they still clamor for action, they still take absolute possession of whatever action has propagated them, in order to augment, strengthen and shape it. They are the creators of the universe, of the artist and of man himself.[12]

They become agents, things somewhere between matter and spirit, as Focillon asserts further:

> At the crossroads of psychology and physiology, forms arise with all the authority of outline, mass and intonation. If for a moment we cease to regard them as anything but concrete and active forces powerfully at work among the *things* of matter and space, we will find ourselves touching in the mind of the artist no more than the larvae of images and recollections, or at best the most rudimentary gestures of instinct.[13]

In another passage he writes: 'matter, even in its most minute details, is always structure and activity, that is to say, form.'[14] Focillon draws on William James when stressing that the form as agent has the potential effectiveness of a gesture:

> If it be true, as James has shown, that every gesture exercises on the life of the mind an influence that is none other than the influence of *all* form, then the world created by the artist acts on him, acts in him and acts on other men.[15]

Based on his interpretation of the artwork as an entity, Schapiro also concludes that works of art have agency. In his presentation 'The Social Bases of Art', given at the First American Artist's Congress in 1936, Schapiro explicates that 'Art has its own conditions which distinguish it from other activities. It operates with its own special materials.'[16] So both Schapiro and Focillon see art not as a passive mirror of society or of the artist, but rather as an active agent with real power to move. The idea that artworks are to be taken seriously as entities – not just having an effect but with the power to initiate action – has been widely taken up and developed in art history in the context of the *visual turn* since the 1990s. William J. T. Mitchell sums up this idea concisely by asking 'What do pictures want?', which is also the title of his book published in 2005.[17] Horst Bredekamp emphasises the agency of artworks with the term 'Picture Act' – the German term *Bildakt* is also the title of a book published in 2010 containing Bredekamp's Adorno Lecture from 2007.[18]

The Relational Model

As important as it is to recognise the work of art in its materiality as autonomous entity, and as possessing agency, one must also be aware that there are far-reaching problems connected with this. An approach that sees the artwork as an independent entity is in danger of construing it as an organism which is ultimately thought of as anthropomorphous: the work of art would derive meaning by analogy with the meaningfulness of human existence – a meaningfulness which cannot be inferred through external, rational structures. Focillon and Schapiro already recognised the problems incurred by such an organic understanding of the work of art. This is what Focillon means when – drawing on the founder of semantics Michel Bréal – he warns against viewing form as a living being:

> And, too, I am fully aware of the criticisms raised by Bréal against every science of forms that 'realizes' form as such and that construes it as a living entity. Where, within this multifarious, and yet highly organized world, are we to consider mankind as standing? Have we left in it room for the mind?[19]

Focillon and Schapiro show us how this essentialist trap – and therefore a new idealism – can be avoided while at the same time enabling an explanation of the specific ontological character of artworks that distinguishes them from idea or pure matter. Although they stress the artwork as an entity independent from its viewers and therefore stress its object status, they do not understand it as a closed unit but rather as a place of negotiation between human actions, material and ideas. The forms of the work of art are inconceivable without the interaction of the artist, even

though they cannot be seen as mere products of his or her mind. This becomes clear in Focillon's comments on 'touch' as a moment in which the artist's tool touches matter and creates a form with its own value, colour, weight, density and movement. He argues:

> Touch is structure. It imposes on the form of the animate being or the object its own form, which is not merely value and color, but also (in no matter what minute proportions) weight, density and motion.[20]

In the zone of contact 'the indestructible [. . .] traces of ardent and vigorous life' emerge.[21] The 'Life of forms', or the reality of the artwork, is not simply a reflection of an inner and independent life fed by a life force. Such a vitalist stance is often attributed to Focillon when he is studied in the context of contemporary thinkers such as Étienne Souriau and Henri Bergson.[22] In fact, though, Focillon translates the vitalist approach into a relational model, which is opposed to such substance thinking. The tensions resulting from this are revealed by Focillon in the opening sentences of his book:

> Whenever we attempt to interpret a work of art, we are at once confronted with problems that are as perplexing as they are contradictory. A work of art is an attempt to express something that is unique, it is an affirmation of something that is whole, complete, absolute. But it is likewise an integral part of a system of highly complex relationships.[23]

Focillon's approach goes beyond a substantialist understanding of living form. He views the form as the result of a contact or touch between material and human. Analogously, in the discussion following his presentation at the American Anthropological Congress in 1953, Schapiro argues that every artistic form is the result of a meeting of the properties of the material and the gestures of the human hand. According to him, one can recognise these 'elements of touch' in the narrow traces left on stone by tools: the pressure applied, the distribution and the momentum. In addition to recognising the aesthetic (one could say formal) qualities we sense that 'these are operations of the human hand; that there is somebody speaking, doing, acting.'[24] By understanding form as the result of a contact between artist and material, both Focillon and Schapiro avoid every kind of idealism which sees artworks as bearers of ideas – be they the ideas of the artist or metaphysically charged ideas in a platonic sense.

However, when the work of art is viewed not as an expression of its substance, but rather as a place of contact between the material qualities of colour, canvas, stone and

the hand, tools and ideas of the artist, then the question arises as to the meaning of the work of art and how this meaning can be accessed. Because if one divests the artwork of its rational character – in other words, if one views it not as an intelligible substrate – then explaining the epistemological relation to it becomes problematic. To solve this problem, Focillon and Schapiro proffer concepts of knowledge and truth, which are completely un-idealistic. In my opinion, their approach is remarkable because it preserves the character of the work of art as a specific and material object while avoiding the trap of essentialist substance thinking. For Focillon, the artist's knowledge of his or her work cannot be described as a notion of form, but rather as process, which is directly realised in concrete action. According to him the artistic idea is procedural even in the mind, in the way that it is being painted or being kneaded.

Focillon states that the artist does not see abstract ideas but rather tone, touch, modelling. He concludes: 'The hand that is in his mind is at work.'[25] Focillon added an essay entitled *Éloge de la Main* (*In Praise of Hands*) to the second, 1939, edition of *Life of Forms*. This title, *In Praise of Hands*, thus encompasses much more than a euphemistic upgrading of craftspersonship: it describes a principle of generating form in which meaning emerges from various factors of equal importance. It is not that formless matter is given a meaningful form by the artist – originating in his or her mind and as a product of his or her will – but materials with their own distinct qualities which come into contact with the artist and through the artistic process take on form. Schapiro also binds knowledge to action. For Schapiro action is not the implementation of a premeditated plan but rather a process, which is based on a reciprocal relation between artist and material, form and man. In an interview conducted in 1993 he says:

> What is a fact? According to most languages, it is a product of labor. Consider the word fact in German, 'Tatsache', which means 'thing done'; in French, 'fait', which means 'made'; or even the Latin base for the English word 'fact', which is the word 'factum' and is related to *manufacture*, which means 'made by hand' . . . What is the truth? The truth is what is *made*.[26]

The knowledge that an artist can have of his or her work is therefore neither instrumental nor is it abstract.

This concept of knowledge could provide a starting point for an epistemological model which draws on speculative realism. Graham Harman, in his analysis of Martin Heidegger's conception of things, emphasises the two attitudes towards things, which is instrumental or reflective.[27] In the concepts of Schapiro and Focillon, the knowledge of an artist is neither the instrumental knowledge which determines the application of tools – as in Graham Harman's analysis of Heidegger – nor is it the knowledge

of reflective distance which Harman analyses in Heidegger's example of the broken tool, that is the insight into the being of the tool at the moment in which it cannot adequately fulfil its use. Harman advocates doing away with the antagonism between the instrumental and reflective knowledge of objects, which Heidegger separates, in favour of a phenomenological knowledge of objects, which allows them a real existence. One could transform this model with the attitudes of Focillon and Schapiro towards a speculative art history in describing accordingly the position of the artist, who plays a role in producing the work of art and as such influences the work's reality as a position lacking the prerogative of interpretation. Since his or her knowledge of the work emerges through negotiation, through involvement with the material, it can never be complete.

Dynamic Definition of Form

We have seen that Focillon and Schapiro have a comparable understanding of the work of art: one that views artworks not as beings of substance but as places of negotiation processes. This understanding requires a dynamic view of the work of art. A dynamic definition of the object is also a trait of speculative realism. But despite the fact that there is agreement about the dynamic nature of objects within the speculative realism movement, there is no agreement about how this dynamism is to be understood. Iain Hamilton Grant's theory that behind every phenomenal manifestation an active field of productivity can be assumed may be reconcilable with Focillon's understanding of living forms and could shed light on his views.[28] According to Grant, forms are mere ephemeral appearances of an underlying dynamic principle. Focillon also maintains the concept of a dynamic principle, which brings about forms. He writes:

the life of forms is renewed over and over again, and [. . .], far from evolving according to fixed postulates, constantly and universally intelligible, it creates various new geometries even at the heart of geometry itself. Indeed, the life of forms is never at a loss to create any matter, any substance whatsoever of which it stands in need.[29]

In contrast to the natural objects that Grant has in mind, for Focillon artworks as artefacts are inconceivable without human intervention and therefore his dynamic principle is to be understood as a negotiation process between two dynamic entities: material and the artist. The artist alternates between a distanced, reflective role and a forming, manipulative role. As Focillon writes in the last sentence of *The Life of Forms*:

Even as the artist fulfills his function of geometrician and mechanic, of physicist and chemist, of psychologist and historian, so does form, guided by the play and

interplay of metamorphoses, go forever forward, by its own necessity, towards its own liberty.[30]

This concept of freedom – it is no coincidence that this is the closing sentence of his book – is thoroughly emphatically charged for Focillon. In his view the artist, who is at the hub of things, and more specifically the artist's freedom, enables the free forms of art and these in turn (in their freedom) impact on the artist and society. Even if one is unsure about subscribing to this ethical-utopian emphasis, one must admit that with this definition of freedom Focillon succeeds in combining the different levels of reality of the work of art and in describing every level as a dynamic principle in itself: material, artist and society. Just as the negotiation process between artist and material moves between the poles of necessity and freedom, the relationship between the artwork and society is equally determined by necessity and freedom. He concludes that 'it is the relationship between these three values that clarifies a work of art not only as something that is unique, but also as something that is a living word in a universal language'.[31] Accordingly, the artwork is an entity just as it is an agent in an overarching structure. Focillon does not continue this thought; there is no conclusion to integrating an understanding of art and society.

Let us turn back to Schapiro, who also sees the principle of dynamism at work not only in the relationship between the artist and his or her material but transfers it to the relationship between the work of art and society. Schapiro already stressed the social character of art in the introduction to his Brooklyn Academy of Music Lecture Series in 1939 when he stated that art is 'social in its communicative and symbolic character', because it is a language and a 'language is social' not only as a 'means of conveying meanings' but also through a 'common mode of transaction and reflection' – in this, 'art not only communicates but makes a community'.[32]

The community that Schapiro refers to is to be understood as a concrete social community which is not only influenced by art but which can come into existence as a community through art. Schapiro's rejection of essentialist theories of art stems from his critical stance on an understanding of art as a product of an innate development process and as independent from social conditions. This becomes apparent in his criticism of Aloïs Riegl's conception of *Kunstwollen* and of the formalism represented by the New Vienna School. In a review of the second volume of the *Kunstwissenschaftliche Forschungen* by the New Vienna School, Schapiro formulates the following objections:

> The multiplicity of conditions which enter into the formation of a work of art is reduced to the action of a 'principle', and the discovered structure or principle is sometimes substituted for the work itself.[33]

His position also leads to the rejection of the concept of autonomy in modernism as propounded by Alfred H. Barr, Jr or Clement Greenberg. Schapiro criticises Barr, Jr's conception of the immanent development of abstract art in its employment of an ahistorical model of cause and effect to the history of art forms. He emphasises:

> [Barr Jr] excludes as irrelevant to [art's] history the nature of the society in which it arose, except as an incidental obstructing or accelerating atmospheric factor. The history of modern art is presented as an internal, immanent process among the artists.[34]

The dynamism of form is, according to Schapiro, not to be understood as the result of a vitalistic, driving principle, which ultimately continues independently from humankind. Instead, Schapiro follows the anti-Stalinist, Marxist views of the New York Intellectuals with their criticism of nationalism, nativism and anti-intellectualism.[35] According to this perspective, the postulation of fully autonomous artistic forms is pure idealism. Art can never be pure; it is always subject to a constant process of negotiation and conflict with other factors or entities. The difference with Focillon's dynamic relational model can perhaps be seen in the emphasis that he places on the autonomy of the work of art as object. In contrast to this, Schapiro stresses the inexorability of the social reality, which is itself influenced by the dynamic activity of the work of art. The dynamic of the object is accordingly determined by its substance as well as its efficacy as agent within sociopolitical relations. Bruno Latour's actor-network theory appears fruitful to me at this point as a means of developing the idea of the dynamic work of art as agency further and with reference to a speculative art history.

The questions that remain are: what implication does a view of the work of art as constituted by relations and dynamic processes have for our understanding of it? Is it possible to understand it as a unit at all under these conditions? And finally: what is the perspective of the viewer who is much further removed from the artwork than the artist in perception and reflective distance?

Focillon's theory cannot help us here, but Schapiro's theory can shed some light on this, although he starts with the unity of the work of art and does not reduce it to mere relations. In place of an essentialist understanding of the unity of the artwork, though, Schapiro understands this unity as analogous to linguistic coherence, as he states in his 1953 essay 'Style': 'A style is like a language, with an internal order and expressiveness, admitting a varied intensity or delicacy of statement.'[36] This, in consequence, leads Schapiro to define the process of reception more exactly. In his essay 'On Perfection, Coherence, and Unity of Form and Content', published in 1966, he criticises the idea of an immediate, simultaneous perception of artworks which is

part of the essentialist concept of unity, describing it as 'an ideal of perception which may be compared with a mystic's experience of the oneness of the world or of God.'[37] Instead, Schapiro sees the perception of an artwork as a process in which the individual parts are brought together and into relation with each other:

> To see the work as it is, one must be able to shift one's attitude in passing from part to part, from one aspect to another, and to enrich the whole progressively in successive perceptions.[38]

He describes this ultimately as a collective and cooperative process: 'It takes into account others' seeing; it is a collective and cooperative seeing.'[39] It becomes clear that Schapiro not only propounds a concept of a negotiation of various factors as regards the aesthetics of production, but also on the level of reception aesthetics. This, too, can be described as a relational theory: one that sees the coherence of an artwork as the result of a successive process in which various elements, factors and agents are involved. By highlighting a continual process of reflection on the object and its perception as a central task for art history, Schapiro identifies the work of the art historian as an equally unending and experimental process as the work of the artist, within which the work of art is only a junction of mental and material movement. By citing the 'collective and cooperative seeing' as a path leading to knowledge, he is equally describing this as a dynamic, unending and relational process.

Although the art historian is more distant from the artwork than the artist, this does not lead to a unique epistemic position. Because the meaning of the work is not considered to be an essence that can be discovered, there is no hermeneutic claim for truth. On the other hand, meaning is not considered to be completely opaque or to be the product of pure projection. Both scholars stress that the meaningfulness of an artwork lies in the specific pictorial quality of the forms and that content is secondary. In response to the possible criticism that when objects are robbed of their content-function, the form is just an empty shell, Focillon states:

> Can form, then, be nothing more than a void? Is it only a cipher wandering through space, forever in pursuit of a number that forever flees from it? By no means. Form has a meaning – but it is a meaning entirely its own, a personal and specific value that must not be confused with the attributes we impose on it. Form has a significance, and form is open to interpretation. An architectural mass, a relationship of tones, a painter's touch, an engraved line exist and possess value primarily in and of themselves. Their physiognomic quality may closely resemble that of nature, but it must not be confused with nature.[40]

And he concludes by stating even more clearly:

> Any likening of form to sign is a tacit admission of the conventional distinction between form and subject matter – a distinction that may become misleading if we forget that the fundamental content of form is a *formal* content.[41]

The meaning of an artwork is not possible without its specific material existence. He writes in a different context: 'whereas [. . .] a sign signifies an object, form signifies only *itself*.'[42] In Schapiro's writings we find almost identical formulations. In 'On Perfection, Coherence, and Unity of Form and Content' Schapiro speaks of the 'pictorial meaning of each figure as a form'.[43] It follows that expressivity is more than a quality of particular works of art; it is, in fact, a basic property of the visual sign, defined as the quality of the material and the traces of workmanship, the properties of *masse, tons, touche de peinture* and *trait gravé* in Focillon's terms. Schapiro brings these ideas together in his essay 'Style' where he writes:

> what counts in all art are the elementary aesthetic components, the qualities and relationships of the fabricated lines, spots, colors, and surfaces. These have two characterstics: they are intrinsically expressive, and they tend to constitute a coherent whole.[44]

In aesthetics the expressive quality of a work of art is described in just this way. The philosopher Susanne K. Langer propounds the idea that artworks are in themselves meaningful, expressive forms in her book *Feeling and Form*, published 1953.[45] In other words their meaning is not contingent on anything external to them. According to Langer, the expression of artistic form is not to be equated with the subjective expression of the artist. Instead, it is a visual articulation without fixed meaning of its own which is independent from context. The expression of artistic form cannot be abstracted from the sensuous material from which it was created. Excerpts archived in Schapiro's literary remains show that he was familiar with and considered Langer's theories.[46]

So we see that on the level of art historical analysis, the sense and meaning of an artwork can be described as the result of a process of negotiation between the poles of artistic activity, material properties, society and the viewer. It can be seen as the product of interaction and friction between multifarious individual entities. Ultimately, this has consequences for the concept of truth, which Schapiro describes succinctly as a heuristic principle searching for knowledge.

Conclusion and Outlook

At this point I would like to make some initial conclusions as to what insights we can draw from the models propounded by Focillon and Schapiro for the issue of a speculative art history as well as to discuss which aspects might be developed further.

To my mind, one of the most promising lines of inquiry is the issue of expression I outlined, because it highlights the problems that arise when combining a substance model and a relational model. Richard Wollheim's ideas on art and expression seem pertinent here. In his text 'Correspondence, Projective Properties, and Expression in the Arts', Wollheim discusses the competing theories, which view the naming of the specific expression of a represented landscape either as the property of the work or as a projective description of the beholder.[47] Wollheim rejects both theories on the grounds that the first falsely attributes human qualities of expression to the artwork while the second neglects the fact that the artwork really does possess qualities of its own which evoke the designation. Wollheim understands the expressional power of an artwork to consist in a correspondence relationship between its formal (or material) properties and the experiential knowledge of the viewer brought about through it. Wollheim ascribes a great deal of importance to the role of the artist in the expression of the artwork. The creative process is understood as behaviour in which the expression is the result of successive artistic processes in which the artist alternates relentlessly between acting and adapting. So to some extent Wollheim steers a course between two extremes. The relational model, presented by Focillon and Schapiro, could fruitfully be used to develop Wollheim's proposition further. This conception manages to limit the primacy of thought and to recognise the intrinsic qualities of objects as such – one of the key concerns a speculative art history should promote.

The model of ceaseless processes of negotiation could pave the way for a perspective on art that combines production aesthetics and reception aesthetics. This would throw the problem of expression into relief by helping to explain the processes at play between material and artist and artwork and observer by not only labelling them as 'correspondence relations' as in Wollheim's theory, but by viewing the processes as containing possible obstacles and power relationships. The artwork would in this perspective assert itself as an object in its own reality, which causes interaction and friction and can in turn take an active part in building social relationships.

Notes

1. Henri Focillon, *L'Art des sculpteurs romans: Recherches sur l'histoire des formes* (Paris: Librairie Ernest Leroux, 1931); Meyer Schapiro, 'The Romanesque Sculpture of Moissac', *Art Bulletin*, 13 (1931), no. 3, 249–352, no. 4, 464–531.

2. Henri Focillon, *Technique et sentiment: Études sur l'art moderne* (Paris: Henri Laurens, 1919), p. III.

3. Philippe Dufieux, '"Penser comme l'artiste, voilà la règle de notre recherche": Henri Focillon dessinateur', in *Henri Focillon*, ed. Pierre Wat (Paris: Éditions Kimé, 2007): 211–26. Annamaria Ducci, 'La mano parlante dello storico dell'arte: i disegni di Focillon', in *Chirurgia della creazione: Mano e arti visive*, ed. Annamaria Ducci (Ghezzano: Felici, 2011), pp. 185–96.

4. Helen Epstein, 'Meyer Schapiro: "A Passion to Know and Make Known"', *Art News*, 82 (1983), no. 5, 60–85, no. 6, 84–95.

5. Thomas B. Hess, 'Sketch for a Portrait of the Art Historian among Artists', *Social Research*, 45, 1 (1978): 6–14; James Thompson and Susan Raines, 'A Vermont Visit with Meyer Schapiro (August 1991)', *Oxford Art Journal*, 17, 1 (1994): 2–12.

6. Walter B. Cahn, 'Schapiro and Focillon', *Gesta*, 41, 1 (2002): 129–36.

7. Quentin Meillassoux, *Après la finitude: Essai sur la nécessité de la contingence* (Paris: Éditions du Seuil, 2005).

8. Henri Focillon, *The Life of Forms in Art*, trans. Charles B. Hogan and George Kubler [1948] (New York: Zone Books, 1996), p. 33.

9. Meyer Schapiro, in an interview with David Craven, together with Lillian Milgram Schapiro, 15 July 1993, in Rawsonville, Vermont. David Craven, 'Meyer Schapiro, Karl Korsch, and the Emergence of Critical Theory', *Oxford Art Journal*, 17, 1 (1994): 42–54 (p. 43).

10. Focillon, *The Life of Forms in Art*, p. 93.

11. Meyer Schapiro, 'Style', in *Theory and Philosophy of Art: Style, Artist, and Society*, Selected Papers, 4 (New York: George Braziller, 1994), pp. 51–102 (p. 92) (first publ. in *Anthropology Today: An Encyclopedic Inventory*, ed. Alfred L. Kroeber (Chicago: University of Chicago Press, 1953), pp. 287–312).

12. Focillon, *The Life of Forms in Art*, p. 127.

13. Ibid. p. 130.

14. Ibid. p. 96.

15. Ibid. p. 133.

16. Meyer Schapiro, 'The Social Bases of Art', in *First American Artists' Congress: Against War and Fascism* I, ed. Jerome Klein (New York City, 1936), pp. 31–7 (repr. in *Social Realism: Art as a Weapon*, ed. David Shapiro (New York: Frederick Ungar, 1973), pp. 118–27 (p. 118).

17. William J. T. Mitchell, *What Do Pictures Want? The Lives and Loves of Images* (Chicago: University of Chicago Press, 2005).

18. Horst Bredekamp, *Theorie des Bildakts: Frankfurter Adorno-Vorlesungen 2007* (Berlin: Suhrkamp, 2010).

19. Focillon, *The Life of Forms in Art*, p. 117.

20. Ibid. p. 110.

21. Ibid.

22. Maddalena Mazzocut-Mis, *Forma come destino: Henri Focillon e il pensiero morfologico nell'estetica francese della prima metà del Novecento* (Florence: Alinea, 1998).

23. Focillon, *The Life of Forms in Art*, p. 31.

24. Meyer Schapiro, 'Style: Comments and Discussion', in *An Appraisal of Anthropology Today: International Symposium on Anthropology*, ed. Loren C. Eiseley, Irving Rouse, Sol Tax and Carl F. Voegelin (Chicago: University of Chicago Press, 1953), pp. 63–6 (p. 65).

25. Focillon, *The Life of Forms in Art*, p. 123.

26. Meyer Schapiro, Interview with David Craven, 20–22 May 1993, in New York, in Meyer Schapiro, Lillian Milgram Schapiro and David Craven, *A Series of Interviews (July 15, 1992 – January 22, 1995)*, Res: Anthropology and Aesthetics, 31 (1997): 159–68 (p. 166).

27. Graham Harman, *Tool-Being: Heidegger and the Metaphysics of Objects* (Chicago and La Salle: Open Court, 2002).

28. Iain Hamilton Grant, *Philosophies of Nature After Schelling* (London: Continuum, 2006); Iain Hamilton Grant, 'Does Nature Stay What-it-is? Dynamics and the Antecendence Criterion', in *The Speculative Turn: Continental Materialism and Realism*, ed. Levi Bryant, Nick Srnicek and Graham Harman (Melbourne: re.press, 2011), pp. 66–83.

29. Focillon, *The Life of Forms in Art*, p. 94.

30. Ibid. p. 156.

31. Ibid. p. 63.

32. Meyer Schapiro, 'Art and Society', lecture and introduction to the Fine Arts Lecture Series at the Brooklyn Academy of Music, February 1939 (p. 3 of a four-page typewritten manuscript), New York, Columbia University Library, Rare Book and Manuscript Library, Meyer Schapiro Collection; quotation follows: David Craven, 'Meyer Schapiro, Karl Korsch, and the Emergence of Critical Theory', p. 51.

33. Meyer Schapiro, 'The New Viennese School', review of *Kunstwissenschaftliche Forschungen* II, ed. Otto Pächt (1933), *Art Bulletin*, 18, 2 (1936): 258–66 (p. 260).

34. Meyer Schapiro, 'Nature of Abstract Art', in *Modern Art: 19th and 20th Centuries*, Selected Papers, 2 (New York: George Braziller, 1978), pp. 185–211 (pp. 187–8) (first publ. in *Marxist Quarterly*, 1, 1 (1937): 77–98).

35. For Schapiro's position in the Marxist debates of the 1930s, see: Andrew Hemingway, 'Meyer Schapiro and Marxism in the 1930s', *Oxford Art Journal*, 17, 1 (1994): 13–29.

For Schapiro's political position from the 1930s to the 1950s see Alan M. Wald, *The New York Intellectuals: The Rise and Decline of the Anti-Stalinist Left from the 1930s to the 1980s* (Chapel Hill, NC and London: University of North Carolina Press, 1987), pp. 210–17.

36. Schapiro, 'Style', pp. 57–8.

37. Meyer Schapiro, 'On Perfection, Coherence, and Unity of Form and Content', in *Theory*, pp. 33–49 (p. 48) (first publ. in *Art and Philosophy: A Symposium*, ed. Sidney Hook (New York: University Press, 1966), pp. 3–15).

38. Ibid. p. 45.

39. Ibid. p. 48.

40. Focillon, *The Life of Forms in Art*, p. 35.

41. Ibid.

42. Ibid. p. 34.

43. Schapiro, 'On Perfection', p. 44.

44. Schapiro, 'Style', p. 57.

45. Susanne K. Langer, *Feeling and Form: A Theory of Art Developed from Philosophy in a New Key* (New York: Scribner, 1953), pp. 24–41. For Langer's philosophy, see Rolf Lachmann, *Susanne K. Langer: Die lebendige Form menschlichen Fühlens und Verstehens* (Munich: Fink, 2000).

46. Schapiro was invited to the annual meeting of the American Society for Aesthetics, from 28 to 30 December 1952, to discuss two papers devoted to 'Symbolism in the Visual Arts'; that by Arthur Szathmary treated in detail Langer's position. Schapiro's notes are devoted to those theories. Meyer Schapiro, notes to 'Symbolism in the Visual Arts' (1952), in Meyer Schapiro Collection, box 199, fol. 3, Columbia University Library.

47. Richard Wollheim, 'Correspondence, Projective Properties, and Expression in the Arts', in *The Language of Art History*, ed. Salim Kemal and Ivan Gaskell (Cambridge and New York: Cambridge University Press, 1991), pp. 51–66.

8 Gothic Ontology and Sympathy: Moving Away from the Fold

Lars Spuybroek

WHEN WRITING WHAT I call the 'Sympathy-book' (*The Sympathy of Things: Ruskin and the Ecology of Design*, 2011) I encountered two specific problems that made it almost impossible to proceed.[1] One was of a theoretical and the other of a historical nature. The scholarship in architecture schools dealing with theory is most often part of history and theory departments, a marriage arranged for practical reasons. Because of the nature of archival work, cross-referencing and the simple fact that it deals with the written word, the discipline of history presented itself as the obvious partner for theory. Needless to say, many dangers have arisen from this connection. One direct threat is that the original friction between them tends to dissipate over time, and that any practical parity takes on a conceptual character. For instance, theories of design might validate themselves through mere historical reference. Or, conversely, theories of design might think of themselves as validated by rewriting history in such a way that its argument logically follows. Another danger – one that we have suffered in architecture over the last thirty years – is that history enables a 'critical' view of the present, making students of architecture conceive of theory and criticality as synonymous, and, worse, leading them to think that critique can be built.

For my part, I do not think that any analytical method of critique can be married with the fundamental synthetic positivity of the act of design, let alone the act of building. I vividly remember being in a panel during the 1999 edition of the ANY conferences held in Paris with architect Peter Eisenman and art theorist Rosalind Krauss.[2] To call the double act unpleasant would be an understatement. While Eisenman was doing a deconstructivist critique of Frank Gehry's Guggenheim Bilbao – comparing the building none too subtly to Speer's *Lichtkathedrale* – Krauss

was seconding him with constant nodding and calling the Bilbao museum 'Mickey Mouse architecture'. Eisenman would proceed by showing his own projects as proof of his deconstructivist theories, while at the same time he had made sure there was a platoon of theoreticians hidden in the audience who would stand up one by one to confirm whatever he was saying. For Eisenman, criticality and building were not two fundamentally different acts of thought. Indeed, they were the very same: the taking apart of one thing was equated with the putting together of something else. In language it is already deeply problematic to write against writing, but there always exists the loophole that allows the written merely as the record of analysis. The object of writing can escape its subject. In architecture, however, it is abundantly clear that we cannot build against building, that we cannot construct deconstruction. It was as if Eisenman would deconstruct in the daytime and have his engineers put structure in during the night when nobody was watching. Theory would present him with the shifts, cuts and folds and engineering would harden it out afterwards. For me this lesson meant one thing: if I was going to write a theory of design, and especially a theory developed from history, I was not going to make it a theory of *how to* design. In that sense, *The Sympathy of Things* is only half a book, since it offers a design theory without design. It presents a philosophy of design without showing how to design with it and without establishing formal rules.

The second problem was as hard as the first. Since I embraced the notion that a theory of design could be historically biased, the question became how can it be so without being traditionalist. The only answer I could find was by doing a 'bad' historical analysis, by doing *ill-disciplined history*. The more I studied John Ruskin the more I felt that a historical treatment of his arguments would bury him deeper into a past that is forever lost. Historiography generally positions a historical figure in his or her own period and reconstructs their development as a development from *their past*, that is by tracing lineages and uncovering evolutionary branches. The fact that Ruskin's notion of the Gothic was itself ahistorical and that his concept of sympathy was radically different from the earlier and better-known ideas of David Hume and Adam Smith, and far closer to those of Alfred North Whitehead and Henri Bergson, who to my surprise never even quoted Ruskin, made such a 'non-story of history' necessary. In itself this does not present problems that cannot be overcome, but the true question emerging from such an approach is how one can write a non-history that is precise and intellectually rigorous. If I was not relying on causality and chronology, on what then?

At this point exactly the book started to flip over. I started to notice that the theory did not lead to design, but that design led to theory, or, as I call it, Gothic ontology – a term that makes historians and philosophers equally mad. From using a philosophy to look at design or base design decisions on, I started to develop a philosophy from

a design aesthetics, and in that way not only making Ruskin into an ahistorical figure, but also turning the Gothic into a philosophy freed from the late Middle Ages and Christianity. Clearly, this can only be partially correct, and that is where the issue of precision comes in. Like incision and decision, the word precision is derived from cutting. By its nature a precise operation cannot consider the whole of Ruskin, nor the whole of the Gothic, and needs to trace parts – a butcher would say 'cuts' – that allow themselves to be lifted from their historical background, while others would safely remain in the body of history. Paradoxically, if we take the term 'lifting' literally, it seems that historical figures transcend history. And though it means that we could speak of the Sympathy-book as ill-disciplined history, it cannot be disqualified as an ill-disciplined method. Though the question remains what half a theory and half a history can be, as yet I have not found the proper word for such an exercise.

In a sense, Ruskin himself construed many ahistorical or meta-historical arguments, and it is not by accident that Paul Frankl called Ruskin a dilettantist.[3] On top of that, many of Ruskin's critics and followers also made attempts to lift him from his Victorian context, often for the same purpose as I have: to make him contemporary. As I say in the introduction, the Ruskins of Marcel Proust, Peter Fuller or Raymond Williams are often as ahistorical as Ruskin's queries. And Kenneth Clark tellingly called his 1964 anthology *Ruskin Today*. In *The Sympathy of Things* I join a tradition that butchers, recombines and plunders the history of the Gothic according to the needs of the present, but invariably uses it as a weapon against classicism, that other architecture claiming the right to historical transcendence. Whereas the latter constantly restates the same universalism, the Gothic is always changing its face and adapting – fitting itself into a bourgeois niche, as in art nouveau, becoming historically self-evident, as in the Victorian revival, or in my case – which is not so much revivalist or expressionist – taking the form of a digitalised incarnation. Though I should stress again, in the book I do not develop the digital argument to the full, I merely make a beginning. Thus my attempt is to dig up and steal the most precious corpse of the English and run away with it as far as I can by developing the notion of Gothic ontology, which is slowly developed into a notion of sympathy.

While I have understood that Ruskinians generally appreciate my reading of Ruskin, it is not a traditional reading, which would stress his naturalism or his stance against machinery. Art historians such as Henri Focillon, Hans Jantzen, Frankl and Jean Boni disparage Ruskin for his reading of the Gothic, which on the whole they tend to ignore. According to them it is incorrect a-structural, and altogether too Christian. But I think Ruskin is extremely precise and to the point. 'The Nature of Gothic' is a chapter in the second volume of *The Stones of Venice*, which also includes the very important chapter 'The Material of Ornament'. In the first volume of this book, we still find a more or less classic notion of the Gothic. Historians of the early nineteenth

century, for example Robert Willis, argue that a valid reading of the Gothic should be based on what they call a 'membrology'.[4] For a proper historical analysis of the Gothic a historian should consider the members or the parts, that is the columns, pedestals, finials, pinnacles, etc. I think there are major disadvantages to such a method. It is true that Gothic architecture consists of very recognisable members; however, to understand their variation through the mere cataloguing of such members will not suffice. Like Ruskin I have been asking myself: what enables such variation? The answer cannot be found in the mere typological substance of members only. I think the answer lies behind the same reason that Ruskin did not write 'The Stones of Salisbury' or 'The Stones of Abbeville', though later he wished he had written the latter.[5] Why did he choose the Venetian hybrid to theorise the nature of the Gothic? And then, even more interestingly, why does 'The Nature of Gothic' not consider the Venetian Gothic at all? What makes that chapter on the nature of the Gothic so valuable is that it considers a meta-story of the history of the Gothic, describing it as detached from its members and parts.

From an ideological viewpoint, Ruskin is very close to the arguments of A. W. N. Pugin, not only as an advocate of the Gothic, but especially as an anti-classicist.[6] Like other protagonists of the Gothic, they are both fulminating against classicism as 'an architecture invented, it seems, to make plagiarists of its architects and slaves of its workmen'.[7] Learning the trade of designing architecture from a classical stance means that one follows the books of Vitruvius, Serlio and Palladio, which constitute the canon of classicism. The art of design becomes an art of copying from the canon, which can only work when all solutions are typologically fixed, wholes as well as parts. The rules of universalism dictate that the rules apply anywhere. Pugin and Ruskin understood correctly that such universalism is always a form of imperial power, making classicism more Roman than Greek in character. The way the Romans colonised foreign land by imposing the same urban grids, the same typologies of amphitheatres and basilicas, is the same power that forces a workman to execute a drawing through stone cutting or wood carving. First the architect needs to plagiarise Vitruvius and then the workmen carve the details and ornaments exactly as the architect drew them up. In this way, architecture makes slaves of its workmen and hedonists of its inhabitants. Ruskin's work on the Gothic, in this anti-classicist sense, is both a moral and a political criticism of design.

Ruskin goes quite far in following Pugin, but while Pugin's criticism is almost completely based on Christian arguments, Ruskin adds in 'The Nature of Gothic' the famous six characteristics which transcend religiosity: savageness, changefulness, naturalism, grotesqueness, rigidity and redundancy. In the context of Gothic ontology I will discuss only the first two characteristics, 'savageness' and 'changefulness', and how they relate to the fifth one, 'rigidity'. Why do these play such an important role

in something as fundamental as ontology? Firstly, because savageness and change-fulness play roles that are crucial in the understanding of discreteness and continuity, a distinction we encounter in science as that of particle and wave, and in philosophy as that of being and becoming, one stressing spatial stability and the other temporal transformation. Ruskin's two characteristics are in fact technical terms that lie at the basis of all mereology, and I think aesthetics has developed solutions both earlier and more precise to conceptualise their relationship. 'Savageness' sounds at first like an awkward term that reminds us of Jean-Jacques Rousseau's noble savage and other Romantic theories of primitive purity, but the way Ruskin describes savageness relates strongly to an invention of the same period as Rousseau's, by Uvedale Price, who came up with the notion of 'rough variation', which lies at the basis of his concept of the picturesque.[8] Roughness is the form of variation that allows things to be discrete, to break away from each other. Gilles Deleuze's stratification is clearly a form of roughness, and, like Price, Deleuze associates roughness with mineralism, geology and tessellation. But I think Deleuze always had a too simplistic concept of roughness, shelving it too swiftly under order, power and territorialisation, as forces opposing smoothness. Ruskin's changefulness coincides with that other notion of variation, namely smooth variation (what Deleuze calls 'continuous variation' and what Bergson calls 'difference in degree'), and was invented earlier by aestheticians like William Hogarth and Edmund Burke.[9] Gothic ontology is an ontology that understands existence as an interaction, or alternation, of two types of variation, one smooth and gradual, and the other incremental and rough – that is, both are neces-sary for things to exist, allowing them to be and to change.

There is a more profound reason why aesthetics cracked these problems earlier and more convincingly than philosophy, and I will try to clarify this as we go along. As two aesthetic categories, smoothness and roughness were first considered in their combination during the development of the picturesque in the late 1750s. Ruskin was the first to apply these concepts to the Gothic, and what is especially important is how they lead to the notion of rigidity. Ruskin has always been accused of being a flawed reader of the structural concepts of the Gothic, but with the concept of rigidity he adds a very novel and important idea.

Wild Design

Savageness is the most complicated characteristic of the six that Ruskin lists. In *The Stones of Venice* Ruskin says: 'Imperfection is in some sort essential to all what we know of life.'[10] This is the first time Ruskin uses the notion of life in *Stones*, though he had already used it in *The Seven Lamps of Architecture* in the chapter 'The Lamp of Life'. When reading the whole of Ruskin's work one constantly encounters life or

vitality, and my main argument in the first pages of the Sympathy-book is that Ruskin, who is often read as a Christian theoretician of the Gothic, is a sort of crypto-vitalist. I say 'crypto' because he is not using the term theoretically, certainly not as explicitly as Hans Driesch or Bergson. Nonetheless, he uses the word 'life' in a very instrumental and very precise manner throughout all of his books, not only when he discusses ornament, or the making of buildings and paintings, or the way paintings compose themselves (which he calls the 'Law of Help'), but also when he talks about matter in general or plants, or social structures and political economy. He constantly refers to this notion of life and vitality, from his earliest to his very last writings. What becomes directly clear is that his usage of the term 'life' is not exclusive to animate beings and includes the inanimate as well.

Life, simply put, means that things are not just there, but are being made and unmade; moreover, that these three stages of existence should be understood in connection to one another. Ruskin states that '[n]othing that lives is, or can be, rigidly perfect; part of it is decaying, part of it is nascent'.[11] Instead of looking at the object in space, he looks at the object in time. Through the object goes a vector that creates it – this is its nascent moment, which relates to Ruskin's earlier ideas about vital beauty in *Modern Painters*[12] – and at the same time breaks it down, which means that part of it is already decaying. For Ruskin three times cooperate in the existence of an object: one of being composed, one of being as such and one of being destroyed. A philosophy of existence cannot simply claim the middle state as the one of stability and safely discard the other two. Being is an activity, and when we relate it more precisely to the notion of savageness we should say being is work. Again and again, Ruskin associates the quality of savageness to the 'wildness' and ruggedness of work-men, to the Gothic stonecutters and the carpenters. Here we recognise the concept of the picturesque from a century before. After Burke had opposed beauty and the sublime, Price positioned the picturesque between these opposing tendencies. Ruskin's vital beauty has to be understood as leading towards the picturesque and the picturesque itself, which Ruskin called the 'parasitical sublime',[13] is already moving away from Price's middle point towards the sublime. So by means of savageness, Ruskin is really positioning a new notion of aesthetical beauty between these two opposing tendencies.

Certainly, Ruskin is famous for describing craft as the potential to make mistakes. However, life or savageness is not expressed by mistakes only. When workmen do their work perfectly – *and most often they do* – they do it with the same vitality as when they do it imperfectly. Workmen certainly do not strive to make mistakes, nor does the Gothic strive for imperfection! When one tries to find imperfections while visiting Strasbourg or Reims, at first you cannot but think that Ruskin was out of his mind, because you cannot build in a more precise fashion than with the Strasbourg Cathedral

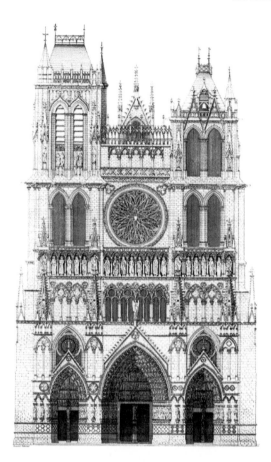

Drawing by G. Dehio and G. von Bezold (*Die kirchliche Baukunst des Abendlandes*, 1884) of the Western front of Amiens Cathedral. The drawing depicts the asymmetry of the spires as if it is a form of design, but any original thirteenth-century drawing of the architect would not show such asymmetry

or come up with a better notion of perfection than in the Reims Cathedral. When you read Ruskin, however, you have to suspend this classicist notion of imperfection. Imperfection is not a perfect design where something went wrong during the execution of the work. Ruskin does not separate design from execution, and neither did the Gothic builders. In fact, stonecutters and carpenters had a certain independence in their working process. Certainly, there was design and there was an architect, but his status was very different than in modern times. Gothic cutters and carpenters were part of guilds consisting of journeymen and masters, and they controlled their own work. In that sense, the organisation of the work was already savage; workers were not just part of a hierarchy but were as much part of a conglomeration of guilds or coop-erations. When we look, for example, at Amiens Cathedral, which is a hundred kilometres west of Reims, we see an unfamiliar kind of asymmetry, neither the full symmetry of Reims, nor the extreme asymmetry of Chartres. What happened? Simply saying something 'has gone wrong' would not explain what we are seeing here. A

nineteenth-century drawing of Amiens shows the asymmetry as if it was designed beforehand, which cannot be correct: no architect in the Gothic age would draw a church as asymmetrical. It does show, however, that the architect was not in full control and that design did not prescribe exactly what part should go where and in what form. Instead, the Amiens Cathedral is an occurrence, a 'vectorised' object, that is as much an event as an object. Or, maybe better put, a thing is as much an event as an object. What allowed the two spires to be asymmetrical? Savageness did. You can understand parts of the cathedral as being drawn and highly controlled – e.g. the rose window or the entrance portal – but the asymmetry of the spires cannot be understood as having been produced from a drawing. As a consequence, Ruskin's notion of imperfection must be based on a broader notion of drawing.

Page showing various wooden templates (bottom) from the *Sketchbook of Villard de Honnecourt*. (Folio 41, thirteenth century)

In the Gothic, an architect would not draw up frontal façades, sections, side façades, axonometrics, isometrics, etc., and then leave the drawings to the locals, withdraw and have them executed in his absence. The architect was one of the master masons among others. In Gothic architecture the building was not legalised by a set of drawings and by the authorisation of the architect, as it is in our age. Let us look at the famous set of sketches made by Villard de Honnecourt, bottom left). We see these strange wooden templates on some of the drawings, which are actually sections of members. They could be sections of columns, of a moulding, of some profile in the building, but we will not find a section in combination with an elevation, as is normal for us. The idea of an isolated section is extraordinary, and historians have shown that identical sections can be found in different columns in

different churches. Similarly, there is no complete plan in Honnecourt's sketchbook. In York Minster, we find the plan partially carved or chiselled in the stone of the wall, which means that problems were sorted out during construction and by various disciplines, not by a mastermind architect. There are different examples of Gothic cathedrals where you see parts of the drawings in full scale of the traceries or the centre lines of linear objects.

The nature of drawing is called tracery. Tracery is generally understood as a formal characteristic of Gothic architecture that we recognise from rose windows, for instance. But the term indicates the importance of the line and how the line is drawn, which can be on paper or parchment, but on stone or wood as well. It is not just the architect who draws. The stonecutters and carpenters were doing as much of the drawing; in fact, both guilds were usually very secretive about their control of the geometric tools they applied. Though Ruskin never discusses carpenters, they were in fact extremely developed in their use of stereotomy, a form of describing the geometry of complex forms in space.[14] What nowadays is still called *l'art du trait* in French is truly a Gothic invention that quickly spread all over Northern Europe. *Trait* means as much a line drawn on paper as a mark scored in stone or scribed on wood. When Ruskin discusses his concept of savageness he often points at the independence of the sculptors doing the ornamental work on Gothic cathedrals, but such independence of the worker was omnipresent and very well organised.

When we return to the discussion of the asymmetry of the spires of Chartres and Amiens, we now understand that such are not accidents happening to a pre-established order, but *accidents happening because of an order*. A Gothic entity cannot be simply theorised as a 'body without organs', and more often the reverse is the case: organs free to assemble a body. In modernism contingency is deeply opposed to order, as we recognise the one from Pollock's drippings and the other from Mies's gridded boxes, but in the Gothic those two were not opposed: the symmetry on the base of the towers allows for the asymmetry of the spires. Or, in organisational terms: the division of work allowed for the freedom of those groups to do their work. It also means that savageness is over-spilled by changefulness, but that changefulness is limited by savageness.

The Rib

I will leave the idea of savageness aside for a while and start a discussion of the notion of *changefulness*. As Ruskin says: 'The vital principle is not the law of Knowledge, but the love of *Change*.'[15] Changefulness is the second type of variation, not the rough variation of savageness, but a smooth or gradual variation, the type of variation that was extensively discussed by Hogarth and Burke when analysing beauty, and was to

inspire the ideas of Charles Darwin. Although in Darwin it never becomes clear how evolutionary development driven by gradualism leads up to sudden bifurcations of the evolutionary branches, this idea of variation becomes the motor of novelty, of newness. Similarly, the following sentence forms the core of Ruskin's theory of the Gothic: 'They were capable of perpetual novelty.'[16] For contemporary architects novelty is virtually incomprehensible and is generally attributed to subjectivity. The philosophy of apriority is an architectural notion. When an architect designs an opera house, for instance, his or her design is for a large part predesigned because of it being an opera house and not a villa or a railway station. All potential newness lies with the subjectivity of the architect being able to stretch or distort the typological mould of the pre-existing.

Before we go over to Ruskin and the Gothic we should consider how architects adhering to classical convictions tend to approach a design. Novelty is suppressed, of course, because it would endanger the notion of typology itself; a church might start to look like a hotel, or worse, the reverse. But not only the whole of a building is directed by typology, the parts are too. An architect designs with a suitcase full of elements that pre-exist the design, such that any possible novelty may only occur through the *combination* of elements, which we discussed earlier as members. Every classicist will tell you that you can only produce something new by recombining the old. For the rebuilding of London after the Great Fire in 1666, for example, Christopher Wren designed thirty churches. When you think about it, it is an amazing commission, not because of its size, but because you have to design thirty different incarnations of the same object. The worst way to approach such a problem would be to start with the first church, then proceed with the second, etc., and simply hope you will finish with thirty reasonably different churches. Instead, it would be much better to design *the systemacy behind a range of churches* before you specify one, similar to Bach's approach in the *Goldberg Variations*. In modern terms, you would have to create a meta-design before you start to actually design each instantiation. First the architect designs the organisation of objects and then he or she specifies and actualises them for each different site and size. This is a powerful idea. However, for a system to spill out variations it must be based on variability, not very different from breeding dogs or roses. And classicism is deeply suspicious of variation, basically allowing only for what I call *proportional variation*. That is, elements are only allowed to vary in size in relation to other elements, and in a limited way. Therefore, Wren was not able to get past a combinatorial logic of the various elements. You can size up a column, but only by scaling up the width with it. If that does not work, then you double the column, as in the front façade of Wren's St Paul's. You are not allowed to vary the elements themselves. Wren could not vary the shape of a circle in such a way that it would not be a circle anymore. A rounded arch needs to stay a rounded

Plans of Piers.

John Ruskin. *Plans of Piers.* (Plate II from *The Stones of Venice*, Vol. 1: Foundations, 1851)

arch. You can only make it smaller or bigger, but it needs to retain the geometry of a semicircle. The actual form of the object repeats the typological notion of that object. So in the organisation of form no variation is possible while it is being materialised. In short, classicism confuses organisation with form; in philosophical terms, it confuses the virtual with the actual. The organisation of things in classicism is always formalised; each thing attains its form as it is moulded by typology.

In Ruskin's concept of the Gothic, however, the idea of an object and its organisation, the passage to reality can only occur through the creation of novelty. The column, the window, the vault – all these 'members' – are not preformed. Bergson would make the same argument, but Ruskin said it fifty years earlier and a bit more precisely, because he did not merely talk about ideas, but about instrumentalising ideas. Ideas are *machine-ideas*; they are operations and strategies. What is perpetual novelty then, exactly? What are those 'millions of variations'[17] for the traceried window, for the webbed vault or for the compound pier? Well, the adverbs already indicate their difference from a classical element: traceried, webbed, compound. Compounded by what, webbed by what? At this point we encounter the most fundamental Gothic invention: *the element that is not an element.* What makes it even more fundamental is that it directly embodies the 'trait', or the score, the linear mark, a non-element we know all too well from tracery: *the linear rib.* It cannot be said loud and long enough what an incredible conception in architecture this is. When you look at a compound pier, it is in fact a bundled column: a column made as a bundle of vertical ribs. And the bundlings can be different all the time. Some of the largest ones are bundles of more than forty ribs, officially called colonettes, 'small columns', but

they are ribs. Ribs can exist in any position: they can interlace into a vault, or weave into a window, fan out, braid, bounce, intersect, anything to make a larger element or member. They can be thick or thin, straight or curved. Though there are certainly 'members' in the Gothic typology of parts, a membrology would not explain what makes the Gothic so utterly unique. When we look at Ruskin's table of piers (see p. 141) it is almost like you are looking at snow crystals. All are different, different in size, yes, but also different combinations of ribs and combination of different amounts of ribs. The same can be seen in tracery windows. Of course we have all these styles of traceries, for example the Middle Pointed, the Flamboyant or the Perpendicular, but it is the invention of the rib that allows the Gothic to make all windows different and new each time they occur. More importantly, it is not merely the combination of ribs that is constantly different, but every time the ribs combine they themselves are changing. In short, the ribs are not moved by an external force (which makes them combine), but they *move internally*, which is another way of saying that they change. Therefore the rib is the vehicle of changefulness, of smooth variation.

The rib is the most irritating element in architectural history because nobody can explain it, not the engineer, not the art historian, not the philosopher, not even the architect. Nobody can explain what it is because it is nothing, it is in itself *indeterminate*. It is not really an element, because it is far too thin to be a column and it is useless when it is part of a vault. When you would remove all the ribs from a web vault the structure would remain intact. The rib is useless, but nonetheless Gothic stonecutters spent half their time carving ribs. They deeply loved it because it forms the heart of the Gothic, that is a world obsessed by linearity and figuration: drawing and materiality, design and craft are of the same order. When we look at the south cloister of Gloucester, for example, we can clearly see that the ribs are framing the glass, but to simply denote the ribs as mullions would not do, since opposite the windows the identical pattern of ribs is used to articulate the stone wall. Whether it is a wall or a window is irrelevant to the patterning of ribs. They are pure articulation. This is absolutely new. In philosophy we have the choice between apriority, which means things are predetermined and preconceived, or monist pulp, according to which things emerge from ungroundedness.[18] That means, we are either in a world of elements where variation becomes meaningless as in Greek elementarism, or we are in a world without elements where variation makes out the substance, as in baroque stucco. But the Gothic has found a solution to that opposition. Ribs are formed but indeterminate, finite but undefined, ill-disciplined but precise. They have highly articulate profiles and exhibit configurational behaviour.

In fact, they are sub-elements, non-elements or proto-elements: they have the exactitude of elements, but lack all definition. Sub-elements exist on the level of figures, existing in a wide range of forms. We see C-figures, S-figures (like Hogarth's serpentine

line for example), O-figures, V-figures, and when we encounter growth structures we see bifurcations based on Y-figures, and sometimes structures, as with cracked glass made up of T-figures. The Gothic consists of a whole alphabet of figures. These figures are not motifs, because usually motifs are hidden in materiality. Motifs are classicist and those tend to be small, such as the meandering bands we find in a Greek or Roman frieze. Gothic figures are not motifs, because they occur on all levels of scale, on ornamental as well as structural scales. However, this alphabet of figures does not constitute a language. Art history is obsessed with language, which is a major handicap to design theory, because the symbolic does not enable any understanding of figuration techniques. Language is never instrumental, whereas with techniques you can carve and chop and chisel. A language-based theory of the Gothic would acknowledge the ogives, ogees, vaults, finials and pinnacles all right, in short the membrology, but not the more basic figuration of these members by ribs. All members are composed of these rib-figures. An ogive, as we understand it, consists of two J-figures, whereas the cusps you see in tracery windows are made of double S-figures.

All these figures are containers of variation of changefulness. They are smooth, they vary gradually within themselves and incrementally from each other. You can stretch the shaft of a J-figure, but you can also keep the shaft the same length and stretch the arch. These are a-proportional variations and thus they are not classicist. The Gothic is very different from the classical mode of operation because it is driven, not by proportional but by *configurational variation*. And here we come to an even more essential point of the Gothic: all the activity of the figures, all that movement, all that continuity does not spill out to deterritorialise the structure, no, it makes the figures *configure, to in fact create structure*. Though not in the way an engineer would understand that term, as a shedding of redundancy; on the contrary, Gothic structure is created *because of redundancy*. The figures are active not for themselves but because they want to find each other. Strictly speaking, Gothic structure is a collaborative effort; again, a form of work, but an excess of work, what Ruskin terms as sacrifice.[19] Figures configure: rose windows, netted vaults or tracery windows are configurations. In turn, they are containers of movement, rotational, flaming, radiating or spoked-wheel movements, but these are all configurations of the sub-movements of the figures. That is the main argument of a Ruskinian reading of the Gothic. The methodology goes from figure to configuration.

The Digital

Both the fundamental variability of all figures and their relationality make the Gothic thoroughly digital. Fairly simple behaviour by individual members resulting in complex and irreducible collective behaviour is a form of computation, which finds its most fundamental form in the digital, though not necessarily electronically. We often

understand 'digital' as meaning 'electronically computed', but the speed of electrons is actually irrelevant to the notion of computing, which refers solely to the method of calculation: a stepwise procedure of iterative adjustments. Some might argue that while these relationships are indeed mathematical in nature, they are not specifically digital. And indeed, many have wondered why I found it necessary to qualify the nature of the Gothic as digital. It would not have been too difficult for me to add digital configurations in the book to illustrate the argument, but I decided against that. What I absolutely wanted to prevent was to create another book in the ANY format where a historical argument would suffice to legitimise a contemporary design solution. I have already been wary of critics comparing the contents of the Sympathy-book to my own work as an architect. While I understand that it was unavoidable, it is incorrect: I discontinued my work as an architect during the writing of the book, because I felt that with a book I could make arguments that I could not make with my work as an architect.

One of those arguments is actually the reverse of the above: most of my contemporaries in digital design have not looked precisely enough at the Gothic, nor at William Morris's elaborations of the Gothic which so strongly followed Ruskin's premonitions. The richness of figuration, the reversal of the baroque-fold argument, the inherent constructivism of configurational patterning, the equation of structure and ornament – all that has still escaped contemporary digital design. On the other hand, most scholars, especially Heideggerians like Hubert Dreyfus and Kenneth Frampton, still understand computers as anti-hands, as mechanical devices that can only calculate what is programmed beforehand, that is as determinist machines. But computers are anything but clockworks driven by linear functions. Sure, they calculate with incredible precision, *but with floating and flexible numbers.* It is a clockwork made up of rubber cogs and wheels, where relations can stretch and shift from linear to squared functions and further, in short, where nothing is predictable and where redundancy rules.

The digital argument therefore should be understood as parallel to the vitalist argument, and like Deleuze's notion of the machinic, vitalism is not a form of organicism where wholes are predetermined but a mixture of the mechanical and the organic. Whitehead, though not a vitalist, called this an 'organic mechanism' in his 1925 *Science and the Modern World,*[20] a philosophy that merges mechanical atomism with organic continuity. I think most digital architecture of today is still wholly in the grip of mere continuity, of what Patrik Schumacher calls 'parametricism',[21] which is nothing but baroque isomorphism or continuous variation. The absolute danger of continuous variation lies in its inherent, Catholic universalism. Parametricists simply miss out on the roughness and savageness and remain in the grip of digital stucco. The problem of parametricism is that it lacks the constructivism of configurationality. It cannot create its own thresholds; it merely keeps on folding and stretching without creating its own channels and obstacles, what Wilhelm Worringer so aptly calls the 'form

problems' of the Gothic. Though the initial variation of changefulness is parametric, it needs to self-stop by hitting into savage obstacles, making things independent and autonomous, and allowing them to break away from continuity. There exists continuity, yes, but only to create discontinuities, discretenesses – in short, what we call *things*.

We are not dealing with vaults or columns, but with textile processes of bundling, interlacing and weaving that are transferred to stone. Flexibility, a textile notion, allows things to emerge, not out of the ungrounded, but out of a world of things that are highly formed but wholly indeterminate. Flexibility of behaviour enables things to create new things that are larger in scale. Reading Worringer through Ruskin's eyes, the notion of *vitalised geometry*[22] – to which Deleuze never ceases to refer – suddenly becomes a very precise description. And let me make immediately clear that the apparent paradox of *lebendige Geometrie* should be read in parallel to Whitehead's organic mechanism. Both Ruskin and Worringer read the idea of vitalised geometry more in ornament than in the larger objects of the Gothic. The latter derived this idea from Karl Lamprecht, the author of *Initial-Ornamentik des VIII. Bis XIII. Jahrhunderts* (1882) – an amazing book on Gothic illumination – which deals mostly with small objects like initials in books, clasps or very small ornaments of everyday objects, all organised by this vitalised geometry.

Ruskin was particularly interested in the intricacy of evolution in Northern design, which we know so well from the fantastic early eighth-century designs of the Lindisfarne Gospels or the Book of Kells. Ruskin discovers this notion of the woven band and the intricate system of bands equally in Indian, Arabian, Egyptian and Byzantine design as in that of Norway and Ireland and even in that of Greece. The question that we should raise is simple: how can a drawing such as an initial on a Bible page be woven and knotted? Are knotting and weaving not unique to material strands? And how about the braiding in a stone capital of a Byzantine column?

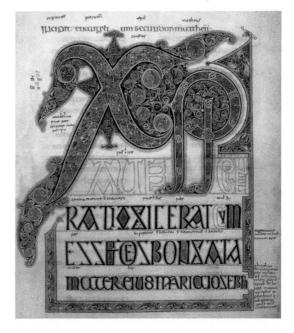

Second initial page of the Gospel of Matthew or the *Chi Rho* page from the Lindisfarne Gospels (AD 680–720), folio 29. Courtesy the British Library, London

Again, everything comes down to the materiality of the drawing, to the *trait* and the tracery. In Byzantine braiding, in Celtic knotwork and in Gothic interlacing the flexibility of non-elements (bands, strips, ribs) computes the form while it is drawn and while it is carved. The idea of braiding your hair or plaiting leather bands is what I called a 'machine-idea' before an operational idea, an idea that takes on form while it is executed based on procedural rules. Therefore the textility can be as easily transferred to stone or ink as to hair and yarn. The materiality of the line is one where lines configure, where the lines are drawn in concert, not being drawn by hand one after the other. *A line draws itself in relation to another line*, a line is not drawn because of the hand that draws it – that is just authorship and authority. Here the lines rule over one another. Keep in mind that lines are rulers. We weave, we interlace, before we draw and then we carve it out. When we look at a Celtic cross, designed in intricate knotwork and carved from stone, the issue is not merely the flexibility of the curving threads, it is also how the rigidity of the configuration coincides with the stone. The stoppage of the configuring meets its materiality, but only by the transfer from the technique of weaving to that of carving. Therefore the operational idea is that of transformation, from figure to configuration as well as from textile to stone.

Ruskin offers us a notion of craft that merges with design. It is not a notion of Arts and Crafts where design is still followed by craft. Instead, he offers us a notion of crafting, of weaving, interlacing, bundling, plaiting – in short, of a flexible materiality that exists on the level of drawing and design. In Ruskin we find an idea of work that is not just in the workmen but in the members and (sub-)elements themselves. The drawing is done by many hands simultaneously, as a collaborative and cooperative effort, and I think there is no better description of computing. In the Sympathy-book I refer to the summer of 1853 when Ruskin was on holiday in Scotland with John Everett Millais. Ruskin spends evenings with Millais discussing his notion of the Gothic, to which Millais makes a few drawings, most of them very small but one in particular Millais some months later enlarged to a huge format. In those few drawings Millais made of the new Gothic – and we are now getting closer to a Gothic ontology – we see the notion of collaboration and of things being active, of labour being part of things. Not just labour, but collaboration. Instead of ribs touching and interlacing, Millais drew angels kissing and holding hands. Things – thing-ribs, thing-fibres, thing-threads – hold hands and while they hold hands they build formations. When Ruskin, in his forties, became interested in political economy and wrote *Munera Pulveris* and *Unto this Last*, he was giving an aesthetic critique of society. Ruskin is not a Marxist, since he has an aesthetic concept of collaboration. Mereologically speaking, things make larger entities because they feel for each other. And even though Morris later adhered to Marxism, I think he always remained loyal to this notion of Aesthetic Socialism. For Ruskin and Morris the social was an aesthetic

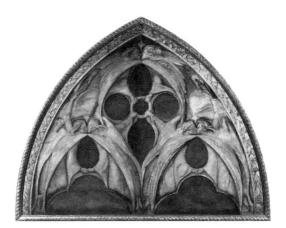

John Everett Millais. *Design for a Gothic window*, 1853, charcoal, gouache and watercolour on paper. 213 × 277 cm. Courtesy private collection

act, not the reverse. Aesthetics precedes all, ethics as well as philosophy. All being is derived from aesthetics, and therefore we need to add the word 'Gothic' to that of 'ontology'. Whereas there are different styles of being, no being can ever be without style. Style is merely the collective agreement to *what* things feel for one another; however, the fact *that* they feel is primary.

We can now understand savageness as something that does not pre-exist change-fulness, but emerges from it. There are pools or reservoirs of variation, containers of gradualism that exhaust themselves, after which things break. Similar to Darwin's notion of species, each entity can only contain so much variation, after that a break or bifurcation necessarily follows. A thing varies until it cannot extend itself any longer by variation. Savageness, in other words, is a notion of growth. A thing does not scale up by adding elements; rather, there are internal cuts, internal fractures. So, to go back to Darwin's gradualism, we now need to add its enemy *saltationism* to the notions of development and growth. Nature does jump, but only after it has been stretched to the limit. And nothing that grows, neither individuals nor species, can grow without self-segmentation. A thing cannot simply scale up (by continuity), it needs to break up and reorganise continuity into segments. In living bodies, this procedure is called limb formation. Let's compare Bourges Cathedral to Salisbury Cathedral, for instance. If we would script this by digital means, we would see that both are produced by the same operational idea, i.e. algorithm. The procedure starts with bundled columns that weave into vaults, which copy lengthwise into a nave that doubles into aisles on both sides, then creates transepts to conclude with a Lady Chapel and an apse. From an operational and digital viewpoint, this is an iterative and incremental way of occupying a site. One could even call it strategic. The algo-rithm is strategic, but the implementation needs tactics. Each operation can only go so far as the site allows. When you compare the site around Salisbury to the site

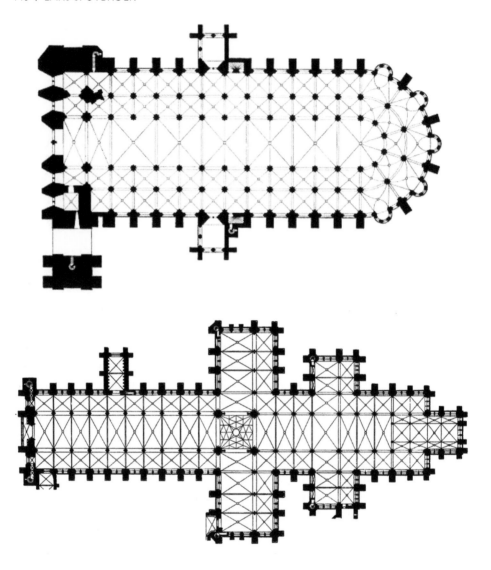

Plans of (a) Bourges and (b) Salisbury cathedrals by G. Dehio and G. von Bezold (*Die kirchliche Baukunst des Abendlandes*, 1884)

around Bourges you see how the script is checked by its environment. While Bourges is in the middle of the city, Salisbury is surrounded by open grassland. Because of this, Salisbury produces two transepts, while Bourges has no transepts at all. Savageness is thus an organiser of changefulness. It is a biological concept of growth that shows us that things not merely scale up, but are organised by internal increments. The body is made by organs and the body cannot do without organs.

Vitality

The third characteristic of Ruskin's list that I want to discuss is *rigidity*. Ruskin is of course notorious among scholars for his lack of knowledge of structural issues. There exists hardly any notion of three-dimensionality in Ruskin's discussion of the Gothic, which is problematic because the concept of the configurational and how it guides growth is a growth within and of dimensions. He nonetheless uses a very interesting term: 'active rigidity'. Active rigidity is what he calls 'the peculiar energy that gives tension to movement and stiffness to resistance'.[23] Generally, engineers understand a structure as stable by being in rest, which is similar to the aesthetic notion of a form being in balance. What is particularly interesting about Ruskin is that he is not denying the notion of rigidity. He is not saying 'all is movement', the usual comment on the baroque. He is going much further. Ruskin is saying that rigidity is a form of action. Every dancer knows how difficult it is to stand still, and if we would put sensors in every beam and column of a building and translate the stresses and strains into sounds we would hear a deafening squeaking and screaming. *Standing still is work*; Ruskin calls this 'life'. Rigidity, then, should be understood in the framework of configurationalism, as having movement and activity on the level of the figure and togetherness, and rigidity on the higher-scale level of the configuration. Rigidity is not a form of rest. The ribs come together to create a rigid structure, but when the object is rigid, this does not mean that the ribs are no longer active; *the ribs are hard at work*. I think this is essential. We always think activity is followed by stability, but the ribs remain active, even when the structure is finished. Ruskin wilfully conflates becoming and being. The activity that makes a thing into being is continuous with the activity that makes it persist as well as the activity that makes it perish.

Again, let us compare the Gothic to classicism in this respect. In Palladio we see geometry, but to make it alive, in other words to make it possible to have feelings for and empathise with the object, it needs to be decorated with leaves, with garlands and cherubs, in short with various instantiations from living nature. They are positioned onto the structure, often on the joints, while the structure remains for what it is. In classicism, to correct the abstract nature of the structure architects add imitations of life. Just to make this absolutely clear, I have used Worringer's terminology: empathy is literally added onto abstraction. That same Worringer comprehended that the Gothic takes on a very different position with its vitalised geometry. Indeed, it reverses the classical stance. Vitalised geometry means life is already in the geometry. The elements of geometry are not like a gridded order that is then decorated afterwards; they are themselves bundling and interlacing, forming a structure while doing so. *Structure is a product of life*. And structure is not the realm of engineers, of pure elementarism; it is the realm of the configurational, a

realm that produces ornament as well as structure. Life is in the elements themselves and, while they are alive, they produce structure. The webbed vault must be seen as a structure as much as an ornament. You find this in the Gothic at all scale levels. In the Gothic you may find large ornaments and small structures. Fences often look like small structures while vaults look like enormous ornaments.

The idea of a vitalised geometry goes directly against Alberti's notion of how to make structures beautiful. According to Leon Battista Alberti, *pulchritudo* and *ornamentum* come on top of structure.[24] First you have the structure, then comes the process of beautifying it. In the Gothic, beauty is already in the figures, it precedes structure. Life is the urge for composition and the striving for configuration, which is remarkably close to Whitehead's remark that beauty is the teleology of the universe.[25] Therefore in the Gothic we cannot distinguish beauty from utility; beauty is a beauty that works. Things are active, they work, and while they do so they come together and produce structure. This means that structure, the becoming of things, is a result of beauty: things feel for each other and that brings them together.

Ruskin's concept of active rigidity should be compared to with that of Eugène Viollet-le-Duc, who is as strong a proponent of the Gothic as Ruskin, but unlike him is always celebrated as a pioneer of modernism. In the Sympathy-book I compared the south cloisters of Gloucester Cathedral to Viollet-le-Duc's iron-masonry structure that is one of his reworkings of the Gothic. In Gloucester all (non-)elements – ribs – collaborate without losing their indeterminacy. Their figural articulation is more important than their structural role. Strangely enough, the ribs look like they are structural and many engineers have tried to define them as such, but they are essentially indeterminate: you cannot define them through forces of either compression or tension. Looking at Viollet-le-Duc's structure, one can clearly observe what the goal of his design is: a cleansing of the Gothic by making every element determinate, being an element either in tension or in compression. Certainly, this cleansing of the Gothic is a precursor to modernism, because it is characterised by the same determinist transparency based on a *geometry without vitalisation* and consisting of purified abstraction.

The Indeterminacy of Actual Things

In the first chapter of the Sympathy-book, 'The Digital Nature of Gothic', I argue that we may compare Ruskin's notions of figure and configuration to the difference engine of Charles Babbage, a contemporary of Ruskin. Babbage not only built the first computer, he was also a cultural critic who wrote a 300-page critique of the Great Exhibition of 1851, in which he looked at industrial and design objects from his computational viewpoint.[26] The idea of computing, he argues, is to make

complexity a configuration of simple tasks. Each complex collaboration of labour can be divided up into very small, simple tasks, an operation which adheres to the so-called division of labour. While Babbage is correct in the case of computing and in how complexity is generated, for him this means that cultural products need to be pure copies of precision.[27] This is of course a horror to Ruskin. Even if Babbage understood the notion of complexity on the level of labour, he did not understand it as driven by variation. In Ruskin's terms, one could say Babbage understood savageness as purged of changefulness, which again leads to purified abstraction. The collectivity of labour is described as incremental, but the increments are not allowed to vary, and the concept of the sheer copying of each task reveals a misunderstanding of his own notion of computing. In that sense my view of the nature of Gothic as digital combines Ruskin's ideas of labour as a free hand with Babbage's idea of the iteration of simple tasks. The notions of repetition and seriality are crucial to the Gothic – another characteristic that distinguishes it from contemporary digital design – but it should be conceived mainly as a rhythmic repetition that enables variation instead of sameness.

Marvin Minsky, the inventor of artificial intelligence, formulated what was later called the Bird's Nest Problem:

> Nobody ever tried to make a computer that can build a bird's nest, instead they're all out there in factories assembling motors. People say, oh yes, the bird gets straws and it sticks them in the nest and glues them in. But a motor is designed to be put together. The debris lying around on the floor of a forest isn't designed to be made into nests.[28]

Again, this is about drawing. A bird's nest cannot be drawn before it is made, because it is made of parts that are ill defined, but at the same time they exhibit the same linearity as ribs, giving the final nest the quality of a drawing. There is indeterminacy around the parts that allows them to be knitted, interlaced, stacked, depending on their own shape as well as that of their neighbours. Each twig brings in an indeterminacy that is at its largest when lying on the forest floor as waste material, and step by step it sacrifices some of that indeterminacy while it is placed in the nest with other twigs. The definition of the object is produced while the parts are being woven, stacked or interlaced with others. This is pure Gothic ontology. There is indeterminacy, but not in the sense of a generalised groundlessness, rather it is an indeterminacy that is related to actually existing things. These things are enveloped in indeterminacy that enables them to interact with others to configure into larger entities that are more determinate, though never in a purified, cleaned-out state. The fact that the bird puts them together is irrelevant in my mind. It is the intelligence of the twigs

that makes them cohere into a Gothic entity: it is their sacrifice, their generosity that makes it work. In Gothic ontology all things are linear, or as Denis Diderot would say, made of fibres and strings,[29] and all fibres are vehicles of what in Diderot's time was called 'sensibility and irritability'.[30] The Gothic universe is a nervous world, made of sinews and tendons, not of hard skeletons or soft flesh, i.e. not of Greek skeletons or baroque flesh. The smallest dimension of things is linearity, not the point-monads of Gottfried Leibniz or the black boxes of Bruno Latour. We are now slowly moving towards my anti-baroque, anti-fold argument. I think the notion of the fold did enormous damage to the argument for digital design, especially when taking on the form of parametricism. The inherent a-materiality of it, the structuring afterwards, the lack of form, the lack of internal thresholds, the lack of repetitive patterns, the lack of colour, the universalism thriving on globalism and, worse, the lack of pattern and ornament – I can go on and on and on.

When I started writing the Sympathy-book, I was still happily reading Deleuze, but the more I proceeded the more I moved away from him. The main reason for this is that in the baroque the notion of movement, that of the fold or singularity, comes after structure. When we look at a typical baroque interior we see in fact nothing but a distorted classicism, which shows us the weaknesses of monism. Everything is already there, and the movement that creates the folds is added later. The folds occur afterwards, in a universe that is already structured. According to Deleuze in *The Fold: Leibniz and the Baroque* (1988), a fold is a singularity on the plane of immanence. When we use a piece of paper to enact the plane of immanence and we fold it, which necessarily takes on the form of a line, be it a sharp crease or a rounded pleat, that line is dependent on the two-dimensionality of the paper surface. The plane of immanence thus precedes the foldings, that is the structure precedes the movement. Gothic ribs are the reverse, they are liberated folds in a sense, line-arities as singular objects that are allowed to collaborate to create larger dimensional entities, but also to disengage from larger entities. In the Deleuzian world of the fold, continuity always precedes singularity, while in the Gothic rib world, entities precede continuity. In the Gothic the movement of the ribs in fact creates structures. Generally, in philosophy we acknowledge two types of worlds, one of pluralism where entities (atoms) are allowed to move, but while they move they cannot change – what we often denote with the 'billiard ball universe'. The other world of monism allows things to change but they cannot move, because they are necessarily aught in the larger structure of the plane of immanence. In a monist world things cannot disengage, which means there is change but no real movement. In atomism there is of course movement, but there cannot be real change since things are controlled by essences and substance. Gothic ontology can cope with both movement and change: there is internal change and external movement. Gothic ontology combines the internalism

of the fold with the externalism of atoms. The rib can flex and twist while at the same time move and connect.

We should now start to look a bit more precisely at what such internalism actually entails. What is it exactly that makes things change or take on form, which is nothing but another way of saying that things act. In contemporary theories of agency such as actor-network theory the concept of action is given, plus the fact that such actions build networks, which overlaps considerably with configurationalism – however, such theories do not explain how things act, or why they feel the need to collaborate.

Sympathy

In order to answer that question we should take a look at a typical Gothic object. In *The Sympathy of Things* I use an example from Ernst Gombrich's book *The Sense of Order*.[31] We are looking at a typical iron hinge, with all the Gothic complexity of Y-figures and J-figures, that is, in classic terms, bifurcations and scrolls. How should we understand this object? Not very differently from how Gothic vaults, columns or rose windows are made by ribs: from figures interacting into configurations, that is

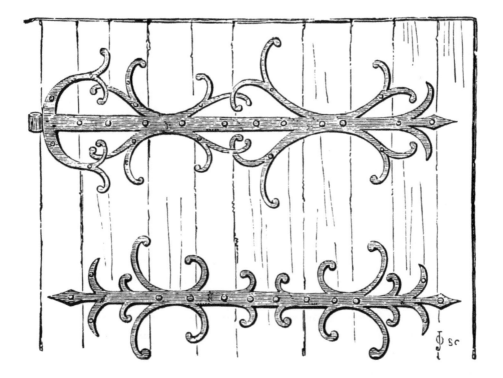

John Starkie Gardner, Hingework at Montréal, Yonne Valley. (Fig. 26 from *Ironwork*, 1893)

a sequential step-by-step procedure of transformations – another argument to denote the nature of the Gothic as digital. Again, this involves a kind of twelfth-century computing. We have the surface of the door, which is two-dimensional, and we have a one-dimensional, linear hinge that needs to distribute itself over that two-dimensional plane. The generation of the hinge configuration starts as a simple line but to become a surface, to imitate a surface, it needs to bifurcate, split and curl over the surface, all the while retaining continuity as a line. Why is that? Firstly, because the hinge is too weak to carry the door and needs to spread itself over the surface to mitigate tension. Secondly, because the hinge needs to occupy the surface area *as a line*, therefore, it can only do so by applying the strategy of forking paths. The hinge uses Y-figures, C-figures, J-figures; as is typical of the Gothic we see sets of figures that configure to make this object. The object is under way or, as Bergson would say, 'in the making' – it is under construction towards two-dimensionality. It is not a pure surface, but it is not a pure line either. Looking at this object with the help of fractal geometry you realise that it is literally between dimensions. If you would try to mathematically define the dimensionality of this hinge, you would find it is something like 1.26, a number in between one and two. The hinge stretches over two-dimensionality but it never becomes fully two-dimensional.

How do we perceive this kind of transitory object? Simply saying we 'see' such an object will not suffice because it is in transit from one dimension to another and our understanding of perception needs to include such a transition. The classic definition of seeing, namely (re)cognising it by cutting the object from its background and tracing its contour, does not apply in this case. The Gothic hinge can be compared to, say, a tree or a set of trails: created over time the object in its present condition still shows those paths from the past that created it. Even though the objects might have stopped developing or growing they exist in time as much as in space. Therefore, perception as mere seeing cannot be enough, because the thing is as much a path in time as an object in space. Seeing needs to be extended by feeling to complete the experience, where the seeing part covers the spatial condition and feeling the temporal one. Though not just feeling, but rather what Whitehead calls 'the feeling of feeling', namely *sympathy*.[32] But first, what is feeling?

In short, I would say feeling is what allows things to switch from the continuity of time to the discreteness of space. Feeling orients things, be it through form, through transformation or through action, since action is nothing but the changing of form. Stretch out your hand and you will notice that you change form. Now, we cannot stretch out our hands without feeling; the body as a whole needs to jump from the continuity of the experience of the self to the actuality of acting in space. Such stretching out of the hand could be the greeting of another person, the picking up of a cup from the shelf or the pointing at a painting on the wall. The same 'form of

transformation' goes for static objects such as a tree or a Gothic hinge or a Gothic vault, for that matter. Things act, and that means all forms are transformations and all transformations are felt. The form is not an expression of that feeling – again, I am not arguing for language or semiotics – feeling and form coexist by a jerking and jolting of movement and stoppage, which is as good a description of Gothic ontology as I can give. Then again, what happens when we look at such an object? Why is it sympathy, and what exactly does the 'sym' denote? It is more than mere correspondence, even more than adaptation: it is a form of mimesis. The feeling of feeling inheres that feeling imitates; there occurs *an internal mimesis* by our feelings of the feelings of objects. How things orient in space is aligned with (or attuned to) how we orient in space; it is really an effect of harmonising and deeply rooted in the notion of beauty. The feeling of feeling allows us to be as different as possible from others and still aesthetically (etymologically rooted in the term 'feeling') resonate with them. It is not mere naturalism, i.e. external mimesis: the hinge does not 'look like' the door, and we do not look like the hinge when we look at it. But, the hinge 'likes' the door and we like what we see. The hinge mimics the flatness of the door in an iron-like fashion, while we mimic the hinge in the us-like fashion.

This concept of *dissimilar mimesis* lies at the conceptual core of sympathy. Therefore to discredit sympathy as a form of sentiment or identification is a complete misunderstanding of what occurs during the act of sympathy. In *Creative Evolution* Bergson gives a poignant example of such an asymmetry of form and sentiment.[33] He takes the example from the eminent entomologist, Jean-Henri Fabre, who described how the Ammophila wasp stings a caterpillar with nine specific stings. The wasp does this to paralyse the caterpillar, drag it to his nest and feed its offspring with the living pray. How does the wasp know where to sting the caterpillar? Does the wasp make use of knowledge or instinct? The first would be highly problematic, since knowledge invokes a form of symbolic mapping mobilised by cognition. If it cannot be knowledge or intelligence then it must be instinct, which would be the standard answer of evolutionary biologists such as Richard Dawkins. According to such thinking, when we cannot explain an animal's behaviour on a conceptual level, then evolution must have hardwired the creature to solve its problems. But, according to Bergson, the wasp's actions cannot be based on instinct either, because the characteristics (size, motion) of the caterpillar are always different, as well as the circumstances under which it is caught. There is so much variation that you cannot automate it, at least not by determinist hardwiring. Bergson argues that there must be something in between these two positions, between knowledge, which allows you to vary on symbols, and instinct, which says the behaviour of the wasp is hardwired. This in-between is what Bergson calls 'intuition'. And, when Bergson explains intuition he often refers to the notion of sympathy.

Let me clarify one thing before I proceed. When writing a book on sympathy I could have approached the topic from a completely different angle. I could have started with primitive magic, what James Frazer called 'sympathetic magic', proceed with the ancient Greeks and their concept of the universe as an animal's body, relating all things through *sympatheia*, making it an argument for organicism. We would then encounter the concept with the Stoics, such as Chrysippus and Posidonius, then move forwards to Hume and Smith who would speak of fellow-feeling, maybe discuss Kepler's 'sympathy of things' and Huygens's 'sympathy of clocks' (very close to resonance), neatly distinguishing one from the other. We would end with Whitehead's and Hartshorne's concepts of sympathy, slowly trying to disentangle it from organicism and giving it an exclusive status while preventing it from becoming psychologised as in Scheler and Stein. This, I think, would have been a mistake. I would have encountered enormous difficulties in establishing the aesthetic basis of the concept and would hardly have been able to make the argument for 'aesthetics as first philosophy'.[34] It is no accident that philosophers, when discussing sympathy in a conceptual manner, often do so by quickly shifting to aesthetic examples. Hume speaks of the audience in a theatre vibrating like strings[35] with the emotions of the actors. Bergson speaks of the painter doing a portrait and only being capable of painting it 'by a kind of sympathy, by breaking down [. . .] the barrier that space puts up between him and his model'.[36] In a similar vein, there must be some kind of mapping of the movements of the caterpillar onto the body of the wasp, even if the latter is a completely different body. The wasp does not 'look like' the caterpillar, but he nonetheless imitates it, and this imitation is an internal imitation that proceeds by way of sympathy, not unlike the procedure of an actor at work.

We should realise that when Bergson speaks of the Ammophila wasp (or the painter) 'being transported into the interior of an object',[37] this is quite literally quoted from German aesthetic theory, where it was termed as *Einfühlung*. This term, which means 'feeling-into' and is directly related to the 'feeling-with' of sympathy, was used very early in an aesthetic context by Johann Gottfried Herder in the late 1770s when discussing the relationship of an onlooker to a sculpture.[38] Later during the nineteenth century it was developed by Theodor Vischer and more precisely defined in the 1870s by his son Robert Vischer who wrote his thesis on the subject.[39] However, Bergson seems more influenced by the psychologist Theodor Lipps, who in fact speaks of *innere Nachahmung*, the term which is truly central to our discussion.[40] Lipps deserves serious rereading. His argumentation is without exception of an aesthetic nature: all our perceptions are driven by internal imitation. What makes Lipps even more important to our discussion is that he uses the term 'sympathy' as a synonym for *Einfühlung*, while later the Americans and English agreed on the term 'empathy' as a translation.[41] It becomes clear from reading Lipps that 'empathy' leads to a flawed notion of *Einfühlung*. Why is that important? When

we use Worringer's understanding of the term we see that for the latter *Einfühlung* is opposed to abstraction, as we find it in his famous thesis *Abstraktion und Einfühlung*. That, however, is a misunderstanding by Worringer of Lipps's work. Worringer was as much influenced by Aloïs Riegl as he was by Lipps, and he re-categorised *Einfühlung* as naturalism, that is as *external mimesis*, and external mimesis fits with the English notion of empathy but not with sympathy. Lipps's examples of *Einfühlung*, what he often calls *Sympathie* in German, are without exception mixtures of abstraction and naturalism. And they must be, because they concern disparate bodies synchronising through feeling.

Lipps always gives many examples in his texts, but we can easily distinguish them in different categories. First there are the examples of similar bodies sympathising, one moving and the other being still. Second, we find examples of dissimilar bodies sympathising, again one moving and the other still. Then, thirdly, we find examples of dissimilar bodies sympathising, while both being still. All of these examples concern sympathising through internal mimesis, and all of them concern the calibration of a body's existence in time with its presence in space. Therefore the notion of sympathy equates time-events with space-objects as much as it does movement and stoppage. As an example of the first category his tightrope walker is the most famous.[42] When I observe a circus performer on a high wire I feel like I am inside his or her body. I am not looking at the performer but I am actually with him or her. There is a collapse of space. I look at the performer but seeing in itself does not explain what actually happens. There is something more going on than just seeing and this something more is an immediate feeling that prepares your body, charging your muscles for action. Sympathy, in other words, is a postural and proprioceptive notion. When I look at the performer on the high wire, there is a closeness between my body and his or her body, just as there is between the body of the wasp and the body of the caterpillar, but those bodies are still disparate and different.

For the second category Lipps offers the example of feelings of rage provoked by looking at a willow tree in the storm.[43] Clearly you do not feel rage because the willow is angry, but because there is a transposition of movement from one body to another. My body imitates the movement of the willow, which is felt by my body as rage. There is a resonance between my body and the body of the willow. What the willow feels, I do not know, but it does feel something because it moves in the wind and I resonate with it, even if I am only resonated by the feeling of rage. This is what Lipps calls *Einfühlung*, but it clearly goes further than a feeling-into, it is a feeling-with, which he acknowledges by using the synonym of sympathy, but it has been the source of the later misapprehensions. I think Worringer's concept of the Gothic as a mixture of abstraction (geometry) and naturalism (vitality) would have been fully confirmed by Lipps, but I also think that Lipps would have told Worringer that all our perceptions are of such

nature. In that sense, Lipps was closer to the notion of a Gothic ontology because for him it was not a choice, but the fundamental way things relate to one another.

This brings us to the third category, the sympathising between forms, without actual motion playing a role. For instance, what happens when we look at a column[44] or the spiral of a shell[45] or the horn of an antelope? The *actual path* of movement – the high wire, the movement of the willow – now becomes the *memorised trace* of a movement – the column rising up, the horn twisting. Reading Lipps, it becomes immediately clear we should not make a qualitative distinction between actual and memorised movement, that is in our Gothic ontology, between movement and structure. In short, Lipps unwittingly uses Ruskin's concept of active rigidity. Concrete bodies that encounter one another can only do so via a sheet of abstraction. The wasp only finds nine points on the body of the caterpillar. The hinge finds only so many points on the flat plane of the door so as to bifurcate and spread out. When I sit on a rock because I am tired I use only a few points on the shape of the rock to adapt my body to the shape of sitting. It is always the same: concrete bodies, disparate and dissimilar bodies, adapt by feeling, by restructuring their bodies and their postures so they fit with one another, but only at a few points. Not to look like each other, but to feel like each other. Therefore, using Worringer's terms, we should state that *sympathy is empathy merged with abstraction*, a formula we can find in various forms in Lipps, Whitehead, Bergson and Ruskin. Empathy leads us into bodies, and when we are in that body we can abstractly adapt and take on form. Empathy is the first stage of sympathy, and abstraction the final stage: the actual act of mimesis.

Gothic ontology teaches us that the real extends itself by mirroring: things reflect one another, and reflect one another internally, that is sympathetically, through the 'imitation of the affects'.[46] Mimesis (representation), copying (reproduction), mimicry (play), reflection (consciousness), mirroring (pattern), symmetry (form) – all machinations of the real. The mimetic act of one body internalising another body is nothing but one body extending itself: *mimesis equals prosthesis*, and vice versa. The reason why I prefer the term 'feeling' over 'affect' is precisely because of the prosthetic connotations of the former. Not only as receptive and absorptive as affect, feeling also moves outwards and touches, points, caresses, strikes and grabs. 'I feel' means as much that stuff enters your body through mimesis as it means that you are extended and prosthetically stretched out over other things in order to encapsulate them. Pet your dog and warm yourself to its coat; prick your fork into a steak and swallow it. What is not pleasure and what is not extension? When children play in playgrounds, when actors play in theatres, when architects make models in studios, they are not contractively absorbing the real on the stage of illusion, no, they are working at the factories of the real, expansively spilling and multiplying it by reproduction. There are no illusions, just likings and likenesses.

Notes

1. The following essay is derived from a keynote lecture delivered at the *Speculative Art Histories* symposium held at Witte de With Center for Contemporary Art in Rotterdam from 2–4 May 2013. The lecture was a reflection on the writing of *The Sympathy of Things* during the years 2009–11.

2. See also *Anymore*, ed. Cynthia Davidson (Cambridge, MA: MIT Press, 2000), pp. 145–89.

3. Paul Frankl, *The Gothic: Literary Sources and Interpretation through Eight Centuries* (Princeton: Princeton University Press, 1960), pp. 557–62.

4. Robert Willis, *Remarks on the Architecture of the Middle Ages: Especially of Italy* (1835). Later redefined by Paul Frankl in *Zu Fragen des Stils* (Weinheim: VCH, Acta Humaniora, 1988), p. 17.

5. John Ruskin, *The Works of John Ruskin*, Library Edition, ed. Edward Tyas Cook and Alexander Wedderburn, 39 vols (London: George Allen, 1903–12), XIX, p. xlvii.

6. Augustus Welby Northmore Pugin, *Contrasts or a parallel between the noble edifices of the fourteenth and fifteenth centuries, and similar buildings of the present day; shewing the present decay of taste; Accompanied by appropriate Text* (Salisbury, 1836).

7. Ruskin, *The Works*, XI, p. 227.

8. Sir Uvedale Price, *On the Picturesque* (Edinburgh: Caldwell, Lloyd & Co. [1796], 1842).

9. William Hogarth, *The Analysis of Beauty*, introduced by Ronald Paulson (New Haven: Yale University Press, 1997), ch. X; Edmund Burke, *A Philosophical Enquiry into the Origin of our Ideas of the Sublime and the Beautiful* (Oxford: Oxford University Press [1757], 1998), sections XIV and XV.

10. Ruskin, *The Works*, X, p. 203.

11. Ibid.

12. Ruskin, *The Works*, IV, pp. 148–207. See also *Vital Beauty: Reclaiming Aesthetics in the Tangle of Technology and Nature*, ed. Joke Brouwer, Arjen Mulder and Lars Spuybroek (Rotterdam: V2_Publishing, 2012), pp. 156–69.

13. Ruskin, *The Works*, XIII, pp. 236–7.

14. Robin Evans, *The Projective Cast* (Cambridge, MA: MIT Press, 1995), pp. 185–6 and 224–35.

15. Ruskin, *The Works*, X, p. 214.

16. Ibid. p. 208.

17. Ibid.

18. A reference to Schelling's concept of *Ungrund* and Deleuze's concept of the *sans-fond* as discussed in Gilles Deleuze, *Difference and Repetition*, trans. Paul Patton (London and New York: Continuum, 2001), p. 221.

19. Ruskin, *The Works*, XVII, pp. 25–42.

20. Alfred North Whitehead, *Science and the Modern World* (New York: Pelican Mentor Books, 1948), p. 81.

21. Patrik Schumacher, *The Autopoiesis of Architecture: A New Framework for Architecture* (London: Wiley, 2010).

22. Wilhelm Worringer, *Form in Gothic* (New York: Schocken, 1964), p. 41.

23. Ruskin, *The Works*, X, p. 239.

24. Leon Battista Alberti, *On the Art of Building in Ten Books* (Cambridge, MA: MIT Press, 1988), p. 154.

25. Alfred North Whitehead, *Adventure of Ideas* (New York: Free Press, 1967), p. 265: 'The teleology of the universe is directed to the production of beauty'.

26. Charles Babbage, *The Exposition of 1851* (London: John Murray, 1851), p. 49.

27. Ibid.

28. Marvin Minsky, quoted by James Gleick in 'Exploring the Labyrinths of the Mind', *New York Times Magazine*, 21 August 1983.

29. Denis Diderot, *Rameau's Nephew and D'Alembert's Dream* (London: Penguin Classics, 1976), pp. 156 and 170: '[I]t has led me sometimes to compare our organic fibres with sensitive vibrating strings. A sensitive vibrating string oscillates and resonates a long time after one has plucked it. It's this oscillation, this sort of inevitable resonance, which holds the present object, while our understanding is busy with the quality which is appropriate to it. But vibrating strings have yet another property – it's one that makes other strings quiver [. . .] All our organs [. . .] are only distinct animals kept by the law of continuity in a state of general sympathy, unity, identity'.

30. Albrecht von Haller, 'A Dissertation of the Sensible and Irritable Parts of Animals' [1752], *Bulletin of the History of Medicine*, 4 (1936): 651–99.

31. Ernst Gombrich, *The Sense of Order* (London: Phaidon, 2006), p. 165. The original is from John Starkie Gardner, *Ironwork, Part I* (London: Chapman & Hall, 1893), p. 63.

32. Alfred North Whitehead, *Process and Reality* (New York: Free Press, 1978), p. 162. And Charles Hartshorne, 'Mind and Body: Organic Sympathy', in *Beyond Humanism: Essays in the New Philosophy of Nature* (Chicago: Willet, Clark & Co., 1937).

33. Henri Bergson, *Creative Evolution* (Mineola, NY: Dover, 1998), p. 173.

34. Graham Harman, 'Aesthetics as First Philosophy: Levinas and the Non-Human', *Naked Punch*, 9 (2007): 21–30. The formula had been used before 2007 by others, and also in the context of Levinas, such as by Kevin J. Vanhoozer in *First Theology* (Downers Grove, IL: IVP Academic, 2002), p. 21.

35. David Hume, *Treatise on Human Nature* (London: J. M. Dent & Sons [1739], 1911), III: p. 299.

36. Henri Bergson, *Creative Evolution* (New York: Dove [orig. English translation 1911], 1998), p. 177.

37. Henri Bergson, *Creative Mind: An Introduction to Metaphysics* (New York: Citadel Press [1903], 1946), p. 161.

38. Johann Gottfried Herder, *Sculpture: Some Observations on Shape and Form from Pygmalion's Creative Dream* (Chicago and London: Chicago University Press [1778], 2002), p. 78: 'The more a part of the body signifies what it should signify, the more beautiful it is; inner sympathy alone, feeling and the transposition of our entire human self into the figure we touch, is the true teacher and instrument of beauty'.

39. Robert Vischer, 'On the Optical Sense of Form: A Contribution to Aesthetics', in *Empathy, Form, and Space: Problems in German Aesthetics, 1873–1893*, ed. Harry Francis Mallgrave and Eleftherios Ikonomou (Santa Monica: Getty Center Publications, 1994), pp. 89–123.

40. Theodor Lipps, 'Empathy, Inner Imitation, and Sense-Feelings', in *A Modern Book of Esthetics: An Anthology*, ed. Melvin Rader (New York: Holt, Rhinehart & Winston, 1979), pp. 371–7.

41. Edward B. Titchener, *Lectures on the Experimental Psychology of the Thought-Processes* (New York: Macmillan, 1909).

42. Lipps, 'Empathy'.

43. Theodor Lipps, 'Die aesthetische Betrachtung und die bildende Kunst', *Ästhetik: Psychologie des Schönen und der Kunst*, vol. 2 (Hamburg and Leipzig: Leopold Voss, 1906), p. 1.

44. Theodor Lipps, *Raumaesthetik* (Amsterdam: E. J. Bonset, [1897] 1966), as translated by Gustav Jahoda in 'Theodor Lipps and the Shift from "Sympathy" to "Empathy"', *Journal of the History of the Behavioral Sciences*, 41, 2 (Spring 2005): 151–63 (p. 157).

45. Theodor Lipps, *Raumaesthetik*, as translated by Vernon Lee in *Beauty and Ugliness* (London: John Lane, 1912), p. 35.

46. Baruch Spinoza, *Ethics*, III, p. 27, III, p. 49 and III, p. 33, in *Complete Works*, ed. Michael L. Morgan, trans. Samuel Shirley (Indianapolis: Hackett, 2002), pp. 213–382 (resp. pp. 292–3, 303, 295). We should add an extra comment on Deleuze's notion of affect. Obviously, when imagining being French, we can see how useless the word 'sentiment' appears as technical terminology, stressing the role of the senses over the body as a whole, and Deleuze soon decided in favour of Spinoza's use of the word 'affect' (*Ethics*, Part III). However, in English, Dutch and German, the related words for feeling are of great use, and it is truly a pity the Anglophone world so rashly adopted Deleuzian affect. Feeling and *Gefühl* have a much broader history and a more complicated etymology that far exceeds that of the Latinate affect. On top of that, we should keep in mind that the body's capacity 'to affect and to be affected' was specifically meant by Spinoza as an '*imitation* of the affects', a meaning completely lost in Deleuze and DeLanda, who always consider feelings reciprocal at best.

9 Serpentine Life: The Nature of Movement
 in Gothic, Mannerism and Baroque

Sjoerd van Tuinen

IN MANY WAYS, movement is a test case for visual art as much as for philosophy: for both, we have to answer the question of whether they create real movement or merely a representation of it. Does the event really take place or is it only an illusion? This is a problem that pertains especially to Mannerism and the baroque, which rely heavily on the vocabulary of force and movement that has invested the field of art since the Renaissance. Although these styles are still dominated by classical figuration, they also introduce all sorts of distortions, deformations and exaggerations in it. Mannerism and the baroque are attempts, within representation, to present the unrepresentable and to render visible the invisible. As a consequence, stable form is no longer the foundation of the image but rather the limit of visual evidence. Inseparable from its relation to the formless, extension itself becomes a delimitation of intensity, a participation in the infinite. Yet the question remains: have these attempts merely produced sensational and metaphorical works of art that are meant to move *us* by generating an illusion of movement in what is undeniably a stable structure or a framed picture, or are they somehow literally moving in themselves?

The second position is held by Gilles Deleuze. In *Francis Bacon: The Logic of Sensation*, he develops a deep connection between Bacon and Michelangelo, since Mannerist painting discovered the 'figural': the point at which abstract movements or forces are rendered visible within classical figuration such that the organic figurability of sensation is enriched with an inhuman becoming.[1] In his *The Fold: Leibniz and the Baroque*, Deleuze then goes on to show how the baroque introduces movement in classical art by means of infinite folding, such that forms would emerge from and dissolve into folds: '[t]he object is maneristic, not essentializing: it becomes an event.'[2] The first position, by contrast, is taken up by Lars Spuybroek in *The Sympathy*

of Things: Ruskin and the Ecology of Design (2011), who contrasts Mannerism and the baroque with the Gothic, arguing that while the former work away from static form to deformation, only the latter directly imitates the vicissitude and variety of living nature and produces movement in its continuous working towards form. For no matter how much we deform the painted figure and render it dynamic, it remains imprisoned within a frame hanging motionless on a wall. And no matter how much we cover a classical structure with lifelike ornament, it remains a lifeless construction. Worse still, each time we produce an image or effect of movement in this way, our experience actually becomes more detached from the real movement that produces an object at rest rather than attached to it.[3] 'The Baroque', Spuybroek therefore concludes, 'is merely distorted classicism.'[4]

The proposition I would like to put to the test is that, to a certain to be determined extent, we should differentiate between Mannerism and the baroque in a way analogous to Spuybroek's distinction between the Gothic and the baroque. For while the Mannerist fine arts certainly do not arrive at the free aggregation of lines of Gothic ornament, as their forms are based on the (dis)proportional variation of the single human body rather than on configural variation,[5] they also lack, or do not yet succumb to, the continuity and smoothness of the baroque. Whereas the baroque brings all movement back to a spectacular sensuality and physicality, we still find a much more abstract, or inorganic, experience in Mannerism. It is that of the life of the serpentine line, or what William Hogarth would later call the 'line of grace'.

Mannerism and Metamorphosis

Unlike the Gothic, Mannerism marks a crisis of classicism. But a crisis is not just an end point; it is also the restoration of conditions and the precariousness of a new beginning. The literature of the sixteenth century, inspired by the grotesques and monstrosities of Ovid's *Metamorphoses*, reveals a deep fascination with the idea of the inchoate and the unfinished, which allow us to pass from one form to the next within an enduring material. Michel Jeanneret has shown how there existed a veritable 'Protean cult'. Art is not a world apart, but a part of the world swept up in 'universal sway'.[6] Following Guillaume du Bartas, Pierre de Ronsard sought to replace the architectural model with the garden model based on variation and participation in movement. As he puts it in a meditation on universal flux: 'Matter endures, form is lost.'[7] Likewise, Bernard Palissy's *Recette Véritable* (1563) is not only a project for an ideal garden, but also a chemistry manual and a transformist natural philosophy. And long before Leibniz, Giordano Bruno had already argued that matter is animated by the permanent desire to realise in all possible configurations or 'worlds' the latent powers of multiplication and transformation that reside

within it. In each case, we are dealing with a syncretic vitalism. Matter does not endure as formless mass waiting for a form to stabilise it. Instead, it must be conceived through a reversal of Aristotelianism, that is as mother and matrix of form, as the general purport of a seed bed, an embryo, or an egg: 'Instead of form actualizing the potential of the formless, the formless contributes to the fulfillment of form!'[8] Of course, saying that all is movement is not the same as actually producing a real movement. Literature and philosophy on creation and cosmology, biology and geology do not suffice to constitute a real rupture with hylomorphism on the level of design or the fine arts. On the contrary, they entail the risk of what Spuybroek calls the 'Kantian trap': the moment when discussing the work of art becomes as important as the work itself. Is this not the risk of Mannerism, which made art and design, precisely by inventing their concepts for the first time, rely on theory like never before? Worse still, once a cognitive or linguistic moment of critical judgement is substituted for aesthetic experience, it may even happen that experience itself is going to be considered a language which can be analysed, commented on and deconstructed. Art then becomes a boring game of complexity and contradiction between empty signifiers: 'Every fading architectural movement is one of language: whether from the 2nd century, the 16th century or the 20th, everything ends in rhetorical mannerism. It always ends in language.'[9]

Still it remains crucial to distinguish between Mannerism as an experience in itself and the way it is usually represented by history. Even if the Mannerists experienced a need for theory, it does not follow that their aesthetics can be reduced to prefabricated concepts alone.[10] If a materialist art history looks for aesthetic experience outside the realm of semiotics, then nothing prevents us from writing a materialist history of Mannerism as well. One way of doing this is by exploring the extent to which the Mannerist break with classical hylomorphism is capable of turning form into the outline of real force. This is, after all, what Deleuze's concept of the figural, adopted from Jean-François Lyotard, enables us to do.

Form in Mannerism is no prerequisite for real movement from one form to the other, as in classicism, but neither is it an inauthentic and paralysed structure of being that must be overcome to gain access to a vital becoming beyond forms. Both understandings of form are still classical insofar as they rely on an opposition between being and appearance. Rather, the iconoclastic revelation of Mannerism is precisely that every form, no matter how classical, is also a form of intensity, such that formal necessity is never more than relative to sensory becoming. As Henri Bergson, from whom Spuybroek too borrows his notion of sympathy of things in the making, writes, 'the very permanence of [. . .] form is only the outline of a movement.'[11] Mannerism is thus neither catamorphic nor formalist in the sense of being limited to forms of representation. This would come down to a misunderstanding of the figural as a way

of escaping from figuration that is different from informal art no less than from formal abstraction.[12] As the figure finds itself in an intimate embrace with an imperceptible outside, it rather establishes a constant communication between form and force, realising a degree of abstraction in the concrete by stretching and twisting natural forms and making figuration escape from itself. The contour 'line is figural', Lyotard writes, 'when, by her or his artifice, the painter or drawer places it in a configuration in which its value cannot yield to an activity of recognition.'[13] Whereas the sensual realm of the figural is always the radical other of language and even of lived experience, a *lapsus* or slippage, the figure is the way in which painting gives it a form.[14] As Deleuze writes, the figural is 'the sensible form related to a sensation', in other words to a movement.[15] Its contorted, spasmodic episodes render visible the perpetually open, systolic-diastolic exchange in sensation between the plane of forces and the figure.[16] Not breaking with classical representation, the figure is thus the elastic expression of the invisible.

Whereas classicism in-forms matter with a transcending form, Mannerism proceeds by the modification and modulation of forces. Even if it cannot be separated from classical hylomorphism, the crux of the figural is that form is modal, not essential. In fact, there are as many modes as there are forces, with each form being its own mode of relating to other forces. This implies, firstly, that form is immanent and variable; secondly, that it is not opposed to matter; and, thirdly, that it is intensively mobile. In the last version of El Greco's *The Expulsion of the Moneylenders from the Temple* (1600), for example, Sergei Eisenstein recognises a 'figure with calf muscles so exuberantly presented that they seem to be slipping off the figure like pantaloons'.[17] Similarly, Deleuze describes 'the counter-fold of the calf and knee, the knee as an inversion of the calf' in *The Baptism of Christ* (1608–14) as conferring 'on the leg an infinite undulation, while the seam of the cloud in the middle transforms it into a double fan'.[18] For both, the contour line moves independently from the figure it delimits in extension, expressing a rhythmic intensity or force that is irreducible to it. As a form of expression rather than a form of content, the line is a 'variable and continuous mold',[19] a line of infinite modulation, at same time that the figure becomes a 'zone of objective indiscernibility or indeterminability'[20] in which stable content gives way to variation. And just as El Greco produced a becoming-calf, the lines in Rosso Fiorentino's *Deposition* (1521) constitute a becoming-insect and in Wtewael's *Deluge* (1590–92) a becoming-plant. In each case, the freed traits of expression confirm Bruno, who saw 'in the faces of many in the human species expressions, voices, gestures, affects, and inclinations, some equine, others asinine, acquiline, and bovine' as they all exude 'a vital principle which, by virtue of the proximate past or proximate future mutations of bodies, they have been or are about to be pigs, horses, asses, eagles, or whatever else they indicate'.[21]

Manner or style, once emancipated from its subordination to content, is precisely this vital principle. To replace manner for essence is to affirm that things exist elastically, as part of a stretch of gradations (more or less human and bovine), rather than substantially (human or ox). Metamorphosis is not a transformation but rather a deformation; not a movement from one form to another, but a movement on the spot, immanent to form itself. It is as if space and time become intrusive, collapsing the traditional distinction between simultaneity and succession, synchrony and diachrony. Whence the importance of rhythm as the abstract ground of all sensation. As Deleuze writes, manner is a virtual or 'excessive presence, the identity of an already-there and an always-delayed'[22] beyond all actual figuration. The great achievement of Mannerist deformation is that it renders time itself visible in figurative painting: not just the empirical time that flows and can be narrated as such, but a virtual time that is always out of step, splitting into so many coexisting becomings in an open 'Whole which is [itself] constantly becoming'.[23] In the distorted ornamental pose of Parmigianino's *Madonna dal Collo Lungo* (1534–40), there is no empirical logic of structure or weight, but an excited linear rhythm whose intensive energy releases itself in vague directions rather than in any decisive gesture or accent. As if in contradiction with the painter's superb draughtsmanship, the levels of foreground and background are utterly ambiguous and the detached figures completely out of scale. At the same time, it is precisely the supple, decorative drawing that makes everything communicate on a sinuous or serpentine line.[24] Because of this tension between content and expression, the figure is capable of a disjunctive inclusion of various potentially incompossible states and events. In breaking up the continuum of successive perceptions and replacing it with the transspatial yet non-sensical simultaneity of different sensuous forms and layers of movement in an abstract, almost cubist fashion, the *figura serpentinata* gathers and fixes a heterogeneous multiplicity of becomings in a transversal coherence. For what appears to be clearly separated in space, 'reciprocally interpenetrates', as Bergson writes, in time. Rather than merely an abstract representation of movement in general, the serpentine line is a temporary abstraction that makes its own becoming immediately felt. It constitutes what Spuybroek calls a 'figure of movement':[25] not an evocation of movement in human perception that remains unmoved by it, but a visible expression of a virtual and intuitive becoming.

Typical of Mannerism, the serpentine figure renders visible the 'fact' of its own affective happening by crystallising the different relations of time and space of which it is made in a single image or 'visual stringing'.[26] For Deleuze, Michelangelo was the first to reveal the figure purely as a modal fact or event. It is said that Michelangelo intended to write a work 'On all the manners of human movement', as a reproof to Dürer, who considered only the measure of bodies, and their variety, with the result

that his figures looked 'as stiff as posts', as Condivi put it.[27] Michelangelo had no time for the simplicity of form as the fifteenth century understood it but sought a form of expression in which movement renders being and becoming, or the essential and the accidental, entirely indiscernible:

> In the history of art, it was perhaps Michelangelo who made us grasp the existence of such a fact most forcefully. What we call 'fact' is first of all the fact that several forms may actually be included in one and the same Figure, indissolubly, caught up in a kind of serpentine, like so many necessary accidents continually mounting on top of one another.[28]

Gothic versus Baroque

Before we see if this vitalist or expressionist interpretation of the serpentine figure can withstand Spuybroek's challenge that a strategy of deformation does not produce a real movement but precisely leads away from it, it is important to distinguish Mannerism from the baroque. As we have seen, Deleuze understands the baroque world as a world of infinite movement from which art extracts and composes its forms by means of its defining 'operative trait': folding onto infinity. Just as Mannerism renders visible the relation of force and form, such that form and being-formed coincide in the figure as an actual trace of virtual movement, the essence of baroque art would be the folding of forces and thus the generation of forms in movement instead of forms representing movement: 'Matter that reveals its texture becomes raw material, just as form that reveals its folds becomes force. In the baroque the coupling of material-force is what replaces matter and form.'[29] It is only in the baroque that the fold exceeds the replication of the contours of a finite body and becomes itself constitutive of form instead of being a mere attribute of something that is folded. By rendering dynamic the relation between ornament and structure, the fold is the manner of expression that conditions the baroque work of art. In this way it combines maximum continuity with maximum discontinuity. It subsumes the work under an infinite sequence of other manners of folding, each of which is virtually caught up in an ever wider, abstract movement.

> We have remarked that the Baroque often confines painting to retables, but it does so because the painting exceeds its frame and is realized in polychrome marble sculpture; and sculpture goes beyond itself by being achieved in architecture; and in turn, architecture discovers a frame in the façade, but the frame itself becomes detached from the inside and established relations with the surroundings, so as to realize architecture in city planning. [...] We witness the prodigious development

of a continuity in the arts, in breadth or in extension: an interlocking of frames of which each is exceeded by a matter that moves through it.[30]

Spuybroek, by contrast, holds that the baroque is 'nothing but an obtrusive form of classicism in which all ornament is subordinated to abstract structure'.[31] He contrasts the linear rib as the operative trait of the configurational machine of the Gothic with the baroque fold and the Leibnizian combinatory. For while the rib proceeds from movement to structure and from variation to differentiation, the baroque fold proceeds in the opposite direction, from structure to movement, adding variation only to what is already differentiated. As Spuybroek points out, it therefore never really emancipates itself from the classical arts and their unity of matter and form. The endless folding and bending of columns, beams, architraves and pedestals in baroque architecture does not put their interrelations at stake, since the massive structure that organises them stays the same. As in classicism, all the elements are pre-existing. While 'in the Gothic, *ornament acts like structure and structure acts like ornament*',[32] in the baroque we merely find straight lines related by curved ornaments. The latter gives us the impression that material structures are themselves produced in a movement of folding, but it is merely a design 'as if' they were moving. Thus, while the Gothic is more than a fancy adding on of ribs and ornament to smooth Greek or Romanesque columns, the continuity and smoothness of the baroque merely hides and reconfirms a structure which is already in place. Either giving us an image of movement or a vague amorphic mass, the infinite fold knows nothing of the free configuration of the rib, its collaborative and emergent strength, and its immediate translation of physical movement into an abstract structure. In order for form and force to really merge, Spuybroek argues, composition must no longer be a matter of combining elements in relations that remain external to them. If the rib is the true abstract proto-element of Gothic curvilinearity, then it is because it is neither ornament nor structural element, or rather, it is both at the same time. The whole structure is a result of the relations between the ribs, that is the tracery by which 'columns transform into vaults into traceries'.[33] Mediating between figure and configuration, the rib moves through all the members of a structure and in this way replaces the distribution of elements on the one hand and the formal relations between them on the other. Things themselves only become parts or elements through their relationality. This is why the rib is not just ornamental but structural and connective. Continuous variability within a member immediately leads to continuous variability between members. Instead of adding rough parts into a smooth whole, we have smooth parts aggregating in a rough or 'picturesque' whole: 'The Gothic successfully combines the elementary and discrete state of things we find in Greek ontology with the flexibility and continuity of Baroque ontology, correcting the one with the other.'[34]

Of course, one could reply that Deleuze's treatment of the infinite fold of the baroque contains many ambiguities, for example that it is deeply indebted precisely to Wilhelm Worringer's conception of the Northern Line, of which the free proliferating curves express an inorganic life that constantly changes its face and adapts to the material at hand – and for this reason, at one point Spuybroek refers to Deleuze as 'the last proponent of the Gothic'.[35] Yet this does not alter the fact that, unlike the Northern Line, the fold merely establishes relations between materials whose life is always already organised in one form or another. Already with a proto-surrealist such as Arcimboldo, it becomes clear that the fold is a compromise with Aristotelianism. Life is indeed everywhere, on the condition that it is always well founded or formed and smoothly functioning. As Leibniz says, every fish is like a pond full of fish, ad infinitum: we constantly move from the abstract to the concrete to the abstract to the concrete, for while the means of movement is abstract (fold), it remains subject to a concrete aim (the organism).[36] Thus, while it is akin to the Northern (and serpentine) lines, the fold as the operative unity of the baroque does not share the same function. Unlike the former, which proceeds from one singularity to the next and simultaneously generates a discontinuous figure and a continuous plane of composition following a free fractal course, the fold constantly streamlines the continuity between a pre-existing plane and a linear singularity. In terms of Whitehead: whereas the broken line traces a stepwise 'becoming of continuity', folding suggests a 'continuity of becoming'.[37] Whereas the Gothic breaks structure into singularities and absorbs what is discrete into continuous variation, folding is thus inseparable from a transcending Whole that it both constructs and grounds itself upon, a theatrical *Gesamtkunstwerk* without which the expressionism of the line would always remain in unstable suspense, precisely as it does in the Gothic: 'The gothic is nonorganic; it is repetitive and not symmetrical, restless and not balanced. It is *the structure that has itself become sensuous and the ornament that has become material.*'[38] Whereas both the line and the fold are solutions to the problem of how to make structure something that is immediately felt ('the only pressing question for architecture', according to Spuybroek[39]), the latter constantly subordinates what we can call, following Deleuze, the 'aesthetical plane of composition' to a 'technical plane' that provides the pre-structured schema for the realisation of sensation. As a result, the seen does not share the same plane as the structured, and the perception of matter obfuscates the material itself. To use Marxist categories: baroque ornament is a fetish that never challenges its signifying structure, just as its organically smoothed out forms offer a false kind of continuity. Despite, or perhaps precisely because of, its *Pathosformeln* and its veneration of the sensuality of the living flesh and its voluptuous folds, the baroque conception of movement is merely theatrical, not real.

For similar reasons, I have elsewhere argued that Mannerism should be detached from Deleuze's readings of Leibniz and the baroque and given a consistency of its own.[40] Unlike Spuybroek, I do take the baroque, like Mannerism, to be an answer to a world in movement. Folding would not have become the encompassing manner in which the baroque re-establishes traditional structures in a new, spectacular whole, if these traditional structures had not been put at risk in the first place. But whereas the Mannerist figure constitutes an immediate expression of the deterritorialising forces of the crisis of classicism, the baroque answers by reterritorialising the Mannerist world, remediating the latter's vacuous abstraction with the unity of the world as infinite *plenum*.[41] Just as Spuybroek, who, as a direct consequence of his 'Gothic ontology', sees Gothic ornamental design and architecture as preparing the advent of a certain kind of modernism, I therefore think that Mannerist fine arts or literature and music can still be understood as immediate precursors to the twentieth-century rupture with representation, just as Deleuze's own modernist allegiance turns out to contain very few neo-baroque but all the more neo-Mannerist tendencies. In order to develop this argument further, let's return to the physics and metaphysics of the serpentine line, a fascination shared by both Deleuze and Spuybroek.

The Grace of the *Figura Serpentinata*

Among the countless reflections upon stylistic procedures for expressing real movement written by the Mannerists, one of the most well-known recommendations can be found in Giovanni Paolo Lomazzo's *Treatise on the Art of Painting* (1584). Lomazzo writes:

> It is reported that Michelangelo upon a time gave this observation to his student, the painter Marco da Siena, that he should always make a figure pyramidal, serpentlike, and multiplied by one, two and three [a stretching based on the proportions of the leg: the lower leg, the muscular part of the lower leg, and the whole thigh]. In which precept (in my opinion) the whole mystery of the arts consists. For the greatest grace and life, that a picture can have, is that it expresses motion, which the painters call the spirit of a picture. Now there is no form so fit to express this motion as that of the flame of fire.[42]

Accordingly, the best way for painting to come alive and express motion is the famous serpentine figure with its alternation of convex and concave forms, where the radius 'jumps' from inside to outside and vice versa, thus creating a typically spiralling effect. The serpentine line articulates contrasts between active and passive, static and dynamic, but also dissolves these contrasts and puts everything in relation with

everything in a general *risonanza*. Deleuze writes: 'It is as if the organisms were caught up in a whirling or serpentine movement that gives them a single "body" or unites them in a single "fact," apart from any figurative or narrative connection.'[43]

When Deleuze writes 'as if' (most frequently in the form of 'everything happens as if' (*tout se passe comme si*)), this is always meant literally. The serpentine line is not a metaphorical representation of movement, just as little as it is itself organic and limited to the proportions of the human body. Rather, it traces the movement of a body without organs that knows its own, purely intensive consistency. Unlike some fancy ornament added to a well-founded structure and producing an imaginary effect, it has a power of visibility that coincides with the movement or happening of the figure's self-aggregating. The serpentine line maps an internal movement, an indivisible synthesis of compossible and incompossible events. Standing at the core of a 'pure kinetics',[44] it is therefore not defined by its movement in (extensional) space, but by its speed. 'Speed is to be caught in a becoming – which is not a development or an evolution.'[45] Speed is the aesthetic quality of the way of being of the body, the discontinuous and spiritual linkage (a 'bond', says Bruno) that is its incorporeal trans-formation (like the smile of the Cheshire Cat, or generally what Deleuze calls becoming-animal). From Giorgio Vasari's famous 'Preface' to the third part of the *Lives* to Lomazzo to Bruno, the Mannerists refer to the compositional unity of works of art interchangeably with 'speed', 'spirit', 'grace', 'charm' or 'manner'. According to Bruno, art 'quickens, softens, charms, animates' matter.[46] While the Mannerists subordinate form to speed and its variations, such that while each of the parts can be distinguished in space by its relative speed and slowness, the manner itself retains an absolute speed, suffusing all its parts and giving them a spiritual orientation that remains 'a whole in each part'. In this sense of internal change as opposed to external movement, manner is the form or shape of a movement itself, and the serpentine figure the outline of a completed movement (as when we say that someone is 'in good shape'), the limit of the movement of an inner mass.

Even if the serpentine figure as ideal of fine art is a Mannerist notion, it is by no means restricted to the sixteenth century. Approximately one century after Lomazzo, Hogarth would argue that the serpentine line has 'the power of super-adding grace to beauty'. The beauty of a form derives from the waving line or the 'line of beauty', the model for which is the proportions of the female body and its parts.[47] But grace pertains not to form but to act; it is a shape in action. According to Hogarth, it is added to beauty when the line waves and winds at the same time in different ways and dimen-sions in continuous variation, thus putting the body in a complicated and constricting posture (as in the dis-proportional verticalisation in Parmigianino). 'The *art of composing well*', Hogarth writes, 'is no more than the *art of varying well*.'[48] Only the serpentine line is therefore the 'line of grace'. Moreover, Hogarth explains that it is a line that cannot

be drawn on two-dimensional paper, but is best represented by 'a fine wire, properly twisted around the elegant and varied figure of a cone' – the cone uniting the geometrical structure of the pyramid with the curves of the line of beauty and with the dimensionality of the line of grace. In the baroque the curvilinear or serpentine execution of forms would be developed still further into a horn or cone that bends, twists and splits as in the cornucopia or seashell. In Angelo Vannelli's and Bernini's *Lumaca* fountain (1652), for example, we can easily recognise why Hogarth was particularly interested in the genesis of surface purely through serpentine lines. But already in Mannerism the serpentine line is less the wire that is twisted around the cone than the fractal, genetic movement that determines the cone's living form. Before Hogarth, Bruno had argued that the serpentine line is the very spirit or soul of the cone: 'The soul is an internal force that shapes itself from the inside like a snail', its form being a 'living art'.[49]

But what exactly do we mean here with the life or grace of the serpentine figure? Again, Spuybroek's contrast between the baroque and the Gothic is extremely useful. Between the beauty of an idealised static form and the sublimity of pure dynamics, as Spuybroek puts it in his readings of Hogarth's concept of the picturesque and Theodor Lipps's concept of posture, the serpentine line merges line and force, form and act, into the abstract unity of the figure. Whereas the baroque builds or captures movement in a static form, Spuybroek shows how the Gothic turns stability and stillness themselves into an activity. This is John Ruskin's concept of 'active rigidity':[50] starting from movement, the artist's main problem is when to stop, and stopping must not be understood as a form of rest or as an imposition of form, but as an act of grace, a self-organising sympathy of things in the making. Only when stasis is completely epigenetic are we dealing with a gesture or posture in its pure state, that is a manner stripped from any subjective or objective substance. A drawing, a sculpture or a structure, precisely to the extent that they are pure (f)acts, then no longer refer to some reality behind the work at hand. Standing on the intersection of form and force, at the point of inversion between structure and event, only they themselves are fully real. As Giorgio Agamben writes, gestures are 'means without ends': *praxis* and *poiesis* are short-circuited, all that is left is perpetual gestation, in which the paint, marble or stone expose their own mediality.[51] Or as Jean-Luc Nancy puts it, instead of being reified images, gestures express a pure *élan vital*, hovering between *energeia* and *dynamis*.[52] Or, finally, as Deleuze says, they are blocs of sensations standing on their own, metastable states of becoming in which movement and posture can no longer be distinguished: 'the young girl maintains the pose that she has had for five thousand years, a gesture that no longer depends on whoever made it'.[53] Thus instead of asking *what* movement looks like (is it beautiful?), the only question that pertains in the Gothic is *how* something moves (is it graceful?). Or, in other words, it does not matter at all what something means; what matters is what it does or how

it is, the open-ended how, manner, being a strictly aesthetic quality. True ontology is aesthetics, Spuybroek argues, since only style really is (acts).[54] But should we not say the same of Mannerism? Would it not be strangely paradoxical to uphold that precisely in Mannerism, manner would never appear in its pure state?

Just as movement is not exterior to form but the interior of form itself, manner, we have seen, is not a form changing, but the form of change itself. The Mannerists, too, do not seek beauty but grace, or a beauty that works.[55] As Bruno writes, there should be no *formabilità finite* since every 'form is an act'.[56] Similarly, Montaigne argues that stability is 'nothing but a more languid motion'.[57] It is true that, if the problem of the Gothic is that of stoppage (the picturesque), then the problem of Mannerism is still how to express movement in classical static form. But unlike the baroque, which, as Deleuze says, has invented the infinite work of art,[58] Mannerism has found its own solution to the problem of movement by inventing the *unfinished* work of art. This does not mean that Mannerism trades in the perfection of art for the imperfection of life. There is little savageness in Mannerism. But there is a combination of wild growth and perfection, such as, for example, in the *grotto* figures of the Boboli gardens, which consist of coarse agglomerations of apparently formless stone and *objets trouvés*. The same can be said of Michelangelo's *non finito* sculptures, which neither 'complete' anything nor do they fit the figure seamlessly into a larger whole. Rather, their serpentine form 'emerges both gradually and all at once',[59] remaining unrecognised even as it vectorises form. Having no aim outside of itself, the serpentine merely reveals its own aberrant 'formation', where formation must be taken both as a noun – its texture and strata – and as a future-oriented gerundive that best captures the forward thrust of creativity activity.[60] Or rather, as Giovanni da Bologna puts it, the serpentine figure serves *solo per mostrar l'eccellenza dell'arte e senza proporsi alcuna storia*.[61] Immune to antique *istoria*, Counter-Reformation rhetorics and Renaissance naturalism, the serpentine line is a mode of isolation from, and dissolution of, figuration and narration. But precisely for this reason, it is neither gratuitous nor dependent on an abstract idea, but the essence or coherence of the work to be done. As Worringer would later say, all art begins with the abstract line as purely expressive possibility. Producing a 'disgrace or deformity (*difformité*)', Deleuze states, is therefore 'the operation of grace itself'.[62] This is also the modernity of Mannerism: by turning every form into a power of metamorphosis, it invents a new way of opening art up to life itself. The serpentine line renders forces by varying and distributing them following the growth of form. Perhaps this is why the Mannerists preferred a biological model for art over the mathematical model of the Renaissance.[63] 'Life alone creates such zones where living beings whirl around, and only art can reach and penetrate them in its enterprise of co-creation [. . .] art itself lives on these zones of indetermination.'[64] For an immediate consequence of the modal

blurring of the essential and the accidental is that the distinction between the factual and the fictional or life and art becomes indiscernible as well. Once variation – as expression of *varietà* – replaces essence, in principle all sort of becomings are possible, such that Lomazzo could catalogue variability according to the exemplary manners of expression: *maestà e bellezza* in Raphael, *furia e grandezza* in Rosso, *cura et industria* in Perino del Vaga, *grazia e leggiadria* in Parmigianino, *fierezza* in Polidoro.[65] The crux of the Deleuzian concept of Mannerism is that form is the false in itself: not an illusion, but the expression of a *Kunstwollen* freed from its subordination to the concept of truth (or natural life). After all, only the true has an essential form (*eidos*); the false has no form, but a delirious and redundant power of variation. The serpentine figure exceeds created nature, because like the Gothic line, it constructs space more than describing it.[66] Struggling with chaos in order to render it sensory and visible, it is a chaosmotic line of intensification, a mobile equilibrium drawing the phase portrait of a system of invisible possibilities. In Mannerism, life is no longer outside art, but *on* the outside of art, an insistence or force captured by the event of art. On their common limit, life becomes fine art and art becomes the pure manner of a possible world, that is the speculative formation of a new plane of consistency sectioning vital activity itself with a new visibility.

Gothic Mannerism?

So how can we specify this limit shared by art and life in the case of Mannerism and where do we locate the serpentine figure, without a doubt the most important principle of Mannerist composition, within Spuybroek's opposition between Gothic and baroque? We have already seen that the serpentine figure is in no way limited to historical Mannerism. Just as it remains central throughout the baroque, it is crucial to the Gothic and even classical antiquity. This raises the question whether it belongs to art history at all or whether, as in Ruskin's 'vital beauty', it is rather a direct extension of nature, sympathising with the functioning, nourishment and breathing of living beings. This becomes clearest in Gothic ornament, where the S-curve never stands on its own. Although we do not leave the line behind, its 'ceaseless melody' is always nested in various ways of interconnection with other figures with which it forms intricate patterns.[67] Between controlled beauty and the uncontrolled unleashing of forces of the sublime, the serpentine line is one of the figures that makes forces stick together in complex heaps (like curled hairdos or crowds in the street), keeping an elastic order on the edge of chaos. Instead of blurring into oblivion by the forces of chaos, the forces that shape a thing are in a continuum with the forces that destroy it. Whatever emerges from chaos, then, every force-form or thing-action emerges clothed. Stasis is only a negative definition of movement, as everything begins with

circulation. Figures stand alone not because of their weight or mass, as in Egyptian or Greek constructions, but because of an elastic integration of forces from part to part.[68] The unsurpassed strength of the Gothic line thus lies in its collaboration and changefulness. Instead of starting with a specific model and then introducing movement in it, it begins with life as general abstraction.[69] With no element preformed, the rib immediately – but always in an adverbially qualified way, i.e. according to a certain manner: traceried, webbed, compounded – relates the variation of the individual figure to a multiplication of possible configurations (column, fan, vault) that can be formed. 'The Gothic provides an *improved view of matter*, not an antimaterial one. But although material, the Gothic offers no direct bodily experience of materiality; again, it is no Baroque, no Rococo, not sensual and physical; it is not happiness, ecstacy or theater but a perfectly ordinary everyday relationship with . . . well, everything.'[70] As a consequence, only the Gothic knows an entirely free configuration, the free play of a beauty that works in relation to anything that comes at hand. 'In short, the line is active and shows *behaviour*.'[71] Being purely active, the Gothic 'conflates work and design' with no respective after and before. Or, rather, it replaces the priority of design with the perpetual novelty of becoming. It thus constitutes an entirely aesthetic plane of composition, a plane on which everything is texture. As Spuybroek says, there is nothing invisible in the Gothic. The optical product and its manual production process entirely coincide and keep adding value to one another; everything that is graceful happens out in the open: 'There is no space separating things, no visual depth; everything is filled in, knitted together. To make is to see, and to see is to make.'[72]

When it comes to opening itself up to life, Mannerist art is far less radical than the Gothic. In fact, following Spuybroek, the Gothic does not even need to open up. If the Gothic is the eternal outside of the classical fine arts, however, then perhaps Mannerism constitutes their intrinsic limit. The serpentine line would then become the line of deterritorialisation intrinsic to the classical stratum of the fine arts bound by the postures and gestures of the human body. Rather than guiding expression into content, as it does in Gothic ornament, it guides content into expression. On the one hand, the serpentine enables the kind of emergence and resurgence of figures celebrated by Spuybroek. From the serpent to the cone to the horn to the cornucopia, everything that exists is exceeded by the forces that shape it. This means that Mannerist art, too, can be seen as an art of aggregate movements – or as Arnold Hauser puts it, more a matter of adding than of (baroque) subordinating.[73] In Pontormo's *Deposition* (1528), the figurative drama is thrust to the outside flanks of the canvas whereas the central focus of the picture comprises an empty space occupied by four hands. From the point of view of design, the predominant structural lines form intersecting curves that whirl about without a primary direction. In El Greco's *Resurrection of Christ* (1605–10), there is an unlimited space occupied by a jumble

of human organs constituting a rough whole made up of torsos, heads thrown back, knees, elbows, uplifted forearms and thighs spread along the canvas in a play of lines that renders it impossible to tell which single body part belongs to whom. In either case, the aggregates do not constituted a totalised unity, but are held together by the broken lines of the figural becoming of a processual or open whole, an accumulation of diverging, melding, mating, intertwining or bifurcating serpentines in constant disaggregation and reaggregation. But, on the other hand, we are still very far from a completely destratified plane of intensities. For Deleuze and Félix Guattari, however, this is not a problem. On the contrary: 'Never believe that a smooth space will suffice to save us.'[74] Even if we do not get out of the theatre, we can drag it along, dismantle it from the inside out in asymptotical approximation of the tipping point where stoppage and act coincide in postures – just as in post-Cézannean visual art, where the problem is how to give form to sensation and simultaneously liberate the figure from all figuration. Pontormo and El Greco's paintings, in this modern sense of using form in the combat against the essentialism of form, are gestural in the making. In the open-ended product, they reveal visible traces of the production process itself.[75] While the act normally remains invisible and is only felt (intensity), the postural moment renders it at least partially visible. Posture is therefore not the appearance of sensation, but its visibility. Mannerism engages in what I propose to call an active figurability, that is a kind of figurative painting that, instead of perpetuating the passive organic seeing of classical art, changes the power of visibility as such.

To say that Mannerism is at the limit, however, is to say that it is not the tipping point itself. In Mannerism, the inversion between structure and ornament, production and product never actually happens. Because the S-figure, contrary to V-, T- and Y-figures, a figure of smooth variation, generally stands alone and lacks a web in which it can bifurcate into something else, the relation between roughness and smoothness remains accidental and indeterminate with respect to the figure's outside. Perhaps this is why Mannerism, unable to integrate the colossal and somewhat amorphous masses (*terribilità*) with the elegance of the Michelangelesque *serpentinata*, did not last long in its historical incarnation and remained an elitist privilige? There is gestural figuration, but with very little opportunity for configuration. Even if it is of Gothic descent, the serpentine figure marks the point of ambivalence and synchronicity between Mannerism and the Gothic, the point where the problem becomes undecidable: is it to give stable figures motion, or the necessity to stop varying? Is it a rendering visible of life, or a visible rendering of life?

Among the numerous anti-classical progenies of the Gothic, Spuybroek accepts a picturesque Gothic, an expressionist Gothic, an art nouveau Gothic, a Victorian Gothic and a digital Gothic.[76] But why would there not be a Mannerist Gothic? What about Ruskin's famous 'conversion' to Tintoretto, that is to a 'Venetian Gothic' as

opposed to Florentine classicism? When art historians point to the presence of the Gothic in Italian Mannerism, they refer to Dürer's influence on Pontormo, or the so-called *gotico internazionale* that connects Ghiberti and Beccafumi (while the former did not yet possess the classicality of the Renaissance, the latter had already given up on it). But one can also look at the castle of Fontainebleau, where the unusual patchwork of wings, towers and stairs suggests that architecture passed over the Renaissance just as the thin legs and thighs, huge bellies, pointy breasts and little floating heads of the paintings appear to carry on the Gothic almost uninterruptedly into the Mannerist age. Or to be precise, perhaps we should say more speculatively that Northern Mannerism continued and combined certain untimely – and only in this Nietzschean sense 'modern', namely as belonging to a people and an earth *to come* – tendencies in medieval and Renaissance art without a break?

In this ahistorical sense of a line that 'does not function to represent, even something real, but rather constructs a real that is yet to come',[77] it should not come as a surprise that both artists and theorists have continued to share the same intuition of the genetic curve or spirit that moves between things and animates them. Like the baroque fold, the serpentine brings together 'architects, painters, musicians, poets, and philosophers'.[78] But unlike the fold, it is not a matter of reconciling art and nature, but 'a "spiritual art," which goes beyond persons and keeps nature in the background, relating them to a chaos from which modern man must emerge'.[79] Deleuze discusses a wide variety of artistic movements, from Bacon and Pollock to Kandinsky and Klee, that deal with the problem of representation in completely different ways. While there is clearly a risk of conflating them, what they share is a fascination with the line both as a generating power of the visible and as a visualisation of the force of creation. In this double sense, the serpentine line is also crucial to the empiricism of Félix Ravaisson, Étienne Souriau and Bergson, only to appear again in the onto-phenomenology of Maurice Merleau-Ponty. For each, the serpentine line forms the propulsive force of composition. The sufficient reason for the existence of the open whole in the very heterogeneity of its smallest parts is a *serpentinare*: an active process of individuation and realisation, an effectuating movement. Merleau-Ponty's concept of the ontogenetic *serpentement* is wrongly translated into English as 'sinuous outline', since this reduces the event to a form. We should rather read it analogously to the concept of *agencement* in Deleuze and Guattari, that is as a formal arrangement and as the act or process of assemblage or aggregation. Historically, *l'agencement* has primarily an artistic sense, that of a beautiful arrangement of rhythms and symmetries. After the Gothic, and in a different modality, it becomes a 'pure eurhythmics'[80] again in Mannerism: the work of art not as representation, but as fact, contingent and open-ended, with the serpentine diagram as an agent of breakthrough which does not belong to institutionalised art, but to a dimension of creation in a nascent state.[81]

Notes

1. Gilles Deleuze, *Francis Bacon: The Logic of Sensation*, trans. Daniel W. Smith (New York and London: Continuum, 2003).

2. Gilles Deleuze, *The Fold: Leibniz and the Baroque*, trans. Tom Conley (Minneapolis: University of Minnesota Press, 1993), p. 19.

3. Lars Spuybroek, *The Sympathy of Things: Ruskin and the Ecology of Design* (Rotterdam: V2_Publishing and NAi, 2011), p. 223.

4. Spuybroek, *The Sympathy of Things*, p. 43.

5. Ibid. p. 20.

6. Michel Jeanneret, *Perpetual Motion: Transforming Shapes in the Renaissance from da Vinci to Montaigne*, trans. Nidra Poller (Baltimore and London: Johns Hopkins University Press, 2001), pp. 11–80.

7. Cited in Jeanneret, *Perpetual Motion*, p. 18.

8. Jeanneret, *Perpetual Motion*, pp. 101, 83. Jeanneret shows how the crisis of Aristotelianism goes together with the renewed popularity of the plastic – as opposed to created – world of Epicureanism, in which form, being accidental rather than essential, comes at the end rather than at the beginning (p. 26). He quotes Robert Lenoble on the naturalist school of Padua: 'Act and form, instead of direction potential and organizing matter, become the ideal term and the end result of the movement of nature and the immanent vows of things' (p. 28).

9. Lars Spuybroek, *The Architecture of Continuity: Essays and Conversations* (Rotterdam: V2_Publishing and NAi, 2010), p. 14. In his rejection of Mannerism, Spuybroek's main antagonists are Robert Venturi and Denise Scott Brown in their *Architecture as Signs and Systems for a Mannerist Time* (Cambridge, MA and London: Harvard University Press, 2004).

10. For a full development of this argument, see Sjoerd van Tuinen, 'Disegno – A Speculative Constructivist Interpretation', *Speculations*, 5 (May 2014): 434–73.

11. Henri Bergson, *Creative Evolution*, trans. Arthur Mitchell (New York: Dover, 1998), p. 128.

12. In *Sahara: L'esthétique de Gilles Deleuze* (Paris: VRIN, 2005), Mireille Buydens provides a quasi-exhaustive overview of a Deleuzean history of style, including prehistoric, Byzantine, Gothic, baroque and modernist art (pp. 130–52), and concluded that, for Deleuze, 'the "enemy" is form' (p. 49). Only in her subsequent book *L'image dans le miroir* (Brussels: La Lette volée, 1998), however, does she turn to the question of Mannerism. Here she polemically opposes Mannerism to Deleuze's (and Bacon's) under-standing of art (p. 98), but again misses Deleuze's own remarks on the matter. According to 'Nietzsche, Bergson or Deleuze', form is 'an inauthentic structure of Being that one has to overcome' in order to gain access to a Life beyond forms. The vitalist negation

of form is simultaneously an exaltation of 'presence' and a negation of 'distance', the latter being precisely the precondition for any form to deploy its contours. The conventions of decorum typical of Counter-Reformation art theorists, by contrast, do not seek to found form on something else, but maintain that everything is form, and that the only possible movement is 'lateral', from one form to another. 'The credo of mannerism is therefore that there is no beyond representation' (p. 49).

13. Jean-François Lyotard, *Discourse, Figure*, trans. Antony Hudek and Mary Lydon (Minneapolis: University of Minnesota Press, 2011), p. 213.

14. Ibid. pp. 129–30.

15. Deleuze, *Francis Bacon*, p. 34.

16. Ibid. p. 47.

17. Sergei Eisenstein, 'El Greco', in *The Visual Turn: Classical Film Theory and Art History*, ed. Angela Dalle Vacche (New Brunswick, NJ: Rutgers University Press, 2002), pp. 195–205 (p. 195).

18. Deleuze, *The Fold*, p. 34.

19. Deleuze, *Francis Bacon*, pp. 97–8.

20. Ibid. pp. 157.

21. Giordano Bruno, *The Expulsion of the Triumphant Beast*, trans. Arthur Imerti (New Brunswick, NJ: Rutgers University Press, 1964), p. 78. Cited in Giancarlo Maiorino, *The Portrait of Eccentricity: Arcimboldo and the Mannerist Grotesque* (Philadelphia: Pennsylvania State University Press, 1991), p. 89.

22. Gilles Deleuze, *The Logic of Sensation*, pp. 51.

23. Gilles Deleuze, *Cinema 1: The Movement-Image*, trans. Barbara Habberjam and Hugh Tomlinson (Minneapolis: University of Minnesota Press, 1986), p. 82.

24. Wylie Sypher, *Four Stages in Renaissance Style: Transformations in Art and Literature 1400–1700* (Garden City, NY: Doubleday, 1955), pp. 110–13.

25. Spuybroek, *The Sympathy of Things*, p. 179.

26. Paul van den Akker, *Looking for Lines: Theories on the Essence of Art and the Problem of Mannerism* (Amsterdam: Amsterdam University Press, 2010), p. 401.

27. Luciano Bellosi, *Michelangelo: Painting*, trans. Geoffrey Webb (London: Thames & Hudson, 1970), p. 18.

28. Deleuze, *Francis Bacon*, p. 160. Deleuze paraphrases Bacon in David Sylvester, *Interviews with Francis Bacon* (New York: Thames & Hudson, 1988), p. 6.

29. Deleuze, *The Fold*, p. 35.

30. Ibid. p. 123.

31. Spuybroek, *The Sympathy of Things*, p. 128; cf. pp. 62–8.

32. Ibid. p. 44.

33. Ibid. pp. 25–6.

34. Ibid. p. 65.

35. Ibid. p. 12.

36. Gottfried Wilhelm Leibniz, *Philosophical Essays*, ed. and trans. Roger Ariew and Daniel Garber (Indianapolis: Hackett, 1989), p. 222.

37. Alfred North Whitehead, *Process and Reality* (New York: Free Press, 1978), p. 35.

38. Spuybroek, *The Architecture of Continuity*, p. 22.

39. Spuybroek, *The Sympathy of Things*, p. 201.

40. See Sjoerd van Tuinen, 'Mannerism, Baroque and Modernism: Deleuze and the Essence of Art', *SubStance*, 43, 1 (2014): 166–90.

41. Only from the perspective of the baroque can we say that Mannerism would be guided by a *horror vacui*. Seen from a Mannerist perspective, the vacuum would be the affect of a smooth space, precisely in the sense that Deleuze argues against Worring that, in the Gothic, 'the abstract line is the affect of smooth space, not a feeling of anxiety that calls forth striation' (Gilles Deleuze and Félix Guattari, *A Thousand Plateaus: Capitalism and Schizophrenia*, trans. Brian Massumi (Minneapolis: University of Minnesota Press, 1987), p. 497), or that Bacon wanted to paint the scream rather than the horror (Deleuze, *Francis Bacon*, p. 38).

42. Giovanni Paolo Lomazzo, *Treatise on the Art of Painting* II, 1, in *A Documentary History of Art. Volume II: Michelangelo and the Mannerists, The Baroque and the Eighteenth Century*, ed. Elizabeth Gilmore Holt (Princeton: Princeton University Press, 1982), pp. 74–86 (p. 78).

43. Deleuze, *Francis Bacon*, pp. 130–1.

44. Deleuze, *Cinema 1*, pp. 50–1.

45. Gilles Deleuze, *Dialogues II*, trans. Barbara Habberjam and Hugh Tomlinson (New York and London: Continuum, 2002), p. 32.

46. Giordano Bruno, 'A General Account of Bonding', in *Cause, Principle and Unity: And Essays on Magic*, ed. Richard J. Blackwell and Robert de Lucca (Cambridge: Cambridge University Press, 1998), pp. 143–76 (p. 146), translation modified on the basis of *Italian Art 1500–1600: Sources and Documents*, ed. Robert Klein and Henri Zerner (Evanston: Northwestern University Press, 1989), p. 185.

47. William Hogarth, *The Analysis of Beauty*, ed. Ronald Paulson (New Haven and London: Yale University Press, 2007), pp. 49, 58–9. At the core of Mannerism stands the variety of bodily expressions interacting with one another. 'Mannerist artists did not think in terms of abstract lines, shapes and colours as the elements of the grammar of painting, but, rather, in terms of human figures' (van den Akker, *Looking for Lines*, p. 400).

48. Hogarth, *The Analysis of Beauty*, p. 45.

49. Giordano Bruno, as cited in Giancarlo Maiorino, *The Cornucopian Mind and the Baroque Unity of the Arts* (Philadelphia: Pennsylvania State University Press, 1990), p. 64.

50. 'That is Gothic ontology: there is plenty of accident, yes, but accident leading to substance, and there are huge amounts of flexibility, but flexibility leading to rigidity' (Spuybroek, *The Sympathy of Things*, p. 67).

51. Giorgio Agamben, *Means without Ends*, trans. Vincenzo Binetti and Cesare Casarino (Minneapolis and London: University of Minnesota Press, 2000), p. 57.

52. Jean-Luc Nancy, *Le plaisir au dessin* (Paris: Galilée, 2009), pp. 35, 49.

53. Gilles Deleuze and Félix Guattari, *What Is Philosophy?*, trans. Graham Burchell and Hugh Tomlinson (London and New York: Verso, 1994), p. 163.

54. Spuybroek, *The Sympathy of Things*, p. 209.

55. See Bertrand Prévost, *La Peinture en actes. Gestes et manières dans l'Italie de la Renaissance* (Paris: Actes Sud, 2007).

56. Giordano Bruno, cited in Maiorino, *The Cornucopian Mind*, pp. 80–1.

57. Michel de Montaigne, *The Complete Works of Montaigne*, trans. Donald. M. Frame (Stanford: Stanford University Press, 1957), p. 610.

58. Deleuze, *The Fold*, p. 34.

59. Deleuze, *Francis Bacon*, p. 160.

60. Maiorino, *The Cornucopian Mind*, pp. 80–1.

61. Emil Maurer, *Manierismus. Figura Serpentinata und andere Figurenideale* (Munich: Wilhelm Fink Verlag, 2001), p. 71.

62. Gilles Deleuze, 'Un manifeste de moins', in Carmelo Bene and Gilles Deleuze, *Superpositions* (Paris: Minuit, 1979), pp. 85–131 (pp. 98, 112).

63. Vicenzo Danti, *The Treatise on Perfect Proportions*, in *Italian Art 1500–1600*, ed. Klein and Zerner, pp. 100–5.

64. Deleuze and Guattari, *What Is Philosophy?*, p. 173.

65. Maurer, *Manierismus*, p. 26.

66. Deleuze, *Cinema 1*, pp. 50–1.

67. This is why Spuybroek contrasts the S-curves of Hogarth to the J-curves of art nouveau. Whereas the latter have one loose end and one fixed end (as in Alfons Mucha's hair drawing), the Gothic has both ends fixed, such that all flexibility is deployed in the middle areas, which remains restless because the tangents act like switches in a railway system (Spuybroek, *The Sympathy of Things*, p. 24).

68. 'What is a curve? It is a line that does multiple things, not just one; it integrates, and therefore it is structural. A line never curves by itself, only in relation to others. We don't design with curves, we just lay out relationships. And relating them makes things take on curvature, because that which relates creates the thing. So the word "movement" is immediately abstracted, because it means nothing other than continuity of relations' (Spuybroek, *The Architecture of Continuity*, p. 165). And as a consequence: 'What we see in nature is a continuity of elements and a discontinuity of bodies. What we find in classicism is a discontinuity of elements and a continuity of bodies' (Spuybroek, *The Sympathy of Things*, p. 34).

69. Spuybroek, *The Sympathy of Things*, pp. 198–200.

70. Ibid. p. 71.

71. Ibid. p. 21.

72. Ibid. p. 85.

73. Arnold Hauser argues that Mannerism proceeds by adding whereas the baroque proceeds by subordinating (Arnold Hauser, *Der Ursprung der modernen Kunst und Literatur: Die Entwicklung des Manierismus seit der Krise der Renaissance* (Munich: DTV, 1964), p. 150).

74. Deleuze and Guattari, *A Thousand Plateaus*, p. 500.

75. Sebastian Egenhofer therefore contrasts the concept of *Manier*, which applies as long as the formed form belongs to the dimension of appearance (iconic separation from material) and is touched upon by a production process only sideways, and *Faktur*, which would start from material in general. In the latter, more strictly constructivist sense of *Manufaktur*, as well as in that of Spuybroek's Gothic, manner is only ever the asymptote. See: Sebastian Egenhofer, *Abstraktion – Kapitalismus – Subjektivität. Die Wahrheitsfunktion des Werks in der Moderne* (Munich: Wilhelm Fink Verlag, 2008), p. 331.

76. Spuybroek, *The Sympathy of Things*, p. 12.

77. Deleuze and Guattari, *A Thousand Plateaus*, p. 142.

78. Deleuze, *The Fold*, p. 34. As a creative act, John Mullarkey writes, the line can happen in art but also in philosophy, where it is the diagrammatic 'out-line of philosophy, what picks philosophy out from the non-philosophical background while also tying its figure to its background conditions' (John Mullarkey, *Post-Continental Philosophy: An Outline* (New York and London: Continuum, 2006), p. 157).

79. Deleuze, *Cinema 1*, p. 225.

80. Maurer, *Manierismus*, pp. 35, 50.

81. Félix Guattari, *Chaosmosis: An Ethico-Aesthetic Paradigm*, trans. Paul Bains and Julian Pefanis (Sydney: Power Publications, 1995), pp. 101–2.

10 Space Always Comes After: It Is Good When It Comes After; It Is Good Only When It Comes After

Andrej Radman

IF WE START paying attention to paying attention we will inevitably come to the same conclusion as Walter Benjamin did in 'The Work of Art in the Age of Mechanical Reproduction': 'Architecture has always represented the prototype of a work [. . .] the reception of which is consummated by a collectivity in a state of distraction.'[1] Today, when artificial environments have become ubiquitous, with more than fifty per cent of the population living in cities, a state of absentmindedness has turned into oblivion despite (or precisely because of) an evermore exuberant architectural production. The (in)famous modernist maxim of 'Less is more' (*Weniger ist mehr*), a nineteenth-century proverbial phrase that underwent a number of mutations – from the postmodern reactionary 'Less is a bore' to the most recent excessive 'Yes is more' – also works in reverse.[2] More can indeed be less. This is, more or less, the lesson of contemporary ecological thought.[3]

We spend most of our lives in autopilot mode – walking, driving – and only a fraction in teleological mode. However, as the philosopher Hubert L. Dreyfus maintains, it is the intentional mode that we tend to notice, whose 'aboutness' has therefore been studied in detail.[4] Having acquired the capacity of understanding, we tend to see purposes and causes everywhere and thus remain oblivious to the profound non-linearity of the world.[5] This is to say that the invariants we rely on do not necessarily have specific causes that can be neatly identified. More often than not, they may only be mapped as a dynamic cascade of many processes operating over time.[6] However disadvantageous this lack of clarity and distinctness may seem to the architect, it will prove the opposite once we fully grasp the Speculative Turn and its

implications for the discipline. It will become apparent that the royal road to the understanding of 'space' is through the non-intentional, non-reflexive and non-conscious. It is through population thinking that we will undergo a biopolitical apprenticeship in *spatialisation*. As Michel Foucault phrases it, 'So after a first seizure of power over the body in an individualizing mode, we have a second seizure of power that is not individualizing but, if you like, massifying, that is directed not at man-as-body but at man-as-species.'[7] Little wonder then that the architecture theorist Jeffrey Kipnis refers to the architect not as an engineer but as a trickster: 'So are we going to be better off trying to understand the neurophysiology of how we perceive things, or are we better off seeing that we're the magicians?'[8] Similarly, the self-proclaimed alchemist architect François Roche makes a case for deception and the forbidden that have largely been absent from the architectural discourse in recent decades: 'We want to consider a premedical system, before Hippocrates, where temperament describes the body as a negotiation between the temperament of the black bile, the blood, the phlegm, etc.'[9] The unique capability of 'imagineers', film directors and magicians, to subordinate scientific aetiology to artistic symptomatology is largely unappreciated by the discipline of architecture save for these exceptions.[10] As long as architects remain reluctant to shake off the habit of privileging awareness over habit they will continue to misplace concreteness in Whiteheadian terms.[11] As Félix Guattari pointedly diagnosed in his plea for a new aesthetic paradigm, 'the paradigms of techno-science place the emphasis on an objectal world of relations and functions, systematically bracketing out subjective affects, such that the finite, the delimited and coordinatable, always takes precedence over the infinite and its virtual references.'[12]

This essay suggests that the dominant architectural history is not speculative enough. Its only merit is to translate a coexistence of becomings into a succession of neat, *logically necessary* types. A case will be made for the role of topology as an antidote to typological essentialism. This intensive geometry will help dispense with the merely representational in favour of the *contingently obligatory* becoming. The appeal that speculative philosophy holds for progressive architecture is not surprising given that it resists subsuming the intensive under the extensive. Everything starts from an aesthetic encounter. Yet the task of speculative thinking is to go beyond the sensible to the potentials that make sensibility possible.[13] Hence, the basic medium of the discipline of architecture is the 'space of experience'. This *spatium,* which is not to be confused with the 'experience of space', does not pre-exist. It subsists as a virtuality. According to Gilles Deleuze, the plane of composition – as a work of sensation – is aesthetic: 'It is the material that passes into the sensation.'[14] Once aesthetics is drawn into the context of production, its realm expands to become a dimension of being itself. While the relationship between technical and aesthetic

planes of composition has varied historically, Deleuze and Guattari remain adamant that neither art nor sensation has ever been representational.[15] Consequently, the mereological relationship – which is perfectly suitable for the realm of the extensive – needs to be radically revamped in order to become capable of capturing (onto) topological transformations. However, we are not arguing for a formalisable or programmable model. Quite the contrary, mereotopology guarantees that techno-logical determinism will be kept at bay. What we need instead is heuristics as a practice of material inference. In his recent presentation, the philosopher Reza Negarestani underscored Peircean abduction as one such form of material inference. In contrast to the classical, i.e. formal logic, abduction is fallible given that information is gathered by way of manipulation. His case is straightforward: one cannot under-stand a system unless one acts on it. The behaviour of a system is in turn dependent on the concept of tendencies which cannot be intuited unless one is to intervene in the causal fabric.[16] So, although logically one advances from space to affordance, developmentally the sequence runs in precisely the opposite direction. 'Affordance' is James Jerome Gibson's neologism for 'would be action' which is always relational, that is non-deterministic:

> An important fact about affordances of the environment is that they are in a sense objective, real, and physical, unlike values and meanings, which are often supposed to be subjective, phenomenal, and mental. But, actually, an affordance is neither an objective nor a subjective property; or it is both if you like. An affordance cuts across the dichotomy of subjective-objective and helps us to understand its inadequacy. It is both physical and psychical, yet neither. An affordance points both ways, to the environment and to the observer.[17]

Or in a more philosophical vein:

> The theory of affordances rescues us from the philosophical muddle of assuming fixed classes of objects, each defined by its common features and then given a name. As Ludwig Wittgenstein knew, you cannot specify the necessary and sufficient features of the class of things to which a name is given. They have only a 'family resemblance'. But this does not mean you cannot learn how to use things and perceive their uses. You do not have to classify and label things in order to perceive what they afford.[18]

The founder of the Ecological School of Perception thus effectively sides with Deleuze who insists that we go beyond the given (space) to that by which a given is given (*spatium*): 'Difference is not diversity. Diversity is given, but difference is that by

which the given is given as diverse. Difference is not phenomenon but the noumenon closest to the phenomenon.'[19] However, by no means does temporal deployment merely actualise some pre-existing atemporal structure. The virtual itself is the product of immanence (contingent, temporal).[20] In his recent book on speculative realism, Steven Shaviro also makes a case for the *detranscendentalisation* of phenomenological aboutness whereby 'intentionality becomes an implicit striving toward, or a potential for becoming, *within* the world, rather than being an underlying principle or structure of correlation.'[21] Neither 'subject' nor 'object' is in control under the affordance theory either. They mutually constrain and even define one another.[22] Perhaps the best way to dispense with the substantialist prejudice is to see them both as derivative, as 'super-jects' and 'object-iles'. These neologisms evoke the sense of subjects and objects as events. The emphasis is on a field of immediate experience as *being* something and not an experience *of* something for someone. Conversely, the degree zero of spatial experience occurs at the level of the non-conscious. As such, it is proto-subjective and sub-representational, i.e. a non-intentionalistic and non-correlational power of being. In the words of Katherine Hayles:

> In the posthuman view [. . .] conscious agency has never been 'in control'. In fact the very illusion of control bespeaks a fundamental ignorance about the nature of the emergent processes through which consciousness, the organism, and the environment are constituted. Mastery through the exercise of autonomous will is merely the story consciousness tells itself to explain results that actually come about through chaotic dynamics and emergent structures [. . .] emergence replaces teleology; reflexivity replaces objectivism; distributed cognition replaces autonomous will; embodiment replaces a body seen as a support system for the mind; and a dynamic partnership between humans and intelligent machines replaces the liberal humanist subject's manifest destiny to dominate and control nature.[23]

In anticipation of our speculative thesis, let us consider the following example as 'proof' of how lethal our attachment to old conceptual baggage can be. It involves emergence, complex systems and topologies that have become a matter of interest for architectural discourse, philosophy and mathematical science alike. The neo-materialist Manuel DeLanda explains that emergent behaviour is to be expected of any dynamic system having the following three properties: multiple parts, extensive communication between them and their substantial mobility.[24] In the early days of the Second World War, the German air force was arguably more successful than the British. As the architects Jesse Reiser and Jason Payne show, British airborne manoeuvres were more concerned with symmetry-based representation than with efficiency, as if objects of experience resided in the head and were insulated from the

environment. The common fighter pilot's slogan, 'If you have to think, you're dead,' rings true. Britain's Royal Air Force's (RAF) insistence upon simple fixed formations had been more conditioned with the colonial aesthetics of pure two-dimensional geometries than the *nomos* of air combat. Their German counterparts (the Luftwaffe), on the other hand, were busy exploring the (phase) space to its full potential by keeping in direct touch with the milieu. The unmediated (direct) perception, according to ecological psychology, circumvents retinal, neural or mental pictures altogether.[25] Perhaps this is why German fighter formations were far more adaptive to contingencies and thus more capable of engaging the enemy by absorbing, deflecting or evading their tactics. The actions by pilots *generated* information for perception. What is at stake here is an emergent property of a dynamic system where the whole is not *of* the parts, but alongside and in addition to them.[26] In the words of the architecture theorist Sanford Kwinter, 'extreme activities involve the mobilization of every inter-acting part in a field, so that every moment of every part instantaneously changes the conditions of the unfolding whole.'[27] This, in a way, is a purely geometrical problem:

> When the British formation changed direction, for example, every plane would retain its fixed position within the assemblage throughout the turn, somewhat like rail-cars on a curving train track. The German formation, however, would rotate and fold over upon itself, the planes in the rear of the formation coming around to take up the front. Not only did this allow for a faster, tighter turn, but it also provided continual and ever-changing protection for each plane by some other in the forma-tion. The shifting positions made it very difficult for an enemy to draw a bead on a single plane, especially one being defended by several others in rotation.[28]

The mapped manoeuvres of the two formations provide a perfect allegory for the difference between sedentary and nomadic distributions in an organisation of space. Namely, the difference between applying a preset, overarching principle in the case of the RAF, and tapping into the latent potentiality of an ad hoc assemblage on the part of the Luftwaffe: geometry of theorems vs. geometry of problems.[29] It is a quin-tessentially architectural problem, not to be confused with the simple opposition between order and disorder. Rather, they are two different, perhaps even comple-mentary, orders of what Deleuze and Guattari have famously called 'striated' and 'smooth' space. In contrast to sedentary space that remains what it is and is then divided, nomadic space is produced through its very distribution. The dual nature of space is explained by Kwinter as follows:

> [O]n the one hand, a fixed and extended milieu with metrical or dimensional prop-erties and, on the other, a fluid and consistent field of intensities (e.g. forces, speeds,

temperatures, colour). The resemblance to Bergson's two types of multiplicity, the numerical (discrete) and the qualitative (continuous), or, more generally, that of space and that of *durée* [. . .][30]

The concept of 'nomadology' is spelt out most explicitly in *A Thousand Plateaus*. Deleuze and Guattari take it to be 'the opposite of a history'.[31] To repeat, with nomadic distribution there is not a single law that stands outside and determines space (n + 1). Instead, the law is produced in the very traversal of space. This will be the basis of our critique of the all-too-transcendental and thus conservative concept of architectural typologies. Deleuze and Guattari offer a clear prescription: 'Subtract the unique from the multiplicity to be constituted; write at n − 1 dimensions'.[32] It is high time we lifted the military monopoly over the 'soft power' of smooth space, where space is subordinate to time and object to relation. The notorious champions of *noopolitik*, Arquilla and Ronfeldt, contrast the mighty soft power to the hard power of *realpolitik*.[33] We ought to tap into the process of epigenesis for our own life-affirming purposes. Now that it is becoming increasingly difficult to rely on the classical political categories, Deleuze provides a crucial distinction between 'left' and 'right'. The political left wards off the hegemonic master signifier (nation, land). Simply put, it ponders the problem rather than let itself be driven by the solution.[34] The artist and neuroscientist Warren Neidich has recently issued a similar plea for the emancipatory process of environmentally directed neuromodulation.[35] Under the concept of epigenesis, space is no longer regarded as an enclosure but in terms of thresholds: 'Enclosures are *molds*, distinct castings, but controls are a *modulation*, like a self-deforming cast that will continuously change from one moment to the other, or like a sieve whose mesh will transmute from point to point'.[36]

The speculative pragmatist Brian Massumi urges us to approach the problem of control in terms of an 'ecology of powers'.[37] In his latest work, this power of local-global becoming is defined as an ontopower, a creative power of becoming: 'The subject's situatedness becomes one of the deciding factors of what transpires. The double involuntary of the feedback and feedforward between the [molecular] dividual and the [supermolar] transindividual funnels through the situation, and is conditioned by the presuppositions and tendential orientations it highlights'.[38] This is to say that the modulation of control can itself be modulated. It will not be easy to live up to this speculative injunction as metaphysics has always been concerned with the striated. The deontologist Peter Wolfendale has recently identified the three distinct post-Heideggerian rejections of metaphysics according to the concept of substance they hold responsible for its onto-theological legacy: *presence* (Derrida), *unity* (Badiou) and *ground* (Meillassoux).[39] According to the architecture theorist Marc Wigley, the history of the ground 'is that of a succession of different names

(*logos, ratio, arche,* etc.) [. . .]. Each of them designates "being", which is understood as presence. [. . .] "supporting presence" for an edifice.'[40] In other words, even before we begin the process of determination, certain things seem always already determined as enduring beyond their transitory predicates and are therefore precluded from affirming the original movement through which they themselves are affected. The cure is to bracket 'natural perception' in which everything appears as an already constitut*ed* body, quality or action.[41] Following the (n – 1) advice of Deleuze: 'To make the body a power which is not reducible to the organism, to make thought a power which is not reducible to consciousness.'[42]

Clearly, a whole new vocabulary needs to be invented, as well as a new set of conceptual tools. Geometry becomes indispensable. Apart from being a branch of mathematics, geometry has always been a mode of rationality. The architect and theorist Bernard Cache argues that it should be taken as a cultural reference.[43] This is no trivial matter, as we may depend upon a 'different rationality' (not irrationality) where the 'law of the excluded middle' or the 'principle of non-contradiction' does not hold.[44] The distinction between linear and non-linear systems thus becomes fundamental. It constitutes what is arguably the single most important conceptual development in contemporary sciences. Whereas linear systems adhere to the 'super-position principle', non-linear systems do not lend themselves to such a simple addition of quantities. This is important if we want to avoid the fallacy of (mere) linear causation. For example, the polymath Henri Poincaré discovered, to his dismay, that the mechanics of no more than three moving bodies, bound by a single relation of gravity and interacting in a single isolated system, produced such complex behaviour which no differential equation, either known or possible, could ever describe. In other words, causal theories need not be deterministic, not even in ideal cases, let alone when the situation is complicated by introducing a degree of chaos as chance into the picture.[45] Any theory of morphogenesis would thus need to confront novelty as an irreducible quality.[46] The 'three-body problem', as it came to be known, triggered a whole new approach to problem-solving that no longer focused on the solution, but on framing the (space of the) problem which would then 'yield' solutions. As is well known to readers of Deleuze, problems get the solutions that they 'deserve'. This means that Poincaré bypassed exact solvability as a way of getting global information and used instead a novel method to investigate the space defining the problem itself.[47] The geometry fit for the purpose of 'dramatisation' has been with us for over a century and it is called 'topology'.

Geometry and topology, while both concerned with space, are distinguished by their different mathematical provenances, explains the mathematician Arkady Plotnitsky. While geometry has to do with measurement, topology disregards it altogether and deals only with the structure of space qua space. As long as one deforms

a given figure continuously – that is, without separating the points previously connected and, conversely, without connecting the points previously separated – the resulting figure is considered the same.[48] The most common example is the topological isomorphism between a donut and a mug. From a topological point of view they are exactly the same. Although this particular example has been repeated ad nauseam, any object with a single hole would do. Topology may be considered as the most 'general' (an exact yet rigorous) geometry whose suitability for thinking the (intensive) relation independent of its (metric) terms cannot be overstated. While perhaps inevitable, its current appeal for architects solely at the formal(ist) level is regrettable, as it rarely goes beyond (bio)mimicry.[49]

Consider Kees Doevendans's recent upgrading of Anthony Vidler's 1977 architectural history classic 'The Third Typology'.[50] Vidler discovered the 'first typology' in the famous primitive hut of Laugier (1755). *Nature* thus became the model for architecture. The 'second typology' coincided with industrial development. The *Machine* was chosen as the model for architecture and figured as its legitimising agent. Form was to emerge from functional requirements. The 'third typology', introduced in the 1960s by Italian neo-rationalists, marked a break with the idea that architecture and urban design had to seek external legitimacy.[51] Instead of a metaphorical approach of representing the city as either natural (organicist fallacy), or mechanical (mechanicist fallacy), the emphasis was put on the city as form. Thus the third typology ostensibly led to an 'ontology of the city' (essentialist fallacy), which was to be found in its morphology as passed down through history. Its champion, Aldo Rossi, defined the 'type' as the very idea of architecture, closest to its essence. The contemporary Dutch urbanist Doevendans, for his part, contributed 'The Fourth Typology'.[52] Notwithstanding his qualification to consider it in terms of a Kuhnian paradigm, the proposed 'Typology of Topology' must be challenged as a symptomatic case of category error. By its very nature, topology does not lend itself to typologising and it is this elusiveness that endows it with the greatest conceptual power. Cache's precious caution to fellow architects from 1998 continues to fall on deaf ears:

One single topological structure has an infinity of Euclidean *incarnations*, the variations of which are not relevant for topology, about which topology has nothing to say. New topological structures can be incarnated in Euclidean space as squared figures as well as curved figures. Topology cannot be said to be curved because it precedes any assignment of metrical curvature. Because topological structures are often represented with in some ways indefinite curved surfaces, one might think that topology brings free curvature to architecture, but this is a misunderstanding. When mathematicians draw those kinds of free surfaces, they mean to indicate that they do not care about the actual shape in which topology can be

incarnated. In so doing, *they should open the mind of architects and allow them to think of spatial structures before styling them as either curved or squared.*[53]

Despite a number of references to Deleuze, Doevendans fails to recognise that it was precisely topological (continuous) modulation that helped Deleuze dispense once and for all with typological moulding.[54] *Pace* Cache's non-representationalist cry, there have been numerous pleas to 'typify topology' in the recent past. In spite of the proclaimed worthy ambition to collapse the figure/ground distinction by defining interstitial local connections, the field approach has but produced a myriad of field-like objects: 'A field condition would be any formal or spatial matrix capable of unifying diverse elements while respecting the identity of each. Field configurations are loosely bounded aggregates characterised by porosity and local interconnectivity. The internal regulations of the parts are decisive; *overall shape and extent are highly fluid [sic].*[55] One cannot be but struck by the irony of an effective reversal of Stan Allen's vector 'From Object to Field'. Field conditions as bottom-up phenomena were meant to introduce a degree of chaos as chance into the morphogenetic process precisely in order to yield novelty without precluding the overall shape.[56] Only this way may we hope to avoid the 'fallacy of tracing' (reified field syndrome), i.e. conflating the actual product with the intensive process of individuation.

There simply is no common measure between topological content and typological form. There is an asymmetry between two odd, unequal irreducible halves of the virtual and the actual, as beautifully illustrated by Henri Bergson's cone, in contrast to phenomenology, which maintains an isomorphic symmetry between the two branches of the empirico-transcendental double. Bergson's 'pure memory' is opposed to the most relaxed level of duration, i.e. matter (space), in the most condensed contraction of the whole (time) into the present. By leaping into a virtual and not a chronological past, Bergson dispenses with the total actuality of teleological reflective judgement.[57] The question arises of the temporal interval between stimulus and response. What appears as a conscious de-cision (cut) or circumscribed perception (snapshot) constitutes an abundance of complex duration, an autonomy of affect replete with (subversive) potentials. The lack of symmetry is the clue to the radical nature of Deleuze's philosophy (of time), as James Williams argues: 'It is inherently anti-conservative and anti-reactionary due to its inbuilt and unavoidable asymmetries of time. There is no represented and original past to go to [Laugier's Nature]. There is no eternal realm to escape to in the future [either], where time stands still [Rossi's Type].'[58] Vidler's 'Three Typologies' all operate under the auspices of representation through analogies with Nature, Culture or History. In stark opposition, there is no re-presentation or any analogy in topological thinking. There is no homology between the engendered (type) and the engendering topology.[59]

Topologically, a thing can no longer be considered as one, a unity, but as a multiplicity, always increasing its lines of connection with other things. It is no longer defined by a form or by functions, but by affordance. The consistency of the thing is not dependent on any logical or psychophysical compounding, 'rather, the very elements to which such compounding is applied are themselves the results of cognitive abstractions from the wholes in question.'[60]

The architect and theorist Lars Spuybroek provides an apt diagnosis of the problem. According to him, architects have difficulties understanding order and contingency in an ontological relationship, as one producing the other. Rather, they see them both as (quasi-stable) structures. The notion of structure can entail many things and is thus difficult to define. Structure itself is often comprised of components that in turn have their own structure. So, in terms of an ordered composition or articulation, structure applies both to the whole and to its constituent parts. Each part may have a recognisable identity and together the parts form a whole, a unity, with a molar identity. An architectural structure is usually taken to be the totality of form, measure, scale, function, space and materials. Be that as it may, the key aspect of structure is the relationship. If mereology is interested in the relationship between the parts, and the relationship of the parts to the whole, the key aspect of structure is 'structuration', or in our terms, mereotopology where, somewhat counter-intuitively, relations remain external to their terms. It should not come as a surprise that Gibson too considered the notion of structure inadequate.[61] The better part of our technological and aesthetic tradition has been oriented towards structure as stable and homeostatic. But a system is more accurately defined by the events as incorporeal effects than by a mere description of the 'physical substrate' in which these events act as quasi-causes (dark precursors). This has become inconveniently evident with the arrival of the Anthropocene and its de-ontologisation of the binary opposition between culture and nature: 'If the will to knowledge characteristic of modernity provided the assurance that the fault line between human culture and nature was indeed factual, the production of the Anthropocene counter-factuality relieves our contemporaneity of the burden of perpetuating this epistemic illusion.'[62] From a Gibsonian point of view, what is required is a concept of structure that is not detached from what it structures. It has to be neither a priori as in organicism, nor a posteriori as in mechanicism.[63] In other words, rather than asking to typologise topology in the vein of Doevendans, *it will always be necessary to topologise type* as in (abstract) machinism.[64] For Deleuze following Spinoza, all individuation is based upon movement and rest.[65] The distinction between the seemingly opposed strata on the one hand and the fluid plane of nature or Body without Organs on the other is simply a question of varying speeds and slownesses within a *single* system (monism). All this is evidence that we have yet to distinguish between the three Ts: the essentialist Typology, the extensive

Topography and the intensive Topology.[66] Spuybroek provides a helpful image of the solid-structure-configuration-pattern-rhythm cascade that may be taken as a diagram of the concrescence of Cartesian space out of topological *spatium*, albeit in reverse:

> Let's put all the forms between solid and liquid on a line. *Solid* is on one side. That's how architects generally understand form: idealised, crystallised, *a priori*, archetypal. No dynamics, no contingency, only memory. [. . .] [T]he first one after solid form going in the direction of liquid is *structure*: it's more open, not necessarily Platonic. It's not the dead clay of Platonism; there are forces, points and lines involved, but it is as static. Then we have *configuration*; it's the word some of the Gestaltists used for form. There is a going back and forth between actual perceptions and virtual memories; it's much more dynamic than structure. Next to configuration, we have the modern notion of *pattern*, which is sort of between information and form; it is generally considered as fully emergent. [. . .] Then, I guess, closest to completely liquid, we have Deleuze's *rhythm*, his continuous variation and modulation. Waves, turbulences, swerves.[67]

A parallel may be drawn with language. Deleuze explains, 'language has no significance of its own. It is composted of signs, but signs are inseparable from a whole other element, a non-linguistic element, which could be called "the state of things" or, better yet, "images".'[68] Language always comes after. Process philosophy, or the ontology of becoming, identifies metaphysical reality with change and dynamism. Ever since Plato and Aristotle, processes have either been denied or subordinated to timeless substances. Change has been seen as purely accidental. Consequently, classical ontology denies any full reality to change as such and continues to impinge upon our epistemologies to this day. By contrast, Deleuzian anti-correlationism *avant la lettre* grants full reality to becoming.[69] It grants full reality to an ontopower which is environmental yet proto-territorial and both logically and onto-logically prior to the categories of (passive) nature and (active) culture.[70]

Despite the all-too-hastily declared dislike of the non-Non-Euclidian geometries, contemporary architecture has not yet broken its allegiance with the arborescent schema in favour of the rhizomatic counterpart. The cart of semantic signification thus precedes the horse of pragmatic significance and will continue to do so until the discipline has fully absorbed the conceptual power of the smooth space (*spatium*) that is *both* emergent *and* constructed by way of inclusive disjunction. For a genuine change to occur, the relation between space (perception) and movement (action) ought to be inverted. Our plea for topologising has no other purpose than to adequately conceptualise the event: it is not about what happens, but what is going on in what happens. Similarly, Kwinter advocates 'radical anamnesis' to recall not

the (contingent) past that has happened but the past that has not happened but could have. This position resists the allure of allowing common sense (*doxa*) to govern all our encounters: 'Through (selective) memory the future becomes possible, a future that the past could not think and that the present – alone – dares not.'[71] Having propositional knowledge about reality does not render the nature of reality propositional.[72] Thinking does not go from proposition to proposition. When we communicate by reference to and with socially coded stimuli, we are not (yet) thinking. Rather, thinking becomes creative by tracing back propositions to the non-propositional field of problems that engenders them. Only through the non-apodictic, that is aesthetic, experimentation can we determine whether an encounter is ethical or not, whether it augments or diminishes our power of action. Hence the necessity of topologising as the only plausible ethico-aesthetical strategy to (provisionally) 'rid ourselves of ourselves' or break the vicious circle of correlationism in which no-thing can be independent of thought and where space is a priori.[73]

An architect's desire to be nameless is no false modesty.[74] Under the commitment to flat ontology it becomes an expression of the highest ambition.

Notes

1. Walter Benjamin, 'The Work of Art in the Age of Mechanical Reproduction', in *Illuminations*, ed. Hannah Arendt (New York: Knopf Doubleday [1936], 1968), p. 239.

2. The maxim 'Less is a bore', a postmodern antidote to Mies van der Rohe's famous modernist dictum 'Less is more', was coined by Robert Venturi. 'Yes is more' is a title from Copenhagen-based architectural practice Bjarke Ingels Group, or BIG. See Bjarke Ingels, *Yes Is More: An Archicomic on Architectural Evolution* (Cologne: Evergreen, 2010).

3. Timothy Morton, *The Ecological Thought* (Cambridge, MA: Harvard University Press, 2010). See also Timothy Morton, *Ecology without Nature: Rethinking Environmental Aesthetics* (Cambridge, MA: Harvard University Press, 2007).

4. Hubert L. Dreyfus, 'Heidegger's Critique of Husserl's (and Searle's) Account of Intentionality', *Social Research*, 1, 60 (Spring 1993): 17–38.

5. Bana Bashour and Hans D. Muller, 'Exploring the Post-Darwinian Naturalist Landscape', in *Contemporary Philosophical Naturalism and Its Implications*, ed. Bana Bashour and Hans D. Muller (New York and London: Routledge, 2014), pp. 1–14 (p. 2).

6. Sanford Kwinter, 'Hydraulic Vision', in *Mood River*, ed. Jeffrey Kipnis and Annetta Massie (Columbus, OH: Wexner Center for the Arts, 2002), pp. 32–3.

7. Michel Foucault, *Society Must Be Defended: Lectures at the Collège de France, 1975–1976* (New York: Picador [1976], 1997), p. 243.

8. Jeffrey Kipnis and Reinhold Martin, 'What Good Can Architecture Do?' (The Harvard GSD, 2010) <http://www.youtube.com/watch?v=HDo40Fr41os/> (accessed 12 February 2015).

9. François Roche, 'Matters of Fabulation: On the Construction of Realities in the Anthropocene', in *Architecture in the Anthropocene: Encounters Among Design, Deep Time, Science and Philosophy*, ed. Etienne Turpin (Open Humanities Press, 2013), pp. 197–208 (p. 199). Cf. François Roche, 'Alchimis(t/r/ick)-machines' <http://www.new-territories.com/roche%20text.htm> (accessed 12 February 2015).

10. Gilles Delleuze, 'Coldness and Cruelty', in *Masochism*, trans. Jean McNeil (New York: Zone Books [1967], 1989), pp. 9–138 (p. 133).

11. Alfred North Whitehead, *Process and Reality: An Essay in Cosmology*, ed. David Ray Griffin and Donald W. Sherburne (New York: Free, 1978), pp. 7–8.

12. Félix Guattari, 'The New Aesthetic Paradigm', in *Chaosmosis: An Ethico-aesthetic Paradigm* (Bloomington: Indiana University Press, 1995), pp. 98–118 (p. 100).

13. Andrej Radman, 'Sensibility Is Ground Zero: On Inclusive Disjunction and Politics of Defatalization', in *This Deleuzian Century: Art, Activism, Society*, ed. R. Braidotti and R. Dolphijn (Leiden and Boston: Brill/Rodopi, 2014), pp. 57–86.

14. Gilles Deleuze and Félix Guattari, *What Is Philosophy?* (New York: Columbia University Press [1991], 1994), p. 192.

15. Deleuze and Guattari, *What Is Philosophy?*, p. 193.

16. Reza Negarestani, 'Frontiers of Manipulation', *Speculations on Anonymous Materials* symposium (2014) <http://www.youtube.com/watch?v=Fg0lMebGt9I/> (accessed 12 February 2015).

17. James Jerome Gibson, *The Ecological Approach to Visual Perception* (Mahwah, NJ: Lawrence Erlbaum Associates [1979], 1986), p. 129.

18. Gibson, *The Ecological Approach to Visual Perception*, p. 134.

19. Gilles Deleuze, *Difference and Repetition* (New York: Columbia University Press [1968], 1994), p. 202.

20. Slavoj Žižek, *Event: Philosophy in Transit* (London: Penguin Books, 2014), p. 144.

21. Steven Shaviro, *Universe of Things: On Speculative Realism* (Minneapolis: University of Minnesota Press, 2014), p. 81.

22. Anthony Chemero and Rob Withagen, 'Naturalising Perception: Developing the Gibsonian Approach to Perception along Evolutionary lines', *Theory and Psychology*, 19 (2009): 363–89.

23. Katherine Hayles, *How We Became Posthuman: Virtual Bodies in Cybernetics, Literature, and Informatics* (London: University of Chicago Press, 1999), p. 288.

24. Manuel DeLanda, *Philosophy and Simulation: The Emergence of Synthetic Reason* (London and New York: Continuum, 2011), pp. 1–6.

25. Gibson, *The Ecological Approach to Visual Perception*, p. 147.

26. Brian Massumi, 'The Thinking-Feeling of What Happens', in *Interact or Die*, ed. Joke Brouwer and Arjen Mulder (Rotterdam: V2_Pub. and NAi, 2007), pp. 70–91.

27. Sanford Kwinter, 'Flying the Bullet, or When Did the Future Begin?', in *Rem Koolhaas: Conversation with Students*, ed. Sanford Kwinter (New York: Princeton Architectural Press, 1996), pp. 67–94 (p. 71).

28. Jason Payne and Jesse Reiser, 'Chum: Computation in a Supersaturated Milieu', *Kenchiku Bunka*, 53, 619 (1998): 19–26 (p. 23).

29. Gilles Deleuze and Félix Guattari, *A Thousand Plateaus*, trans. Brian Massumi (Minneapolis: University of Minnesota Press [1980], 1987), pp. 387–467.

30. Sanford Kwinter, 'La Cittá Nuova: Modernity and Continuity', in *Architecture Theory Since 1968*, ed. Michael K. Hays (Cambridge, MA: MIT, 1998), pp. 586–612 (p. 593).

31. Gilles Deleuze and Félix Guattari, *A Thousand Plateaus* (London and New York: Continuum [1980], 2004), p. 23.

32. Deleuze and Guattari, *A Thousand Plateaus* (2004), p. 6.

33. John Arquilla and David Ronfeldt, *The Emergence of Noopolitik: Toward an American Information Strategy* (Santa Monica: RAND, 1999), p. x.

34. Gilles Deleuze, *Negotiations: 1972–1990*, trans. Martin Joughin (New York: Columbia University Press, 1995), pp. 126–7.

35. Warren Neidich, 'Neuropower: Art in the Age of Cognitive Capitalism', in *The Psychopathologies of Cognitive Capitalism: Part One*, ed. Arne De Boever and Warren Neidich (Berlin: Archive Books, 2013), pp. 219–66.

36. Gilles Deleuze, 'Postscript on the Societies of Control', *October*, 59 (1992): 3–7 (p. 4).

37. Brian Massumi, 'National Enterprise Emergency: Steps Toward an Ecology of Powers', in *Beyond Biopolitics: Essays on the Governance of Life and Death*, ed. Patricia Ticineto Clough and Craig Willse (Durham, NC and London: Duke University Press, 2011), pp. 19–45.

38. Brian Massumi, *The Power at the End of the Economy* (Durham, NC and London: Duke University Press, 2015), pp. 15, 42.

39. Peter Wolfendale, *Object-Oriented Philosophy: The Noumenon's New Clothes* (Falmouth: Urbanomic, 2014), p. 222.

40. Mark Wigley, 'The Translation of Architecture, the Production of Babel', in *Architecture Theory Since 1968*, ed. Michael K. Hays (Cambridge, MA: MIT, 1998), pp. 658–75 (p. 662).

41. Marc Boumeester and Andrej Radman, 'The Impredicative City: or What Can a Boston Square Do?', in *Deleuze and the City*, ed. Hélène Frichot, Catharina Gabrielsson and Jonathan Metzger (Edinburgh: Edinburgh University Press, 2016).

42. Gilles Deleuze and Claire Parnet, *Dialogues* (New York: Columbia University Press, [1977] 1987), p. 124. See also Gilles Deleuze, 'The Interpretation of Utterances', in *Two Regimes of Madness: Texts and Interviews 1975–1995* (Los Angeles: Semiotext(e), 2006), pp. 89–112 (p. 92).

43. Peter Macapia's interview with Bernard Cache in *Saint Ouen l'Aumône* (2008) <http://www.adrd.net/crowdcast/video/11.html> (accessed 25 May 2011). Cache and Macapia discuss several conceptual changes in the contemporary use of geometry in the field of architecture.

44. A term borrowed from Scott Lash's book, *Another Modernity: A Different Rationality* (Oxford: Blackwell, 1999). For the relation between the principle of sufficient reason and the principle of non-contradiction see Sjoerd van Tuinen, 'Deleuze: Speculative and Practical Philosophy', in *Genealogies of Speculation: Materialism and Subjectivity since Structuralism*, ed. Armen Avanessian and Suhail Malik (London and New York: Bloomsbury, forthcoming).

45. Arkady Plotnitsky, 'Chaosmologies: Quantum Field Theory, Chaos and Thought in Deleuze and Guattari's *What is Philosophy?*', *Paragraph*, 29, 2 (2006): 40–56 (p. 45).

46. Sanford Kwinter, 'Landscapes of Change: Boccioni's Stati d'animo as a General Theory of Models', *Assemblage*, 19 (1992): 52–65 (p. 52).

47. Manuel DeLanda, *Intensive Science and Virtual Philosophy* (London: Continuum, 2002), p. 154.

48. Arkady Plotinsky, 'Algebras, Geometries and Topologies of the Fold: Deleuze, Derrida and Quasi-Mathematical Thinking (with Leibniz and Mallarmé)', in *Between Deleuze and Derrida*, ed. Paul Patton and John Protevi (New York: Continuum, 2003), pp. 98–119 (p. 99).

49. The same concern is expressed by Sanford Kwinter in: 'A Discourse on Method', in *Explorations in Architecture*, ed. Reto Geiser (Basle: Birkhäuser, 2008), pp. 34–47 (p. 46).

50. Anthony Vidler, 'The Third Typology', in *Architecture Theory Since 1968*, ed. Michael K. Hays (Cambridge, MA: MIT, 1998), pp. 284–94.

51. Aldo Rossi, *The Architecture of the City* (Cambridge, MA: MIT, 1982). Rossi's book sketches out the concept of Rational Architecture further developed in the book *Architettura Razionale*, published in 1973 on the occasion of the XV Milan Triennale.

52. Kees Doevendans, 'Sustainable Urban Development and the Fourth Typology', in *Ecopolis: Sustainable Planning and Design Principles*, ed. Dimitra Babalis (Florence: Alinea Editrice, 2006), pp. 31–8.

53. Bernard Cache, 'Plea for Euclid', in *Projectiles* (London: Architectural Association, 2011), pp. 31–59 (p. 40) (emphasis added).

54. Sanford Kwinter, *Architectures of Time: Toward a Theory of the Event in Modernist Culture* (Cambridge, MA: MIT, 2001), pp. 26–8.

55. Stan Allen, 'From Object to Field', *AD*, 67 (May–June 1997): 24–31 (p. 24) (emphasis added).

56. For examples of non-formalist architecture see Deborah Hauptmann and Andrej Radman, 'Northern Line', in *Deleuze and Architecture*, ed. Hélène Frichot and Stephen Loo (Edinburgh: Edinburgh University Press, 2013), pp. 40–60.

57. Henri Bergson, *Matter and Memory* (New York: Dover [1896], 2004), p. 197.

58. James Williams, *Gilles Deleuze's Philosophy of Time: A Critical Introduction and Guide* (Edinburgh: Edinburgh University Press, 2011), p. 4.

59. Paul M. Churchland, *Plato's Camera: How the Physical Brain Captures a Landscape of Abstract Universals* (Cambridge, MA: MIT Press, 2012), p. 110.

60. Barry Smith, 'Values in Contexts: An Ontological Theory', in *Inherent and Instrumental Values: Excursions in Value Inquiry*, ed. G. John M. Abbarno (Lanham: University Press of America, 2015), pp. 17–29 (p. 17).

61. James Jerome Gibson, *The Ecological Approach to Visual Perception* (Mahwah, NJ: Lawrence Erlbaum Associates [1979], 1986).

62. Etienne Turpin, 'Who Does the Earth Think It Is, Now?', in *Architecture in the Anthropocene: Encounters Among Design, Deep Time, Science and Philosophy*, ed. Etienne Turpin (Open Humanities Press, 2013), pp. 3–10 (p. 4).

63. Michael J. Braund, *From Inference to Affordance: The Problem of Visual Depth-perception in the Optical Writings of Descartes, Berkeley and Gibson* (Ottawa: Library and Archives Canada, 2009), p. 67.

64. Lars Spuybroek, 'Machining Architecture', in *NOX Machining Architecture*, ed. Andrew Benjamin and Lars Spuybroek (London: Thames & Hudson, 2004), pp. 6–13 (p. 9).

65. Manuel DeLanda, 'Nonorganic Life', in *Incorporations: Zone 6*, ed. Jonathan Crary and Sanford Kwinter (New York: Zone, 1992), pp. 129–67. See also Gilles Deleuze, *Spinoza, Practical Philosophy* (San Francisco: City Lights Books [1970], 1988), p. 123, and Deleuze and Guattari, *A Thousand Plateaus* (2004), pp. 254, 261.

66. Celia Lury, 'Topology for Culture: Metaphors and Tools', at *Colloquium 1: Thinking Topologically? A Topological Approach to Cultural Dynamics* (2007) <http://www.atacd.net/index.php%3Foption=com_content&task=view&id=107&Itemid=88.html> (accessed 25 May 2011).

67. Lars Spuybroek in an interview by Arjen Mulder, 'The Aesthetics of Variation', in *Interact or Die*, ed. Joke Brouwer and Arjen Mulder (Rotterdam: V2_Pub. and NAi, 2007), pp. 132–49 (pp. 141–2).

68. Gilles Deleuze, 'Letter to Uno on Language', in *Two Regimes of Madness: Texts and Interviews 1975–1995* (Los Angeles: Semiotext(e), 2006), pp. 201–2 (p. 201).

69. Rosi Braidotti in an interview by Timotheus Vermeulen, 'Borrowed Energy', *Frieze*, 165 (2014) <http://www.frieze.com/issue/article/borrowed-energy/> (accessed February 2015).

70. Brian Massumi, 'National Enterprise Emergency: Steps Toward an Ecology of Powers', in *Beyond Biopolitics: Essays on the Governance of Life and Death*, ed. Patricia Ticineto Clough and Craig Willse (Durham, NC and London: Duke University Press, 2011), pp. 19–45 (pp. 27, 29).

71. Sanford Kwinter, 'Radical Anamnesis (Mourning the Future)', in *Far From Equilibrium: Essays on Technology and Design Culture* (Barcelona: Actar, 2008), pp. 140–2 (p. 142).

72. Ray Brassier, 'Nominalism, Naturalism, and Materialism: Sellars' Critical Ontology', in *Contemporary Philosophical Naturalism and Its Implications*, ed. Bana Bashour and Hans D. Muller (New York and London: Routledge, 2014), pp. 101–14.

73. Quentin Meillassoux, *After Finitude: An Essay on the Necessity of Contingency*, trans. Ray Brassier (London and New York: Continuum, 2006), p. 5.

74. Ben van Berkel and Caroline Bos, *Move: (3) Effects: Radiant Synthetic* (Amsterdam: UN Studio and Goose Press, 1999), p. 26.

11 Speculation, Critique, Constructivism: Notions for Art History

Kamini Vellodi

THE FOLLOWING IS an exploration of the potency of the philosophical notions of speculation, critique and constructivism for art history. It is not a contribution to art historical methodology, if by method we understand a form conjured in advance of thought's activity and superimposed onto its material in order to represent it and render it intelligible. Indeed, method so understood is a problem for art history – not perhaps in its genesis, but in its application.[1] For, as applied, method mediates the experience of the object, risking an abstraction into the vicissitudes of discourse conducted in the name of a given form of thought. In this regard, Svetlana Alpers raises a prescient point when she states that, 'it is characteristic of art history that we teach our graduate students the methods, the "how to do it" of the discipline [. . .] rather than the nature of our thinking.'[2] It is precisely this somewhat overlooked issue of art history's *thought* which I wish to address here, and it is to this end that the notions of speculation, critique and constructivism will be attended to.

My claim is that if art history may be understood as a discipline of thought that re-presents its objects to itself through the mediation of method (the mediation that method permits), in order to *speculatively* determine the meaning of these objects on the basis of given meaning, then the problem of the 'difference' of works of art beyond such representation resists its disciplinary attention and demands an alternative notion of thought.

I explore the characteristics and limitations of such a 'speculative image of thought' implicit in much art historical practice, through an appeal to the philosophy of the nineteenth-century American pragmatist C. S. Peirce. His thought is instructive for the discipline's self-reflection in light of its recent interest in the notion of the speculative. This interest has been triggered by the emergence of the latest star to bedazzle

the intellectual firmament, perhaps to the point of a certain blindness: speculative realism.[3] But Peirce's speculative philosophy is notably distinct from the position(s) assumed by speculative realism. And I would argue that it bears greater conceptual and methodological relevance for art history than the latter. The speculation of speculative realism, to put it in the terms of one of its most prominent advocates, Quentin Meillassoux, concerns that which goes beyond the Kantian 'correlation' between 'subject' and 'object'. It concerns the 'absolute' that is 'anterior' to all experience and judgement, that which exists independently of and 'indifferently' to us, pertaining to a world 'where humanity is absent'.[4] Art history, however, is always directly or indirectly concerned with man-made objects of experience and as they are empirically given to the historian (subject). As such the critique of 'correlation' would seem to have little to offer it.

In contrast to the speculation of speculative realism, Peirce's concept of speculation remains firmly rooted within this, human-centred, world. Moreover, Peirce supplies a pragmatic and semiotic concept of the speculative, as that which pertains to future meaning on the grounds of established meaning, which is of particular importance to art history. He articulates a conception of thought as speculative method that strongly resonates with the way in which art history as a 'scientific' enterprise – which may be provisionally defined as an enterprise that proceeds through the application of method to ascertain knowledge – has embraced the notion of speculation. His philosophy thus offers a way of clarifying the philosophical stakes, and possible limitations, of this scientific image to which the discipline arguably remains indebted.[5]

This 'diagnostic' juxtaposition of Peirce's philosophy with art history is followed by a somewhat experimental presentation of an alternative philosophical position. I argue that rather than a concept of the speculative as understood through Peirce, what is demanded both for a qualitative transformation of art history – a transformation that is of its form of thought and not just a renewal of its methods – and for attention to the work of art in the difference that resists representation, is a return to the notion of critique. For whereas I understand speculation as the methodical determination of future meaning (of works of art) on the basis of what has already been established – thus entrapping difference, as that which exceeds meaning, within the laws of resemblance – critique is that activity that attends to the limits and bounds of the (representational) form of thought upon which this determination of meaning proceeds. Moreover, I understand critique not just in this Kantian sense of attending to the conditions of art historical inquiry, in order to determine the natural bounds and limits of this inquiry, but more specifically in the sense of what Gilles Deleuze calls an 'immanent critique', which critiques the very form of thought assumed in such an inquiry in order to circumvent the limits hitherto imposed upon it.[6] Deleuze supplies us with a new conception of thought as a singular construction initiated by

the experience of the work of art in its non-representable difference. It is the potentials for the question of art history's thought of such a constructive critique – in contrast to the (Peircian) methodical speculation that implicitly resonates with its existing practices – which I will here consider.

Critique and Speculation

To set up this combative scene between critique and speculation, we might begin with a preliminary distinction. Criticism – from the Greek *krisis* [shifting, judging, discerning] and the Latin *criticus* [careful examination] – has, in Western philosophy since Kant, been understood as the practice that investigates, through an exposure of its conditions, the limits of something, either to consolidate those limits (as Kant does) or to extend beyond them. Speculation – from the Latin *speculārī* [observed from a vantage point, to watch, examine, or observe], *specula* [watchtower], *specĕre* [to look], *speculum* [mirror] – means to engage in reflective thought, especially thought with a conjectural or theoretical nature.[7] In common parlance, traceable from the sixteenth century onwards, speculation retained the sense of a reflection, generally indirect or mediated, undertaken from a superior vantage point, and (sometimes) in contrast to practical knowledge.

Such commonsensical definitions have been reinforced by the most notable philosophical adversaries and advocates of these terms: Kant, for whom speculation, as non-empirical thought (thought beyond experience), had to be checked, by critique, in order that it did not fall into dogmatism, and Hegel, who affirmed speculation as the reflective activity of thought that transgresses limits in order to grasp an 'Absolute'.[8] Criticism is a grounded, and grounding, study of an already given/existent state (the faculties of cognition already exist); speculation is a reflective act executed from a vantage point, involving a postulation of something yet to come. But insofar as the speculative postulation of future possibilities may involve, as its founding moment, a critical exploration of the conditions of these possibilities, insofar as the overcoming of limits demand acknowledgement of those very limits, the two activities are not so easily disentangled as such cursory definitions would suggest.

Kant's 1781 *Critique of Pure Reason* is the first philosophical text in which the relation, as a distinction, between speculation and critique are integral to the philosophical claims. I will set out this distinction, for the question of what a critical rather than a speculative art history might entail rests upon it.

Kant aims to ascertain those cognitions that are 'universal' and 'necessary' – for it is upon this ground that the attainment of knowledge of objects is possible. Nothing is knowable in thought alone. But necessary and universal cognitions cannot be sourced immediately from experience, which is lawless. They are, rather, sourced

from the subject's faculty of reason.[9] Critique sets out to establish the limits of reason in its 'pure' or a priori exercise, to determine the 'sources and boundaries' of reason independently of – but not completely beyond – the field of experience. The purpose of this endeavour is twofold: firstly, to prevent reason from speculating on that which goes beyond the domain of all possible experience – an illegitimate use of reason that has, for Kant, problematically characterised the history of metaphysics and led it into 'empty' dogmatic assertion; secondly, to ground our knowledge of the objects of our possible experience by supplying the a priori concepts through which we can represent those objects to ourselves. Thus critique involves a laying out both of all our 'ancestral' concepts, which comprise 'pure cognition', and of those a priori representations supplied by the sensibility, which constitutes the general conditions under which possible objects of experience are given to us.[10] The purpose of critique is both *negative*, serving not for the amplification but only for the 'purification' of our reason, keeping it free from the illusions of speculative use, and *positive*, in so far as it grounds the 'extension' of reason beyond the boundaries of given sensibility (while nevertheless retaining it within the field of possible experience). Critique is both *regulative* (it regulates reason) and *conditioning* (it determines the general conditions of our possible experience).

There are two (mutually implicated) speculative 'horizons' here, both of which Kant wishes to eliminate: the speculative exercise of reason, stripped of anything coming from experience; and the speculative object to which one cannot attain in any experience.[11] There is a speculative horizon on the side of the subject (the subject's exercise of pure reason) and one on the side of the object (the object beyond all possible experience of it – the *noumena*).[12] The investigation of noumenal reality – the reality of objects 'in themselves' – is not Kant's concern. He is not even concerned with objects.[13] His concern is solely with the 'subjective' limits of pure reason as inscribing its legitimate use in the quest for knowledge of the objects of possible experience, and the laying out of these limits as a 'groundwork' for all cognition. Critique is thus the 'well-groundedness' of thinking. It is transcendental (independent of experience), but not speculative (beyond all possible experience).

Critique and Speculation in Art History's 'Scientific' Image of Thought

Now, if speculation concerns – as it does for Kant and the speculative realists, *but not, as we will see, for Peirce and the pragmatic tradition* – that which goes beyond the world of the senses, then it would seem to have little to offer art history, which is concerned with objects of experience – documents, texts, archival materials, as well as the work of art itself – as they can be known.[14] It would be ludicrous to assert that art history is concerned purely with the cognitive capacities of the subject or the

pure limits of reason. But neither is it concerned with the object 'in itself', beyond the sensible properties by which it is given to us.[15] For even when art history engages, as it has so often done, in problems concerning the nature of the work of art, it never undertakes such study as an end in itself. Rather, such questions are always integrated into the analysis of actual works, a process that in turn always implicates the art historian as an interpreting subject. 'Objectivity' in art history is not aimed at capturing the 'absolute' status of an object but – as Erwin Panofsky, perhaps the term's most famous advocate and an avowed Kantian, clarified – about determining the conditions for the investigation of the field of possible objects given to the subject (the historian). This determination is, furthermore, not achieved transcendentally (in the Kantian sense of this term), but empirically, in an ongoing engagement with empirically given objects. It is the nature of this determination that would distinguish speculation in art history from a speculative philosophy of art.[16] Art history is a specific mode of thought about a specific field of objects – artworks – in their sensible, experiential and historical character. It is neither a speculative metaphysics nor a transcendental science (in the Kantian sense of a science that provides a systematic outline of the edifice (of pure reason) from principles with 'full guarantee for the completeness and certainty of all the components that comprise this edifice'[17]), but an empirical science that takes its departure from experience, with the aim of providing laws, general propositions and theory for what exists and is given in experience.

And indeed, understood not as a reflection on the Absolute, but as a theorising that extends beyond the *immediate* givens of experience – but *not beyond all possible empirical verification* – the notion of the speculative is by no means new to art history. For ever since its self-understanding, in the nineteenth century, as a scientific discipline of thought, or *Kunstwissenschaft*, extending beyond the positivistic inquiry raised as a possibility for the discipline by August Comte (an extension that, not coincidentally, reflected the explosion of Kant and Hegel onto its scholarly horizon), art history has implicitly embraced the idea of integrating within its conduct theoretical 'vantage points' from which to ground the assessment of empirical particularities.[18] This ambition, formative of art history's disciplinary self-identification and its accompanying characteristics of 'objectivity', grounding in facts, epistemological orientation and methodological impetus – an ambition which, to re-emphasise, we must distinguish from a speculative theory of art/speculative aesthetics, from which the pioneers of *Kunstwissenschaft* generally sought to distance themselves – continues to fuel art history and its scientific image, and drive its appeal to, and application of, concepts (a practice through which art history harbours *philosophical* inclination – a point I will return to later).

At the crucial, and still current, moment of the discipline's formation of its scientific image of thought, these vantage points onto empirical study, formulated as

'principles', 'laws' and 'concepts', were fused with a critical moment involving the observation of limitations and conditions of inquiry, of the 'bounds and limits' of art history's conduct.

We might cite a few notable examples of this critical *and* speculative scientific image of art historical thought. The critical moment in Aloïs Riegl's project concerns the limits of (Gottfried Semper's) materialist art history, giving rise to a new form of thought in which the concept of the *Kunstwollen* [artistic will] functions as a speculative concept, to be grasped on the 'basis of observation of monuments or the basis of surviving textual evidence'.[19] Panofsky formulates an explicitly critical art history, where this critique is imparted with its Kantian sense as the explication of 'a priori' conditions or 'Archimedean points' of the knowledge of the objects (works of art) specific to art historical inquiry – a process which, again, begins with 'observation' of the works themselves.[20] Speculative principles such as 'perspective' are activated upon this critical groundwork. Wilhelm Worringer arrives at the concept of 'abstraction' as a critique of the concept of empathy that he finds inadequate when empirically tested, and held up to 'that vast complex of works that pass beyond the narrow framework of Graeco-Roman and modern Occidental art'.[21] Heinrich Wölfflin formulates his famous 'principles of art history', the 'universal', 'general' '*a priori* forms of representation', that 'condition the architectural work as well as the work of representative art' through a comparative analysis of actual works.[22] Hans Sedlmayr critiques the 'subjectivist' tendencies in art historical writing, observing that a 'rigorous art history' is one in which a first, empirical 'commentary' level is supplemented by a second, speculative 'hypothetical' level.[23]

Despite their differences, these cases are united by, firstly, the grounding of the speculative/theoretical instances of inquiry in a critique of prior assumptions of art history and, secondly, by the methodological interaction of the speculative (as theoretical moment) with the empirical – for the principles that extend beyond specific works nevertheless demand constant testing against actual works for their validation. Speculation here might be best understood as an activity of theoretical mediation of empirical data (through method) operating within a groundwork cleared by critique. In this sense, it resonates less with Kantian transcendental philosophy than with philosophical pragmatism.

A Peircian Art History? Pragmatic Speculation and Method

The pragmatic philosophy of Peirce – a philosophy oriented towards the 'conceivable bearing [of conceptions] upon the conduct of life' – provides a powerful conceptual horizon for addressing the nature of art history as a science and, in particular, the functioning of speculation within it in terms of a methodical

mediation between theory and the empirical.[24] Peirce's philosophy has been subject to much, often reductive, attention from art history for its famous tripartite classification of signs – into icons, indices and symbols.[25] However, perhaps more than the specificities of his semiotic classifications, it is the pragmatic principles of his philosophy – the notion of a science as critical but 'observational' method, as experimental synthesis of general principles and particular cases, and as a progressive speculative determination of meaning on the basis of previous interpretations, conducted among a community of subjects – that bear the most productive implications for art history's methodological self-reflections[26] – as both Panofsky and his brilliant student Edgar Wind intimated.[27]

The notion of speculation, rescued from its moorings in transcendental philosophy and given a decidedly empirical cast, is integral to Peirce's system. 'Speculative', he writes, 'is merely the Latin form corresponding to the Greek word "theoretical" and is here intended to signify that the study [of signs and their essential conditions] is of the purely scientific kind, not a practical science, still less an art.'[28] This 'science', although called a 'process of reasoning', and although called 'theoretical', is not stripped of experience and the 'practical' element of determination. The speculative thus loses its Kantian, transcendental, sense as that which illegitimately goes beyond all possible experience. Indeed Peirce explicitly rejects Kant's claim that there can be a priori, transcendental concepts, or a pure reason.[29] Instead, speculation is integrated within an 'observational science', where observation is the process of noticing the *actual* effects of signs outside the intellect. Speculation – the theoretical determination of future meaning that is checked through observation[30] – and critique – the laying of a groundwork for speculation through the exposure of bounds and limits – are mutually implicated activities in the processual activity of meaning-determination.

Method is the centrepiece of Peirce's epistemology and it is conceived dynamically. This dynamic conception reflects Peirce's radical conception of the sign as open, as 'anything which stands for something (called an object) to something (called an interpretant).[31] The interpretant perpetuates the signalling process, pivoting around the *same* object ad infinitum – but ideally towards an ultimate meaning, grounded in what Peirce calls a 'final interpretant', an outcome that will be shown to be always present and on which everyone will consent (insofar as everyone, at least ideally, thinks rationally) after the 'sufficient development of thought'.[32] This procedure of thought's ongoing grounding and control proceeds through a method that incorporates experiment into what Peirce calls 'diagrammatic' visualisation – a process by which we attain 'laws' with increasing certainty, moving from speculative particulars to definite generals through an ongoing testing against real cases.[33] One observes the correspondence, or resemblance, of schematic principles with the observed cases, and adjusts the method accordingly, until we arrive at a coherent and regulated system

grounded in similitude. Thought tightens its grasps on itself as the speculative meaning of that which it interprets is consolidated.

This conception of speculation as a methodical theorising that extends beyond the immediate givens of experience, but not beyond all possible empirical verification, bears obvious resonance with art history in its established practices. The conception of science as observational clearly has significance for a discipline that takes as its objects things that are observed. This was an analogy not lost on Panofsky, who wrote that for both a (humanistic) art history and a (natural) science, 'the process of investigation [which culminates in a priori principles] seems to begin with observation.'[34] Indeed, if Panofsky may be said to be the figurehead of art history's 'Kantian syndrome', it is perhaps more accurately in the terms of this pragmatic Kantianism, where so-called a priori principles (which are in any case never truly a priori since they are not independent of experience) are methodically *deduced* – through an observation of their adequacy when tested against real/actual cases – rather than given in advance.[35]

Like Peirce, Panofsky conceives of method as an 'elastic' groundwork: 'Every discovery of an unknown historical fact, and every new interpretation of a known one, will either "fit in" with the prevalent general conception, and thereby corroborate and enrich it, or else it will entail a subtle, or even a fundamental change in the prevalent general conception, and therefore throw new light on all that has been known before.'[36] It was this elastic, critical groundwork conceived, and refined, through dynamic engagement with actual, observable works or documents that had likewise been upheld by Riegl, Worringer and Wölfflin. Wind is heir to such an outlook. He describes the historian's method as an appeal 'to a system of grammatical and critical rules, on which he bases his interpretation and which, in their turn, are tested by being applied.' He criticises the Kantian system for its transcendentalism, for the '*a priori* and generalised method of reasoning', and for its orientation towards 'truth'. The method of the historian must instead integrate erratic 'intrusions' into its process of 'discovery', which can only be accounted for 'if the methodical rules of investigation are considered as part of the experimental hypothesis.' The historian must 'insert himself into the process, and the rules according to which he does so are proved by the outcome of the experiment to be either true or false, or doubtful.'[37] 'Science' here is a dynamic process of observation, in which thought consolidates its purchase on itself and its objects, through experimental method.

But according to such an image of thought, which ultimately aims to consolidate itself under the aegis of law, the more thought thinks, and the more it progresses towards the attainment of its groundwork, the greater the risk that method, even if originally conceived elastically and processually, detaches itself from its real object – the work of art. This desire to ground, this steering of interpretation towards

representational 'closure', this aim to know 'with certainty' are, surely, some of the strongest after-effects of *Kunstwissenschaft*'s legacy for scholarship. And such ambitions fuel the preoccupation with the methods by which they can be attained, indubitably in favour of a problematisation of the implicit beliefs in certainty, knowledge and representation as values.[38]

When, for instance, Robert Echols and Frederick Ilchman, referring to the scholarship on Jacopo Tintoretto, state that before anything else a 'solid foundation' must be built through an 'investigation of the facts of the case', without which 'the work on this subject will never come to an end', they expose the perniciousness of this drive towards representational closure. Indeed, the work on this artist – strikingly unorthodox and yet taken as 'representative' of sixteenth-century Venetian painting – may be cited as an example of art history's speculative projection of interpretation on what has already been established, in order to 'deepen the knowledge already acquired'.[39] For almost without exception, the 'fact' of the motto attributed to Tintoretto by the sixteenth-century writer Carlo Ridolfi, that the artist effected a synthesis of Titian's *colorito* and Michelangelo's *disegno*, thereby fusing two artistic traditions, is reiterated as the grounding, interpretative horizon for discourse. Such reliance on scholarship's prior discoveries exposes at least three problematic features: *firstly, the detachment of discourse and speculative interpretation from the experience of the artwork; secondly, the grounding of the form of future discourse on what art history already knows of its object; and thirdly, the orientation of scholarship towards a speculative totality of interpretations.* Here we find the scholarly, scientific thought of artwork as a form of representation, as an ongoing, progressive, collective and cumulative endeavour that builds upon itself, practising the Peircian supposition baldly stated by Arnold Hauser, that 'the meaning that a work assumes for a later generation is the result of the whole range of previous interpretations.'[40]

The risk of a certain idea of critique, as *groundwork*, is that the ground is subsequently *uncritically* assumed. Method is what converts the critical impulses of art history into a habitual form of inquiry that foregrounds speculation on content (meaning) as theoretical prediction over the critical interrogation into conditions and limits. This is indeed the risk posed by Peirce's philosophy, and to all art history that practices under such a scientific image. Panofsky himself was not free from it, allowing 'critique only a brief moment of passage' before consolidating the methods (iconography, iconology) that were so evidently successful.[41] His statement that things are always 'involuntarily' assumed before investigation commences, that we know in advance what it is for which we search and to this extent 'the beginning of our investigation always seems to presuppose the end', are indicative of this destiny of groundwork as foreclosure.[42] It is attention to the work of art as something other than an object of knowledge that is, as a consequence, suppressed.

From Speculation to Construction: Deleuze's Immanent Critique

But what if art history were to consider an alternative notion of critique? Critique not as a groundwork that cements thought in its own presupposed image, not as a search for the 'sources and boundaries' of its 'natural' conduct as determined prior to its practice – but critique as the undoing of all previous assumptions, as a movement of thought outside the conditions of an inherited image? What if art history were to move away from the Kantian notion of critique as the regulative determination of its epistemological reaches (preserved by Peirce within an empirical horizon) towards a Nietzschean idea of critique as the amplificative process of determining the forces that shape thought and bring about its genesis?

Using Nietzsche as the means of taking 'Kant beyond Kant', Deleuze articulates such a possibility of critique as creation. For him, 'that which forces thought to raise up and educate the absolute necessity of an act of thought' provides the conditions for a critique, inasmuch as 'the conditions of a true critique and a true creation are the same: the destruction of an image of thought which presupposes itself and the genesis of the act of thinking in thought itself.'[43] Critique is no longer the grounding of thought in its own image via the delimitation of its conditions of operation. Critique is total and immanent, a genesis of thought anew occasioned by something exceptional in experience.

Inaugurating the critical project from the assumption that thought is rational, Kant is unable – for Nietzsche, and for Deleuze in Nietzsche's wake – to realise his declared project of an *immanent* (the critique of reason by reason itself) and *total* (insofar as nothing should escape it) critique of reason. As Nietzsche puts it, 'how should the tool be able to criticise itself when it can, precisely, only use itself for the critique? It can't even define itself.'[44] Kant's critique, Deleuze states, 'begins by believing in what it criticises', investing critique as a force that bears upon the claims of reason, but not upon reason itself.[45] Peirce too initiates critique from the unwavering conviction that everyone can (and should) think rationally. Insofar as art history, in its scientific image of thought, implicitly (and quite often explicitly) retains this rationalist prejudice, its critique may also be said to be an incomplete project, operating in the name of an image of thought upon which it has decided in advance.

Embracing the possibilities envisioned by Nietzsche, Deleuze takes up Kant's betrayed gauntlet, laying out the terms and stakes of a total and immanent critique. No longer that which applies transcendental principles as the conditioning of knowledge, critique is newly conceived as that which bears on the forces that constitute these principles as mutable values, as that which examines the internal principle of their genesis to unleash the 'radical whirlwind' of thought let loose by their unhinging.[46] From the Kantian critique, content with 'criticizing things in the name of

established values', including the established value of reason, we pass to 'the genetic and plastic principles that give an account of the sense and value of belief, interpretations and evaluations'.[47] This is a critical process no longer arbitrary and indiscriminate, undertaken through the cold lens of reason, but rather 'vital', and undertaken as an imperative, because, as Nietzsche puts it, something 'wants to live and affirm itself, something we might yet not know or see'.[48]

While Peirce foregrounds process, experimentation and the dynamism of interpretation in his conception of thought, this is undertaken from the reassuring auspices of reason. But for Deleuze, to think (which is to think creatively) is to liberate from assumed terms, given territory, or conceptual horizon – including trenchant rationalist presuppositions. Thought is not a regulatively critical, purifying procedure of determining its own legitimacy. Thought as creative act is a violent occasion instigated by the embrace of the illegitimate, by the encounter with that which we do not yet know or see.

Again, we note the reversal of the Kantian criteria in which critique excavates the a priori conditions of possible experience, determining a regulative horizon forever in excess to the actual objects of our real experience. For Deleuze, the experience of reality – not reality in the mediated guise of a given object, but the transcendental reality of differing beyond the transcendent determinations of subject and object – becomes the source of thought anew. With this, speculative enterprise is abandoned. Speculation as that which ideally or absolutely traverses possible (and real) experience is rejected. Insofar as for Deleuze thought begins with experience, the speculative search for the object 'in itself' beyond the experiential horizon of a subject is patently not a philosophical ambition to which he aspires. Insofar as the genesis of thought undoes the 'vantage points' from which it can reflect upon and represent its condition, speculation, as the (Peircian) grounded mediation between the theoretical and the empirical, is also rejected. *Speculation is altogether displaced, by construction.*[49]

Much rests on this notion of construction, pivotal to the Deleuzian ontology. Construction is a practice of concepts that replaces the use of 'petrified', ready-made concepts with a creation of concepts, or at the least the awakening of a dormant concept to 'play it again on a new stage, even if this comes at the price of turning it against itself'.[50] For, once again invoking Nietzsche, Deleuze tells us that 'you will know nothing through concepts unless you have first created them – that is, constructed them in an intuition specific to them.' Constructivism 'requires every creation to be a construction on a plane that gives it an autonomous existence'.[51] Construction thus abandons the Kantian transcendental synthesis of a priori, 'petrified' concepts and sensible forms. It departs too from the Peircian empirical synthesis of general principles and particular cases. Constructivism engages a synthesis of difference – the difference in the sensible that exceeds the determination of given

concepts. This is a disjunctive synthesis, which remains disjunctive by retaining the terms it relates as disjoined and irreducible to each other.[52]

Constructivism is a resolutely anti-methodical and unmediated activity that springs not from reasoning, and not from a 'taste' for thinking, but under the impulse of a shock.[53]

And it is the work of art that conditions this experience. Understood not as a form to be reflected upon or represented, and not as a historically sanctified entity whose purchase on a disciplinary image of thought is established, it is the work of art as a 'capture of difference in its differing', which supplies the occasion, as well as the paradigm, for a thought as critical creation.[54] In Deleuze's constructivism, a new idea of critique as the destruction of a pre-existing image of thought is bound with a new ontology of art as the capture of difference. It is as such that its potentials for art history may be grasped.

Here we would find a work of art functioning as a condition for a new type of inquiry – one that displaces a transcendental critique as a search for the sources and boundaries of art history's natural conduct as established prior to its practice with an immanent critique staged through the singular real experiences of an artwork that *occasions* its operation; one that challenges the *established* values of certainty, knowledge and representation with an affirmation of that which is unknowable and un-representable, that which is different, in the work of art; one that foregrounds the *experience* of the work in its difference over the methodical, mediated procedures of thought, and begins from this experience, rather than from the groundwork erected by the accumulated wealth of scholarship; one that in its materialisation lingers in this field of difference, without seeking recourse to the ascertained terms of discourse. Constructivism attends to what continues to confront us experientially beyond the disciplinary parameters of knowledge and completion of fact. The work of art would be the object of this thought not as one among many possible objects given to be reflected upon, but as a singular occasion that forces thought beyond the discourse we already know and from which we customarily make speculative propositions.

Deleuze's Constructivism and Art History?
The case of Negroponte's *Madonna and Child*

In an easily overlooked side chapel of the Church of San Francesco della Vigna in Venice hangs a mysterious, half-forgotten altarpiece by an artist cloaked in obscurity. This *Madonna and Child*, the only known work by Jacopo da Negroponte, declares itself as a work not to be ignored, and yet frustrates ambitions to know it. An enthroned Virgin, dressed in a gown of rich gold brocade, her elegant head framed by a bejewelled nimbus, sits in a highly ornamental and almost fantastic

marble throne of exquisite relief and *trompe l'œil*. On her lap, the Christ Child lies as though floating. To either side of the couple stand onlooking angels of disproportionately diminutive scale, while behind the throne a mass of flowers and shrubbery bloom. In the foreground, a variety of birds in meticulously rendered plumage peck and strut. A festoon of fruit and pink ribbons crowns the throne in a perfect arch, above which hovers the figure of God, bursting from a sky where winged angels swim in clouds.

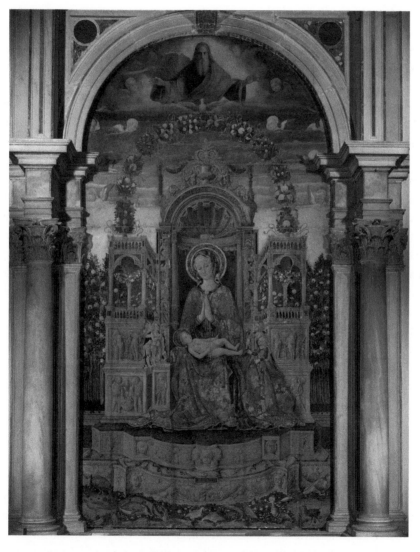

Jacopo da Negroponte, *Madonna and Child Enthroned*, 1455, egg tempera on panel, 300 × 235 cm. San Francesco della Vigna, Venice, 2016. Image copyright Scala, Florence

We are presented here with a rich panoply of elements, a strangely enticing and unresolved synthesis of hybrid traits half-identified. But there are few facts about the circumstances of the work's production, about its maker or about its reception. As such it has received barely any attention from art historians. The fact that the artist was a monk is attested to by the signature on the painting: *Pater Antonio Negroponte pinxit*. Otherwise, all that is 'known' is speculated on the basis of previously held facts that concern the work only indirectly. The hypothesis, for instance, that it was painted around 1450 is determined by our knowledge of other works from that period. But this leaves us with very little.

The experience of a work that stands before us in such stubborn silence is distressing. We are tempted to turn away from that which frustrates the urge to render intelligible. But rather than accede to this temptation, such initial confrontation might instead be looked upon as an occasion.

It is perhaps at such a juncture that a speculative practice of art history and an immanently critical, or constructive, practice diverge. For to a speculative practice, in the sense in which we have understood it, even such a mysterious work is considered as an object of experience that *can* be known – and neither as an object that can only be experienced nor as an absolutely ineffable object, outside all possible experience and knowledge. Here the work, in all its mystery, is related to what we, as a collective community of art historians, have already given meaning to, via the laws (for example) of resemblance and (historical and semantic) contiguity. The traits of the work we experience are referred to the intelligible terms of art history: the patterned exuberance of flora and fruit are referred to the style of the International Gothic, the magnificent sculpted throne is referred to a Mantegna-esque revival of classical antiquity and to the forms of contemporary Venetian architecture, the figure of God is referred to the chromatism and curious starkness of Lorenzo Lotto (it seems to be a later addition by another hand), the bejewelled nimbus is referred to Orthodox Cretan Icon painting. Based on what we know of the stylistic evolution of Venetian painting, we date the work; based on what we know of the distinguishing features of contemporaneous schools of Italian painting, we infer the painter's relations with trends within and outside Venice; based on the hallowed accumulation of previous scholarship, we render intelligible, and 'plausible', our speculations, giving foundation to experiments in thinking initiated by the experience of an unknown difference. We thus see how the slide into the terrain of discourse and interpretative battle begins. We see how the observational method sets to work, synthesising the particular cases given to experience with generic principles already deduced, in the name of a continuous determination of meaning. We see how the unknown is framed within the known. Perhaps the former will, as Panofsky said, 'shed new light' upon the latter, but its difference is nevertheless subordinated to the terms already possessed

in advance of this relation. The problem of the work of art's difference, as the unintelligible that resists the grip of meaning and the grasp of knowledge *and in this resistance becomes productive*, is subsumed by such methodological urges.

Constructivism, on the other hand, concerns precisely the affirmation of the experience of this difference that resists the reassuring domain of representation in order to produce. Thought does what the work does, again. In place of a referral of difference to the groundwork of petrified concepts, difference is affirmed through the creation of concepts or the replay of a dormant concept 'on a new stage'. And what is disjunctive in the work is kept so.

Constructivist affirmation is something that may take place both within another artistic practice and within the enterprise of writing, where writing is understood as the re-materialisation of the difference that thought is made to think in the encounter with the work.[55] Thus two further questions, intertwined inasmuch as the first finds expression as the second, pose themselves: firstly, how might the 'historian' attend to the future affirmations of a work's difference in other artistic practices? Secondly, how might he write in such a way that preserves an experience of difference and makes it experienceable again?

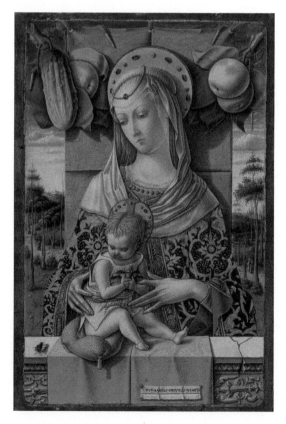

Carlo Crivelli, *Madonna and Child*, *c.*1480, tempera and gold on wood, 36.5 × 23.5 cm. Courtesy the Metropolitan Museum, New York, 2016. Image copyright the Metropolitan Museum of Art/Art Resource/Scala, Florence

Turning to the first, let us consider the highly idiosyncratic practice of the Venetian painter Carlo Crivelli (1430–95), another practice veiled in obscurity. Here, we find once again the combination of classicism and Gothic, of austere friezes with ripened fruit and flora encountered in Negroponte's work – but now extremised. Crivelli's work synthesises the 'traits' of Negroponte's into a new coherent, albeit bizarre, style. In *The Madonna and Child* (1480), the delicately veiled Virgin, standing behind a mantle adorned with classical relief and who like Negroponte's Virgin gazes downwards to her right with tilted head, is again crowned by an ornamental, Byzantine-style nimbus and is again dressed in heavy ornamental brocade. Behind her head hangs a heavy garland of fruit and vegetables, enlarged to the grotesque and beyond the proportions religious symbolism reasonably requires. Her delicacy has been exaggerated to mannerism, seen especially in the sinewy fingers that grasp the Holy Child like lifeless tendrils. The traits of artifice and ornament in Negroponte's work are taken to excess, while the naturalism is apparently lost altogether. The brocade is more metallic, the gaze cooler, the palette has become overcast and foreboding – but there are no signs of Negroponte's observational rendering of aviarian or floral detail. It is as though only what is strange in Negroponte's work is emphasised and everything else forgotten.

We find here artistic practice operating as immanent critique. Crivelli does not slavishly copy everything in Negroponte's work. Neither does he attend to the established aspects of Negroponte's work from the (transcendental) position of assuming them as established and given in advance of the critical process of painting in order to more firmly ground his own practice. Rather there is a process of selection, of discrimination, whereby what is excessive *makes itself* return against the norm, in the process producing something again obscure and rendering what was originally uncertain even more so. It is perhaps not irrelevant in this regard that Crivelli had no immediate followers and remained formally marginal in the subsequent development of Venetian painting.

Attention to this phenomenon of affirmation must guard itself against the tempting and obvious draw of the historian's category of influence, which naturally rears its head whenever two practices between which resemblances are noted are being discussed. But it is not *for* resemblance that we are discussing the Crivelli-Negroponte relation, even though this relation involves resemblance. We are attempting to think the critical notion of *return* against the descriptive category of *influence*. Influence considers the way one thing resembles, through a conscious and voluntary appeal, the established forms of its source, while leaving those established forms intact in the process. But return is the critical affirmation of the excessive as an *imposition* of the source, which has nothing to do with 'artistic intention', and is a process by which the source becomes disfigured and difficult to identify. Something 'in'

Negroponte's work (which is at once beyond the work) returns 'by itself' – because it is so strange it refuses to be ignored.

Accordingly, a certain conception of writing is called upon. One that does not just describe this state of affairs, treating what is dynamic as a given actuality to be neutrally restated. At the same time, it is not necessary that the abandonment of scientific rigour or 'objectivity' should mean a return to the exuberant rhetorical and ekphrastic devices of nineteenth-century art criticism, where unapologetically subjective assessments were guided by a somewhat dubious relation to the concept of taste. Actually, Deleuze's philosophy supports the 'impersonality' that the objective historian aspires to. But this impersonality is yet more radical than the impersonal position permitted by any objectively indiscriminate approach to artworks via the meditation of method or theoretical 'vantage points'. To write, Deleuze says, is certainly not to impose a form onto the matter of lived experience. Writing goes beyond the matter of lived experience.[56] Writing is the expression of the difference that thought is made to think, that the thought it embodies is made to think by the experience of a work in its difference from the matter of lived experience. The work is a capture of difference, constructive thought is a re-capture of this difference in concepts and constructive writing re-materialises this difference. Thus writing functions as the moving barometer of the exceptional state of affairs whereby difference becomes the object of a new kind of experience, and in this becoming discriminates itself from other works, while inciting the one who experiences to create new concepts adequate to the experience. This at once challenges the anodyne indiscrimination of the 'objective' approach and the over-discrimination of a 'subjective' one.

It is to this end that we may consider the Negroponte *Madonna* as a 'disjunctive synthesis'. Painting functions here as difference without resolution, capturing difference as traits – traits of naturalism, of Mannerism, of classical antiquity, of Venetian Gothic, of Byzantinium – without resolving them harmoniously. The work is the scene of a collision, the site of an opening towards resolutions beyond its disjointed form. It is in this sense of irresolution that it 'wants to live', and that it presses upon art history as insistence. Yes, of course, the work looks to the established elements of the past and the contemporary. But it does so as an extractor of the traits it fuses to produce something strange and excessive to each of them and the respective traditions to which they belong. This is its distinguishing feature: its functioning as a disjunction that gestures towards the future of artistic practice and calls out, as injunction, to the task of thinking.

Deleuze's concepts – of disjunctive synthesis, of construction, of difference – are 'played again' on the stage of art history. 'Art History' was never an explicit problem for Deleuze. It was always singular works of art with which he was concerned, stripped from the empirical data of historical connections and circumstances. So in attempting

to replay his concepts on the art historical stage we are perhaps already engaging in the kind of constructivist reversal that he advocates. It is in articulating the possibility of such constructions, which are not the constructions *of* art history, that Deleuze's philosophy has something to offer art history. And yet, strangely, this is perhaps nothing more than what certain works of art can and do offer. Negroponte's Virgin may remain obscure to us, but she has made us think.

Notes

1. This is intimated by Georges Didi-Huberman, when he speaks of art history's 'spontaneous instrumental and uncritical use of certain philosophical notions'. The problem is that of the application, which assumes the terms applied as given, and in so doing sanctions them. *Confronting Images: Questioning the Ends of a Certain History of Art* (Philadelphia: Pennsylvania State University Press, 2004), p. 6.

2. Svetlana Alpers, 'Is Art History?', *Daedalus*, 106, 3 (1977): 1–13 (p. 9).

3. In Quentin Meillassoux's words, correlation is understood as 'the idea according to which we only ever have access to the correlation between thinking and being and never to either term considered apart from the other', that we cannot grasp an object in itself in isolation from the subject and we cannot grasp a subject that would not always already be related to an object. *After Finitude* (London and New York: Continuum, 2008), p. 5.

4. Ibid. p. 26.

5. Contemporary views on this scientific classification of art history vary considerably. Sympathisers include Mark Roskill who states that 'art history is a science, with definite principles and techniques, rather than a matter of intuition or guesswork'. *What Is Art History?* (New York: Harper & Row, 1976), p. 9. See also W. E. Kleinbauer, *Modern Perspectives in Western Art History* (New York: Holt, Rinehart & Winston, 1971), pp. 1–104. Donald Preziosi argues to the contrary: 'art history is not an empirical or experimental science' but the reasons why he thinks so are unclear. *Rethinking Art History: Meditations on a Coy Science* (New Haven: Yale University Press, 1991), p. 9.

6. Michael Podro defines a critical art history as one that goes beyond the 'archaeological' search for historical facts and studies 'the concept of art'. He does not, however, define more precisely the concept of critique, and refers to the art historical interest in Kant with respect to the somewhat vague 'opposition between human freedom and the constraints imposed by the material world'. *The Critical Historians of Art* (New Haven: Yale University Press, 1984), pp. xviii, xxi. For the sake of simplicity, throughout this essay the nomination 'Deleuze' will be used to refer both to texts written by Deleuze, and to texts written by Deleuze with Guattari. It will be clear to the reader which texts are being referred to in specific cases.

7. Note the etymological overlap between speculation and theory (from late Latin *theōria*; Greek θεωρία [looking at, viewing, contemplation, speculation]). *Oxford English Dictionary* (Oxford: Clarendon Press, 1987).

8. Kant defines dogmatism as 'the presumption of getting on solely with pure cognition from (philosophical) concepts according to principles, which reason has been using for a long time without first inquiring in what way and by what right it has obtained them. Dogmatism is therefore the dogmatic procedure of pure reason, without an antecedent critique of its own capacity.' Kant critiques metaphysics for speculatively dealing with the problems of pure reason – God, freedom, immortality – without an antecedent examination of the capacity or incapacity of reason for such a great undertaking. Such ungrounded speculation leads to dogmatism. Immanuel Kant, *Critique of Pure Reason* (Cambridge: Cambridge University Press, 1999), Preface to the Second Edition, Bxxxvi. Throughout the notes I will use the standard means of referencing Kant's texts in their A and B editions (which is clearly marked within the Cambridge edition).

9. Ibid. A2.

10. Ibid. A12, 14, Bxxxiv. Kant's use of the notion of the ancestral is particularly interesting, given its renewal by Meillassoux for whom it designates, however, something quite contrary: 'any reality anterior to the emergence of the human species' and beyond the 'correlation' of thinking subject and sensible object. *After Finitude*, p. 10. For Kant, cognition includes elements supplied both by the sensibility – the faculty through which objects are given to us – and the understanding, through which they are thought.

11. When Kant characterises transcendental philosophy as 'a philosophy of pure, merely speculative reason', he is distinguishing it from the containment of anything 'practical' which 'belongs to empirical sources of cognition.' Ibid. A15/B29.

12. These are mutually implicated, insofar as the speculative use of reason attends to 'objects' in their condition beyond the possible experience of them.

13. 'Our object is not the nature of things, which is inexhaustible, but the understanding, which judges about the nature of things, and this in turn only in regard to its *a priori* cognition.' Immanuel Kant, *Critique of Pure Reason*, A13.

14. On art history as a discipline of 'specific knowledge of the art object' see Didi-Huberman, *Confronting Images*, p. 1.

15. See Erwin Panofsky: 'In epistemology the presupposition of this "thing in itself" was profoundly shaken by Kant: in art theory a similar view was proposed by Aloïs Riegl. We believe to have realised that artistic perception is no more faced with a "thing in itself" than is the process of cognition: that on the contrary the one as well as the other can be sure of the validity of its judgments precisely because it alone determines the rules of the world (it has no other objects than those that are constituted by itself).' *Idea: A Concept in Art Theory*, trans. Joseph Peake (London: Icon, 1924), p. 126.

16. As clarified by Jean Louis Schaeffer, the speculative theory of art, or speculative aesthetics, that arose in the aftermath of Hegel's philosophy, aimed to provide a philosophical legitimation of the ontological function of Art as the vehicle of truth. Its search for the ideal essence of Art is 'always deduced from a general metaphysics'. Artworks are deciphered as empirical realisation of this ideal essence, as determined by speculative aesthetics (*Art of the Modern Age: Philosophy of Art from Kant to Heidegger*, trans. Steven Randall (Princeton: Princeton University Press, 2000), p. 7). In contrast, the speculation within scientific art history takes the analysis of actual, empirically given *works* of art as its starting point for theoretical claims. Whereas speculative aesthetics sacralises Art over its empirical instantiations as artworks (p. 13), speculation in scientific art history foregrounds art works over the idea of Art. Speculative aesthetics is the counterbalance to scientific knowledge (p. 11).

17. Kant, *Critique of Pure Reason*, B27.

18. Mitchell B. Frank and Daniel Adler remark that 'Kunstwssenschaft traditions included speculative statements that many empirical scientists would have dismissed.' *German Art History and Scientific Thought* (Farnham: Ashgate, 2012), p. 5. Cf. Donald Preziosi's remarks on the 'rich speculative tradition' rising from art historical practice at the turn of the nineteenth century, in *Rethinking Art History*, p. 3.

19. Aloïs Riegl, 'The Main Characteristics of the Late Roman *Kunstwollen*', in *The Vienna School Reader: Politics and Art Historical Method in the 1930s*, ed. Christopher S. Wood (New York: Zone Books), pp. 87–104 (p. 94).

20. Erwin Panofsky, 'The Concept of Artistic Volition', trans. Kenneth J. Northcott and Joel Snyder, *Critical Inquiry*, 8 (1981), 17–33 (p. 18).

21. Willhelm Worringer, *Abstraction and Empathy: A Contribution to the Psychology of Style*, trans. Michael Bullock (London: Routledge Kegan & Paul, 1953), p. 8.

22. Heinrich Wölfflin, *Principles of Art History*, trans. M. D. Hottinger (New York: Dover, 1950), pp. 8, 13, 7, 227.

23. Hans Sedlmayr, 'Towards a Rigorous Study of Art', in *The Vienna School Reader: Politics and Art Historical Method in the 1930s*, ed. Christopher S. Wood (New York: Zone Books), pp. 133–79 (p. 139).

24. C. S. Peirce, *Philosophical Writings*, ed. Justus Buchler (New York: Dover, 1955), p. 253.

25. See, for instance, the work of Margaret Iversen: 'Saussure versus Peirce: Models for a Semiotics of Visual Art', in *The New Art History*, ed. A. L. Rees (London: Camden Press, 1985), pp. 82–94.

26. *Collected Papers of Charles Sanders Peirce*, 6 vols, ed. Charles Hartshorne and Paul Weiss (Cambridge, MA: Harvard University Press, 1931), VI, p. 490; *Essential Peirce*, 2 vols (Bloomington: Indiana University Press, 1998), II, p. 218. This seems to be the point made by James Elkins in his paper: 'What Does Peirce's Sign Theory Have to Say to Art History?', *Culture, Theory, and Critique*, 44, 1 (2003): 5–22: 'the muddling negotiation

between the enforcing rigor of logic and the myriad phenomena of experience is Peirce's real lesson for art history' (p. 19).

27. Erwin Panofsky, 'The History of Art as a Humanistic Discipline', in *Meaning in The Visual Arts* (London: Penguin, 1983), pp. 23–51. Edgar Wind, 'Some Points of Contact Between History and the Natural Sciences', in *Philosophy and History: Essays Presented to Ernst Cassirer*, ed. Raymond Klibansky (New York: Harper & Row, 1963), pp. 255–64. The infiltration of Peircian ideas into art history through Wilhelm Dilthey, the absorption of whose hermeneutics into art historical scholarship is acknowledged, warrants further attention. Otto Pächt makes a direct reference to Dilthey's method in his description of (a rigorous) art history as a practice beginning with a hypothesis and continuing as a verification through an extended process of deduction and inference via a testing against empirical cases. Otto Pächt, *The Practice of Art History: Reflections on Method*, trans. David Britt (New York: Harvey Miller, 1999), p. 30.

28. *Essential Peirce*, II, p. 328.

29. *Essential Peirce*, I, p. 67.

30. For it is future meaning that is the destination of Peirce's semiotic: 'the conclusion of a Reasoning proper must refer to the Future', *Essential Peirce*, II, p. 359.

31. Ibid. p. 272.

32. *Collected Papers of Charles Sanders Peirce*, II, p. 92.

33. *Essential Peirce*, II, pp. 502, 303. I have written in more detail on Peirce's concept of the diagram, and its distinction from Deleuze's diagrammatics, in my article 'Diagrammatic Thought. Two Forms of Constructivism in C. S. Peirce and Gilles Deleuze', *Parrhesia*, 19 (2014): 79–95

34. Wind argues for the integration of scientific and historical research. Panofsky argues for the grounding of the latter on the former as well as retaining the awareness of the singularity that demarcates their distinction – the specificity of the object that is the work of art. Note Panofsky's description, in 'The History of Art as a Humanistic Discipline', of the method of the humanist art historian beginning with observation, commencing with interpretation and finally culminating in classification and coordination into a coherent system that 'makes sense' (pp. 29–30).

35. Didi-Huberman, *Confronting Images*, p. 6.

36. Panofsky, 'The History of Art', pp. 32–3.

37. Wind, 'Some Points of Contact Between History and The Natural Sciences', pp. 260–1.

38. This is a central point of contention in Didi-Huberman's work. *Confronting Images*, pp. xv–9.

39. Detlev Von Hadeln, *The Burlington Magazine for Connoisseurs*, 48, 276 (March 1926), 116.

40. Arnold Hauser, *Philosophy of Art History* (London: Routledge, 1959), p. 3.

41. Didi-Huberman, *Confronting Images*, p. 5.

42. Panofsky, 'The History of Art', pp. 29, 32.

43. Gilles Deleuze, *Difference and Repetition*, trans. Paul Patton (London and New York: Continuum, 2001), p. 139.

44. Friedrich Wilhelm Nietzsche, Notebook 2 [87], in *The Late Notebooks* (Cambridge: Cambridge University Press), p. 76.

45. Gilles Deleuze, *Nietzsche and Philosophy*, trans. Hugh Tomlinson (New York: Athlone Press, 1983), p. 90.

46. Didi-Huberman, *Confronting Images*, p. 5.

47. Deleuze, *Nietzsche and Philosophy*, p. 93.

48. Friedrich Wilhelm Nietzsche, *The Gay Science* (Cambridge: Cambridge University Press), p. 307.

49. In *Nietzsche and Philosophy*, Deleuze shows how Nietzsche critiques the (Hegelian) idea of speculation in favour of 'dramatisation'. Whereas speculative propositions bring a proposition into play from the point of view of dialectically-inflected form, a dramatic proposition supplants the absolute determination of speculation with 'relative determinations which correspond to the forces entering into synthesis with or in the idea' being problematised: 'The dramatic proposition is synthetic, therefore essentially pluralist, typological and differential.' *Nietzsche and Philosophy*, pp. 152, 9.

50. Gilles Deleuze and Félix Guattari, *What Is Philosophy?* (London: Verso, 1994), p. 83.

51. Ibid. p. 7.

52. On this notion of disjunctive synthesis, see, for example, Gilles Deleuze and Félix Guattari, *Anti-Oedipus* (London: Continuum, 2004), pp. 84–5.

53. 'Men think rarely, and more often under the impulse of a shock than in the excitement of a taste for thinking.' Deleuze, *Difference and Repetition*, p. 132.

54. Ibid. p. 56.

55. 'It goes without saying that Nietzsche leads philosophy and thought in general into a new element. What is more, this element implies not only new ways to thinking and "judging," but also new ways of writing, and maybe acting.' Gilles Deleuze, 'On Nietzsche and the Image of Thought', in *Desert Islands and Other Texts, 1953–1974*, trans. Mike Taormina (Los Angeles: Semiotext(e), 2004), pp. 135–43 (p. 136).

56. Gilles Deleuze, *Essays Critical and Clinical*, trans. Daniel W. Smith and Michael A. Greco (London and New York: Verso, 1998), p. 1.

12 The Potentiality of Art, the Force of Images and Aesthetic Intensities

Bertrand Prévost

Translation by Bernard Schutze

Is IT STILL possible to evoke the potentiality of art or the force of images without coming up against the double stumbling block of rhetorical platitude or aesthetic mysticism? The field seems to be mined ... At least since the Italian Renaissance, in fact, the vocabulary of force has never ceased to occupy the field of art – precisely the *vocabulary*, so that this potentiality was to be determined only under the modes of invocation or evocation, existing only rhetorically: nothing more than lip service. Sometimes one speaks of 'effect', sometimes of 'movement', 'all the while knowing full well' – common sense tells us that an image which is inert, still and material by definition, cannot in itself possess a force of change, except if it be the viewer who grants it one by way of subjective representation.

As early as 1435, in *De pictura*, Leon Battista Alberti observed that: 'Painting contains a divine force (*vim admodam divinam*) which not only makes absent men present, as friendship is said to do, but moreover makes the dead seem almost alive. Even after many centuries they are recognised with great pleasure and with great admiration for the painter.'[1] Though, in keeping with the humanist's style, he was speaking metaphorically in so far that this force can only be captured from the exterior by stepping back, and it never allows itself to be penetrated as such, i.e. to be differentiated or divided. For in order to speak concretely of the potentiality of an image one must never lose sight of the fact that the concept of potentiality depends on an economic dimension which, minimally, presumes a quantitative variation according to a plus and a minus. It thus becomes apparent that the force of images in fact presupposes another question regarding the very idea of aesthetic quantities. If they

vary as a plus and a minus, what is it that varies in this plus? If this image, or this part of an image, can be said to be more forceful than another, by what measure can this be counted? How does one quantify its elements? This is not so much a question about the nature or essence of aesthetic force as it is about its consistence, because we are basically only asking the following question: what grows in an image?

To the letter, this paradoxical way of neutralising all forms of potentiality through the designation alone is entirely based on what can be called a humanist aesthetic regime, which even to this day, is far more pervasive then we may think. For the force of the images that is expressed in such a regime is founded on evidence – the evidence of the clear and distinct. In such a regime, the aesthetic or visual potentiality is first expressed as light. Let us not forget the proposition with which Alberti begins *De pictura*: 'The painter is concerned solely with representing what can be seen.'[2] Light therefore asserts itself as the element of the image, the condition of possibility of any image; a fully natural condition, since this light is none other than that of the sun's rays. As Poussin stated: 'Painting is an imitation made on any surface with lines and colours of all that is to be found under the sun.'[3]

Who will effectively challenge that painting can exist without light? What would there be left to see? Would this amount to a violation of its very phenomenality, of the fact that it appears? These objections are those of common sense, because it is precisely this natural clarity that is the foundation of the 'as we can see', which makes this distinction a natural and well founded action. Because the lights of evidence are as much logical as phenomenological, and as much intellectual as sensory. It is thus thanks to the lights of iconological intelligence that Erwin Panofsky can explain how to distinguish Judith and Salome, precisely where their iconographies are extremely close, for this iconological intelligence is itself founded on the clarity of the image.[4]

But how can one not realise that it is in basing images on a condition of luminosity – as one speaks of 'conditions of possibility', in other words of that which founds its potentiality – that one dissipates and dazzles all their force? Because the intrinsic property of light, at least as an element, resides precisely in its capacity to undifferentiate, to neutralise any possibility of *making a difference* in the potentiality, in maintaining the potentiality as evident, so that all quantification of the visual force becomes impossible and that one does not know what is added in the image, other than visibility to visibility and clarity to clarity. Even if the most well-advised theorists still viscerally tie this visual potentiality to such a primary luminosity:

> Even if the rhetoric of the whole and the parts, in its most academic aspects, has made it possible to think of a painting as though it were a whole comprised of separate parts, it is always an immediate effect that prevails, an effect in which the

mimetic-pictorial mass acts like a unit. The intensity's emission point is initially not localizable, any successful painting at first radiates.[5]

*

We are still far from putting the evidence regime of images behind us, for there is no point in criticising the evidence of the clear if one does not also touch on the evidence of the distinct. This is because evidence is effectively its mode of division and can readily be an object of quantification. In what mode, or according to what dimension? According to the *extent*, in the most classical sense of the *extensio*. Inscribing an image in an extensive dimension is as foundational a gesture as making it dependent on natural light. Moreover, it should come as no surprise that Alberti once again had a hand in this. This name in fact only serves to designate the modern turn that the entire discourse on art underwent since the Renaissance, a turn that sealed the alliance of art (its theory, rather) with philosophical and scientific modernity. Since the figure of the artist as an expert in perspective and as a scholar of geometry and mathematics is widely known, we will not explore the matter much further: one need only think of the treatises by Alberti (who complemented his *De pictura* with a small treatise, *Elements of Painting*, a series of geometry exercises), Piero della Francesca, Dürer, the writings of Leonardo da Vinci, etc., to get a good sense of the painter-surveyor's competencies as a measurer of the world. Moreover, the ideological dimension of the phenomenon does not escape us: in order for painting to become serious, it had after all to be submitted to a criterion of measure, in other words to the realm of the quantifiable. But we are aiming for something that goes beyond what is ordinarily understood by the notion of a 'mathematisation of nature', which the artist and scientist have in common. At a deeper level, what is at stake here concerns the inscription of the art image in the order of material substance, the *res extensa* to use Descartes's terms. This decision, as has been said, is crucial, for it provides an apparent solution to the question of aesthetic quantity.[6] What is an image made of? Not of a block of infrangible matter, but of composed matter, that is of differentiated forms. Whatever the nature of the image may be, Renaissance fresco, abstract painting, contemporary installation, it does not appear to escape the evidence of the *extensum*: it is divided into parts that are exterior to one another, *partes extra partes*, the sum of which constitutes the whole of the image. A composed whole, comprising figures, subsets, details, etc.; one does not even need the signifying form to distinguish the parts, since one can abstractly measure two centimetres of blue here, three millimetres of paint layer there: the whole of the painting is by nature extensive. This is why the debate between iconologists and formalists is laughable: the disagreement is in fact solely based on the choice between an infinite division

for one (the formalist), who adds the non-semiotically formed parts, and a finite division for the other (the iconologist), who adds only the figures, characters and signifying elements. But in both cases, the principle of division remains the same: the addition of a part to another results in a homogenous whole, from a 'purely' formal point of view or from a signifying point of view.

The introduction of all sorts of 'dynamisms' into the image changes nothing in the matter if what makes up this dynamism can be reduced to a sum of the extensive parts. Artists themselves have to a large degree contributed to thinking in these terms. Take the case of Italian Futurism and the central place that mobile, dynamic and energetic elements have within it: 'a galloping horse does not have four legs, it has twenty'. This also applies to more ancient periods: one need only consider the commonplaces about 'dynamism' in baroque painting (the role of the diagonal or centrifugal composition with Rubens, for instance), the upward momentum of late Gothic art . . . However, one can question if these are really dynamisms, to the extent that what we are trying to consider as a plastic *movement* is in fact always understood according to an extensive division, in other words in eminently *mechanistic* terms. In transferring the dynamism on extensive parts, one merely explains the image through a simple mechanism that conceives movement only by way of the clash of bodies which are themselves immobile, only by the clash or simple succession of pauses and of parts. This is precisely the cinematographic illusion of potentiality as a movement that Henri Bergson never stopped denouncing: movement is not the adding up of stops, the sum of pauses, for this would ultimately make it impossible, in accordance with Zeno's famous paradox. It is always consciousness that isolates extensive parts after the fact (which does not at all mean that movement is not divisible, only that it cannot be so on the condition of an extensive divisibility).

However, the argument to avoid the stumbling block of the mechanism and to think of an authentic aesthetic potentiality appears to be already known. One can effectively argue that if the force of an image cannot be copied from its extensive quantities, it is because it has more to do with its *qualities*: colours, nuances, touch, aspects, etc. The qualitative is held in high regard, thus allowing it to definitively settle its accounts with the cold divisions of extensive divisions and to give the impression of seizing the singular potentiality of the art image. For example, colourist stances, to speak only of colour, have always been a defence of colour as a quality. Moreover, it is precisely within the perspective of a rehabilitation of sensible qualities that the discourse of pictorial modernity emerged. We know according to what rhetoric modernism – whether it be at work in art history or in any other critical discourse – ruled on colour with the turn of the twentieth-century avant-gardes: through the idea of a 'conquest', or better yet of an 'affirmation', of colour. Not that the sensible qualities did not previously receive the attention they deserved: all of

Renaissance art theory bears witness to the great care that was given to thinking or categorising them (take, for instance, the important place given to the aspects and qualities of surfaces in book one of *De pictura*). But, so we are told, these qualities attain their 'autonomy' in regard to illusionism in general and the *ut pictura poesis* in particular.

This historical perspective at least has the advantage of shedding light on what is at play in quality: 'it asserts itself', which must be understood in the following manner: it is presented as a *pure quality*. By nature opposed to quantity, quality cannot be seized except by the evidence of its indivisibility. Which is to say that it has a specifically inhibiting effect. To treat colour as a quality always symptomises a forbidden, petrifying gaze. One can say nothing of quality, except to say *it*, to acknowledge it in its evident totality, to designate it with an undifferentiated this: 'this red', 'this green', 'this transparency', etc. The critical discourse about sixteenth-century Venetian painting is quite revealing in this regard. The 'effects' of colour, matter and light for painters like Titian, Veronese or Tintoretto are readily discussed in this context.[7] Particularly, the way in which Panofsky describes Titian's use of colour speaks volumes. He first isolates colour: 'First, he *conceived of pigments as inducing an aesthetic effect sui generis* and *sui iuris*; he interpreted colour neither as a mere referent to reality [. . .] nor, if I may say so, as undigested paint. [. . .] We can appreciate his colours on their own, and in relation to each other, just as *we may enjoy precious stones*'. Or further on: 'In a quite late picture such as the Munich *Crowning with Thorns* the very flames of the chandelier look like the petals of beautiful, white-and-rose coloured flowers.'[8] Isolated in its evidence, the coloured quality can only be approached via a movement, metaphor and comparison. Even better, the relationship that is established between isolation and the colour of the object of *pleasure* that it thus becomes (the, quite common, comparison with precious stones or flowers perfectly express this fetishistic enjoyment of the isolated object). Even if it is only to reject its authenticity, the fact that Panofsky talks about the '"hairiness" of the hair'[9] in the portrait of a young girl by Titian is quite significant: this almost makes one think of the *virtus dormitiva* through which Molière's doctors tried to explain the effectiveness of sleeping pills . . . In short, the sensible quality shows its deep collusion with tautology and redundancy.

Such is the impasse to which evidence leads us: that of offering but one alternative between extended forms and sensible qualities, parts and aspects, between a more or less infinite division and a generic or specific qualitative division. To the purely mechanical transitivity (in other words to the illusion of transitivity, since the latter ends at the limits of forms and qualities, without ever crossing them) of extensive forms, one adds, even opposes, the intransitivity of sensible qualities. The image is thus fully realised in its *substance*. How can one in fact not see that the

articulation of forms (whether they be material or semiotic) and qualities only further encyst a deep-rooted substantialism? If qualities can only be conceived when they are based on extended things, something the modernist credo confirms, since the 'affirmation of the colour' is necessarily accompanied by an 'affirmation of the surface', it is because the first operates like accidents of the second, i.e. of immutable substances.

Relegated to extension and qualities, the force of evidence suddenly seems quite weakened and the aesthetic dynamism quite immobile. However, there appears to be a way to think a force of the image beyond the evidence of the here and now: one can oppose the realised work with a *potential work*. The extensive and qualitative states can be replaced through the dynamic of a potential image, one that is more profound, for it touches on the very genesis of the image. Be it only for the time being, let us put the immobility of realised extensive and qualitative states aside in order to focus on the original movement of a sovereign incompleteness: the open, unfinished work, always in a state of becoming. Michelangelo's *non-finito* thus provides the paradigm to think the proceedings of an inchoative form. Historically, one must acknowledge the Italian Renaissance's role in granting a very particular place to these 'potential images', by sometimes giving them a truly theoretical, if not epistemological status: one need only think of the *componimento inculto* in the work of Leonardo or Raphael,[10] this jumble of lines can be said to operate like a genetic milieu for motifs in a process of becoming; or take the way in which Andrea Mantegna's cloud formations welcome improbable figures: horsemen, human profiles, etc.; or further still the way in which Piero di Cosimo draws inspiration from stains and puddles of spit. Alberti apparently even granted 'inchoative images [*inchoatarum similitudinum*]' the status of a veritable origin myth of sculpture.[11] Clouds, blotches, stains, boulders, 'imaginative milieus', in which the figure, which is in a process of being born, is better understood as a *figura figurans* than as a 'figured figure', on the model of nature itself considered as *naturans* and not natured. 'What attracts sixteenth-century man to [. . .] chaos is not simply the endless succession of metamorphoses, but the potential, the reserves of energy that they contain: they symbolise the promise of movement. The attraction towards the inchoative resides in chaos.'[12] In fact it is all of art history that could be summoned here in the name of 'the image made by chance',[13] the hidden image, the double image: from the simple duck-rabbit image to the must sublime anthropomorphic landscape.[14] Dario Gamboni thus placed a long history of the 'potential image' under the aegis of 'ambiguity' and the 'indeterminate', a history that neither begins nor ends with the Renaissance, since the medieval Christian marble panels are considered on the same level as the ink and wash drawings of Victor Hugo, the work of Turner, Monet, Odilon Redon's 'suggestive art', the Nabis group and other symbolists.[15]

To grasp the image in its sovereign dynamic is therefore to realise a movement of determination, from the indeterminacy of vague forms with barely evident qualities to the determination of the accomplished work; it is to view not so much the work in activity, as the *potentiating work*. We know what this distinction owes to Aristotle's metaphysics: a thing can be designated according to its potentiality (*dynamis*) or instead according to its actuality (*entelecheia*). This latter term, invented by Aristotle himself, traditionally designates a thing as an actuality, an effective reality, a completed reality. On the contrary, *dynamis* designates the being of that which is not yet accomplished or realised, the capacity of being a thing, and the thing itself. It is most often this distinction that nourishes any art theory that situates itself along the horizon of production (*poïésis*), in so far that one views the works as completing a potentiality: 'For the activity is the end, and the actuality (*energeia*) is the activity (*ergon*); hence the term "actuality" is derived from "activity," and tends to have the meaning of "complete reality (*entelecheia*)".'[16] The classical example that the eighteenth century held up is the statue in the marble block, which resides there as a potential before the artist brings it forth through their final work.

This is the interpretation of potentiality that has broadly prevailed in the West, in so far that it understands potentiality as a *capacity to be*, denoting a lesser existence, because it exists independently of its completion. Potentiality is thus assimilated with the *possible* (*possibilitas*): that which may or may not be. This is without a doubt where the problem originates, there where Aristotle himself had nevertheless envisaged, be it but to immediately turn away from it, another solution by turning potentiality into a 'principle in the patient itself which initiates a passive change in it by the action of some other thing, or of itself qua other'.[17] (What the Romans in this case translated by *potential.*) The assimilation of potentiality with the possible in fact draws a sort of vicious circle from which it must be said, plainly, that nothing can be gained – not only on a logical or theoretical level, but precisely on the level of the image itself. Bergson masterfully elucidated the intellectual trickery whereby the possible is made to pass for the opposite of what it is:

> But there is especially the idea that the possible is *less* than the real, and that, for this reason, the possibility of things precedes their existence. They would thus be capable of representation beforehand; they could be thought of before being realised. But it is the reverse that is true. [. . .] If we consider the totality of concrete reality or simply the world of life, and still more that of consciousness, we find that there is more and not less in the possibility of each of the successive states than in their reality. For the possible is only the real with the addition of an act of mind which throws its image back into the past, once it has been enacted. But that is what our intellectual habits prevent us from seeing.[18]

One sought a genetic movement, an inchoative dynamic, which would presume that potentiality is given before the actuality, that the actuality is the actualisation of a potentiality. Yet, one encounters a possible which is always-already completed and which is only retrospectively potentiating. Bergson states that the 'possible is therefore the mirage of the present in the past'.[19] Aristotle had no problem stating that 'actuality is prior to potentiality',[20] precisely as soon as you define potentiality as possibility. The argument is based on common sense: how could I effectively see a virtual man in the child, the possibility of a man, if I had not previously encountered an actual man – an anteriority that is both chronological and logical – and how could I conceive a visual potentiality which is not based on a *visible*, which precisely merges 'what is seen' and 'what can be seen' into a single notion?[21] Drawing on Bergson's critique, Gilles Deleuze adeptly describes the vacuity of this concept of the possible as soon as one seeks to make it correspond with potentiality:

> To the extent that the possible is open to 'realisation', it is understood as an image of the real, while the real is supposed to resemble the possible. That is why it is difficult to understand what existence adds to the concept when all it does is double like with like. Such is the defect of the possible: a defect which serves to condemn it *as produced after the fact, as retroactively fabricated* in the image of what resembles it.[22]

There is a good chance that art historians will not feel concerned by what they will view as quibbles likely to interest only philosophers. Yet these issues touch directly on their object of study. For to speak of the 'potentiality' of a form, a figure, a quality and a signification implies that they must have already been seen, observed, experienced; they must already have shone, clearly and distinctly, in the light of evidence. The semiotic or visual indetermination to which potentiality was tied, now reveals itself for what it is: an entirely determined and completed form or signification, which has been torn away from the here-and-now present to render it simply 'possible'. One thus understands why there is nothing to be gained with the possible: it says nothing of the genesis of evidence, but through a sort of stationary jump, it merely doubles it: light on light.

This is a way to say that the possible does not in any way make an image grow. We already saw how the consideration of sensible qualities operated a doubling of the quality on itself: Titian's colours, for instance, are not in any way enriched by their sole analogical movement (by way of metaphor or comparison). What *real* relation is established between the *Crowning With Thorns* and the 'flower petals', and more broadly between the Titianesque colouring art and 'precious stones', if not the mere movement from one quality to another, if not the passage from an actual quality

to a *possible* quality? This is to say that the introduction of a *possible* quality *changes* nothing about the quality in question.

The sensible qualities of images certainly are not the only ones in which such redundancies occur. Renaissance painting often provides both art historians and the spontaneous gaze of viewers with the opportunity of such image 'enlargements', through the simple adjunction of possible parts or moments, which are always external to the image. Therefore, in a spatial mode, one can for instance enlarge the space of Pierro della Francesca's *Flagellation*, by seeing the *possibility* in the background staircase – with the addition of a few stairs – of a representation of the Scala Santa at St John Lateran's Basilica.[23] Or, this time on a temporal mode, one can add an episode before or after the representation of an action to situate it in a narrative continuum.[24] If these narrative additions are always unrestricted, it is because they take place on the level of a pure possibility that does not in any way affect the image to which they refer.

This is a way to say that one is still faced with a problem of quantity. If the possible cannot make an image grow, it is because it is copied from that of which it is the possibility and thus only makes it possible to envisage a homogenous growth. Ultimately, this reveals only the fundamental characteristic traditionally attributed to any quantity: its homogeneity. Whether it be about extensive quantities or qualities, one always begins with the principle that there must at least be a certain resemblance, and at most a perfect identity to establish the reality of a quantity, or of a *quantum*.

*

The main difficulty resides in thinking a visual potentiality that is indeed *one* but, nevertheless, not undifferentiated, a potentiality with divisions that would not be of an extensive or qualitative order. This strange unity has a name: it is called intensity. For intensity can never be confused with the extensions and the qualities that envelope it; it always neutralises or cancels itself out within them. Let us take the example of a temperature degree, i.e. an intensive unit; it cannot be measured outside of the matter through which it is felt, yet it is not copied from the parts (extensive sizes) which make it up: two snowballs provide more water, but not more cold. Clearly, intensity cannot be explained (in extensions and qualities), but it is implicated *in* or *under* extensions and qualities. So that in a certain way, the intensity does not add a supplementary or external dimension to that which is displayed in an image: forms, significations, aspects. Rather, it follows a transversal movement through which the force settles in the form and the signal in the sign. And the unbelievable gift that intensity gives us is thus to reintroduce the sensible in singular images (and not simply to 'rehabilitate the question of the sensible', on a theoretical mode, at least in

regard to the exterior of empirical visual works), i.e. a way of considering a sensing that has less to do with a reception of a totality of senses or faculties than with the production of something to be sensed, of a *sentiendum*.

It is due to the fact that intensity is sensed that it is indeed more than a physical notion but really an aesthetic principle. When Richard Serra, for instance, states that 'gravity has always been a problem in sculpture. How that problem is resolved is part of any definition of making sculpture.'[25] The 'gravity' in question cannot be reduced to a physical quantity. This is not in any way a physicalism. The proof is that Serra considers the whole history of *painting* as a history of weight: 'I can record the history of art as a history of the particularization of weight. I *have more to say about Mantegna, Cezanne, and Picasso than about Botticelli, Renoir, and Matisse*, although I admire what I lack.'[26] The weight, therefore, does not refer to an extensive quantity (the paintings of Mantegna, Cezanne or Picasso are obviously not heavier than Botticelli's) but to an intensive weight, which presupposes degrees of potentiality.

It shall be a great step forwards for science and art when they will have attained the deep conviction that aesthetic potentiality must be thought through the mode of intensity, against the evidences of extension and quality. For in truth the *intensum* constitutes the great omission of our aesthetic tradition, at least since the Italian Renaissance. It is an entire history that one would have to revisit here, one that links the neutralisation of intensity with the advent of modern science and philosophy, notably through the decoupling of force and intensive measures: the physicist's knowledge was to be restricted to a mechanics of forces, and the intensities (speed, temperature, pressure) were always to be expressed by an extensive scale. But, as of the fifteenth century, this advent was to be accompanied by a theory of art and the primacy it gave to extension. It is not that intensity is totally absent for the classical (and maybe the modernist) theory of art, but it still remains under the sway of representation, in the name of an expression of passions. When Alberti, for example, writes that: 'The istoria will move the soul of the beholder when each man painted there clearly shows the movement of his own soul.'[27] One understands that intensity is always extended as a represented intensity and not as an active intensity, which would become one with painting. Renaissance humanism in reality was putting an end to a 'Christian aesthetic', presuming that this expression has a meaning, which was in every regard opposed to evidences of extensions and aspects: an 'aesthetic of intensity'[28] that presupposed that the mysteries of faith were more *sensed* than known and that they thus served less to represent real situations than to make present a potentiality given only by way of a figure.

This priority given to intensity can, however, only be considered as a precondition. For in disentangling the intensive from the extensive and qualitative, one runs the risk of seeing the image dissipate, not the idea or the concept of the image, but the singular image, *this* image, with its specific forms and qualities. Intensity is never present without

them. It is pointless to explain one by way of the others; but it would be too easy to ignore the way in which intensity is distributed in extension and qualities, in the name of a 'cancelling' or a 'neutralisation'. For, if one must perhaps think as a philosopher to recognise the necessity of a theory of intensity, it is just as important to think as an art historian, to remain firmly linked to all the intensity determination processes, as well as the differentiation processes, precisely because intensity is never given 'in general' but always presupposes the questions 'where?', 'how?' and 'when?' It is thus that one practices a 'superior empiricism', to use Deleuze's formulation, in the image of the Nietzschean will to power, which while having the value of a principle also designates

an essentially *plastic* principle that is no wider than what it conditions, that changes itself with the conditioned and determines itself in each case along with what it determines. The will to power is, indeed, never separable from particular determined forces, from their quantities, qualities, directions. It is never superior to the ways that it determines a relation between forces, it is always plastic and changing.'[29]

Nowadays, Georges Didi-Huberman's work excels in its masterly way of locating intensities that are always linked, local and singular; intensities that are plastically distributed. From the depths of Fra Angelico's four false marble panels to the force of presence of a 'simple' minimalist cube, the dancing gait of Aby Warburg's Nympha to the choreographic intensity of a contemporary artist, Israel Galvàn, or the dramatic, indeed tragic intensity of four photographs taken in 1944 by members of the Auschwitz *Sonderkommando*. In each case, the art historian and philosopher sets out not to explain the intensity of these images, but to make them available, at least temporarily, to comprehension. This comprehension need not be added to an interpretation, as though a phenomenological moment had to give way for a semiological and/or analytical moment. For, to the extent that the signal resides in the sign, this comprehension is *already* interpretive, meaning that: it is already differentiated; it already presupposes a mode of division of and in the image.

To reiterate, the great advantage of thinking aesthetic potentiality in terms of intensity is based on the possibility of reintroducing sensing in the selfsame image, this 'selfsame' of the image does not in any way signify a theoretical ideal, but rather an empirical singularity which manifests itself through its concrete differences. Jean-Christophe Bailly rightly observes 'that we should consider the aesthetic dimension as the site of the arrival and excitation of these singularities, in other words as the very field of intensity, or intensification, of singularity. And one should add, in paraphrasing Aristotle, that men take pleasure in intense singularities, and that painting is what ensures the regimes of these singularities in the visible.'[30] For it is pointless to call on a potentiality that can be sensed, if this sensing were not localisable in an

image, or at least articulable according to its distinctions. In this regard one can, in a certain way, observe a proximity between the Christian tradition and a particular aesthetic discourse of a phenomenological type, precisely regarding the question of the infrangible, unanalysable, given as one block and which is affirmed through the evidence of faith in one case, and that of the phenomena in the other (and it is clearly no coincidence that an entire current of contemporary phenomenology turned to theology – the question of light being essential here). One needs to put an end to the idea of an undifferentiated sensing all the while reintroducing a difference into sensing, in other words according to intensive differences that presume thinking the image as a *heterogeneous quantity*. The expression is paradoxical, for it is precisely through homogeneity that one traditionally defines quantity. How is one then to conceive that an image, i.e. a quantity of space, matter, forms, qualities and meanings, can at the same time be thought as a *quantum*, as *a* quantity, but one that is not homogenous? This quantity would not be reducible to the sum of its parts (extensive quantities), just as it would not be reducible to the sum of its qualities. Drawing alternately on Nietzsche and Bergson, Deleuze persistently denounced the illusion that homogenous quantity represents.[31] The mode of division of intensive quantity is effectively quite particular: it is not indivisible for it 'does not divide without changing in kind, in fact it changes in kind in the process of being divided.'[32] And: 'An intensive quantity may

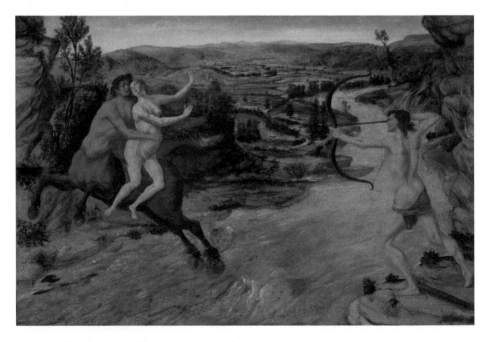

Antonio del Pollaiuolo, *Hercules and Deianira, ca.*1475–80, oil on panel transferred to canvas, 67.4 × 94.8 cm. Courtesy Yale University Art Gallery, New Haven

be divided, but not without changing its nature. In a sense, it is therefore indivisible, but only because no part exists prior to the division and no part retains the same nature after division.'[33] Suffice to say, if the intensive divisions are never adequate to the extensive and qualitative divisions, if they are never distributed according to the order of forms and aspects, this does not mean that they are alien to them, but that they do not coincide with the extensive and qualitative state of things in and through which they are expressed. One can therefore never recognise an intensity for itself, but rather only seize it by following the distortions it produces in extensions and qualities. Visual paradoxes, plastic contradictions, semiotic implausibilities, etc.: an intensity does not show itself without constraining evidence, without sowing a seed of heterogeneity in formal and qualitative homogeneity. Intensity is the site of an active difference, since it is always discontinuous to the gaze not only of the continuity of the image taken as a totality, but also, if not above all, of each local continuity. In the Pollaiuolo brothers' painting depicting *Hercules and Deianira*, the Nympha-intensity derives as much from the iconographic individuality of the Deianira character as from the upstretched tree right next to her, as though Deianira could only escape her abductor by transforming herself into a tree, becoming Daphne by the same token; or further still, in the white foam of the river, through the merging of her transparent dress with the water's folds. There is no iconographic evidence in this formal and qualitative discontinuity. The aesthetic intensity is always extensively and qualitatively transversal.

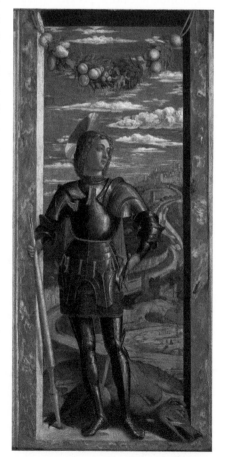

But in the same way that it produces implausibilities, the intensity can be located in conceptual impossibilities. This derives precisely from its aesthetic nature: it can be sensed but it cannot be represented intellectually. Take, for example, Mantegna's *Saint George* at the Venice Academy, and the

Andrea Mantegna, *San Giorgio*, 1460, tempera on panel, 66 × 32 cm. Courtesy Gallerie dell'Accademia, Venice. Image copyright Archivio fotografico del Polo Museale del Veneto, with permission of the Italian Ministry of Culture and Tourism

strange dragon-path-mountain. It is iconographically apparent that the dragon is missing one of its traditional attributes (its extensive part): the tail. Yet this tail rapidly becomes an intensive singularity, intensively entering the landscape in the serpentine form of the rising path. The aesthetic intensity here becomes the corollary of the plastic idea, which is problematic in so far that this idea cannot be intellectually thought via the means of representation, but can 'only' be sensed. This is obviously not a restriction or a lack of any sorts, but rather a way of insisting on the part of the signal in the sign, on the aesthetic expressivity of the idea.

Nevertheless, the heterogeneity of the intensity cannot be reduced to a difference or even a contradiction between given situations, a bit in the manner of the rabbit-duck image. Let us set things straight: it is not so much that the visual contradiction or paradox as such produce the intensity, but rather that an intensity is expressed *in* the forms and qualities only as a paradox. Yet, though the intensity is effectively problematic, to the extent that it introduces an imbalance, a discrepancy between given situations, this 'problematicality' always evolves in a transitive dimension. This is a reminder that intensity is as much differentiated as differentiating, that it produces or 'works' differences and that its problematic elements are, by definition, fully given. The problem here consists rather in the precipitating of a given situation (pictorial, aesthetic . . .). This transitivity of intensity is absolutely fundamental to avoid the pitfall we have continuously denounced: to turn aesthetic potentiality into a monolithic, undifferentiated evidence. Intensity does something, it makes things become, transform – this is why it is a potentiality; it always seals a becoming. From the point of view of painting, for instance, and to remain in this field, it becomes clear that a certain number of problems are forbidden or impossible, not because of a moral law, but in view of the abstract intransitivity that they introduce: no becoming-painting of painting, no becoming-colour of painting, no becoming-form of painting, etc. Precisely because colours, forms and surfaces constitute givens[34] of painting and because one does not introduce any heterogeneity by placing them beside one another.

We insist on this crucial point, for it concerns the capacity of the plastic force not to remain abstract, like an ineffable potentiality, but on the contrary to singularise itself by infiltrating given situations – forms, qualities, matters, significations – to affect, precipitate and make them become other. It is thus that the image exposes 'things' on the level of aesthetic potentiality which in and of themselves are alien to any given form relating to images or to art, whether material or technical, signifying or functional. It can, for instance, be a *material*: take how Mantegna's painting mobilises the mineral element, which is not only strangely emphasised in all of his iconography (under the guise of statuaries, ruins, stone carving), but which also infiltrates the very style of his work, giving rise to cold, marble-like painting combining grisaille painting practice with the dry style of tempera. This also applies

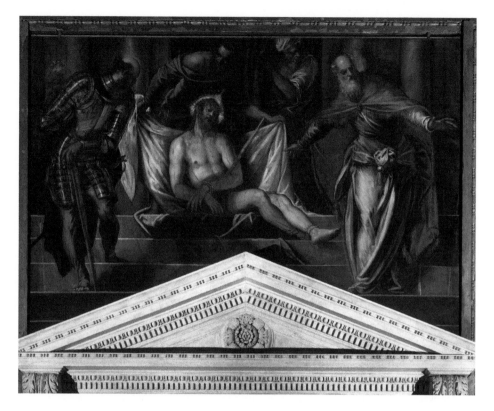

Tintoretto, *Ecce Homo, ca.*1566–7, oil on canvas, 285 × 400 cm. Courtesy Scuola Grande di San Rocco, Venice

to dyes in Tintoretto's work. Dyes impacted his painting like an imaginative force, which is evident in his technical gestures and signature, as well as in the represented bodies, local colours and also in the broader dramatic scenes – all is awash with Tintoretto, everything caught in a flow of dyes. Yet, we must immediately point out that Tintoretto's painting activates an *impossible* dye, a dye that never existed (even if sixteenth-century Venice was arguably the European capital of the dyeing industry), or that exists only in so far that it subsists in and through his painting.[35] Such materials-potentialities can take on more tangible forms. In this regard, much could be said about the importance of make-up in Manet's painting, which pictorially transfigures the face-surface relation.[36] Likewise, one could analyse the place of the garden in Monet's later painting, a place that goes far beyond the mere representation of flower beds in Giverny, in so far that it introduced a floral-pictorial virtuality which reshuffled the cards of what we comprehend composition to be. Yet, materials do not benefit from a privileged treatment here, for it could just as well be about images transforming *semiotic forms* into aesthetic potentialities. For

example, the role of allegory for Botticelli, which is not in any way limited to an iconographic given, but which practically implicates all of his painting, notably the abstract set-ups, the spatial paradoxes in which the open and closed are merged, strange dramatic scenes with no outcome, a stylistic coldness, etc., i.e. an entire manner of pictorially or aesthetically *making* allegory.[37] But these are also *techniques* that the image can transfigure into aesthetic intensities, for example in the work of contemporary artists as varied as Giuseppe Penone, for his use of the imprint (moulding, transfer, frottage, development),[38] or Hubert Duprat for his way of practising an expanded marquetry, a potentiality-marquetry (take for instance the importance of jointing).

The few cases examined here show that the virtuality of an image is always *more* than all its actualised forms would have one believe: matter, form, quality, signification, technique and function. For the aesthetic potentiality is, literally, not identifiable, to the extent that it opens up an otherness and operates through difference. We concede that these examples are extremely limited and that each deserves a long and deeply thought out monograph of its own. Yet we must, in a certain manner, understand that we are concerned with something beyond the example and its rhetorical function, which assumes that the example cuts across the general and the particular. It is, rather, about exposing singularities that contain a transversality, a structural fact within themselves and which can in their turn organise a stylistic territory and an aesthetic world. At the same time, we understand that aesthetic virtuality is indeed the corollary of plastic invention, in so far that a potentiality is never given but always in a process of construction.

Notes

1. Leon Battista Alberti, *On Painting*, trans. John R. Spencer (New Haven: Yale University Press, 1966), p. 63.

2. Ibid. p. 43.

3. *Nicolas Poussin, letter to M. de Chambray*, 1 March *1665*, reproduced in *A Documentary History of Art*, ed. Elizabeth Gilmore Holt, 2 vols (Garden City, NY: Doubleday, Anchor Books, 1958), 2, p. 158.

4. See: Erwin Panofsky, 'Introduction', *Studies in Iconology* (Oxford: Oxford University Press, 1939), pp. 12–14.

5. Jean-Christophe Bailly, *L'Atelier infini. 30 000 mille ans de peinture* (Paris: Hazan, 2007), p. 18 [trans. Bernard Schutze].

6. In this perspective, it is quite significant that Georg Simmel sought to directly tackle the question of aesthetic quantity by considering only a change in the artwork's

dimensions; see Georg Simmel, 'On Aesthetic Quantities', in *The Conflict of Modern Culture and other Essays*, trans. K. Peter Etzkorn (New York: Teachers College Press [1903], 1968), pp. 81–5.

7. See in particular Johannes Wilds, *Venetian Art from Bellini to Titian* (Oxford: Oxford University Press, 1975).

8. Erwin Panofsky, *Titian: Problems in Iconography* (New York: New York University Press, 1969), pp. 14–15.

9. Ibid. p. 15.

10. On Leonardo's *componimento inculto*, see Ernst Gombrich, 'Leonardo's Method for Working out Compositions', in *Norm and Form: Studies in the Art of the Renaissance* (London: Phaidon, 1966) and Daniel Arasse, *Léonard de Vinci. Le rythme du monde* (Paris: Hazan, 1997), pp. 270–92.

11. See Leon Battista Alberti, *La statue (De statua)*, ed. Oskar Bätschmann, trans. Dan Arbib (Paris: Ed. Rue d'Ulm – Musée du Quai Branly, 2011), pp. 62–3.

12. Michel Jeanneret, *Perpetuum mobile. Métamorphose des corps et des œuvres de Vinci à Montaigne* (Paris: Macula, n. d.), pp. 92–3 [trans. Bernard Schutze].

13. See the famous study by Horst W. Janson: 'The "Image Made by Chance" in Renaissance Thought', in *De artibus opuscula XL: Essays in Honor of Erwin Panofsky* (New York: New York University Press, 1961), pp. 254–66.

14. See in particular the remarkable work by Michel Weemans on sixteenth-century Flemish landscapes as a visual exegesis: *Herri Met de Bles. Les ruses du paysage au temps de Bruegel et d'Erasme* (Paris: Hazan, 2013). On the double image see, among others, the exhibition catalogue: *Une image peut en cacher une autre*, ed. Jean-Hubert Martin (Paris: RMN, 2009).

15. See Dario Gamboni, *Potential Images: Ambiguity and Indeterminacy in Modern Art* (London: Reaktion Books, 2002).

16. Aristotle, *Metaphysics*, Book 9, 1050a 21–23, in *Aristotle* in 23 Volumes, trans. Hugh Tredennick (Cambridge, MA: Harvard University Press, 1933). See in particular Giorgio Agamben, 'Privation Is Like A Face', in *The Man Without Content* (Stanford: Stanford University Press, 1999), pp. 64–5.

For Aristotle, the pro-duction into presence, effected by ποίησις both for the things whose ἀρχή is in man and for those that exist according to nature, has the character of which then, possesses itself in its own end has the character of ἐνέργεια. This word is usually translated as 'actual reality', contrasting with 'potentiality', but in this translation the original sonority of the word remains veiled. To indicate the same concept, Aristotle also employs a term he himself coined: ἐντελέχεια. That which enters into presence and remains in presence, gathering, in an end-directed way, into a shape in which it finds its fullness, its completeness; that

which then, ἐν τέλει ἔχει, possesses itself in its own end. Ἐνέργεια, then, means being-at-work, ἐν ἔργον, since the work, ἔργον, is precisely *entelechy*, that which enters into presence and lasts by gathering itself into its own shape as into its own end.

17. Aristotle, *Metaphysics*, Book 9, 1046a 10–11.
18. Henri Bergson, *The Creative Mind and Introduction to Metaphysics* (New York: Dover, 2007), p. 81.
19. Ibid. p. 82.
20. Aristotle, *Metaphysics*, Book 9, 1050a 2–3.
21. Ibid. 1048b 12.
22. Gilles Deleuze, *Difference and Repetition*, trans. Hugh Tomlinson (New York: Columbia University Press, 1994), p. 212.
23. See Marilyn Aronberg Lavin, 'Piero della Francesca's *Flagellation*: the Triumph of the Christian Glory', *The Art Bulletin*, L (1968): 321–42 (p. 325).
24. For an example, among many others, see the way in which Ronald Lightbown reconstructs an entire scenario to explain the strange contraction of the centaur's finger in Botticelli's painting *Pallas and the Centaur*. Ronald Lightbown, *Botticelli: Life and Work* (Berkeley: University of California Press, 1978), p. 83.
25. Richard Serra, *Writings/Interviews* (Chicago: University of Chicago Press, 1994), p. 145.
26. Ibid. p. 128.
27. Alberti, *On Painting*, p. 77.
28. As Georges Didi-Huberman aptly put it in: 'Puissances de la figure. Exégèse et visualité dans l'art chrétien', in *L'image ouverte. Motifs de l'incarnation dans les arts visuels* (Paris: Gallimard, 2007), p. 224 [trans. Bernard Schutze].
29. Gilles Deleuze, *Nietzsche and Philosophy*, trans. Hugh Tomlinson (New York: Columbia University Press, 1983), p. 65.
30. Jean-Christophe Bailly, *L'Atelier infini. 30 000 mille ans de peinture*, p. 57 [trans. Bernard Schutze].
31. Gilles Deleuze, *Bergsonism*, trans. Barbara Habberjam and Hugh Tomlinson (New York: Zone Books, 1990), p. 31. See, for example, Friedrich Nietzsche: 'In reality there is nothing "added," nothing "divided," two halves of a thing are not equal to the whole.' In *Nietzsche: Writings from the Late Notebooks*, ed. Rüdiger Bittner (Cambridge: Cambridge University Press, 2003), Notebook 40 [38], p. 45.
32. Deleuze, *Bergsonism*, p. 42.
33. Deleuze, *Difference and Repetition*, p. 237.
34. 'Givens' and not 'data', because there is considerable risk here of lapsing into an essentialism. It suffices to empirically acknowledge that painting has up to now worked a lot with surface, forms and colours – which does not in any away presume its 'essence'.

35. See: Bertrand Prévost, 'Tintoretto's Ecce Homo', *WdW Review* (2013) <http://www.wdwreview.org/image/tintorettosecce-homo/> (accessed 2 April 2015).

36. See Jean Clay, 'Onguent, fard, pollen', in *Bonjour Monsieur Manet* (Paris: Centre Georges Pompidou, 1983), pp. 6–22.

37. On all these aspects, allow us to refer to Bertrand Prévost, *Botticelli. Le manège allégorique* (Paris: Ed. 1:1, 2011).

38. See Georges Didi-Huberman, *Être crâne. Lieu, contact, pensée, sculpture* (Paris: Minuit, 2000).

13 Impossible! Bergson after Duchamp after Caillois

Sarah Kolb

WITH HIS PHILOSOPHY of intuition, Henri Bergson has been recognised as one of the most influential figures in the history of historical avant-gardism.[1] Nevertheless, art historians have not yet focused in depth on his particular importance for one the most famous artists of the twentieth century, whose epoch-making *oeuvre* is to be understood in direct contradistinction to the paradigms of classical avant-gardism: Marcel Duchamp. And yet, a comparative analysis of their works is anything but far-fetched.[2] After all, when Duchamp came to Paris in 1904, planning to start a career as an artist, the phenomenon of Bergsonism was just about to reach its peak, and particularly to become one of the most relevant sources for the contemporary art trends of Fauvism, cubism and Futurism. Since Duchamp came into contact with all these trends in the course of his first 'attempts of swimming' up to 1912,[3] it is obvious that he was conscious of Bergson's philosophy and its impact. But while leading avant-garde artists such as Henri Matisse, Filippo Tommaso Marinetti, Albert Gleizes and Jean Metzinger related to Bergson's philosophy in order to reinforce their artistic principles,[4] Duchamp finally decided to take another fork[5] and to break with any kind of dogmatism or unambiguity, be it artistic, scientific or metaphysical. However, the deeply novel conception of art that Duchamp developed as a result of this weighty decision is to be seen, as will be argued in the following, in immediate relation to Bergson's dichotomic conceptualisation of life and death, intuition and intellect, memory and matter, perception and action, precision and indifference, creativity and dogmatism, or *durée* and *tout fait*.

Staircase and Passage

As Duchamp turned his back on the contemporary art scene in order to push on with that highly independent-minded kind of 'avant-gardism' which Clement Greenberg would finally address as an unsurpassable role model for 'advanced-advanced art',[6] his crucial point of departure was his notorious *Nude Descending a Staircase, No. 2*, completed in January 1912. At that point, he was in close contact with the so-called Puteaux Cubists, a group of artists and writers (not least including his two elder brothers, Jacques Villon and Raymond Duchamp-Villon), whose concept of multiple perspectives was characterised not only by a number of rigid formal criteria, but also by an intellectual approach which would eventually turn out to be quite inspiring for Duchamp. Still, when he wanted to show his latest painting in the Puteaux Cubists' exhibition at the Salon des Indépendants in March 1912, Gleizes and Metzinger, the two heads of the group, resolutely rejected his *Nude*, objecting not only to its literary title, but also to the fact that it suggested a human figure in motion instead of the traditional pose.[7] However, it was clear from the start that his painting would pose a challenge to the orthodox cubists. After all, whereas his colleagues referred to Bergson's intuitionist concept of qualitative multiplicity with their multiple perspectives, Duchamp had deliberately decided to bring in an intellectual perspective by adopting the

Marcel Duchamp, *Nude Descending a Staircase, No. 2*, 1912, oil on canvas, 147 × 89.2 cm. Courtesy Philadelphia Museum of Art – The Louise and Walter Arensberg Collection. Philadelphia Museum of Art, Object Number 1950-134-59. Image copyright Artists Rights Society (ARS), New York/Estate of Marcel Duchamp

method of chronophotography and adding a literary title to his latest painting. Of course, it was out of the question for him to meet the Puteaux Cubists halfway by changing the title or contributing another work according to their obliging suggestion.[8] Instead, he affirmed his attempt to represent, with his multiple temporal perspectives, nothing like a coherent figure in terms of a qualitative synthesis, but in fact an analytical 'abstraction of movement'.[9] Thus his *Nude* can be understood in the strict sense of Bergson's critique of 'cinematographic thinking' as escapist, of which more later.

On the occasion of his radical disagreement with the Puteaux Cubists, Duchamp decided to distance himself from the Parisian art scene and to take a time-out in Munich during the summer of 1912.[10] This spontaneous retreat would prove to be more than productive, even seminal. Skipping back and forth between his modest studio and the Neue Pinakothek, and purposely relying on his own eclectic vision as well as on the sterling achievements of art history, Duchamp made several sketches and two oil paintings, which show an entirely new quality. Thus Duchamp's Munich period demarcates not only the conclusion of his career as a painter or avant-gardist in the traditional sense, but also the starting point of a long history of gimmickries, experiments and objections with which he was to revolutionise art history.

Right from the start, Duchamp's Munich work was entirely devoted to the very subject which would henceforth be central to his multifaceted *oeuvre*: the so-called 'Bride', first mentioned in a sketch titled *Mechanism of Chastity / Mechanical Chastity (First Study for: The Bride Stripped Bare by the Bachelors)*. And yet, as this Bride is invariably linked to the counterpart of a number of 'Bachelors' according to Duchamp's basic idea, it can be regarded as a 'subject' only in the ambivalent sense of an object of desire, agreement or dispute. This is what primarily becomes apparent with Duchamp's first Munich painting titled *The Passage from*

Marcel Duchamp, *The Passage from Virgin to Bride*, 1912, oil on canvas, 59.4 × 54 cm. Courtesy Museum of Modern Art (MoMA), New York, 2016. Image copyright the Museum of Modern Art, New York/Scala, Florence

Virgin to Bride. Whereas with his *Nude Descending a Staircase* Duchamp intended to represent an 'abstraction of movement' by an accumulation of static positions or terms, with *The Passage from Virgin to Bride* he aimed at transcending this chronological perspective while turning towards a completely different kind of movement in the broader sense of qualitative progress and becoming.

Indeed, with regard to *Passage* there is no point in trying to distinguish discrete positions or moments or to locate the two supposed subjects of the painting, 'Virgin' and 'Bride'. On the contrary, any attempt to stabilise the two figures would actually interfere with the crucial point of the painting. As Jonathan Crary aptly remarks, 'words like *virgin* and *bride* denote discrete, whole, and delimited entities, while *passage* describes something open, in process, and dynamic' in terms of 'a becoming that has no subject':

> Instead, within a framed and limited space, we have an active field of potentially infinite relationships, of floating elements, which resist being inserted into a structural logic. It is a 'field of freeplay', where oppositions are not contradictions and where any form is free of any necessary relation to any other.[11]

Similarly, Robert Lebel, in his pioneering monograph on Duchamp, infers that *Passage* does not figure the Bride's 'loss of virginity', but rather the 'transformation of one form into another', pointing to Duchamp's interest in 'problems of psyche and the organic'.[12]

Whereas Crary and Lebel refer to Nietzsche and Freud in order to point to Duchamp's new-found primacy of becoming, they notably neglect the crucial role, much more obvious, assigned to Bergson's popular philosophy of evolution.[13] Significantly, in his literal bestseller *Creative Evolution*, first published in 1907 and awarded the Nobel Prize for Literature in 1927, Bergson exemplified his radical critique of 'cinematographic thinking' by alluding to the problem that thought is necessarily based on a principle of discrimination. According to Bergson, concepts like 'child' or 'man' are 'mere views of the mind, *possible stops* [. . .] along the continuity of a progress'; 'if language were here molded on reality', Bergson argues, 'we should not say "The child becomes the man," but "There is becoming from the child to the man."'[14] In the first proposition, he explains, 'becomes' is nothing but a verb of indeterminate meaning, comparable to the uniform movement of a film, whose function is to superpose successive pictures in order to imitate real movement. But when we say 'There is becoming from the child to the man' (just as Duchamp stresses *The* Passage *from Virgin to Bride* – my emphasis), then 'becoming' comes to the front as a 'subject', referring to the reality of movement itself, and no longer to its cinematographic imitation.[15]

By analogy with Bergson's metaphor of cinematographic thinking, one is drawn to the conclusion that Duchamp's *Nude* does not figure an imitation, but in fact a cinematographic 'abstraction of movement'. At the same time, it seems that with his painting *Passage*, he made his first major step beyond the illusionary concept of a clearly defined subject as such. There is, therefore, every indication that in a next logical step, with his second Munich painting titled *Bride*, Duchamp definitely abandoned the specious concept of before and after, while all the more implying a concrete becoming and rite of passage, this time touching the outmoded idea of a former virgin and later wife. Thus, with Bergson it seems natural to argue that Duchamp's focus turned away from subjections and towards becoming once and for all. Consistently, with a sole exception, *Bride* was supposed to be Duchamp's last painting in the traditional sense.

Painting of Precision, Beauty of Indifference and Infrathin

Duchamp's next major project, which he took up as early as 1912 in order to implement it after he had arrived in New York in 1915 and to declare it 'definitively unfinished' in 1923,[16] was a deeply conceptual mixed-media work titled *The Bride Stripped Bare by Her Bachelors, Even*, also known as the *Large Glass*. Although this large-scale work is basically structured like a traditional painting, it opens an entirely new perspective due the fact that it lacks opacity in favour of a principle of transparency. Yet, in his corresponding notes, Duchamp designates this work as a 'painting', which he defines not merely as a 'picture on glass', but rather as 'a "delay in glass" as you would say a "poem in prose" or a "spittoon in silver".[17] Pointing to Duchamp's conviction that, at the end of the day, 'the spectator makes the picture', Dalia Judovitz remarks that Duchamp introduces this notion of delay 'in terms of a deferral, a passage that postpones the pictorial becoming of painting', while, by using the medium of glass, he 'denies one of the signatory marks of painting, that of figure/ground relations'.[18]

To set a basis for this pictorial becoming, against the background of its transparency, the *Large Glass* is structured in three sections: the lower 'Bachelor's domain', featuring a complex mechanism organised in central perspective; the upper 'Bride's domain', dedicated to an organic-mechanical entity reflecting the concept or reality of the fourth dimension; and, last but not least, a central 'Horizon' or 'Bride's dress', ambivalently separating and linking those two domains.[19]

This threefold structure is more than illuminating with regard to Duchamp's decision to move on from subjections and towards becoming, for the master plan of the *Large Glass* casts a light on Duchamp's deeply novel concept of the image as such. In striking parallel to the theory of perception which Bergson put forth in his book

Matter and Memory in 1896,[20] the Bachelors symbolise the changing viewpoints of any individual entity, intentional subject or arbitrary spectator; the Bride allegorises a quasi-objective or universal 'intuition of duration', that is a mode of 'pure perception'; and the central Horizon or Bride's dress represents the semi-permeable medium of the intermediary image.

Moreover, the three sections of the *Glass* can in no way be understood statically or independently of each other. Actually, the contrary is the case. In compliance with Bergson's notions of intellect, intuition and imagination, Duchamp insists on the fact that they are specifically intertwined, emerging one way or another only in the context of ever-changing backgrounds and different possible approaches.

However, the new perspective of these different possible approaches does not only affect the meaning of the *Large Glass*, but Duchamp's attitude towards art in general. With his dichotomic methodical vocabulary, summarised in his formula 'painting of precision, and beauty of indifference',[21] Duchamp referred not only to his time-consuming work on the *Glass* as well as to a number of other elaborate works, but also to his diametrical concept of the 'ready-made', which, as Linda Dalrymple Henderson has pointed out, directly traces back to Bergson's popular essay on *Laughter*.[22] As a matter of fact, whereas Bergson refers to a stumbling man as an exemplary object of ridicule right at the outset of his argument,[23] in 1917, Duchamp seizes on the very same kind of situational humour, as Bert Jansen remarks, with a wall coat rack nailed to the floor of his studio and titled *Trébuchet (Trap)*, which literally means 'stumbling block'.[24]

To get an idea of Duchamp's manifold approaches to art, one might also invoke his Mona Lisa with retouched moustache and beard as well as the 'hot ass' connoted in its title *L.H.O.O.Q.* (1919); his self-staging alias *Rrose Sélavy* (1921), in terms of a photomontaged female alter ego who would finally function as author of several of his prospective works; a number of 'boxes' containing meticulous reproductions of his notes and miniatures of his works (1914–66); his quasi-metaphysical concept of 'infrathin' (*inframince*), first made public within the framework of a special issue of the art magazine *View* (1945);[25] his acephalous mannequin with a water tap on its leg, titled *Lazy Hardware* and dressing a shop window of a New York bookstore (1945); or, last but not least, his truly unsettling assemblage *Given: 1. The Waterfall, 2. The Illuminating Gas* (1946–66), conspicuously appearing as an homage not only to the Statue of Liberty, but also to Gustave Courbet's scandalous painting *The Origin of the World*, while seeming to subtly hint with his title at Bergson's pivotal concept of duration first unrolled in his *Essay on the Immediate Data of Consciousness*.[26]

In sum, it seems fair to say that with his methodical pluralism, Duchamp espouses that paradoxical 'method of intuition' which Bergson defined in terms of an approximation to the variability and fleetingness of reality in his famous *Introduction to Metaphysics* of 1903:

Marcel Duchamp, *Étant donnés: 1° la chute d'eau, 2° le gaz d'éclairage . . . (Given: 1. The Waterfall, 2. The Illuminating Gas . . .)* (inside view), 1946–66, bricks, velvet, wood, parchment over an armature of lead, steel, brass, synthetic putties and adhesives, aluminium sheet, welded steel-wire screen and wood; Peg-Board, hair, oil paint, plastic, steel binder clips, plastic clothespins, twigs, leaves, glass, plywood, brass piano hinge, nails, screws, cotton, collotype prints, acrylic varnish, chalk, graphite, paper, cardboard, tape, pen ink, electric light fixtures, gas lamp (Bec Auer type), foam rubber, cork, electric motor, cookie tin and linoleum. Courtesy Philadelphia Museum of Art – Gift of the Cassandra Foundation. Philadelphia Museum of Art, Object Number 1969-41-1. Image copyright Artists Rights Society (ARS), New York/ Estate of Marcel Duchamp

No image can replace the intuition of duration, but many diverse images, borrowed from very different orders of things, may, by the convergence of their action, direct consciousness to the precise point where there is a certain intuition to be seized. [. . .] By providing that, in spite of their differences of aspect, they all require from the mind the same kind of attention, [. . .] we shall gradually accustom consciousness to a particular and clearly-defined disposition – that precisely which it must adopt in order to appear to itself as it really is, without any veil.[27]

In terms of this 'clearly-defined disposition', which shall bring consciousness 'to appear to itself as it really is, without any veil', namely by the medium of images not only 'as dissimilar as possible', but also 'borrowed from very different orders of things', for obvious reasons one is tempted to think not only of Duchamp's ready-mades, but also of his chosen one, the Bride. Whereas the concept of the ready-made, as Thomas Zaunschirm has pointed out, is not least connected to the idea of free choice in the face of a pre-made object of desire, a 'ready maid',[28] the Bride with her highly dissimilar appearances just seems to shout for a counterpart in order to appear 'without any veil'. In view of his abstract painting, his enigmatical notes, his female alter ego, his alienated Mona Lisa, his acephalous mannequin or his seedy peepshow, for Duchamp

it is not merely beauty, but rather 'beauty of indifference' that lies in the eye of the beholder. Exemplarily, the correlation of Duchamp's method of 'precision painting' with this 'beauty of indifference' emerging from images 'as dissimilar as possible' and 'borrowed from very different orders of things' becomes plausible in view of the *Large Glass*. As Octavio Paz makes clear, the Bride with its manifold apparatuses and aspects, as opposed to the Bachelors, is characterised by a principle of transformation:

> The Bride is a 'wasp' who secretes by osmosis the essence (gasoline) of love. The wasp draws the necessary doses from her liquid tank. The tank is an 'oscillating bathtub' that provides for the Bride's hygiene, or, as Duchamp says somewhat cruelly, for her diet. In the *Given*, ideas become images, and the irony disappears: the tank is turned into the lake, and the 'wasp-motor' into the naked girl, creature of the waters. But the best example of these changes – from the liquid state to the gaseous or vice versa, equivalent to mutations of gender – is the Milky Way of the *Large Glass*, manifestation of the Bride in the moment when, as she is being stripped, she reaches the fullness of delight. The Milky Way is a cloud, a gaseous form that has been and will again be water. The cloud is desire before its crystallization; it is not the body but its ghost, the *idée fixe* that has ceased to be an idea and is not yet perceptible reality. Our erotic imagination ceaselessly produces clouds, phantoms. The cloud is the veil that reveals more than it hides, the place where forms are dissipated and born anew. It is the metamorphosis, and for this reason, in the *Large Glass*, it is the manifestation of the threefold joy of the Bride as she is stripped bare: ultrarapid instantaneous communication between the machine state and that of the Milky Way.[29]

In the light of her hazy appearance, the Bride seems to be predestined to be associated with Bergson's postulate of the hidden nature of duration, virtually emerging by 'intuition', or, to put it with Duchamp, by 'precision painting, and beauty of indifference', combined with an aspiration of 'infrathin'. Thus one can infer that Duchamp's methodic approach goes with those three basic rules that are fundamental to Bergson's method of intuition according to Gilles Deleuze. Rule one, 'the stating and creating of problems', could be defined as the aim of 'precision painting'; rule two, 'the discovery of genuine differences in kind', as a result of 'infrathin'; and rule three, 'the apprehension of real time', as a contingent manifestation of 'beauty of indifference'.[30]

What if Creation Precedes Theory?

What can we learn if we look at Duchamp's art through Bergsonian glasses, with a view to highlighting potential correspondences or interferences between their works? Does it make sense to speak of an immediate influence of, or reference to, Bergson's

philosophy in terms of Duchamp's highly eclectic *oeuvre*? Is it not more likely that Duchamp's recourse to Bergson is but one of myriads of reference points essentially characterising his work?

Yes and no. On the one hand, it obviously does not make sense to argue that Duchamp's *oeuvre* would not be conceivable beyond the scope of Bergson's philosophy, but, on the other hand, it would be just as disproportionate to reduce Bergson's impact to only one random factor among many. After all, Bergson's philosophy can be viewed not merely as a *paradigmatic manifestation of* that particular zeitgeist of which Duchamp, once that he had emancipated himself from the paradigms of historical avant-gardism, would manage to stay ahead. Rather, Bergson's philosophy can be viewed as an ideal-typical *instrument to transcend* that zeitgeist, which actually proved to be less open-minded than it appeared to be. Note that Bergson, in an interview given in 1911, vehemently objected to the Puteaux Cubists' claim to theoretically reinforce their artistic work by saying: 'For the arts I would prefer genius, and you?'[31]

In view of Bergson's conservative attitude towards art, which is beyond debate,[32] one can proceed on the assumption that he would most certainly have objected to Duchamp's experimental approach as well. But at the same time, in retrospect it seems quite likely that he would still have had to concede one significant advantage to it. With regard to Duchamp's work, it would eventually be far too simplistic to argue 'that theory precedes creation', for, on closer inspection, rather the reverse is true. Even though Duchamp was intent on referring to theories, he would always make a point of doing so playfully, which is arbitrarily. Whether Duchamp, subtly hinting towards the iron/ironical laws of anarchism, defined himself as an 'an-artist' or as a 'respirator', as a chess player, a player on words, or as *Rrose Sélavy*, his art basically defies stringent definition and is in no way overly intellectual, but rather hedonistic and lambent and as such literally drawn from life.

Hence it is scarcely by mere coincidence that simultaneously with Duchamp's late success within the contexts of minimalism, pop art, Fluxus, happenings and conceptual art, neo-Bergsonism emerged as a new field of critical reflection, featuring an entirely new generation of images. In other words, if poststructuralist and postmodernist philosophies are characterised by an emphasis on the notions of processuality, discontinuity, heterogeneity, subtlety and self-organisation, which obviously trace back to Bergson, this focus can equally be observed in the fine arts from the 1960s onwards in terms of minimalist, conceptual, performative or seemingly trivial practices coevally tracing back to Duchamp. Thus one can safely say that Bergson's and Duchamp's works have a similar direction of impact, namely in terms of a primacy of immanence that can dawn on the recipient at best by means of perpetual re-enactment, or, to put it another way, of deliberate speculation.

Duchamp explicitly referred to this kind of approach in a lecture given in 1957 by pointing to a fundamental difference between what an artist intends to realise and what he or she actually does realise. Thus defining the artist as 'a mediumistic being' whose decisions in the creative act 'rest with pure intuition', Duchamp revealingly invoked a so-called 'art coefficient' being immanent in each work of art, and proving to be the decisive factor for its life and afterlife.[33]

From this perspective, when it comes to the specific 'art coefficient' contained in Duchamp's work, it may well be that he never intended to realise a kind of art which could potentially be described within Bergsonian terms. But what he did realise with his disparate *oeuvre* is not only an ideal-typical point of origin for ever-changing interpretations and future trends featuring a primacy of becoming, but also a new, surprisingly positive image of the ready-made, which is peculiarly apt to cast a new light on Bergson's philosophy.

Whereas Bergson devalued the ready-made to revalue the singularity of intuition, it was left to Duchamp to revalue 'The Idea of Fabrication', first mentioned in his *Box of 1914*, in terms of a primacy of concept to which realisation is only subsidiary. In practice, this idea refers to *3 Standard Stoppages, an experiment on 'canned chance' which Duchamp put into practice in 1913 by dropping three straight horizontal threads, each one metre long, from a height of one metre onto a horizontal plane in order to create 'a new image of the unit of length', 'casting a pataphysical doubt on the concept of a straight line as being the shortest route from one point to another'.*[34] Accordingly, it seems natural that Duchamp came up with the idea of using chance as 'a means of depersonalising all decisions pertaining to form', as Herbert Molderings remarks with reference to a range of experimental strategies that he developed in the context of his magnum opus:

> In the hypothetical world of the *Large Glass*, it is chance that determines measure and form; it determines the geometry of the happenings in the domain of the *bride* and in the *bachelor machine*. Its presence is threefold and operates on three different levels: point, line and surface. 'Wind – for the draft pistons / Skill – for the holes / Weight – for the standard stops / to be developed', Duchamp writes in one of his notes in the *Green Box*.[35]

Likewise, it was also left to Duchamp to revalue manufactured goods themselves by defining them as art with his ready-mades, for which he offered some precise conditions of production shortly after he arrived in New York in 1915. In one of his notes of that time, published in the *Green Box* of 1934, Duchamp remarkably considered the possibility to create a ready-made in terms of a 'rendezvous', that is by 'planning for a moment to come (on such a day, such a date, such a minute), "to

inscribe a readymade", which 'can later be looked for (with all delays)'.[36] In fact, as he made a number of ready-mades according to this variant idea of fabrication, Duchamp even went to the lengths of inscribing an apparently meaningless text, an abstract piece of prose, on four postcards, which he arranged into a work addressed to his patrons Walter and Louise Arensberg and titled *Rendezvous of Sunday, February 6, 1916.*[37]

Duchamp's ready-mades can thus be understood in terms of a rendezvous with the unforeseen of duration by means of an intentional recourse to the very 'immediate data of consciousness' that Bergson had invoked in terms of an apprehension of real time or duration (*durée*). By implication, Duchamp's concept of the ready-made seems to refer not least to that controversial method of 'intuition', which Bergson had defined in terms of a foundation of his philosophy in his famous Bologna lecture of 1911:

> What is this intuition? If the philosopher has not been able to give the formula for it, we certainly are not able to do so. But what we shall manage to recapture and to hold is a certain intermediary image between the simplicity of the concrete intuition and the complexity of the abstractions which translate it, a receding and vanishing image, which haunts, unperceived perhaps, the mind of the philosopher, which follows him like his shadow through the ins and outs of his thought and which, if it is not the intuition itself, approaches it much more closely than the conceptual expression, of necessity symbolical, to which the intuition must have recourse in order to furnish 'explanation'. [...] What first of all characterizes this image is the power of *negation* it possesses. [...] It seems to me that intuition often behaves in speculative matters like the demon of Socrates in practical life; it is at least in this form that it begins, in this form also that it continues to give the most clear-cut manifestations: it forbids. Faced with currently accepted ideas, theses which seemed evident, affirmations which had up to that time passed as scientific, it whispers into the philosopher's ear the word: *Impossible!*[38]

Impossible! That is what Duchamp's inner demon might have whispered as well when he made up his mind to refrain from that unquestioned glorification of Bergson's philosophy, in other words from that questionable Bergsonism which was the order of the day in avant-garde circles in 1912. And if so, that might be one of the reasons that in a countermovement, in one of his cryptic notes of 1913, he projected a:

> Possible | *The figuration of a possible.* | (not as the opposite of impossible | nor as related to probable | nor as subordinated to likely) | The *possible* is only | a physical 'caustic' {vitriol type} | burning up all aesthetics or callistics.[39]

As he conceived the physical 'caustic' of his art in terms of a 'Possible without the slightest grain of ethics of *aesthetics* and of metaphysics', as another note dating back to 1913 reveals, Duchamp also considered it necessary to raise the question: 'The physical Possible? yes, but which physical Possible. rather hypophysical',[40] while adding in another note: 'The possible is | an infrathin [. . .] implying | the becoming – the passage from | one to the other takes place | in the infrathin. | allegory on "forgetting"'.[41] Against this background, it makes sense that he conceived '*The Bride Stripped Bare by Her Bachelors, Even*: to separate the *ready-made, wholesale* from the *ready found*', not least stressing that 'The separation is an operation.'[42]

Unsurprisingly, when Denis de Rougement – who had presented his book *Talk of the Devil* in a New York window display designed by Duchamp in 1943 – asked him 'What is genius?' in 1945, Duchamp would answer with one of his puns, pointing not only to the mentioned 'impossibility of iron' (*impossibilité de fer*) as contrasted with his predilection for irony, but also to the resonating impossibility of making (*impossibilité de faire*) as against the possibility of letting things happen.[43] Thus one can hypothesise that Duchamp related to Bergson's method of intuition like he chose a number of ready-mades, which is in terms of an open-ended rendezvous with a *ready-found* philosophy serving as an ideal point of departure for his subversive *oeuvre*.

Diagonal Science and Philosophy of Art

Against the background of this open-ended involvement, it is clear that an interconnection between Bergson's and Duchamp's works is to be seen not so much in the sense of an assertive recourse as in the sense of an oblique reference. Hence, Duchamp's approach can be described by analogy with that theory of 'diagonal science' which the French philosopher and writer Roger Caillois finally outlined in 1959 after implicitly pursuing it in his own work since he had turned his back on surrealism and its glorification of the irrational in the mid-1930s.[44] 'When it comes to rigorous investigation', Caillois writes in 1970 with reference to his transdisciplinary approach, 'genius almost always involves borrowing a proven method or fruitful hypothesis and using it in a field where no one had previously imagined that it could be applied.'[45] Whereas he approves that the 'evolution of science partly lies in the progress of its own classifications', Caillois points out that the fundamental 'problem is that specialization encourages scientists to penetrate ever more deeply in the same direction, making it harder for them to discover, observe, or imagine revolutionary perspectives.'[46] In favour of these new perspectives, implying the possibility to perceive or suspect 'the coherent picture that would give unity and meaning to the whole',[47] Caillois thus makes the case for his concept of 'diagonal sciences':

These sciences bridge the older disciplines and force them to engage in dialogue. They seek to make out the single legislation uniting scattered and seemingly unrelated phenomena. Slicing obliquely through our common world, they decipher latent complicities and reveal neglected correlations. They wish for and seek to further a form of knowledge that would first involve the workings of a bold imagination and be followed, then, by strict controls, all the more necessary insofar as such audacity tries to establish ever riskier transversal paths. Such a network of shortcuts seems ever more indispensable today among the many, isolated outposts spread out along the periphery, without internal lines of communication – which is the site of fruitful research.[48]

Now that the present essay suggests establishing a transversal dialogue between Bergson's philosophy of intuition and the physical 'caustic' of Duchamp's art, it is of peculiar interest that Caillois's attempt to promote a kind of knowledge that would go along with 'the workings of a bold imagination' was not least inspired by his perception of their antagonistic positions. Already in 1938, in one of his early diagonal essays, Caillois referred to that specific 'myth-making faculty' (*fonction fabulatrice*) which Bergson had introduced in *The Two Sources of Morality and Religion* in 1932.[49] Stating that mythical representation functions like '*a quasi-hallucinatory image*' able to 'provoke, in the absence of instinct, the behavior that instinct itself would have triggered,'[50] he associates it with a faculty to reveal some of the neglected correlations to which he would later refer in terms of his diagonal approach. And still in 1970, as he united 'texts as diverse as one could imagine' just as if 'a demon had pushed him' in his anthology *Cases d'un échiquier* [Spaces on a Chessboard],[51] Caillois referred to Duchamp as one of the great 'liberators of imagination', pointing to his highly specialised book on chess, *L'opposition et les cases conjuguées sont réconciliées* [Opposition and Sister Squares Are Reconciled], which had fascinated him since its publication in 1932 as he considered that it could 'provide a key to the entire activity of the author'.[52] Moreover, Caillois's interest in Duchamp is emphatically reflected in an essay on 'Figurative and Non Figurative "Painting" in Nature and Art', which he published alongside of his first plea for 'diagonal sciences' in 1959.[53] After opening his argument with reference to the wings of a butterfly, suggesting that their chatoyant surfaces seem to represent something like the 'ready-made work' of a painter,[54] Caillois draws upon a range of nineteenth-century Chinese artists, who, 'instead of painting, contented themselves with slicing slabs of marble, framing them, titling them, signing them and presenting them as such to the public, as if it were a matter of veritable paintings', in order to come to the conclusion which just seems obvious from a present-day perspective:

Duchamp's audacity signifies that the essential lies in the responsibility taken by the artist by putting his signature on any object which he has or has not made, but

which he masterfully makes his own as he uncovers it as an oeuvre able to provoke, exactly like a master's painting, the artistic emotion.[55]

Likewise, Caillois's own scientific research was motivated by a fundamental bias against the abstract language of philosophy in favour of a downright interest in 'every eyewink of reality and imagination' (not to cite Bergson's with his 'immediate data of consciousness'), which he would particularly recognise in everyday objects or phenomena like insects, stones, dreams, myths, the images of a poetic language or the bold activities of heart and mind.[56] Thus it is arguable that with his heterogeneous *oeuvre*, Caillois drew back, just like Duchamp did and as Bergson would put it, to 'many diverse images', belonging to 'very different orders of things', which might coincide in order to 'direct consciousness to the precise point where there is a certain intuition to be seized.'[57]

Beyond the horizon of traditional art historical practice and its prevailing hapto-phobia with more experimental, subjectivist or historicist methods, what we have already begun to learn from Duchamp could be further established with Bergson and Caillois. An advanced philosophy of art would thus be one that combines the poten-

tialities of intuition and a bold imagination with the need for precision and strict controls.[58] Finally, in the light of that 'logic of the imaginary' which Caillois brought onto the scene with his diagonal sciences,[59] art and its attendant histories and theories are no longer about substantive messages, but

Marcel Duchamp, *Étant donnés: 1° la chute d'eau, 2° le gaz d'éclairage . . .* (*Given: 1. The Waterfall, 2. The Illuminating Gas . . .*) (outside view), 1946–66, wooden door, iron nails, bricks and stucco. Courtesy Philadelphia Museum of Art – Gift of the Cassandra Foundation. Philadelphia Museum of Art, Object Number. 1969-41-1. Image copyright Artists Rights Society (ARS), New York/Estate of Marcel Duchamp

rather about questioning their contingent effects and affects upon a particular environment or beholder. By means of a transversal approach, an advanced philosophy of art might thus have to deal with unstoppable transformations of dominant structures of knowledge, outpacing self-referential interpretations in favour of a blooming field of reciprocal actions and attractions, which can be cultivated by anyone willing to join the game. In view of that promising perspective, which can be derived from the philosophies of Bergson, Duchamp and Caillois, finally it might be most productive not to let oneself get carried away with their *élan vital* or waterfall flow, but to take an independent stand against the impressiveness of their illuminating gaze.

Notes

1. Cf. François Azouvi, *La gloire de Bergson. Essai sur le magistère philosophique* (Paris: Gallimard, 2007), pp. 218–34; Mark Antliff, *Inventing Bergson: Cultural Politics and the Parisian Avant-Garde* (Princeton: Princeton University Press, 1993); *Bergson and the Art of Immanence: Painting, Photography, Film*, ed. John Mullarkey and Charlotte de Mille (Edinburgh: Edinburgh University Press, 2013); Mary Ann Gillies, *Henri Bergson and British Modernism* (Montreal and Buffalo: McGill Queen's University Press, 1996); Hilary L. Fink, *Bergson and Russian Modernism, 1900–1930* (Evanston: Northwestern University Press, 1999); Francesca Talpo, 'Der Futurismus und Henri Bergsons Philosophie der Intuition', in *Der Lärm der Straße. Italienischer Futurismus 1909–1918*, ed. Norbert Nobis (Hanover and Milan: Sprengel Museum Hannover, 2001), pp. 59–71; et al.

2. A detailed analysis of this correlation is included in my doctoral dissertation near conclusion with the working title: *Bildtopologie. Spielräume des Imaginären nach Henri Bergson und Marcel Duchamp*.

3. See Pierre Cabanne, *Gespräche mit Marcel Duchamp* (Cologne: Galerie Der Spiegel, 1972), p. 31.

4. Cf. Henri Matisse, 'Notes d'un Peintre', *La Grande Revue*, II, 24 (25 December 1908): 731–45; Filippo Tommaso Marinetti, 'Manifeste du Futurisme', *Le Figaro*, 51 (20 February 1909): 1; Albert Gleizes and Jean Metzinger, *Du 'Cubisme'* (Paris: Figuière, 1912).

5. One of Duchamp's notes to the *Large Glass* is titled 'The Fork' (1915), cf. Arturo Schwarz, *The Complete Works of Marcel Duchamp* (New York: Delano Greenidge Editions, 2000), p. 629.

6. See Clement Greenberg, 'Counter-Avant-Garde' [1971], in *Marcel Duchamp in Perspective*, ed. Joseph Masheck (Englewood Cliffs, NJ: Prentice-Hall, 1975), pp. 122–33 (pp. 123–4): 'The Futurists discovered avant-gardeness, but it was left to Duchamp to create what I call avant-gard*ism*. In a few short years after 1912 he laid down the precedents for everything that advanced-advanced art has done in the fifty-odd years since.

[. . .] With avant-gardism, the shocking, scandalizing, startling, the mystifying and confounding, became embraced as ends in themselves and no longer regretted as initial side-effects of artistic newness that would wear off with familiarity.'

7. Cf. Calvin Tomkins, *Marcel Duchamp. Eine Biographie* (Munich and Vienna: Carl Hanser Verlag, 1999), pp. 98–101.

8. Incidentally, his *Nude* would anyway become one of the most conspicuous works of contemporary art as soon as it provoked a public scandal at the New York Armory Show in 1913.

9. *Marcel Duchamp: Interviews und Statements*, ed. Serge Stauffer (Stuttgart: Hatje Cantz, 1992), p. 18.

10. Cf. *Marcel Duchamp in München 1912*, ed. Helmut Friedel, Thomas Girst, Matthias Mühling and Felicia Rappe (Munich: Schirmer/Mosel, 2012); Rudolf Herz, *Marcel Duchamp. Le Mystère de Munich* (Munich: Moser Verlag, 2012).

11. Jonathan Crary, 'Marcel Duchamp's *The Passage from Virgin to Bride*', Arts Magazine, 51 (January 1977): 96–9 (pp. 98–9).

12. Robert Lebel, *Marcel Duchamp* (Cologne: DuMont, 1972), pp. 28–9.

13. In 1958, in an interview with Laurence S. Gold, Duchamp stated: 'I agree that in so far as they recognize the primacy of change in life I am influenced by Bergson and Nietzsche. Change and life are synonymous. We must realize this and accept it. Change is what makes life interesting. There is no progress, change is all we know.' Quoted in *Marcel Duchamp: Interviews und Statements*, p. 67 [trans. author].

14. Henri Bergson, *Creative Evolution* (New York: Barnes & Noble, 2005), p. 257.

15. Cf. Ibid. pp. 257–8.

16. Cf. *The Definitively Unfinished Marcel Duchamp*, ed. Thierry de Duve (Halifax: Nova Scotia College of Art and Design, 1991).

17. *Salt Seller: The Writings of Marcel Duchamp*, ed. Elmer Peterson and Michel Sanouillet (New York: Oxford University Press, 1973), p. 26.

18. Dalia Judovitz, *Unpacking Duchamp: Art in Transit* (Berkeley, Los Angeles and London: University of California Press, 1998), p. 60.

19. For a detailed analysis of the structure of the *Large Glass*, see Jean Suquet, *Miroir de la Mariée* (Paris: Flammarion, 1974), *LE GRAND VERRE: Visite guide* (Paris: L'Échoppe, 1992); Schwarz, *The Complete Works of Marcel Duchamp*, pp. 141–6 et al.

20. Henri Bergson, *Matière et mémoire. Essai sur la relation du corps à l'esprit* (Paris: Félix Alcan, 1896) / *Matter and Memory*, trans. Nancy Margaret Paul and William Scott Palmer (New York: Zone Books, 1990).

21. *Marcel Duchamp. Die Schriften. Band 1: Zu Lebzeiten veröffentlichte Texte*, ed. Serge Stauffer (Zurich: Regenbogen-Verlag, 1981), p. 95.

22. Henri Bergson, *Le Rire. Essai sur la signification du comique* (Paris: Alcan, 1900) / *Laughter: An Essay on the Meaning of the Comic*, trans. Cloudesley Brereton and Fred

Rothwell (New York: Macmillan, 1911). See: Linda Dalrymple Henderson, *Duchamp in Context: Science and Technology in the Large Glass and Related Works* (Princeton: Princeton University Press, 1998), p. 63. Incidentally, Henderson also refers to cubist theory in this context: 'Indeed, Duchamp's detached, mechanical practice and his name for it, Readymade, place these works directly in opposition to Bergsonian Cubist theory and painting.' Henderson, *Duchamp in Context*, p. 63.

23. See Bergson, *Laughter*, p. 8.

24. See Bert Jansen, 'Marcel Duchamp: De schoonheid van indifferentie', *Jong Holland*, 21, 2 (2005): 10–18.

25. *View: The Modern Magazine*, Marcel Duchamp Number, series V, no. 1 (March 1945). Cf. also Duchamp's ephemeral notes on infrathin in: Marcel Duchamp, *Notes*, ed. Paul Matisse (Paris: Flammarion, 1999), pp. 19–47.

26. Henri Bergson, *Essai sur les données immédiates de la conscience* (Paris: Alcan, 1889) / *Time and Free Will: An Essay on the Immediate Data of Consciousness*, trans. Frank Lubecki Pogson (London: George Allen & Unwin, 1910).

27. Henri Bergson, *An Introduction to Metaphysics*, trans. Thomas Ernest Hulme (Indianapolis: Hackett, 1999), pp. 27–8. First publication: 'Introduction à la métaphysique', *Revue de Métaphysique et de Morale* (29 January 1903): 1–36.

28. Cf. Thomas Zaunschirm, *Bereites Mädchen Ready-made* (Klagenfurt: Ritter, 1983).

29. Octavio Paz, *Marcel Duchamp: Appearance Stripped Bare*, trans. Donald Gardner and Rachel Phillips (New York: Arcade, 1990), p. 112.

30. Gilles Deleuze, *Bergsonism* (New York: Zone Books, 1990), p. 14.

31. Maurice Verne, 'Un jour de pluie chez M. Bergson', interview with Henri Bergson, *L'Intransigeant*, 11456 (26 November 1911): 1, quoted in: Mark Antliff, *Inventing Bergson*, p. 3.

32. In 1913 Bergson stated: 'Je déclare que je ne saurais approuver les formes révolutionnaires dans l'art.' See Villanova, 'Celui qui ignore les cubistes', *L'Éclair* (29 June 1913), quoted in Azouvi, *La gloire de Bergson*, pp. 226–7.

33. See Marcel Duchamp, 'The Creative Act', lecture given by Duchamp within the scope of a convention of the American Federation of Arts in Houston, Texas in April 1957, in *Art News*, 56, 4 (Summer 1957): 28–9.

34. Marcel Duchamp quoted in *MARCEL DUCHAMP*, ed. Anne d'Harnoncourt and Kynaston McShine (New York: Prestel, 1989), pp. 273–4. In a note that he added to his *Box of 1914*, Duchamp states: 'The Idea of Fabrication: If a straight horizontal thread one meter long falls from a height of one meter straight onto a horizontal plane twisting *as it pleases* and creates a new image of the unit of length. / 3 patterns obtained in more or less similar conditions: *considered in their relation to one another* they are an *approximate reconstruction* of the measure of length. / The 3 *standard stoppages* are the meter diminished.' Quoted in Schwarz, *The Complete Works of Marcel Duchamp*, p. 595.

35. Herbert Molderings, *Duchamp and the Aesthetics of Chance: Art As Experiment*, trans. John V. Brogden (New York: Columbia University Press, 2010), ebook.

36. Marcel Duchamp, *Duchamp du signe. Écrits*, ed. Michel Sanouillet (Paris: Flammarion, 2005), p. 49.

37. *Rendez-vous du Dimanche 6 Février 1916 (à 1h ¾ après midi)* not least reveals some striking correspondences with the theme of the *Large Glass*, see Schwarz, *The Complete Works of Marcel Duchamp*, pp. 190–4.

38. Henri Bergson, 'Philosophical Intuition', in Bergson, *Key Writings*, ed. Keith Ansell Pearson and John Mullarkey (New York: Continuum, 2002), pp. 233–47 (pp. 234–5).

39. Duchamp, *Duchamp du signe*, p. 104 [trans. author].

40. Ibid. p. 51.

41. Ibid. p. 21.

42. Ibid. p. 41.

43. See *Marcel Duchamp: Interviews und Statements*, p. 32.

44. As for Caillois's dissociation of surrealism, see: Roger Caillois, 'Letter to André Breton' [1934], in *The Edge of Surrealism: A Roger Caillois Reader*, ed. Claudine Frank (Durham, NC and London: Duke University Press, 2003), pp. 84–6; Claudine Frank, 'Introduction to "Letter to André Breton" and "Literature in Crisis"', in *The Edge of Surrealism*, pp. 82–4; and Roger Caillois, *Procès intellectuel de l'art* (Marseille: Les Cahiers du Sud, 1935). Caillois's concept of 'diagonal sciences' traces back to an article that he published under the title 'Après six ans d'un combat douteux', *Diogène*, 25 (April–June 1959) and which he incorporated into *Méduse et Cie* under the title 'Sciences diagonales' in 1960. See Roger Caillois, 'Nouveau plaidoyer pour les sciences diagonales', in *Cases d'un échiquier* (Paris: Gallimard, 1970), pp. 53–9 (p. 53, note 1).

45. Caillois, 'A New Plea for Diagonal Science', in *The Edge of Surrealism*, pp. 343–7 (p. 344).

46. Ibid. pp. 344–5.

47. Ibid. p. 344.

48. Ibid. p. 347.

49. Caillois, 'The Function of Myth', in *The Edge of Surrealism*, pp. 113–23 (p. 115). First published under the title 'La fonction du mythe', in *Le mythe et l'homme* (Paris: Gallimard, 1938), pp. 13–32. Cf. Henri Bergson, *Les deux sources de la morale et de la religion* (Paris: Alcan, 1932).

50. Caillois, 'The Function of Myth', p. 117.

51. See Roger Caillois, 'Préface', in *Cases d'un échiquier*, pp. 7–11 (p. 8): 'En hommage un peu ironique à cette dispersion fondamentale, je réunis ici les textes les plus divers qui se puissent concevoir: un démon, tant je crains qu'ils ne jurent ensemble, me pousse à le mettre à l'épreuve et à vérifier qu'ils s'accordent.'

52. Roger Caillois, 'L'Imagination rigoureuse' [1968], in *Cases d'un échiquier*, pp. 34–46

(pp. 43–4). Cf. Marcel Duchamp and Vitali Halberstadt, *L'opposition et les cases conjuguées sont réconciliées* (Paris and Brussels: Éditions de l'Échiquier, 1932).

53. Roger Caillois, 'Natura Pictrix. Notes sur la "peinture" figurative et non figurative dans la nature et dans l'art', in *Oeuvres*, pp. 501–8; first published in *Cahiers du Musée de poche*, 1 (March 1959); republished in *Méduse et Cie*. As for Caillois's first plea for 'digaonal sciences', cf. above, note 44.

54. See Caillois, 'Natura Pictrix', p. 501: 'Que l'aile des papillons soit ou non ce qui ressemble le plus à un tableau, il faut avouer que l'historie de la peinture ne révèle aucune préférence spéciale des peintres pour ces surfaces chatoyantes, où leur travail paraît tout fait. [. . .] Je constate cette abstention sans la commenter. Je soupçonne seulement qu'elle vient du fait que l'aile est déjà perçue comme tableau, de sorte que la peindre serait moins représenter la nature que dédoubler une œuvre.'

55. Ibid. p. 506 [trans. author].

56. See Roger Caillois, 'Préface', in *Cases d'un échiquier*, p. 7: 'Le langage philosophique me rebute. [. . .] Au cours de discussions abstraites, il m'arrive, comme on dit, de regarder une mouche voler, ce qui n'est le signe d'un esprit ni tendu ni entendu. Au fait, j'ai été justement intéressé par les mouches qui volent (au moins par les scarabées et les papillons), par les cailloux, les images de la poésie, les rêves, les mythes, les démarches hasardeuses du cœur ou de l'esprit, en un mot par tout clignement d'œil du réel et de l'imaginaire.'

57. Cf. above, note 27.

58. Cf. Henri Bergson, 'Introduction (première partie)', in *La pensée et le mouvant. Essais et conférences* (Paris: Gallimard, 1999), pp. 1–23 (p. 1): 'Ce qui a le plus manqué à la philosophie, c'est la précision. Les systèmes philosophiques ne sont pas taillés à la mesure de la réalité où nous vivons. Ils sont trop larges pour elle. Examinez tel d'entre eux, convenablement choisi: vous verrez qu'il s'appliquerait aussi bien à un monde où il n'y aurait pas de plantes ni d'animaux, rien que des hommes; où les hommes se passeraient de boire et de manger; où ils ne dormiraient, ne rêveraient ni ne divagueraient; où ils naîtraient décrépits pour finir nourrissons; où l'énergie remonterait la pente de la dégradation; où tout irait à rebours et se tiendrait à l'envers. C'est qu'un vrai système est un ensemble de conceptions si abstraites, et par conséquent si vastes, qu'on y ferait tenir tout le possible, et même de l'impossible, à côté du réel.'

59. Cf. Roger Caillois, *La Pieuvre: Essai sur la logique de l'imaginaire* (Paris: La Table ronde, 1973).

14 Economies of the Wild: Speculations on Constant's *New Babylon* and Contemporary Capitalism

Bram Ieven

Beginning New Babylon, or, 'Speculative Art History? What Did You Expect?'

IN 1958, THE Dutch artist Constant Nieuwenhuys (1920–2005), who usually went by the name of Constant, designed a temporary habitation for a group of Roma people based in Alba, Italy. It was to be a flexible and transportable construction: a sort of tent, easy to take apart and easy to rebuild, but big enough to shelter the entire Roma community that would be travelling with it. The design, though never executed, was the beginning (the prequel, one is tempted to say) of a much more ambitious and far more comprehensive project: New Babylon.

Part architecture, part painting and part writing, New Babylon is the name for an entire ecosystem of ideas, aesthetic visions, conceptual fragments and architectural images.[1] For a period that lasted over a decade, Constant concentrated all of his efforts on elaborating New Babylon in writing, through painting, collages, composite maps, lithographs and in architectural scale models. His writings give an exposition of the urban planning behind the new global city that was to be New Babylon. In his essays, Constant describes New Babylon's ingeniously constructed, air-conditioned atmospheres, its economic and technological foundations, and how these would abolish capitalism as we know it. The paintings and lithographs that belong to the New Babylon series give us a view of the city from different angles and in varying lighting conditions, a crucial aspect of the atmospheric design Constant had in mind for his city. What is striking in this regard is that the colours in these painting are reasonably subdued, with Constant opting for egg-yolk yellows and differing shades of ochre and amber rather than the more saturated primary colours we have come to associate with utopian painting since modernism. And yet Constant's colours

vibrate; they appear to emit light, reminding one of the darker colourism of the later work of Titian (the quality of which is still the subject of debate).[2] As such, subdued but vibrant, these paintings give the viewer an aesthetic sensation of the new, transmutable atmospheres and living spaces that New Babylon would consist of. More reminiscent of constructivism, Constant's scale models represent sectors, intersections and plazas of the future city; together with the paintings and drawings, these scale models give an idea of how it would feel to move through the city and to change its architecture based on one's needs (a happy privilege of its users).

In sum, New Babylon comprises a decade of work: theoretical work, artistic work but, above all and more to the point, the work of imagination. I believe that the best way to talk about New Babylon and do justice to its consistency and diversity is to refer to it as a body of work (paintings, collages, drawings, scale models, writings) that constitutes an ecosystem of ideas on the nature of art, creativity and a post-sedentary society. As such, New Babylon is what the art institutions of our times would call an artistic research project.[3] Only this time around, we are not dealing with the neo-liberal cul-de-sac of contemporary knowledge production that wishes to subject even aesthetic knowledge to the barren strictures of contemporary capitalism; this time, we are dealing with the real thing: an audacious and wildly imaginative research project that can serve as an antidote for despondent resignation to the rules of neo-liberal research poisoned by ideologies of market and measure. New Babylon is an artistic research project purposely working in multiple artistic media at the same time; it employs and puts to work the distinct forms of conceptual and aesthetic knowledge that writing, architectural design and painting can produce to patiently close in on its goal: a radical critique of existing society that takes play and creativity as the principles for political change.

This sort of speculative, multi-media way of elaborating an idea is driven by what I want to call an economy of the wild: an economy of knowledge in which aesthetic and conceptual insights interact, are rubbed against each other, collide as well as collaborate with no predetermined outcome, but with the aim of producing a rich reserve of aesthetic and political insight – each insight a fragment from a collision between different regimes of knowledge and imagination, triggering reflection on art, artistic research, and creativity both in the 1960s and in our own time. Understanding knowledge production as an economy, Steven Connor pointed out more than two decades ago,

> allows and obliges the critic [or, in this case, the artist-researcher] not only to order and distribute the elements of his field of study in an inert relationship of equivalences and distinctions, but also to show the processes of exchange, circulation and interested negotiation which brings these relationships dynamically into being.[4]

As a rule, such artistic research projects arise from concerns proper to the social formation of the times. This is, in any case, how I choose to understand Marquard Smith's suggestion that 'each historical moment has its own *epistémè* of re-search'.[5] The research undertaken by Constant via New Babylon adumbrates the endeavour of 1960s counterculture to think the impossible, to go beyond capitalism by recalibrating ideas of communality, creativity and urbanism. But because of this historically determined '*epistémè* of re-search', New Babylon also speaks to our own times, which seem to maintain a privileged relation with the 1960s: the 'Sixties' dream of a society revolving around creativity and flexibility, mediated by non-hierarchical 'spaces of flow', has become our reality, its cognitive and epistemic tactics have become our nightmare.[6]

The best way forward, I believe, is to see whether we can develop an art historical heuristics that will allow us to turn this double-edged dream-cum-nightmare shared by the 1960s and our current juncture into a productive knowledge constellation; that is to say, a form of looking, reading and writing that makes possible a critical speculation on the conditions and imminent futures of our own social formation, our own regimes of thought, urban life and economic production. In New Babylon, dream and nightmare congregate around the notions of creativity and flexibility, the principles for an exodus from capitalist oppression for Constant, but the leading principles for contemporary capitalism's advancement and integration into even the smallest fibres of our social lives. Like Constant's New Babylon project, the structural role contemporary capitalism grants to flexibility and creativity was made possible through a series of ongoing technological innovations. While Constant's analysis of the 'age of automation'[7] led him to predict that 'creativity' would transform from the exclusive property of artists into a general and democratised good for all citizens, leaving behind the strictures of a capitalist mode of production and top-down urban planning, we must draw a different conclusion. Creativity and flexibility, both flourishing in urban centres all over the globe, are today at the very heart of contemporary capitalism.

Under the form of capitalism which today shapes the material grounds and cognitive horizon for our political imagination, citizens mostly reside in (or in close proximity to) medium-sized cities that are connected to other cities scattered over the globe by means of communication networks, and in these cities they are continuously tested on their creativity and flexibility skills, both in the workplace and at home. Today, indeed, creativity and flexibility have become the pinnacles of a new form of capitalism. For the purpose of this essay, I will call this contemporary capitalism. Through giving it the predicate of 'the contemporary', I wish to point out that the social and economic principles of creativity and flexibility, proper to capitalism today, tend to hold us captive in the *here and now*, in the 'not too distant future'.

Why would that be? The short answer, for now: today's labourers (cleaners, sales people, writers or teachers) all work from 'project to project', projects being medi-um-sized tasks that require collaboration and the success or failure of which is the worker's own responsibility. It is 'the project' that generates the moral virtues of contemporary capitalism (creativity and flexibility) and it impoverishes our political imagination. It does this through its double take on time: everything is on a short-term basis yet, at the same time, we need to rush from project to project, get involved in multiple projects at the same time overlapping each other, and so on.[8]

My hypothesis is that 'the project', and thus the dictate of the contemporary, is what determines our own historical *epistémè* of re-search. To contrast this with the *uncontemporary* elements we find in a work of art like New Babylon is what, to my mind, constitutes the task of a speculative art history.

New Babylon enabled Constant to elaborate upon ideas of architecture and urban space that would never have been possible had he been a practising architect or urban planner. Understandingly, though, critical attention for the project came from historians working in these domains.[9] Some of Constant's writings on New Babylon also appear in anthologies on situationism, a movement that he helped found but quickly abandoned.[10] But what if we wish to take New Babylon for what it is, an interdisciplinary and multi-medial artistic research project? What if we wish to develop a historical heuristics that takes New Babylon for the artistic research project that it wanted to be? And what if we wish to bring the ideas and insights of New Babylon to bear upon our own time? How would we go about developing such an approach to art?

Frankly, that seems an audacious undertaking, one that is perhaps impossible to execute because New Babylon spans over a decade and consists of essays, roughs and drafts executed in different mediums spinning off in multiple directions. That is to say, it is difficult precisely because New Babylon's ideas and insights result from a recalcitrant collision between different artistic mediums and their corresponding regimes of knowledge. In the remainder of this essay, I have a less ambitious aim: to take just one strand of thought from New Babylon's wild economy of ideas, to hold it up against the context of its own time and then to discuss it in conjunction with our own time. Rather than using the speculative to gain free passage to the meta-physical domains of the good, the beautiful or the sensory, far removed from anything approximating history, I am more interested in speculating on the *radical historicity* of works of art such as New Babylon to see how their ideas, not in spite of but because of their very historical situatedness, reverberate in our own time and become the starting point for breaking with the tyranny of the contemporary, for a 'resistance to the present'.[11] This must also mean that the speculative is not only reserved for the critic or historian, whose task is not to remain stuck in the disciplinary deserts

of either historicism or formalism, but to establish a 'diffractive conjunction' between the aesthetic and political moments she finds in a work of art and the political moment of her own time.[12] The speculative must also be present in New Babylon. And it is teased out precisely through a dynamic conjunction of two political and aesthetic moments executed through analysis and interpretation: the aesthetic and political momentum of New Babylon, on the one hand, set to work against the aesthetic and political impasse of our own time, on the other. While this diffractive reading must organise itself around the concepts of creativity and flexibility, our task is to show the distinctive approaches to those concepts in contemporary capitalism and in New Babylon. The best way to drive home this distinction is by looking at how New Babylon arranges the concepts of creativity and flexibility, not around the coordinating concept of the 'project' but around a politicised idea of play. Play, or more accurately the politicisation of play as the starting point for political and aesthetic critique, is what lies at the heart of New Babylon.

Politicising Play

In reality, the modern urbanist regards the city as a gigantic centre of production, geared to the efficient transport of workers and goods, to the accommodation of people and the storage of wares, to industrial and commercial activity. The rest, that is to say creativity, life, is optional and comes under the heading of recreation and leisure activities.

The fact that constant growth in leisure time in this age of automation poses an acute problem, that young people are protesting more and more vociferously against the interminable boredom of present-day life, must in itself be sufficient reason for us to overhaul those famous urban planning functions and to resist a view of the city as a machine for living, a *machine à habiter* as Le Corbusier put it.[13]

New Babylon was not simply the result of Constant's enduring dissatisfaction with the principles of modern urbanism and the International Style of architectural design. He was not averse to the specific technical advancements achieved by urban planners in the first half of the twentieth century, just as he was not dismissive of avant-garde movements and their relevance for the early twentieth century. But the specific procedures they developed led to a form of calculated, top-down planning that resulted in seemingly functional but in reality restricting and deterministic grids. Constant's endeavour was to recuperate these technical advancements while starting out from a very different approach to city life.

The city, Constant argued, 'is not a functional object.'[14] By the middle of the 1930s, however, and under the influence of the International Congresses of Modern Architecture (CIAM) led by the influential architectural historian Sigfried Giedion

and the well-known architect Le Corbusier, city planners in the Netherlands were busy designing the extension plans of demographically booming cities like Amsterdam and Rotterdam. In accordance with the principles of the 'functional city' that were outlined in the CIAM's Athens Charter from 1933, Amsterdam's city planner Cornelis van Eesteren (who was also one of the main contributors to the charter) had begun to implement his plans for an enlarged Amsterdam, the environment in which Constant would spend his teens. But Van Eesteren's solution to the social and demographic challenges of Amsterdam were inspired by the calculated and blueprint-oriented, top-down form of urban planning typical of the CIAM.[15] Constant's approach to the city would by very different. The city, he argued, should be approached as 'a plaything'.[16]

The concept of play is key to understanding New Babylon and its striving for a creative and flexible living environment. What Constant rejected was the top-down, inflexible nature of the functional city as much as the predictability of it. It confined users to living in a blueprint, predesigned by one individual in a specific historical and political moment. It did not invite play. Allowing for little improvisation, and functionally designed only with the dominant economic and social system in mind, the functional city must be rejected, Constant concluded. But to reject it means that we labour on an alternative, and that task, he argued, also requires us to analyse the economic conditions under which change becomes possible. My aim below is to show that Constant's coupling of economic and aesthetic concerns is brought together under the rubric of play. Play is, as it were, the paradigm around which the critical task of New Babylon (to analyse its own political moment through multiple artistic media) and its aesthetic task (to imagine a different future by gathering forms of knowledge and playing them off against each other) are gathered. Together, and precisely because of their discordant, fragmentary take on a unique historical moment, they constitute an economy of the wild.

Constant quickly realised that the economic conditions that would make play possible would have to be very different from the conditions upon which humankind had hitherto been forced to build its society. Instead of an economy of scarcity, play requires an economy of affluence. If there is affluence, this means that there is an affluence not only of goods but also of time: time to spend on activities other than labour and the manufacturing of goods, as there are plenty, in other words leisure time or, indeed, time for play. Only under such conditions does it become possible for play to be the basis of society. Adopting a discourse and research approach that is closely aligned with the kind of new-left Marxism that was freeing the theory from its restrictive and outdated jargon, Constant analyses the 'means of production' of existing societies and queries the changes in technology from the past two centuries. In his book-length study on the subject, *Opstand van de homo ludens* (1969), Constant

concludes that changes in technology have led to a boost in productivity, making the time ripe to overthrow capitalism as we know it in favour of a society based on play.[17]

To understand this congregation of divergent ideas and insights a little better, I will discuss a part of New Babylon that up until now has received very little attention in art history: the writings that belong to the project. My reasons for focusing on those writings have not only to do with the fact that they have been undervalued, but, more importantly, I think that by reading Constant's ruminations on New Babylon attentively we can come to understand why he believed that New Babylon was not just a utopian dream but the articulation of a possible future for society in the mid-1960s. This seems striking, and it is, of course – but perhaps not entirely, as at the very least it is worth pointing out that Constant's methods are widely different from those of utopianism.

The distinctiveness of the approach taken by Constant – so very different in many respects from other writings of situationism but so familiar with its discourse and desires as well[18] – is revealed splendidly in his criticism of 'social justice'. All uprisings against the powers that be, Constant explains, were motivated by a desire for social justice. But, he quickly adds, 'in times when there is a shortage in productive capacity, justice for all means scarcity for all.'[19] In a society dominated by scarcity and poverty, there is little room for play. The implications of this idea are far-reaching, at least for Constant. One of its conclusions, not stated explicitly by Constant but, I believe, implied in the quote below, is that the political imagination of modern utopianists had hitherto been shaped around the presuppositions and conditions of a society struggling with scarcity, which forced them to translate their liberatory ideas into rigid, inflexible economic regimes of control. In times of scarcity, Constant writes,

> social justice inevitably means giving up on play, on creativity and culture. The Utopia of Thomas More is a strictly organized labor camp where individual freedom has been sacrificed for the good of productivity. The only 'play' known to Utopia is the allegorical fight between virtue and vice, which always ends in a victory for virtue and has *therefore bereft play of its very essence*.[20]

So what is essential to play in Constant's opinion? The answer must allow for the beginning of our analysis of play, both in Constant's work and in our understanding of speculative art history.

It seems to me that the answer must be that, for Constant, the contingency of play is its essence: the contingency of play taking place, as much as the indeterminacy of its outcome. If we bring this to bear upon the concept of politics that can be inferred from New Babylon, then the conclusion seems to be that in New Babylon *the outcome of a political struggle – which is to say, the outcome of an argument or disagreement*

within a community, as much as the fact that it takes place at all – must be contingent, undetermined. Or else New Babylon is just another utopia.

This is the first step in my reading of Constant's concept of play. The fact that it was developed in the context of the New Babylon project seems to imply that it has an important role in it. I would go as far as to say that with Constant's concept of play, we are at the heart of the paradigm that lies behind New Babylon. For our political imagination, however, indeterminacy and contingency remained unimaginable as long as the conditions of productions did not change. During the last century, Constant argues, technological advances in the means of production, or the 'era of automation' as he more generally calls it, have opened a window for radical political thought to escape being determined by scarcity. With the possibility of a transition from an economy of scarcity to an economy of affluence, human beings not only acquire more free time; more essential is that the concept of play as an undetermined, contingent activity now moves to the very heart of New Babylon's conception of politics.

Constant's writings on New Babylon and its playing man are guided by an astute awareness of the interdependence between the economic and social formation of a community and its way of organising the use of creativity and political imagination. 'Professional artists', he argues, 'are the product of a specific financial economy.'[21] The era of automation and its effect on art unfolded in two stages for Constant. In the first stage, a large amount of capital is required to create the necessary infrastructure for automated production, and this leads to a decline in the investment in art, which in turn leads the artists to dissociate themselves from the ruling classes. Artists then become more sympathetic to the labourers working in poverty. I doubt, though, that this part of Constant's argument is tenable. At the very least we must observe that the market for art grew explosively in nineteenth-century Europe. At the same time, cities such as Paris, London and Berlin witnessed a geographic boom and a democratisation of their educational art institutions. The dissymmetry that existed between a growing market and a growing supply, along with the very unpredictability of success, is most likely what led a number of experimental painters to associate themselves with the workers and their movements for social justice.

The most important point for Constant's New Babylon project, however, is that the post-war era signalled the beginning of a second phase of the era of automation. While the avant-garde reached its zenith in the interwar years, we can simultaneously witness a rise in production made possible by new technologies and forms of organisation in the workplace. But the impact on culture of technological advances in the workplace, in infrastructure and in transportation only becomes clear during the decades following the Second World War, when Europe and Asia's economies were rebuilt. Countries like West Germany in the West and Japan in the East quickly

developed their own economic strategies for recovery (ordoliberalism in the case of Germany, the just-in-time Toyota strategy in the case of Japan). Further advancement in the technology of production, Constant optimistically concluded in his writings of the 1960s, can only lead to a reduction of the human labour involved in the production process, and this will leave all of us with a lot of time on our hands. This is why, Constant argues, both creativity and flexibility can become the general property of all citizens and influence the way they spend their lives. What once belonged exclusively to the artist (creativity) or to the educated individual (flexibility) now becomes available for everyone, the reason being, indeed, the re-articulation of time in an affluent society like New Babylon, time which now becomes available in large amounts to all.

Once again, this concept of time changes the nature of play, making it possible for play to become a political concept. Play is now not only understood as contingent; it is also understood as delimited, generalised. While in a society that operates under the conditions of scarcity time is a valuable good, time loses nothing of its value in New Babylon's affluent society. Quite to the contrary. The fact that it is available in large amounts alters the nature of time and what takes place in it, such as play. Play can take several hours, several days or just a brief instant, and it is, as I pointed out above, always contingent. This constitutes the second part of my interpretation of play in Constant's New Babylon project.

Together, these two principles – the contingency of play and its creation of a political moment in which time is stretched – being available in large amounts are the basis for the politics of play developed by Constant through New Babylon. Operating alongside each other, these two principles create a politicised concept of play that I believe can be brought to bear upon the concept of the 'project' that dominates contemporary capitalism. Play, though similar to the project in its use of creativity and flexibility, is also able to constitute a radical aesthetic and political critique precisely because of its alternative notion of time. Unlike the multitude of professional projects we must undertake in contemporary capitalism, projects that constantly overlap and require us to rush from one task to the next, New Babylon's generalised condition of play escapes the principles of scarcity and moral responsibility that shape the concept of the project in today's economic and social formation.

The figure of the artist has been determined by the social and economic formation of the West as much as by anything else. In an economy of scarcity, very few resources can be spent on art. Accordingly, being an artist remained an exclusive, lonely and somewhat adventurous occupation for the daring few. With the increase of free time, in the case of New Babylon at least, the situation changes. But not necessarily to the advantage of the artist. In fact, for Constant, the generalised creativity that has been made possible through the advancement in the technologies of production not only

lead to a change in society as we know it, they also signal the end of the figure of the artist that is coterminous with society. This has an impact on how Constant develops the architectural and painterly forms of knowledge production that also belong to his project but to which I have not paid any attention yet.

In a society that no longer holds a meaningful role for the artist and his or her products of singular aesthetic beauty, the employment of aesthetic activities such as painting must now be distributed among its citizens. In fact, aesthetic activity and play lie in each other's conceptual proximity. Play is nothing but a generalised condition of what we also find in an aesthetic situation: creative employment of the imagination, absence of predestined purpose and a lack of an interest in it, the feeling of pleasure in all of its different forms, and so on.

When one looks closely at the paintings, drawings and scale models of New Babylon, what strikes the eye is that Constant then developed these in accordance with the principles of play that I expounded upon in this essay. This means, for example, that New Babylon is not an architectural project for a new city in the normal sense, since Constant does not predetermine the use and modulation of space and light, a task that is usually that of an architect or city planner. At best, Constant's scale models give us a fragmentary idea of the architecture of New Babylon, showing us only how basic structures rise up from the ground and reach into the sky to support platforms on which the daily life of New Babylon's inhabitants will take place. Constant's scale model for the Yellow Sector of New Babylon for example, designed in 1958 and now held in the permanent collection of the Gemeentemuseum, The Hague, shows a transparent juxtaposition of overlapping Plexiglas roofs, divided into different multifunctional spaces through the use of simple metal structures on each of the platforms. New Babylon's reality, its bustling activity, necessarily remains an abstract reality for the viewer, but in New Babylon's actual reality, the users of the Yellow Sector can change it in accordance to their needs. This sort of unpredictable, flexible architectural environment is, indeed, what the iron supporting structures are supposed to make possible. As an artist-designer, then, Constant's maquettes are experiments in designing for creative citizens rather than for passive consumers. As such, they are fragments from an alternate political imagination, guided by play rather than scarcity.

Constant's roughs and drafts for New Babylon focus on the supporting structures of the different sectors of the city. But unlike the scale models, his sketches and lithographs possess a dynamic quality, as if they were moving, bristling with life. Ladders are found everywhere, connecting one platform to the next, shooting off in multiple directions, and the busyness of the transportation arteries of a sector are rendered visible by means of expressive lines that suggest rapid, continuous movement. This is the main task of the sketches and lithographs: not just to give

another, two-dimensional idea of what the sectors of New Babylon look like, but to render visible its state of flux and continuous activity. The paintings that Constant made throughout the 1960s, finally, all attempt to capture the atmosphere of New Babylon.

Living, AD 2015: Aesthetics and the Architecture of Capitalism

From the very start of his career, Constant had been a prolific artist, writer and organiser. In the late 1940s he collaborated with the Danish painter Asger Jorn to establish the COBRA movement, for which he also drafted a manifesto. On a national level, Constant had been actively involved in collaborating with Dutch poets and writers to establish the 'experimental group', for which he also wrote several texts and founded a journal (*Reflex*). That Constant would continue to write while working on New Babylon is therefore not so surprising. But what distinguishes his writings on New Babylon from his earlier manifestos, is that they form an intrinsic part of his artistic inquiry. Constant used these writings to elaborate the principles of the new society that New Babylon would be, and he was able to do so by developing a notion of play that not only altered the principles of politics and economy, but also the roles of the artist and the architect. On the basis of this, Constant developed what I term an artistic research project.

If we now take a step back to ask what Constant's New Babylon tells us about the relevance and therefore import (though not necessarily impact) of art for our own times, in our own entrenched fields of knowledge acquisition, what can we conclude? The speculative element of New Babylon is not only to be found in the interpretation of the critic or art historian, and, accordingly, its relevance for our time cannot only be accounted for by the keen interest of a critic who desires to read Constant's project in conjunction with our own times. The speculative element of New Babylon lies in how it chose to deal with the aesthetics and politics of its own era. Herein lies the import of a project like New Babylon: combining different artistic media, it not only produces different forms of knowledge proper to these media. By playing off against each other the moments of fragmentary insight that each sketch of New Babylon produces, the project becomes a *work* of art, something that takes on a life in our mind and sparks our imagination in unexpected ways. As such, it functions as a work of art, an *oeuvre*, rather than a static object that lends itself to creative analysis.

The more we view of New Babylon, the more sketches and scale models we study, the longer we ponder over Constant's use of colour and how it tends to break with a modernist tradition in colourism (a tradition which, if we stop to think about it, has had a notable influence on the meaning we tend to attach to colour, even though

it represents only a very small part of painterly tradition: the post-Courbet and pre-Constant era), the more New Babylon becomes a *paradigm* for an artistic research project. Only this time, the paradigm dictates that an artistic research project engages itself with its own time in such a way that it rethinks the premises of its time through the prism of different artistic media and the different forms of knowledge that they can yield. As such, an artistic research project like New Babylon necessarily remains a singular, aesthetic undertaking: no general laws of research can be inferred from it, and its engagement with its own time makes it highly particular or situated.

And yet this last observation deserves some qualification. Looking at the principles for urbanism that Constant developed through New Babylon, we cannot fail to notice that a good deal of those principles have actually been realised: flexibility of space, so-called spaces of flows, migratory possibilities, etc. New Babylon almost reads like a blueprint for post-industrial society. And in a way it is. Only, the ideas that Constant (and many authors and artists of the 1960s along with him) articulated were at that particular time elements of a moment; they constitute a political moment.

As it turns out, capitalism is very adept at recuperating those moments and aligning them with its own course of action. But so, perhaps, is art, or certain artistic research, such as New Babylon. New Babylon brings together fragments of a political and aesthetic moment: fragments from the specific social formation of the Netherlands (a country that was struggling with spectacular demographic and urban growth and was forced to review its entire urban planning system in the mid-1960s); fragments from life in Amsterdam (a growing city that would soon witness one of the first counterculture movements of the 1960s, the Dutch Provo's which, not surprisingly, would embrace New Babylon as their ideal society); but also remnants from a wider, more sociological discourse on the rise of post-industrial society, the tertiary industry, immaterial labour and the New Left in general. And yet to bring this to the attention of the reader does not yet make for a speculative art history; what would make it speculative is if we were to delve into New Babylon to find those ideas and sentiments of the time reflected in it in such a way that they turn into truly novel ideas that can help us understand our own political and aesthetic moment. In the case of New Babylon, I believe its acuteness for our own moment lies in its creative employment of ideas of flexibility, flow and bottom-up approaches to social issues. Admittedly, if we stop to think about it, New Babylon paints a pretty bleak picture for us: many of its creative and exuberant ideas have in the mean time been appropriated by capitalism, the very system Constant thought would be overthrown by New Babylon. In the neo-liberal situation we have nothing but flexibility. But, at the same time, New Babylon's concept of

play allows for a counter-narrative to the project-based work frenzy of contemporary capitalism. It provides an element of uncontemporaneity in a global economic system dominated by the tyranny of the contemporary. As such, it was and remains a speculative project.

Notes

1. A large number of the New Babylon series, seventy-five works in total, are in the collection of the Gemeentemuseum, The Hague (the Netherlands). The inventory and images can be consulted online: <http://www.gemeentemuseum.nl/en/masterpieces/themes/new-babylon> (accessed 16 March 2015).

2. For Constant's early ideas on colour, see his essay: 'On Spatial Colorism', in *Constant's New Babylon: The Hyper-Architecture of Desire*, ed. Mark Wigley (Rotterdam: Witte de With Center for Contemporary Art and 010 Publishers, 1998), p. 74. On Constant's love of Titian, see the interview with Hans den Hartog Jager in *Verf: hedendaagse Nederlandse schilders over hun werk* (Amsterdam: Atheneum, 2011), pp. 15–25, and Thomas Doebele's documentary *Avant le départ* (VPRO, 2005), in which Constant visits and discusses Titian's *The Entombment* (*c*.1520). On the importance and aesthetic controversy around the later work of Titian, see *Late Titian and the Sensuality of Painting*, ed. Sylvia Perino Pagden and Giovanna Nepi Sciré (Venice: Marsillio, 2008).

3. In today's educational context, the idea of artistic research has become the favoured strategy of art institutions to legitimise their educational programmes. The proliferation of MFA programmes in artistic research in Europe and elsewhere may partly be thanks to the fact that the pedagogy and methodology behind artistic research remained undefined whereas its rhetorical power, its legitimising force, seems to be phenomenal. A cursory look at the rhetoric in writings on the topic paints a bleak picture. Artistic research, one reads, is a 'social innovation', something that 'does not imply strict rules, but basic guidelines' (see Mika Hannula, 'River Low, Mountain High: Contextualizing Artistic Research', in *Artistic Research*, ed. Annette Balkema and Henk Slager (Amsterdam: Rodopi, 2004)), and 'not knowing what exactly artistic research is, is a good thing', in fact it is a 'challenge' (Michael Swab, in the editorial for the inaugural issue of *JAR: Journal for Artistic Research* (2011) <http://www.jar-online.net/index.php/issues/editorial/480> (accessed 16 March 2015)). All of this may be true, but it has not stopped the educational apparatuses defining research in a narrow way, along the lines of market and measure.

4. Steven Connor, *Theory and Cultural Value* (Oxford: Blackwell, 1992), pp. 57–8.

5. Marquard Smith, 'Theses on the Philosophy of History: The Work of Research in the Age of Digital Searchability and Distributability', *Journal of Visual Culture*, 12 (2013): 375–403 (p. 377).

6. This is arguably one of the most forceful conclusions of Fredric Jameson's analysis of capitalism and culture in: *Postmodernism, or, the Cultural Logic of Late Capitalism* (New York: Verso, 1999). For a less explicitly Marxist approach to the appropriation of the counter-culture of the 1960s by postmodernist epistemic principles see Marianne DeKoven, *Utopia Limited: The Sixties and the Emergence of the Postmodern* (Durham, NC: Duke University Press, 2004).

7. Constant, 'Unitary Urbanism', in *The Situationists and the City*, ed. Tom McDonough (New York: Verso, 2009), p. 148.

8. In *Pressed for Time: The Acceleration of Life in Digital Capitalism* (Chicago: University of Chicago Press, 2014), Judy Wajcman studies how 'the rhythm of our lives, the very meaning of work and leisure, is being reconfigured by digitalization.' Unlike most recent studies on accelerated capitalism, which focus on how the individual subject or worker manages her time, Wajcman's study focuses on the time squeeze with the household as her unit of study. This allows her to demonstrate that the flexibility and creativity required of today's workers is not restricted to those working in the tertiary sector, or even to workers per se; it has become a generalised condition to which every member of the average household in the United States and Europe has become subjected.

9. The most comprehensive study of New Babylon is by architectural historian and critic Mark Wigley in *Constant's New Babylon*. Another treatise on New Babylon in the sphere of urban theory is the section devoted to it in Simon Sadler, *The Situationist City* (Cambridge, MA: MIT Press, 1999), p. 122.

10. For example, a transcript of Constant's 1960 lecture 'Unitary Urbanism', which outlines the economic and urban principles of New Babylon, was published in *Constant's New Babylon*, and then reprinted in *The Situationists and the City*, pp. 112–22.

11. I am borrowing this expression from: Gilles Deleuze and Félix Guattari, *What Is Philosophy?* (New York: Verso, 1995), p. 104.

12. The metaphor of diffraction was introduced by Donna Haraway and adopted by Karen Barad, who defines her 'practice of diffraction', somewhat non-committally, as 'reading diffractively for patterns of difference that make a difference'. See the interview with Karen Barad in *New Materialism: Interviews and Cartographies*, ed. Rick Dolphijn and Iris van der Tuin (Open Humanities Press, 2012), pp. 48–50, available at <http://open-humanitiespress.org/new-materialism.html> (accessed 16 March 2015).

13. Constant, 'Unitary Urbanism', p. 114.

14. Ibid. p. 114.

15. For an excellent overview of Cornelis van Eesteren's work as Amsterdam's city planner and as one of the intellectual forces behind the CIAM, see Kees Somer, *The Functional City: The CIAM and Cornelis van Eesteren, 1928–1960* (Rotterdam: NAi Publishers, 2007).

16. Constant, 'Unitary Urbanism', p. 114.

17. Constant, *Opstand van de homo ludens* (Bussum: Brand, 1969).

18. To get an idea of how Constant's work on the city compares to that of Guy Debord, for example, a comparative reading of Debord's 'Introduction to a Critique of Urban Geography' and Constant's 'Unitary Urbanism' would be very productive. For both texts, see *The Situationists and the City*.

19. Constant, *Opstand van de homo ludens*, p. 52.

20. Ibid. pp. 52–3 (emphasis added).

21. Ibid. p. 31.

15 From Étienne Souriau's *The Shadow of God* to Mats Ek's *Shadow of Carmen*

Fleur Courtois-l'Heureux

How MAY WE speculate about a character? There are characters of fiction who do not let history remain indifferent, who are tirelessly re-enacted, re-edited, remodelled, made sacred, demystified. Their actions, their personality, their style, their morality or immortality become the object of various interrogations and reinterpretations. Without a doubt, Carmen is one of those characters who have imposed themselves as an aesthetic and conceptual entity, spanning freely across arts and literature. As operas, plays and choreographies renew successively her presence, Carmen also encroaches on the fringes of intellectual culture. Beyond symbol or caricature, she becomes instrumental and is sometimes translated into what Gilles Deleuze calls a 'conceptual character'. In other words, a fictional character that hustles history possesses within itself the possibility of becoming the partial or total living figure of a philosophical problem. With Alfred North Whitehead, for instance, Carmen allows for the opposition of two points of view: the philosophers' and the censors'. The official censor, just like a naive child, considers Carmen morally and sees exclusively the representation of an ingenuous and unprincipled woman. On the contrary, the philosopher shall be attentive to the way music, singing, and dancing all contribute to representing a woman whose morality is certainly disturbing but out of purpose on stage.

> Of course smugglers are naughty people, and Carmen is carefree as to niceties of behaviour. But while they are singing their parts and dancing on the stage, morals vanish and beauty remains. [...] But the retreat of morals in the presence of music, and of dancing, and the general gaiety of the theatre, is a fact very interesting to philosophers and very puzzling to the official censors.[1]

How does a character call for speculation in the philosophical field, on the one hand, and in the choreographic field, on the other? A concrete example is seemingly the best way to ascertain whether the 'possibles' of such a question are well grounded. Would it be possible to test the concept of the one through the gesture of the other without falling into too simplistic a chiasmus? As an example – and somehow out of constraint – I have chosen to talk about Carmen and, more precisely, to discuss the 'speculated' Carmen through the choreography staged by Mats Ek in 1992. I will probe and compare the ideas of this Swedish choreographer and transplant them into the conceptual world of metaphysics. One concept has drawn my attention, and will play a role as an experimental axis between dance and philosophy: the concept of 'separating love' that Étienne Souriau developed in his book *L'ombre de dieu* [*The Shadow of God*] written in 1955.

Carmen emerged from Prosper Mérimée's[2] quill in 1845, prior to Georges Bizet's famous lyrical version from 1875. As is well known, the story caricaturises the exotic and barbarous eroticism of a Gypsy woman. While working in a cigar factory in Seville, Carmen seduces Don José, a Basque corporal destined for a military career. Her charms are the cause of him going astray: transforming him into a bandit and forcing him to commit crimes of the worst kind. Carmen only loves him as long as she does not feel obliged to. She refuses to be bound by any duty. 'If I love you, beware!'[3] she insists. Certainly, Don José wins her love by excelling in the wrong-doings she challenges him with. And by going against his own moral principles, he does everything possible to win that *amour fou*. Yes, he shall win it but only for a brief moment, only to lose it again afterwards. Mistake, challenge, ill-conceived speculation or 'a possible' nipped in the bud? He must pay attention to the love this woman may grant him, but he also should remember that she loves only when a true love abstains from trying to temper her. 'If you do not love me, I love you, and if I love you, beware!' Carmen's warning is less concerned with the dignity of the 'good Basque soldier', the dignity he had to lose in order to conquer her, than it is with her own insatiable desire to love exclusively when she is not forced to. Exhausted by the idolatrous love that he vows to her, Carmen prefers to die rather than to sacrifice her 'mode of existence'[4] for Don José. Her mode of existence, her aura? Being Carmen, being a love spell, means vanishing as soon as the spell is accomplished, as soon as she feels craved after. Mérimée wrote at the end of the story:

'You mean to kill me, I see that well', she said. 'It is fate. But you'll never make me give in.'

'I beg you', Don José tells her, 'Be reasonable! Listen to me! Every bit of the past is bygone. Alas!, you well know it: it is you who made me go astray; it is for you that I turned into a thief and a murderer. Carmen!, my Carmen!, let me save you and in so doing save myself!'

'Jose', she answered, 'what you ask is impossible. I don't love you anymore. You still love me, and that is why you want to kill me. If I liked, I could tell you some other lie, but I don't want to give myself the trouble. Everything is over between us. You are my rom [husband], and you have the right to kill your romi, but Carmen will always be free. A calli [bohemian] she was born, and a calli she'll die.'

'Is Lucas the one you love?', asked Don José.

'Yes, I have loved him – as I loved you – for an instant – less than I loved you, perhaps. But now I don't love anything anymore, and I hate myself for having loved you.'

Don José threw himself to her feet, seized her hands, damping them with his tears. He reminded her of all the happy moments they spent together. He offered to remain a bandit to please her. He offered her everything as long as she would love him once again.

She said:

'Loving you again? That is impossible! Living with you? I won't hear of it!' Rage took over him. He drew his knife. He wished she was afraid of him and asked him for mercy, but this woman was the devil itself. 'For the last time', he cried, 'will you stay with me?'

'No! no! no!', she replied stamping her foot. And she pulled off the ring he gave to her and cast it into the bushes.

He hit her twice.[5]

In its Latin sense, the word 'Carmen' means alternately a magic formula from which one can derive the term 'charm', a religious or judicial formula, and a song or poetry. Mérimée's Carmen inherited the charms used in the magical witches' formulas. She is a Gypsy, an expert not only in spells and elixirs, but also in amorous seduction. She bewitches her victims with her black, almond-eyed gaze, her dancing and languishing gestures, her joy and her impertinence, with her forbidden, provocative liberty and beauty. Her charm is certainly bewitching but above all it is a test to which, openly and rather mischievously, she constantly puts whoever wants to possess her. A test? Perhaps, like the one that the sirens sing to Ulysses and that the rhyme, mentioned above, adopts in the manner of a wave, or even in that of a fateful swirl for those who would have succumbed already to her charms: 'If you don't love me, I love you and if I love you, beware!' In other words, she confines love in 'non-reciprocity' and becomes the angel of such a problematic message.

In philosophy, loving is irrevocably a deed of either the powerful, whose infinite goodness does not need perfecting, or that of the human piety, mimicking to the best of its ability the divine example. But if the Gypsy woman sometimes indulges in an exchange of religious knick-knacks, she is totally foreign to charitable love. The

non-reciprocity test that she proposes is of another nature and of another taste. Her siren rhyme has much more affinities with Nietzsche's formula: 'If I love you, does it concern you?'[6]

In this regard, loving is the opposite of a contractual reciprocity. Loving does not commit anyone but myself. If you feel like being committed to this rush of mine, which touches you lightly or chills you, such a love shall thereby not be mine anymore but it shall be a fortress, quite dead and forsaken, in the hands of the most envious individuals. Loving is not an act stemming from a reciprocal commitment but from a solitary power. Defining reciprocity (viewed not as a blazing event but as a binding contract between two people) as a necessary condition for 'love' becomes for Carmen a hateful injunction. It is an order-word that she abjures, execrates and abhors. If she bewitches, it is not so much to possess the other but to allow him to dispossess himself from such an order-word.

Mats Ek's *Carmen*

In 1992, Mats Ek, a contemporary Swedish choreographer and director of the Cullberg Ballet (from 1985 to 1993), took on the challenge of making Carmen dance.[7] Ek's process is above all singular for its humorous code-play, extending from classic ballet to tragicomedy. Against the trend of abstract contemporary dance, he wisely infuses dramatic art in his multiple re-productions of the classical choreographic repertoire (*Antigone* (1979), *The Swan Lake* (1987), *Sleeping Beauty* (1996)). For his *Carmen*, Ek offers a game which, paradoxically, rather than degrading into pastiche or satire that would portray souls, instead intensifies them. How does he succeed with such a transition through the mere medium of dance? Regarding our concrete problem, would Carmen's performance, namely her humour, nourish or transform the Nietzschean vision of love?

Humour in Ek's hands is not a weapon of destruction: the systematic discrepancies between different performance levels result in a well-construed speculative machine. He does not laugh at the colonial image that views Carmen as an erotic and untamed creature; quite the opposite, he uses it as a seduction tool, which his Carmen handles with delight and impishness. A lucid and playful conscience slips into the colonial pattern. The halving of the character constitutes, in itself, a drama plane that also hosts a gestural splitting. The evocative and harmonious gestures of classic ballet are rife with redundancies, exaggeration, ruptures and abrupt inversions of movement, which are appropriated by modern and contemporary dance. But it is less such a rifeness than the mode to be rife with which gives Carmen's new world such a particular tint.

The infection Ek inoculates does not bespeak a relativistic threat of a contemporary dance dialectically solving the excess seriousness of classical and modern dance. This

is neither about mocking traditional codes nor about reducing them to dust. In Ek's choreography of Carmen, her stage presence embodies a metaphysical challenge. His humour does not limit itself to a blurring of boundaries: it takes the piece to new performance levels and manages to make us the partners in a new vision of Carmen. Ek substitutes the classic image of the femme fatale for the image of a tricky fox – not the figure of a black widow from which no one escapes, but rather that of a fox escaping from traps with polymorphic and baroque language. The fox is more elusive than startling. But how abstract does all this look at this stage! Preliminaries oblige, traps oblige.

Let us return to the example of Habanera: 'Love is a rebellious bird [. . .]. Love is a Gypsy child; it has never, ever, known the law; if you love me not, then I love you; and if I love you, beware!' The song is well known and it is easily associated with the choreographic image that many operas and ballets have alternately staged: Carmen, a demonic woman, scrutinises her suitors from head to toe, in a dignified, intrusive and provocative manner. Ek caricatures this presence, expected and speculated upon by all. Nevertheless, it is not Carmen who is rendered grotesque by such a caricature but rather the speculative projection of what one expects of her. 'Evading capture', elusive, the dancing Carmen applies trickery to the grotesque role which connotes her, and which she sends back to us: she naughtily overacts it, showing that the stereotyped characterisation of the femme fatale is nothing but an exotic mask.

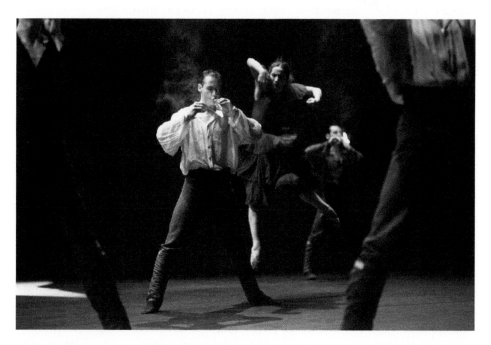

Carmen performed by the Cullberg Ballet, choreography by Mats Ek, Stockholm, 1996. Image copyright Lesley Leslie-Spinks

Besides being polymorphic in the way she appears to us, she is sometimes like an animal spasmodically sniffing the ground, sometimes rather like the Queen of Sheba. The dancer balances and oscillates between two levels of Carmen's embodiment: on the one hand her speculated fantasy and, on the other, her 'warning' ('if I love you, beware!'). The dancer excels at artfully holding her own characterisation at bay and thus avoiding merging with it. She does not incarnate it but she extends the experiment of non-reciprocity.

Two controversies seem blatant in the stage embodiment of Carmen. On the one hand, we have the double play between an exotic femme fatale and a cunning fox lying in wait, appearing and disappearing in dazzles. On the other hand, we find a gestural humour shedding light on a polymorphic art, of which the intelligence and the rapidity of execution act like a charm: we are seduced by the dancer's ability to multiply the different levels that make of Carmen a truly ambiguous and unassailable character. Neither the symbol of an object of desire nor that of immortality. Souriau will help us respond to the controversies contained in Ek's *Carmen*. In his work *L'ombre de dieu*,[8] loving beings are instituted by Nietzsche's formula: 'If I love you, does it concern you?'[9] This formula is a reference to Goethe. In *Wilhelm Meister's Apprenticeship*, Philine is the woman who says: 'If I love you, does it concern you?' Goethe probably derives this quote from Spinoza's *Ethics*, Book 5, proposition XIX: 'He, who loves God, cannot endeavour [*conari*] that God should love him in return.'

The 'Separating-Love' in *L'ombre de dieu*

It is my hypothesis that Ek's *Carmen* succeeds in making love exist in an anti-Platonic way and urges us, by means of his art of dance, to experiment, under the rules of a humorous necessity, with the metaphysical proposition of the 'separating-love', as developed by Souriau in his work. According to Plato, as Souriau reads him, love promulgates a praise of infidelity. Indeed, in the Platonic dialectic of the sensible and the intelligible, the idea of love is attained only by the systematic exercise of an infidelity to the loved-beings, to the benefit of objects that become more and more elevated: the Ideas. Thus Souriau reminds us of the nature of the Platonic formula: 'The idea of the improvement of love by infidelity, by the abandonment of the primary object for a more elevated and nobler one. Beyond the beautiful beings, love Beauty itself, said Plato.'[10]

But then a double error slips into this idealist conception. Firstly, Plato confuses love's value with that of its object. Similarly, by associating love's object with an ideal and impossible object, Don Juan keeps meeting women in a recurring, deserting way, the one way that can venerate the impossibility of finding real love. Honouring perfection implies testifying to the imperfections of all beings, and of oneself to begin

with! Secondly, Plato confounds the art of loving and the art of contemplating, by postulating that the idea of Beauty, which one will eventually manage to recognise in the loved being, is more important than the fact of loving someone for what s/he actually is. Souriau objects to Plato and exerts a demand for fidelity to the loved being and not to the shadow that s/he engenders in him/her. Souriau says: 'True love is compelled to conserve the privilege of the loved one.'[11]

Is Souriau harking back to Christian fidelity? No. In fact, fidelity in the Christian sense is nothing but a prolongation of the Platonic infidelity to the loved-beings, benefiting the ideal shadows transmigrating through them. Husband and wife swear fidelity not for themselves but for a religious ideal. Souriau confronts us with a completely different form of fidelity. This form will bear witness to a demanding love, one that requires a resistance to the Platonic temptation, that is to love what the loved being conveys as transcendence, soul, erotic fantasy, ideas. For all that, Souriau does not presume that one should love the body for what it is, rather than the soul that would be hidden in it, in other words the moment of incarnation. If love is fidelity, it is so in the sense of one having to attach oneself to the loved being in a radical manner: running every conceivable risk, including that of refusing oneself to a being even more deserving to be loved.

Radically, because a loved being has its own value, its own dignity and its own demanding efficiency: it engages the one who loves in respecting the distance between the loved-being and the transcendence, the aura or the soul that it mediates. In this way, a real love will be 'separating' when the one who loves makes the necessary separation so that the loved one will not be the apologist for idolatry. Certainly, the loved one mediates a 'beyond', but on the one hand, s/he does not merge with this beyond, while, on the other, s/he invents the level of immanence that allows for such a mediation. I love her or him not because I recognise in her or him a sublime aura; I love her or him because s/he has succeeded, innocently and subtly, in an exquisite pirouette: to mediate in my sensibility and in my intelligence a transcendence that s/he has succeeded in taking charge of. I love her or him because it compels me to engage in it and it teaches me to love her or his art of mediation and of separation. Souriau writes: 'Love assumes the distance between the loved being and the spiritual form which conferred this aura on him, while idolatry ignores it.'[12]

Carmen is not only a mediator of the kind of love that demands anti-idolatrous separation, she is also its ambassador. Far from being the black widow who weaves insurmountable traps and devours her prey, Carmen puts her head in the lion's mouth in order to remind him better that she is only an occasion to let the shadow of love sparkle. By letting herself be killed, she negotiates a more important matter: she disarms the reciprocity that is expected from her. If she loves, she knows that the aura bestowed upon the loved one, 'the mediator of love', is only temporary, and, by

doing so, she puts on watch the idolaters who might confound her 'non-reciprocal love' ('If you don't love me, I love you') with their reciprocal kind of love ('If I love you, you have to love me and reciprocally'). It is by a trail of circumstances that the loved one is invested with a charge of love, and s/he could easily be disinvested from it. The equilibrium is always precarious and Carmen sings this disparity like the perpetual adventure of occasions.

Love is *Bohème*: it transits like many circumstantial flashes through the fleeting mediators – whose ambassador is Carmen – to the idolatrous. Don José, the prototype of the idolatrous, sometimes iconophile and sometimes iconoclast, has neither heard the warning nor succeeded in the test: to love Carmen as a temporary mediator of love, to stay faithful to her crafty power to catch the occasion for love. This speculative presence of Carmen is what Ek makes us experience. Thanks to a polymorphic and humorous choreography, he succeeds in elaborating Carmen outside an idealist vision: the gestures 'dance' those 'winks' that are events and speculative clockworks of a crafty, foxy machine, to confront oneself with a love that separates the levels of immanence from those of transcendence.

Notes

1. Alfred North Whitehead, *Modes of Thought* (New York: Free Press, 1968), p. 13.
2. Prosper Mérimée, *Carmen* (Paris: Editions d'art de l'intermédiaire du Bibliophile, 1929).
3. The formula comes from the song 'L'amour est un oiseau rebelle' [Love is a rebel bird], a *habanera* written by Sebastián Iradier which was inserted in the first act of Bizet's opera in 1875. In the nineteenth century, *habanera* referred to a Cuban contredanse mixing face-to-face ballroom dances imported by colonists and Afro-American slaves' *candombé*. Spanish colonists from Argentina and Uruguay would take over the *habanera* to create *tango*. A dance but also a musical genre, *habanera* was also listened to by Catalan fishermen.
4. Etienne Souriau, *Les différents modes d'existence* [1943], introduced by Bruno Latour and Isabelle Stengers (Paris: Presses Universitaires de France, 2009).
5. Mérimée, *Carmen* [trans. author].
6. Friedrich Nietzsche, *Le Gai savoir* (Paris: Gallimard [1882–6], 1950), pp. 181, §141.
7. Mats Ek's ballet is made for the music composed in 1967 by Russian composer Rodion Chtchedrine. In this version, voices from Henri Meilhac and Ludovic Halévy's booklet for Bizet's opera are replaced by rhythm sections of drums and strings.
8. Étienne Souriau, 'Chapitre IV: L'amour séparant', in *L'ombre de dieu* (Paris: Presses Universitaires de France, 1955), pp. 126–72.
9. Ibid. p. 168: 'Si je t'aime, est-ce que cela te regarde?'

10. Ibid. p. 164: 'l'idée de perfectionnement de l'amour par l'infidélité, par l'abandon de son premier objet pour un objet plus élevé et plus noble. Par delà les êtres beaux, aimez le Beau lui-même, disait Platon.'

11. Ibid. p. 164.

12. Ibid. p. 171: 'L'amour assume la distance de cet être à la forme spirituelle qui lui conférait cette investiture, tandis que l'idolâtrie la méconnaît.'

Notes on Contributors

Armen Avanessian studied philosophy and political science in Vienna and Paris. After completing his dissertation in literature, 'Phenomenology of the Ironic Spirit: Ethics, Poetics, and Politics of Modernity' (in Bielefeld), he was a freelance journalist and editor in Paris and a publisher in London. In 2007 Avanessian took up his current position at the Peter Szondi Institute for Comparative Literature at the Free University Berlin. In 2011 he was a Visiting Fellow in the German Department at Columbia University and in 2012 at the German Department at Yale University. In 2012 he founded a research platform on Speculative Poetics including a series of events, translations and publications: <www.spekulative-poetik.de>. Avanessian has published *Phänomenologie ironischen Geistes. Ethik, Poetik und Politik der Moderne* (Fink, 2010) and (together with Anke Hennig) *Präsens. Poetik eines Tempus* (Diaphanes, 2012). He has also edited several volumes, including (together with Winfried Menninghaus and Jan Völker) *Vita aesthetica. Szenarien ästhetischer Lebendigkeit* (Diaphanes, 2009), (together with Luke Skrebowski) *Aesthetics and Contemporary Art* (Sternberg, 2011), *Realismus Jetzt! Spekulative Philosophie und Metaphysik für das 21. Jahrhundert* (Merve, 2012), (with Björn Quiring) *Abyssus Intellectualis. Spekulativer Horror* (Merve, 2013), among many other titles.

Érik Bordeleau is researcher at the SenseLab (Concordia University, Montreal). He is the author of *Foucault anonymat* (Le Quartanier, 2012, Spirale Eva-Legrand 2013 award) and of *Comment sauver le commun du communisme?* (Le Quartanier, 2014). He is interested in the current speculative turn in contemporary continental thought and has recently published an article entitled 'Bruno Latour and the Miraculous Present of Enunciation' in the book *Breaking the Spell: Contemporary Realism Under Discussion* (Mimesis, 2015). He is also co-editing and publishing an

article in *Nocturnal Fabulations: Ecology, Vitality and Opacity in the Cinema of Apichatpong Weerasethakul* (forthcoming in 2016, Immediations book series, Open Humanities Press).

Adi Efal is a postdoctoral fellow at the a.r.t.e.s graduate school for the humanities, University of Cologne. Before, she was a Gerda Henkel research fellow at the Thomas Institute of the University of Cologne (2012–13) and a Fritz Thyssen fellow at the art history institute of the University of Cologne (2010–12). In 2010 she was a fellow at the IFK Vienna, in 2007–8 a fellow at the Rosenzweig Center for German Jewish Culture in the Hebrew University of Jerusalem, and in 2005–6 at the ENS Paris. She has been publishing in the fields of art historiography and art theory. She is responsible for the Hebrew translations of Alain Badiou's *L'éthique* (2002) and Jacques Rancière's *Le partage du sensible* (2004). Between 1999 and 2009 she taught in various academic institutes in Israel, among them the Tel-Aviv University and the Bezalel Academy of Art and Design in Jerusalem.

Francis Halsall is a Lecturer in the History/Theory of Modern & Contemporary Art at the National College of Art and Design, Dublin where he is director (with Declan Long) of MA Art in the Contemporary World (<www.acw.ie>). In Spring 2014 he was visiting Critical Studies Fellow at Cranbrook Academy of Art (Mi.) discussing the themes of 'Systems' and 'Objects', and he is currently Research Fellow at the Department of Art History and Image Studies at the University of the Free State, Bloemfontein, SA. His research practice is situated across three main areas: (1) the history, theory and practice of modern and contemporary art; (2) philosophical aesthetics; and (3) systems thinking. He has published widely in both academic and more informal styles (e.g. catalogue essays) and participated in numerous public talks and discussions in all three areas. Francis Halsall is currently completing a short book called *Systems Aesthetics* and a major research project on Niklas Luhmann's aesthetics (Philosophy, University College Dublin). Publications include the books *Systems of Art* (Peter Lang), *Rediscovering Aesthetics* (ed.) (Stanford University Press) and *Critical Communities and Aesthetic Practices* (ed.) (Springer Verlag). Recent work, ideas and publication details can be found at <www.alittletagend.blogspot.com>.

Fleur Courtois-l'Heureux has a PhD in Philosophy from the Université libre de Bruxelles (2009). She was a postdoctoral researcher in anthropology of dance at the University Blaise Pascal, Clermont-Ferrand (2009–10) and is now a Postdoctoral Researcher at the National Fund for Scientific Research (FRS-FNRS, 2010–14). She experiments with contemporary philosophical concepts through a prism of arrangements which are specific to the field of dance. She works inside the GECo (Groupe

d'Etudes constructivistes), which is part of the PHI-Research Centre in Philosophy at the ULB. Courtois-l'Heureux is also Professor of Philosophy at the INSAS, Brussels' college for actors and directors in theatre and cinema. She has published *Arts de la ruse. Un tango philosophique avec Michel de Certeau* (Editions modulaire européennes, Coll. « Divin et sacré », 2010) and various papers, such as 'Bon pied, bon œil: expériences fétichistes de l'objet à l'épreuve de la danse', in *L'Année Mosaïque* (n°1, 2012).

Bram Ieven is a philosopher and cultural theorist. He is an assistant professor of Dutch Studies at Leiden University, where he teaches and does research on Dutch art and politics from modernism to the present day. Recent essays have dealt with the aesthetics of Bernard Stiegler (published in *New Formations*) and Jacques Rancière (published in *Rancière and Film*, Edinburgh University Press).

Vlad Ionescu studied philosophy and art theory at the Institute of Philosophy, KU Leuven. In 2012 he defended his PhD thesis on the aesthetics and epistemological grounds of the modern science of art as it appears in the work of Aloïs Riegl, Heinrich Wölfflin and Wilhelm Worringer. Besides publishing on Deleuze's interpretation of these authors (in *Deleuze Studies*) he has published on the aesthetics of Jean-François Lyotard (*Esthetica, Cultural Politics*). Finally he has co-translated and co-edited the writings of Lyotard on contemporary art and artists in a series of volumes published by Leuven University Press (2009–13). He has taught history and theory of architecture in Brussels, Leiden and Ghent. Currently, he is a researcher at the Faculty of Architecture and Art, University of Hasselt.

Sarah Kolb, art theorist and curator, is university assistant at the Institute of Art History and Art Theory at the University of Art and Design in Linz and is doing a doctorate on Henri Bergson and Marcel Duchamp at the Academy of Fine Arts in Vienna. After studying philosophy, physics, history of arts, et al. at the University of Vienna she was IFK Junior Fellow at the International Research Centre for Cultural Studies in Vienna (2005–6), IFK Abroad Fellow at the collaborative *research centre 'Media and Cultural Communication'* in Cologne (2006–7), curator at the Wiener Secession, Association of Visual Artists (2007–8) and scholarship holder at the Duchamp Research Centre at the Schwerin State Museum (2011–12). After numerous publications in the fields of philosophy and art theory she is currently co-editing an anthology on *The Logic of the Imaginary. Diagonal Science after Roger Caillois.*

Bertrand Prévost, art historian and philosopher, is Maître de conférences at the University of Bordeaux. He has worked mainly on Renaissance Italian art and theory (*La peinture en actes. Gestes et manières dans l'Italie de la Renaissance,* Actes Sud,

2007; *Botticelli. Le manège allégorique*, Ed. 1:1, 2011; *Peindre sous la lumière. Leon Battista Alberti et le moment humaniste de l'évidence*, Presses Universitaires de Rennes, 2013). His research focuses on an aesthetic theory of expression, based on an expanded notion of cosmetics.

Andrej Radman has been teaching design studios and theory courses at TU Delft Faculty of Architecture and the Built Environment since 2004. In 2008 he was appointed Assistant Professor of Architecture and joined the teaching and research staff of the Delft School of Design (DSD). As a graduate of the Zagreb School of Architecture in Croatia, Radman received a Master's Degree with Honours and a Doctoral Degree from Delft University of Technology. His current research focuses on new materialism in general and radical empiricism in particular. Radman is a member of the National Committee on Deleuze Scholarship, and production editor and member of the editorial board of the peer-reviewed architecture theory journal *Footprint*. He is also a licensed architect with a string of awards from national competitions, including the Croatian Association of Architects annual award for housing architecture in Croatia in 2002.

Elisabeth von Samsonow, artist and philosopher, is Professor of Philosophical and Historical Anthropology at the Academy of Fine Arts, Vienna, and Visiting Professor at the Bauhaus University Weimar (2012–13). She is a member of GEDOK Munich, foreign correspondent for *Multitudes* and editor of *Recherche*. She is involved in various international activities both as an artist and curator. Her teaching and research focus on collective memory, the relationship between art and religion, female identification, sacral and profane androgyny, and the dissolution of the modern self. Her work as an artist is concerned with the systematic and symbolic place of sculpture in the framework of contemporary multimedia. Her publications include: *Die Erzeugung des Sichtbaren. Die philosophische Begründung naturwissenschaftlicher Wahrheit bei Johannes Kepler* (Fink, 1987), *Fenster in Papier: Die imaginäre Kollision der Architektur mit der Schrift oder die Gedächtnisrevolution der Renaissance* (Fink, 2001), *Was ist anorganischer Sex wirklich? Theorie und kurze Geschichte der hypnogenen Subjekte und Objekte* (Walther König, 2005), *Anti Elektra. Totemismus und Schizogamie* (Diaphanes, 2007), *Egon Schiele: Ich bin die Vielen* (Passagen Verlag, 2010) and *Egon Schiele Sanctus Franciscus Hystericus* (2012). Artistic projects include: *The Secrets of Mary Magdalene*, Jerusalem 2008; Performance/procession en honneur de l'Électre, Innerschildgraben/NÖ. 2009; *Ariadne, sculpture pour le chemin de Dionyse*, Mistelbach en Autriche 2011; *Hippo Hypno Schizo Hoch Zeit*, performance dans le Musée Freud Bergstrasse dans le cadre de Vienna Art Week 2011, *Elektra* Belvedere Vienne, Expo GOLD curateur: Thomas Zaunschirm; *Samsonow Transplant*

Parasonic Orchestra. Von Samsonow is also translator and editor of several German editions of Giordano Bruno. See also <www.samsonow.net> and <http://pages.akbild. ac.at/anthropologie/samsonow.html>.

Lars Spuybroek received international recognition after building the *HtwoOexpo* in 1997, the first building in the world that incorporates new media and consists of a continuous geometry. With his Rotterdam-based office NOX he built the *D-Tower*, an interactive structure changing colour with the emotions of the inhabitants of a city, and the *Son-O-house*, a public artwork that generates music by visitors exploring the space. Spuybroek has won several prizes and has exhibited all over the world, among them presentations at the Venice Biennale, the Centre Pompidou in Paris, the Victoria & Albert in London and the Guggenheim Bilbao. He taught at many different universities such as Columbia University in New York, the Bartlett in London and the ESARQ in Barcelona, and from 2001 to 2006 he was Professor of Digital Design Techniques in Kassel, Germany. Since 2006 he has been Professor of Architecture at Georgia Institute of Technology in Atlanta and has held the Ventulett Distinguished Chair until 2011. He published the first fully theoretical account of his work titled *The Architecture of Continuity* with V2_NAI Publishers (2008). He started the Research & Design book series with *The Architecture of Variation* (Thames & Hudson, 2009) and *Textile Tectonics* (NAI Publishers, 2011), publications that combine theoretical with methodological research and design. His latest book titled *The Sympathy of Things: Ruskin and the Ecology of Design* (NAI Publishers, 2011) is a theoretical revisiting of the ideas of John Ruskin within the framework of both historical and contemporary thought.

Kerstin Thomas, art historian and philosopher, is director of the Emmy-Noether research Group, *Form und Emotion. Affektive Strukturen in der französischen Kunst des 19. Jahrhunderts und ihre soziale Geltung* at Johannes Gutenberg University in Mainz. The aim of this project is to explore how aesthetic forms transfer emotions. Thomas is interested in art history and aesthetic theory and has published several books and articles on the way in which artists like Seurat, Puvis de Chavannes, Gauguin and Cézanne make use of mood to appropriate the world, among which are *Welt und Stimmung bei Puvis de Chavannes, Seurat und Gauguin* (Deutscher Kunstverlag, 2010) and *Stimmung. Ästhetische Theorie und künstlerische Praxis* (Deutscher Kunstverlag, 2010). Currently, she is working on a book on Meyer Schapiro.

Sjoerd van Tuinen is Assistant Professor in Philosophy at Erasmus University Rotterdam and Coordinator of the Centre for Art and Philosophy (<www.caponline. org>). In 2009 he received his PhD for a dissertation on Deleuze and Leibniz at Ghent

University. He is editor of numerous books, including *Deleuze and the Fold. A Critical Reader* (Basingstoke: Palgrave Macmillan, 2010), *De nieuwe Franse filosofie* (Amsterdam: Boom, 2011) and *The Polemics of Ressentiment* (New York and London: Bloomsbury, forthcoming 2017), and is the author of *Sloterdijk. Binnenstebuiten denken* (Kampen: Klement, 2004). He is currently finalising a monograph in which he proposes a philosophical concept of Mannerism, entitled *Matter, Manner, Idea: Deleuze and Mannerism*.

Kamini Vellodi is Lecturer in Contemporary Art Practice and Theory at Edinburgh College of Art, University of Edinburgh, and a practising artist. Her research focuses on the conceptual and methodological implications of Deleuze's philosophy for art history, and her work has appeared in publications including *Art History, Parrhesia* and *Zeitschrift fur Kunstgeschichte*. She is currently completing a book on Jacopo Tintoretto and Deleuze's philosophy of the diagram for Bloomsbury Press.

Index